Spoils of Knowledge

Library of the Written Word

VOLUME 111

The Handpress World

Editor-in-Chief

Andrew Pettegree (*University of St. Andrews*)

Editorial Board

Ann Blair (*Harvard University*)
Falk Eisermann (*Staatsbibliothek zu Berlin – Preußischer Kulturbesitz*)
Shanti Graheli (*University of Glasgow*)
Earle Havens (*Johns Hopkins University*)
Ian Maclean (*All Souls College, Oxford*)
Alicia Montoya (*Radboud University*)
Angela Nuovo (*University of Milan*)
Helen Smith (*University of York*)
Mark Towsey (*University of Liverpool*)
Malcolm Walsby (ENSSIB, *Lyon*)
Arthur der Weduwen (*University of St. Andrews*)

VOLUME 90

The titles published in this series are listed at *brill.com/lww*

Spoils of Knowledge

Seventeenth-Century Plunder in Swedish Archives and Libraries

By

Emma Hagström Molin

BRILL

LEIDEN | BOSTON

Cover illustration: King Gustavus Adolphus of Sweden (1594–1632) with Jesuits in the background burning books. Excerpt from copper plate in Uppsala University Library.

This book was originally published by Makadam Publishers (Gothenburg) under the title Krigsbytets Biografi. Byten i Riksarkivet, Uppsala universitetsbibliotek och Skokloster slott under 1600-talet. ISBN 978-91-7061-180-3. (2015)

Library of Congress Cataloging-in-Publication Data

Names: Molin, Emma Hagström, author. | Öhman, Judith Rinker, translator.
Title: Spoils of knowledge : seventeenth-century plunder in Swedish archives and libraries / by Emma Hagström Molin ; translated by Judith Rinker Öhman.
Other titles: Krigsbytets biografi. English | Seventeenth-century plunder in Swedish archives and libraries
Description: Leiden ; Boston : Brill, [2023] | Series: Library of the written word, 1874-4834 ; volume 111 | "This book was originally published by Makadam Publishers (Gothenburg) under the title "Krigsbytets Biografi. Byten i Riksarkivet, Uppsala universitetsbibliotek och Skokloster slott under 1600-talet." ISBN 9789170611803 (2015)." | Includes bibliographical references and index.
Identifiers: LCCN 2022051522 (print) | LCCN 2022051523 (ebook) | ISBN 9789004472051 (hardback) | ISBN 9789004538238 (e-book)
Subjects: LCSH: Archival materials—Sweden—Uppland—History—17th century. | Books—Sweden—Uppland—History—17th century. | Libraries—Sweden—Uppland—History—17th century. | Sweden. Riksarkivet. | Skoklosters slott. | Uppsala universitetsbibliotek.
Classification: LCC DL603 .M6513 2023 (print) | LCC DL603 (ebook) | DDC 025.3/41409485034—dc23/eng/20221220
LC record available at https://lccn.loc.gov/2022051522
LC ebook record available at https://lccn.loc.gov/2022051523

Typeface for the Latin, Greek, and Cyrillic scripts: "Brill". See and download: brill.com/brill-typeface.

ISSN 1874-4834
ISBN 978-90-04-47205-1 (hardback)
ISBN 978-90-04-53823-8 (e-book)

Copyright 2023 by Koninklijke Brill NV, Leiden, The Netherlands.
Koninklijke Brill NV incorporates the imprints Brill, Brill Nijhoff, Brill Hotei, Brill Schöningh, Brill Fink, Brill mentis, Vandenhoeck & Ruprecht, Böhlau, V&R unipress and Wageningen Academic.
All rights reserved. No part of this publication may be reproduced, translated, stored in a retrieval system, or transmitted in any form or by any means, electronic, mechanical, photocopying, recording or otherwise, without prior written permission from the publisher. Requests for re-use and/or translations must be addressed to Koninklijke Brill NV via brill.com or copyright.com.

This book is printed on acid-free paper and produced in a sustainable manner.

PRINTED BY DRUKKERIJ WILCO B.V. - AMERSFOORT, THE NETHERLANDS

For my family

Contents

Preface IX
Acknowledgements X
List of Figures XII
Abbreviations XIV

Introduction: In the King's Treasury 1
1. Uncovering Spoils of Knowledge in Swedish Collections 3
2. Writing Histories from Spoils: Methodological and Contextual Considerations 8
3. Cases and Sources: Spoils in Inventories, Lists and Catalogues 16
4. Some Prerequisites for Swedish Imperial Collecting 21

1 Placed in Chests: The Making of Cultural Spoils in Seventeenth-Century Europe and Beyond 24
1. Plundering and Ruining in the Age of Grotius 27
2. Plundering, Ruining and Cultural Plunder in Swedish Sources 31
3. Cultural Plunder in Livonia and Prussia 36
4. Collecting and Conserving Archives and Libraries 40
5. The Notable Absence of Spoils, *Spolia* and Trophies 45
6. Conclusion: Unstable Spoils of War 49

2 Archive Trouble: The Mitau Files in Vasa History 52
1. Archive Fever in Vasa Administration 53
2. The Documents from Mitau 58
3. The Material, Geography and Rarity of Archival Spoils 61
4. 'As a Soul within a Body': Archive Rooms 63
5. Utter's Archive Order: Documents Narrating Vasa History 65
6. The Mitau Documents' Transformations 67
7. Restitution and Rebirth 72
8. Post-Fire Order, Collectors and Thieves 76
9. Conclusion: Archive Trouble 81

3 Library Confessions: Catholic Books, Jesuit Epistemology and Temporality at Uppsala University Library 84
1. 'It Is Not Extraordinary': Library Beginnings 85
2. The Material, Geography and Confession of Library Spoils 89
3. Parting of the Prussian Spoils 95

4	Library Materialisations 98
5	Ordering the Collections 103
6	The Effects of Spoils 110
7	Material and Immaterial Movements 114
8	Mould and Disorder: The Challenges of Preservation 117
9	Back in the War Chests 123
10	Conclusion: Library Confessions 124

4 War Museums: *Spolia Selecta* in Carl Gustaf Wrangel's Skokloster 127
1. The Encyclopaedic Museums of Skokloster: Beginnings 128
2. The Creation of the Rothkirch Spoils 131
3. Confessional Spoils 133
4. Varieties of Booty 135
5. Practical Spoils 137
6. The Wrangel Library at Skokloster: Past and Present 138
7. Discrepancy in the Descriptions and Numbers of Wrangel's Book Spoils 142
8. *Bibliotheca Selecta, Spolia Selecta* 146
9. Wrangel's Armoury and the Rothkirch Spoils 148
10. Art Chambers, War and Genealogical Spoils 151
11. Skokloster's Geography 155
12. Skokloster's Narrative and Temporal Tangle 159
13. Conclusion: War Museums 162

Conclusion: Spoils of Knowledge, Triumph and Trouble 164
1. Making Spoils in the Seventeenth Century 164
2. Triumph and Trouble: The Effects of Knowledge Spoils 169
3. Enduring Instabilities: From Spoils of Knowledge to Swedish Spoils of War, Reconstructions and Restitutions 171

Bibliography 175
Illustrations 190
Index 210

Preface

This book is the English translation of my PhD thesis, earned in the history of ideas and published in Swedish in 2015. Multidisciplinary at its essence, it merges perspectives and approaches from art as well as book and media history with those from the history of science and ideas. While the chapters have been directly translated into English and thereafter somewhat altered, I have chosen to rewrite the introduction and conclusion altogether. As I have wanted to do justice to the works and debates that inspired and assisted the research I undertook as a PhD student between 2010 and 2015, I have only made moderate updates to the bibliography of this book during my review of the manuscript. Nevertheless, since much has happened since 2015 in the field of cultural looting and collection studies, I have wanted to acknowledge this by including a selection of recent works that have been important to the internationalisation of my topic. All in all, this means that particularly my discussion of previous scholarship and methodology has a certain temporality to it. My hope is that this temporality provides the reader with a useful historiographical gaze on the field(s).

Acknowledgements

I owe the deepest gratitude to my patient editor, Andrew Pettegree, for his interest in my research and for making this book happen: a simple thank you is not enough! I also wish to thank Judith Rinker Öhman for her excellent work with the translation and copy editing of the manuscript. Many thanks to the Swedish foundations that financed Judith's work: Anérstiftelsen, Delegationen för Militärhistorisk forskning, Åke Wibergs stiftelse and Stiftelsen Konung Gustaf VI Adolfs fond för svensk kultur. A special thank you goes to all the wonderful archivists, librarians and museum officials, both in Sweden and abroad, who have assisted my research for over ten years.

I am indebted to many colleagues and friends who have supported my scholarly development and the internationalisation of my research. First of all, I wish to thank Helen Smith, William H. Sherman, Mark Jennings and Simon Ditchfield, who all patiently listened to my broken English when I was a visiting PhD student at the Centre for Renaissance and Early Modern Studies at the University of York. Brita Brenna, who reviewed my dissertation that I defended in June 2015, offered me valuable criticism that I have tried to consider when adapting the thesis to this book. I can only hope that I have succeeded to some extent, and I could not have wished for a better opponent. For this, I owe Brita many thanks. I also wish to thank the review committee for their important remarks: Mårten Snickare, Hjalmar Fors, Eva Nilsson Nylander and Leif Runefelt, thank you very much!

I had the great privilege to spend five months at the Max Planck Institute for the History of Science in Berlin as a visiting postdoc in 2016. My sincerest thanks to Lorraine Daston, who invited me, and to all the generous scholars at the MPI with whom I enjoyed many fruitful discussions. I especially want to thank Jaya Remond, Clare Griffin, Sebastian Felten, Katja Krause, Tamar Novick, Anja Sattelmacher, Minakshi Menon and Ryan Dahn for their friendship. In April 2016, I was invited to give two lectures in Warsaw, which was a highly rewarding experience. A special thanks to Katarzyna Wagner, who organised everything, and to Magdalena Wroblewska and all the wonderful scholars and museum officials who made my visit so memorable. I also want to thank Elisabeth Wåghäll Nivre, who invited me to join the workshop Skokloster as a Laboratory of Collection Studies in 2017, and to Gerhild Williams, who invited me to the *Frühe Neuzeit Interdisziplinär* Conference in 2018, which was a truly inspiring meeting.

Thanks to the Swedish Research Council, which awarded me a postdoc that took me back to Berlin in 2017, and to Anke Te Heesen and the Lehrstuhl für

ACKNOWLEDGEMENTS

Wissenschaftsgeschichte that housed me for two years. Anke is a benevolent mentor and I am obliged to her, not least when it comes to the making of this book. To the dear colleagues I met at the HU – Eric Engstrom, Lara Keuck, Mathias Grote, Susanne Saygin, Kerstin Pannhorst, Alrun Schmidtke, Allison Huetz, Anne Greenwood MacKinney, Alfred Cheesman, Laura Hassler, Carla Seeman and Seraphina Rekowski – thank you for making the Lehrstuhl such a terrific academic environment and workplace. I am also very grateful to have had the opportunity to talk at the Translocations conference in Berlin in December 2019, organised by Bénédicte Savoy's research group at the Technische Universität. A special thanks to Robert Skwirblies, who invited me to write for the Translocations anthology, and to Isabelle Dolezalek, who invited me to Universität Greifswald to talk about spoils and object-biographical method in January 2020. In December 2020, I had the opportunity to present part of my introduction chapter and book proposal at the colloquium led by Daniela Hacke at the Freie Universität. My sincere gratitude to Daniela Hacke, Birgit Näther and the all the participants who had an interest in and took the time to review my work.

Since 2017 the Department of History of Science and Ideas at Uppsala University is my academic home in Sweden, a big thank you to my lovely colleagues there, it is a great pleasure to work with you. Above all, I owe many thanks to my brilliant and generous colleague Hanna Hodacs, for reading the entire manuscript draft and supplying me with insightful suggestions for how to improve it. Thank you for pointing out its weaknesses, and for being such a great and fun discussion partner. Any errors that remain are of course my own. Lastly, a special thanks to my interdisciplinary mate Cecilia Rodhén for listening to my endless ranting about how to analyse plunder, and for bringing my attention back to the core of my thoughts: classification.

To my beloved family and friends who have supported me when I have needed it the most – Mum, Dad, Johanna and family, Erez, Helena, Lydia, Per, Daniel, Johan, Silke, Jaya, Annika, Lisa and Mari – thank you all for all the fun, and for your patience and faith in me. Now, let's have some champagne.

Stockholm, April 2022

Figures

1. The Swedish Empire at its height, in 1658. Wikimedia Commons 190
2. Soldiers plundering a farm during the Thirty Years War, by Sebastiaen Vrancx. Wikimedia Commons 191
3. Map of Danzig (Gdańsk) area. Skokloster Castle 192
4. Map of the historical region Livonia. Wikimedia Commons 193
5. Parts of the Mitau spoils preserved in the Royal Armoury in Stockholm. Photo: Göran Schmidt 193
6. Copperplate depicting Gustavus Adolphus, with Jesuits in the background burning books. Photo: Uppsala University Library 194
7. Tre Kronor Castle burning in 1697. Wikimedia Commons 195
8. First page of Per Månsson Utter's 1622 list of the documents from Mitau in the new cabinet. Photo: The National Archives 196
9. Per Månsson Utter's 'coat of arms book', arranged to show the ancestry of various people of the Swedish nobility, including the Vasas. X4, UUB. Photo: Uppsala University Library 197
10. The Royal Castle Tre Kronor in Stockholm in the 1660s. Wikimedia Commons 197
11. Call number Schirren no. 6, or a parchment document from the early thirteenth century that became spoils in Mitau 1621. Photo: The National Archives 198
12. Map over Uppsala before the fire of 1702. The library had then been moved from building P, *Consistorium academicum*, to building O, 'Gustavianska academien'. From Johan Benedict Busser, *Utkast till beskrifning om Upsala* (Bromberg: Uppsala, 1979 [1769]). Wikimedia Commons 199
13. Drawing of the building that housed the old Uppsala University Library, c.1700, U65, UUB. Photo: Uppsala University Library 200
14. The two first catalogues, K2 and K3. UUB. Photo: Uppsala University Library 201
15. A page from catalogue K5a, UUB, showing how the Lutheran theology is described in different ways – first as 'our' and then as 'the latest' or 'Lutheran'. Photo: Uppsala University Library 202
16. Skokloster Castle around 1860, in Julius Axel Kiellman Göranson's guide. Wikimedia Commons 203
17. Map of Denmark, seventeenth century. Wikimedia Commons 204
18. First page of the list recording Wrangel's Rothkirch spoils, in the catalogue '*Bibliotheca Rothkirchiana equestris*', E 8580, Skokloster collection, RA Marieberg. Photo: The National Archives 205

FIGURES

19 Interior of the library at Skokloster. Photo: Jens Mohr, Skokloster Castle 206
20 Jousting shield with connection to a Danish princely wedding. Photo: Skokloster Castle 207
21 Prayer book that has belonged to a Berete Knutsdatter, Wr. teol. 8:o 47:1–2, Skokloster Castle. Photo: Bengt Kylsberg, Skokloster Castle 208
22 Bible in Icelandic whose provenance notation has been cut out, Wr. teol. fol. 8, Skokloster Castle. Photo: Fredrik Andersson, Skokloster Castle 209

Abbreviations

BAV *Biblioteca apostolica vaticana*, the Vatican Library
RA *Riksarkivet*, the National Archives
RR *Riksregistraturet*, the Royal Registry
SAOB *Svenska akademins ordbok*, the Swedish Academy Dictionary
SS *Skokloster Slott*, Skokloster Castle
UUB *Uppsala Universitetsbibliotek*, Uppsala University Library

Introduction: In the King's Treasury

Let me begin with an emblematic event that took place almost 400 years ago, in a royal treasury in May of 1635. Europe was then in the midst of the Thirty Years War, an incomparable tragedy that took eight million lives. In this complex conflict, which rearranged the political and religious layout of the European continent, one upcoming Protestant kingdom was able to secure its position as a northern European empire: Sweden.[1] King Gustavus Adolphus, the Lion of the North who had brought Sweden into the war in 1630, was killed at the battle of Lützen in November 1632. Nonetheless, he was posthumously named 'Gustavus Adolphus the Great' by the Swedish Parliament of the Estates (*Riksdag*), and has later been regarded as one of the greatest military commanders in history.[2] As his successor, Queen Christina, was only five years old in November 1632, Sweden was ruled by a trustee government led by the late king's most reliable official, Chancellor of the Realm Axel Oxenstierna, who kept the Swedish war campaign running. Due to Oxenstierna's diplomatic work, Sweden was in alliance with Catholic France from 1631, just one aspect in support of the argument that the Thirty Years War was not primarily a religious conflict. In 1635, French diplomacy had even saved the Swedish troops from a quite desperate situation in the German lands. When the peace treaty of Westphalia was finally signed in 1648, the Swedish Empire was one of its greatest beneficiaries (see figure 1 on page 190).[3]

Far from the brutal war scenes of the continent was the late Gustavus Adolphus' treasury, securely located in Tre Kronor Castle in Stockholm. In May 1635 the French envoy Charles Ogier visited the treasury, guided among its splendours and marvels by two Swedish aristocrats: Sten Båth and Gustaf Horn. They started by presenting an old drinking horn, and told of its legend: a knight had once taken the very same horn from the devil, after a hard battle on a dark night. This was how the knight had received his noble family name, Trolle (English equivalent: troll or ogre). Båth and Horn continued. They presented a number of large silver goblets, a ceremonial sword of steel, a quiver adorned with emeralds and two globes in silver, the last of these given to Gustavus Adolphus by the Tatars' Kahn and the city of Nuremberg, respectively.

1 Peter H. Wilson, *The Thirty Years War. Europe's tragedy* (Cambridge, Massachusetts: The Belknap Press of Harvard University Press, 2011), p. 4.
2 Carl von Clausewitz, *Vom Kriege. Hinterlassenes Werke des Generals Carl von Clausewitz* (Bonn: Ferd. Dümmlers Verlag, 1952), pp. 262, 864.
3 Wilson, *The Thirty Years War*, pp. 9, 462–463, 576–577, 757–58.

Then, Ogier noticed and described precious spoils (*spolia*) appropriated by Gustavus Adolphus from Würzburg and Munich. There were, for instance, valuable paintings by famous artists in gilded frames, most of them bearing the Bavarian coat of arms. Ogier specifically mentioned a painting depicting the Blessed Virgin. It had originally been a gift from the Polish King Sigismund III to William V of Bavaria, both of whom were opponents of the Swedish King. According to Ogier, the portrait of the Virgin was a sublime work.

He continued, commenting on the presence of the many sacred objects at hand in the treasury:

> Not without bitterness, we Catholics could here see crucifixes of solid gold, consecrated chalices and bishops' staffs and other ecclesiastical objects, plundered [*direpta*] from German churches, several of which were richly adorned with the most precious jewels and valuable stones.[4]

Ogier became quite emotional as he contemplated the church objects; they had been brutally snatched from their religious milieu to be exhibited in the secular treasury of a Protestant king. One particular crucifix holding a relic – a piece of the True Cross – inspired Ogier to lean forward and kiss it, to show his reverence. According to Ogier's journal, this action made Båth and Horn laugh.[5] The devil's horn, however, had been treated with the greatest respect by the two earlier on in the tour. Ogier had great difficulty maintaining his equanimity. In his diary, he summed up his experience of that day by exclaiming *o rerum vices!*: 'oh, the changes of things!'. In the Swedish King's treasury, Ogier witnessed how rapidly things could change: for 800 years, the bishops and princes of the Holy Roman Empire had collected precious things in

4 Interestingly, the passage has been translated from Latin into Swedish in different ways; for instance, Ogier kissing the crucifix is left out in Charles Ogier, *Fransmannen Charles d'Ogiers dagbok öfver dess resa i Sverige med franska ambassadören, grefve d'Avaux, år 1634. Ett bidrag till fäderneslandets sedehistoria för denna tid* (Stockholm: Rediviva, 1985 [1828]). I have mainly used the 1914 edition, Charles Ogier, *Från Sveriges storhetstid. Franske legationssekreteraren Charles Ogiers dagbok under ambassaden i Sverige 1634–1635* (Stockholm: Norstedt, 1914), pp. 107–109, quote from p. 109, in close comparison with the first Latin edition published 1656; see Charles Ogier & Claude de Mesmes Avaux, *Caroli Ogerii Ephemerides, sive, Iter Danicum, Suecicum, Polonicum* (Paris: Peter Le Petit, 1656), pp. 250–254, quote from p. 253.
5 Ogier & Avaux, *Caroli Ogerii Ephemerides*, p. 253; see Ogier, *Från Sveriges storhetstid*, p. 109; a relic crucifix similar to the one Ogier described is preserved in the Swedish History Museum's collections; see Barbro Bursell, 'Krigsbyten i svenska samlingar', in A. Grönhammar & C. Zarmén (eds.), *Krigsbyte* (Stockholm: Livrustkammaren, 2007), p. 16.

their churches and treasuries, only for everything to be removed by Gustavus Adolphus and his men in a single day.[6]

Through this significant episode, Ogier articulates rather different yet coexisting notions of spoils of war in the seventeenth century, a discrepancy that is essential to the history that unfolds in this book. The two aristocrats Båth and Horn showed off Gustavus Adolphus' spoils to a foreign diplomat without reflection or shame, as they had rightfully been taken by the victor in a just war, according to the war laws of those days.[7] Ogier, however, felt resentment. Nonetheless, his experience of the spoils was likewise multifaceted and cannot be simplified into mere bitterness. While the ecclesiastical objects stirred his inner emotions, he noted the Bavarian coat of arms on the paintings more distantly. Most importantly, and regardless of whether the objects described were spoils or not, Ogier reflected in great detail upon the materials of the treasures, their previous owners and geographical origin, and their object histories. This highlights a context of object circulation and consumption and the stories this generated, of which spoils were essential parts. Within the flow of seventeenth-century collection culture, and just as Ogier's witness confirms, things were repeatedly ascribed with meanings and narratives and had impacts based on their material, geographical origin, genealogical connections, confessional and temporal properties. Just as archival documents, books, fine crafts, paintings and sacred objects were consumed through trade and inheritance and were given as luxury gifts, war enabled an extensive consumption of knowledge and splendour. How this played out in seventeenth-century Sweden is the core issue in what follows.

1 Uncovering Spoils of Knowledge in Swedish Collections

This book offers novel perspectives on plundering Swedish commanders and the spoils of war in Swedish collections: a controversial yet well-known heritage connected to the era of the Swedish Empire (*Stormaktstiden*, literally the Age of Greatness, 1611–1721). Much of the booty was abducted from continental collections during the many campaigns of the seventeenth century, when Sweden, besides engaging in the Thirty Years War, on several occasions was at war with Poland, Denmark and Russia. The Swedish rulers of the time were frequent and large-scale plunderers, starting in the 1620s with King Gustavus

6 Ogier & Avaux, *Caroli Ogerii Ephemerides*, p. 254; see Ogier, *Från Sveriges storhetstid*, p. 109.
7 Erik Norberg, 'Krigets lön', in A. Grönhammar & C. Zarmén (eds.), *Krigsbyte* (Stockholm: Livrustkammaren, 2007), pp. 69–82.

Adolphus of the Vasa dynasty, Chancellor Axel Oxenstierna and later Queen Christina. When the Queen abdicated in 1654 she was succeeded by her cousin, Charles Gustav of Zweibrücken-Kleeburg, who consequently founded a new royal lineage. King Charles X Gustav was followed by son and grandson Charles XI and Charles XII, the three of them constituting the Swedish Caroline era. It was not only the rulers but also many high-ranking military officers and aristocrats who had the privilege of taking part in the plundering of valuable collections. With the death of Charles XII in 1718 the Swedish Empire, and the approximately hundred years of plundering that accompanied its wars, ended.

Swedish spoils, as I discuss in more detail below, have intrigued historians as well as officials in archives, libraries and museums through the years: their great number, economic value and status as difficult heritage have been addressed in different ways, and will certainly continue to attract researchers in the future. Notably, for centuries foreign researchers have travelled from the areas once plundered by Swedish rulers, and in this way have played an important role in drawing attention to this peculiar heritage, as well as contributing to important research, such as inventories of certain provenances.[8] This research was particularly strong in the second half of the nineteenth century, and contributed to the establishment of the word provenance (*proveniens*) in the Swedish language.[9] While this book contributes to the specialised subject of wartime plundering, and Swedish spoils in particular, it also relates the Swedish case to the vast interdisciplinary field of early modern collection studies, and to recent developments in writing histories from things. My starting point may seem trivial: I set out to demonstrate that spoils are historically contingent and intricate objects, as Ogier's testimony from the royal treasury initially illuminated. What appears to be a matter of course, however, is immediately complicated if we take into account previous research on Swedish spoils.

8 See for instance Beda Dudík, *Forschungen in Schweden für Mährens geschichte* (Brno: Carl Winiker, 1852); Eugeniusz Barwiński, Ludwik Birkenmajer & Jan Łoś, *Sprawozdanie z poszukiwań w Szwecyi* (Kraków: Nakłaem Akademii Umiejętności, 1914); Carl Schirren, *Verzeichnis livländischer Geschichtsquellen in schwedischen Archiven und Bibliotheken* (Dorpat: W. Gläsers Verlag, 1861–1868); Józef Trypućko etc. (eds.), *The catalogue of the book collection of the Jesuit College in Braniewo held in the University Library in Uppsala*, vol. 1 (Warsaw: Biblioteka Narodowa, 2007). I will return to this research in the concluding chapter.

9 See 'proveniens', *Svenska akademins ordbok* (SAOB), https://www.saob.se/artikel/?seek=proveniens&pz=1, access 9 August 2021; Emma Hagström Molin, 'Restitutionen verhandeln', in I. Dolezalek etc. (eds.), *Beute. Eine Anthologie zu Kunstraub und Kulturerbe* (Berlin: Matthes & Seitz, 2021), p. 220.

My investigation of Sweden's most curious heritage primarily targets spoils of knowledge; that is, plunder containing information of different kinds.[10] It is what the librarian and expert Otto Walde once characterised as 'the literary war booty of [Sweden's] heyday': archival documents, manuscripts and printed books. Walde's two extensive volumes dealing with the subject, published in 1916 and 1920, respectively, are still regarded as the reference work on the subject.[11] His study should be placed in the context of a number of works published around 1900, presenting the histories of some of Sweden's most important cultural heritage institutions: the National Archives, Uppsala University Library and Skokloster Castle.[12] All three institutions were established in the seventeenth century, which coincided with the war campaigns and plundering of Swedish rulers and commanders. The large amounts of spoils that were abducted from enemy archives, libraries and treasuries were generally inventoried, packed in chests and shipped to the kingdom of Sweden, where they helped to establish new collections or were integrated into already existing ones. Through classification and spatial organisation by different officials, the information seized was processed into accessible knowledge.

While the presence of war booty in Swedish collections is impossible to ignore, the attitude towards it has noticeably changed over time. Around 1900, when Walde published his works, the existence of plunder was a reminder of long-gone imperial glory. Simultaneously, however, the spoils were perceived as something alien, non-Swedish, that did not fit well with the narrative of national collections, which were intended to exhibit and preserve Swedish cultural heritage. Booty was explicitly perceived as an inferior category in relation to the rest of the collections. Items categorised as Catholic books in Swedish

10 Peter Burke argues that defining knowledge is as difficult as answering the question 'What is truth?'. He distinguishes information – or raw material – from knowledge, which is information that has been processed, or 'cooked'; see Peter Burke, *A social history of knowledge. From Gutenberg to Diderot. Based on the first series of Vonhoff Lectures given at the University of Groningen (Netherlands)* (Cambridge: Polity Press, 2000), p. 11. My focus on the classification and organisation of spoils and collections means that I am indeed approaching information that has been managed, i.e. knowledge. However, my study underlines that knowing plunder and organising it entailed a constant battle with matter rather than content.

11 Otto Walde, *Storhetstidens litterära krigsbyten I* (Uppsala: Almqvist & Wiksell, 1916); Otto Walde, *Storhetstidens litterära krigsbyten II* (Uppsala: Almqvist & Wiksell, 1920).

12 Severin Bergh, *Svenska riksarkivet 1618–1837* (Stockholm: Norstedt, 1916); Claes Annerstedt, *Upsala universitetsbiblioteks historia intill år 1702* (Stockholm: Wahlström & Widstrand, 1894); Olof Granberg, *Skoklosters slott och dess samlingar. En öfversikt* (Stockholm: Konstföreningen, 1903).

libraries, mainly abducted from the Jesuit Order's colleges, have been depicted as useless in the Protestant kingdom, both by Walde in 1916 as well as into the present day.[13]

This study distances itself from this line of thought and the National Romantic tradition from which it derives. Instead – and drawing upon scholarship focused on collecting, objects and knowledge circulation in early modern Europe, and more recent efforts in Sweden to illuminate and exhibit spoils – I argue that the meaning of the concept of spoils of war, and the uses and powers of the objects it designates, should not be taken for granted but rather must be examined from a distinct historical perspective in order to be understood. This means that epistemological categories of archives and libraries, such as Catholic, Jesuit, Protestant and Swedish, and systems of classification and collection orders, are historicised and analysed in what follows.[14] These categorisations have largely been ignored in previous scholarship. I argue, however, that they reveal how booty was understood and interacted with its new settings and that, followed over time, they disclose change. Thus, this study carefully considers practices of plundering and exact descriptions of spoils and their organisation in certain spaces and in a variety of sources.

While most of today's scholars and cultural heritage institutions agree that looted cultural heritage is highly problematic, Ogier's testimony highlights that the seventeenth-century understanding of plunder and booty in Europe was far more ambivalent. This was, as mentioned, largely because the victor's right to plunder was protected by law.[15] This means not least that a precise description of plunder as spoils of war is conspicuous in its absence from the empirical material that is analysed in what follows. In fact, the term spoils of war, *krigsbyte*, simply did not occur in the Swedish language until 1712, when its first use is registered in a Swedish dictionary.[16] In recent years, Anja-Silvia Goeing,

13 Walde, *Storhetstidens I*, pp. 15–16, 18; Margareta Hornwall, 'Uppsala universitetsbiblioteks resurser och service under 1600-talet', *Nordisk tidskrift för bok- och biblioteksväsen*, 68 (1981), p. 68. Lars Munkhammar, 'Böcker som krigsbyte', in S. Nestor & C. Zarmén (eds.), *Krigsbyten i svenska samlingar. Rapport från seminarium i Livrustkammaren 28/3 2006* (Stockholm: Livrustkammaren, 2007), p. 31. Annestedt, *Upsala universitetsbiblioteks*, pp. 30–31.

14 Here, epistemology refers to the understanding of knowledge and its scope and limits in a broad sense; see Chapter 3, pp. 85, 88.

15 See Hugo Grotius, *De jure belli ac pacis libri tres, In quibus jus naturæ & gentium, item juris publici præcipua explicantur* (Paris: Nicolas Buon, 1625); Edgar Müller, 'Hugo Grotius und der Dreißigjährige Krieg Zur frühen Rezeption von *De jure belli ac pacis*', *The Legal History Review*, 77 (2009), pp. 499–538; on Gustavus Adolphus reading Grotius, see p. 518. The legality of plundering is discussed in further detail in Chapter 1.

16 Haquin Spegel, *Glossarium-sveo-gothicum eller Swensk-ordabook, inrättat them til en wällmeent anledning, som om thet härliga språket willia begynna någon kunskap inhämta*

Anthony Grafton and Paul Michel have underlined the paradox of warfare in relation to collecting. On the one hand, they argue, it has destroyed and scattered collections throughout history, while on the other it has contributed to spreading knowledge.[17] Fritz Redlich was already thinking along these lines in the 1950s, when he raised a number of relevant questions in relation to early modern plundering of what he called cultural objects. When it came to books, entire library collections and the like, he asked, what roles these objects played when they reached their new place of abode.[18] The question is not whether, but rather how, plundered knowledge was transmitted.

With these considerations in mind, this book unravels the meanings and effects of spoils of war beyond their immediate connotation as signs of triumph for the conqueror, having deprived the enemy simultaneously of its cultural richness and history. To be able to implement this in depth, the analysis is mainly focused on knowledge plunder taken by two significant but different actors, King Gustavus Adolphus and Field Marshal Carl Gustaf Wrangel, during their respective war campaigns in Polish Livonia and Prussia and Denmark. Thus, spoils in the form of archival documents taken from Mitau (Jelgava) Castle in the Duchy of Courland, Livonia; manuscripts and printed books taken from the Jesuit colleges in Riga, Livonia and Braunsberg (Braniewo), Prussia, together with the chapter library in Frauenburg (Frombork), Prussia; and books abducted from the noble family Rothkirch's estate in Denmark take centre stage here. I start my investigation of these spoils during the campaigns, discussing raiding and the laws of war of that time in relation to collecting, how the plunder took place and how it was depicted. I then move on to analyse how these spoils of knowledge were handled in the Swedish Kingdom's Archive, which later became the National Archives; in Uppsala University Library, which was the first university library in Sweden; and in Wrangel's Skokloster Castle, which was built to house his encyclopaedic collections and developed into a museum early on. In each case, I introduce the officials and scholars who were entrusted with the spoils as well as with the royal and noble collections in question.

 (Lund: Abraham Habereger, 1712), p. 74; see 'krigsbyte', SAOB, https://www.saob.se/artikel/?seek=krigsbyte&pz=1#U_K2633_98676, access 9 August 2021.

17 Anja-Silvia Goeing, Anthony T. Grafton & Paul Michel, 'Questions framing the research', in A. Goeing etc. (eds.), *Collectors' knowledge. What is kept, what is discarded* (Leiden: Brill, 2013), pp. 7–8; see also Jānis Krēsliņš, 'War booty and early modern culture', *Biblis*, 38 (2007), pp. 21–23.

18 Fritz Redlich, *De praeda militari. Looting and booty 1500–1815* (Wiesbaden: Franz Steiner Verlag, 1956), pp. vii–viii.

This means that I am mainly occupied with the collection contexts of victors, and their servants' perceptions of the spoils. Both victors and servants were predominantly male, but this does not mean that female rulers such as Queen Christina and aristocrats such as Wrangel's wife Anna Margareta von Haugwitz did not take an interest. While Christina has been the subject of many studies, and her interest in the pillaging of Prague in 1648 is well known, von Haugwitz deserves more scholarly attention.[19] There were also active female plunderers – later I will discuss a soldier's wife – as well as females who were made into booty.[20] I have thus made female actors visible whenever possible, although the study's core sources are not ideal in this sense as the lists, inventories and catalogues I mainly address were composed by male officials.

While the human voices that are heard in this study are limited, then, the strongest stress is placed on what were and are mute: the plundered things themselves. Which properties of the abducted objects helped to create, shape and arrange rooms and spatial orders for knowledge collections in the Swedish Empire? What meanings and qualities were attributed to the plunder when officials handled, described, viewed and in other ways dealt with it? In other words, material processes in the form of collection fusions and arrangements are scrutinised here, as they reveal how the spoils contributed to as well as challenged their new epistemological contexts. Lastly, and in each case, I address how the perceptions of plundered objects and thus their identities have changed over time. The enquiry's main focus is on the seventeenth century, but by pointing to some extent to the spoils' fate in later times, I am able to expose important changes. The spoils' extended histories include both requests for restitution and researchers trying to reconstruct lost collections, and I will close this book with a discussion of these enquiries.

2 Writing Histories from Spoils: Methodological and Contextual Considerations

In the introduction to the edited volume *Early Modern Things* (2013), Paula Findlen declared the history of material culture to be one of the most promising

19 Alina Strmljan, '"Der Prager Kunstraub" zwischen Kulturpolitik und Selbstinszenierung' in I. Dolezalek etc. (eds.), *Beute. Eine Anthologie zu Kunstraub und Kulturerbe* (Berlin: Matthes & Seitz, 2021) pp. 79–83; see also Eva Nilsson Nylander, *The mild boredom of order. A study in the history of the manuscript collection of Queen Christina of Sweden* (Lund: Institute of ALM and Book History, Lund University, 2011), pp. 37–40.

20 See Chapter 1, p. 28. Women in campaigns have been studied by Maria Sjöberg, *Kvinnor i fält 1550–1850* (Möklinta: Gidlunds, 2008).

fields for researchers wishing to develop transecting accounts of the past, whether these histories are local and comparative or global and cross-cultural.[21] *Early Modern Things* may be seen as representative of the multidisciplinary field of historical research dealing with objects, which has thrived in recent decades. Material culture overall has come to engage a larger group of humanistic scholars and this material turn, or the turn to things, has included rich ontological discussions of what things are and what they do.[22] In the following, I address some key trajectories and works in the field of writing histories from things that have been central to how this study approach spoils. Firstly, an essential source of analytical inspiration are enquiries that have taken into consideration the biography and transformative qualities of objects in motion. Secondly, the field of collection studies has been of great importance, especially scholarship that, as Goeing, Grafton and Michel have done, has explicitly brought together collecting and plundering.

A fundamental text of material culture studies is Igor Kopytoff's 'The cultural biography of things': an exploration of object-biographical method in which he deals with the commodity. Kopytoff argues that commodities change as they circulate in society, and are able to have a different status to different people at the same time. His important insight lies in seeing objects as processes, a thought that has been picked up and developed by a number of scholars.[23] When writing the histories of spoils in archive, library and museum collections, I argue that an object biographical viewpoint, although without executing strict object biographies in this book, can offer new insights into these accounts. This is because, as John Randolph has suggested, biography

21 Paula Findlen, 'Early modern things. Objects in motion 1500–1800', in P. Findlen (ed.), *Early modern things. Objects and their histories 1500–1800* (New York: Routledge, 2012), p. 6.

22 For a summary view see, for instance, Tine Damsholt & Dorthe Gert Simonsen, 'Materialiseringer. Processer, relationer og performativitet', in T. Damsholt etc. (eds.), *Materialiseringer. Nye perspektiver på materialitet og kulturanalyse* (Århus: Århus Universitetsforlag, 2009), pp. 9–34; Anita Guerrini, 'Material turn in the life sciences', *Literature Compass*, 13 (2016), p. 469–480; Rosemary A. Joyce & Susan D. Gillespie, 'Making things out of objects that move', in R. A. Joyce & S. D. Gillespie (eds.), *Things in motion. Object itineraries in anthropological practice* (Santa Fe: School for Advanced Research Press, 2015), pp. 5–7; on the subject of object ontology, Bill Brown argues that we only start to see the 'thingness' of objects when they fail us, and thus ontologically separates objects from things; see Bill Brown, 'Thing theory', *Critical Inquiry*, 28 (2001), pp. 1–22, especially p. 4. In this book, 'object' and 'thing' are used synonymously.

23 Igor Kopytoff, 'The cultural biography of things. Commoditization as process', in A. Appadurai (ed.), *The social life of things. Commodities in cultural perspective* (Cambridge: Cambridge University Press, 1986), pp. 64–90, especially pp. 65–68; Guerrini, 'Material turn', p. 470; Janet Hoskins, 'Agency, biography and objects', in C. Tilley (ed.), *Handbook of material culture* (London: SAGE, 2006), pp. 74–75.

uncovers what a traditional institutional perspective obscures: the heterogeneity and coming into being of objects and collections.[24] Scott Lash and Celia Lury have, in their object-biographical study of the cultural artefact *Trainspotting*, argued objects to be manifold. They are repeatedly coming into existence in new forms, as well as they are embedded in complex settings, from which they cannot be separated.[25] This view on objects captures the dynamic between one haul object and its many individual spoils, and their entanglements with shifting spatial and temporal contexts. In each Chapter, I demonstrate how a booty object of a certain origin can be mixed with plunder from other locations as well as fused with other collections, and how in this process certain individual spoils can surface temporarily and distinguish themselves, only to disappear again into the material landscape of plenty.

A number of researchers who have engaged with objects and collections in early modernity, for instance Daniela Bleichmar and Carla Nappi, have found them to be elusive, slippery and unstable.[26] The analytical key to unlock this object instability and transformation within collection contexts is classification. As Geoffrey C. Bowker and Susan Leigh Star have pointed to, practices of classification are not historically constant but can be partly durable, transformable or abandoned over time.[27] A turn to classification within collections, as observed by Kate Hill in *Museums and biographies* (2012), reveals the affects and meanings that curators impose on objects.[28] One important enquiry

24 John Randolph, 'On the biography of the Bakunin family archive', in A. M. Burton (ed.), *Archive stories. Facts, fictions, and the writing of history* (Durham N.C.: Duke University Press, 2005), p. 210.

25 Scott Lash & Celia Lury, *Global culture industry. The mediation of things* (Cambridge: Press Polity, 2007), pp. 17–19, 21–25. Annemarie Mol and Marianne de Laet have also discussed object boundaries through the specific technology of a water pump, see Marianne de Laet & Annemarie Mol, 'The Zimbabwe bush pump. Mechanics of a fluid technology', *Social Studies of Science*, 30 (2000), pp. 225–227.

26 See for instance Daniela Bleichmar, 'Seeing the world in a room. Looking at exotica in early modern collections', in D. Bleichmar & P. C. Mancall (eds.), *Collecting across cultures. Material exchanges in the early modern Atlantic world* (Philadelphia: University of Pennsylvania Press, 2011), pp. 15–16; Jessica Keating & Lia Markey, 'Introduction. Captured objects. Inventories of early modern collections', *Journal of the History of Collections*, 23 (2011), pp. 209–210; Carla Nappi, 'Surface tension. Objectifying ginseng in Chinese early modernity', in P. Findlen (ed.), *Early modern things. Objects and their histories 1500–1800* (New York: Routledge, 2012), pp. 32–33; Camilla Mordhorst, *Genstandsfortaellinger. Fra Museum Wormianum til de moderne museer* (Köpenhamn: Museum Tusculanums Forlag, 2009), p. 19.

27 Geoffrey C. Bowker & Susan Leigh Star, *Sorting things out. Classification and its consequences* (Cambridge, Massachusetts: MIT Press, 1999), pp. 1–16, 42.

28 Kate Hill, 'Introduction', in K. Hill (ed.), *Museums and biographies. Stories, objects, identities* (Woodbridge: The Boydell Press, 2012), pp. 1–2, 5.

that directly has dealt with the consequences of dislocated cultural objects is Bénédicte Savoy's comprehensive investigation of the grand-scale looting ordered by Napoleon in the German lands. Savoy has analysed how the spoils were used in the French context, as well as their restitution. On the subject of restitutions, she has concluded that these events transformed the identity of abducted works of art. When returned to the areas from which they had been taken, they were often placed in newly established museums, where they came to be regarded as national objects of public concern.[29] In line with this, the case studies of this book demonstrate that the tracked archival documents, books and manuscripts seldom stayed the same, despite the fact that we as researchers want to lock them, as well as other cultural heritage objects, into certain definitions.

When the *Journal of the History of Collections* was established in 1989, it paved the way for a specialised field in which different types of collections were connected to relevant historical knowledge cultures.[30] Michel Foucault's work, especially *Les Mots et les choses* (1966), has been highly influential in research on collections and knowledge production in general and has been highlighted as the classical study within the field.[31] Already in the 1960s, Foucault pointed to the enchanting characteristics of archives, that together with Jacques Derrida's 1994 paper 'Mal d'archive: une impression freudienne' sparked an archivisation of the historical sciences.[32] Since then, it has been first and foremost cultural historians who have pointed to archives as sites where the order, management and state control of knowledge can be examined.[33] Museology's

29 Bénédicte Savoy, *Kunstraub. Napoleons Konfiszierungen in Deutschland und die europäischen Folgen* (Vienna: Böhlau, 2011), especially pp. 392–397; Bénédicte Savoy, 'Looting of art. The museum as a place of legitimisation', in S. Nestor & A. Grönhammar (eds.), *War-booty. A common European cultural heritage* (Stockholm: Livrustkammaren 2009), p. 19. Savoy's research group Translocations, active at the Technische Universität in Berlin 2017–2020, focused on dislocated cultural heritage broadly.

30 Goeing, Grafton & Michel, 'Questions framing', pp. 3–4.

31 Paula Findlen, *Possessing nature. Museums, collecting, and scientific culture in early modern Italy* (Berkeley: University of Califronia Press, 1994), p. 55; Mordhorst, *Genstandsfortaellinger*, pp. 21–26.

32 Carolyn Steedman, *Dust* (Manchester: Manchester University Press, 2001), pp. 1–12; see also Antoinette Burton, 'Introduction. Archive fever, archive stories', in A. Burton (ed.), *Archive stories. Facts, fictions, and the writing of history* (Durham: Duke University Press, 2005), pp. 1–23.

33 See for instance F. X. Blouin & W. G. Rosenberg (eds.), *Archives, documentation, and institutions of social memory. Essays from the Sawyer Seminar* (Ann Arbor: University of Michigan Press, 2007); Ann Blair & Jennifer Milligan, 'Introduction', *Archival Science*, 7 (2007), pp. 289–296; Randolph C. Head, 'Preface. Historical research on archives and knowledge cultures. An interdisciplinary wave', *Archival Science*, 10 (2010) pp. 191–194;

approach to exhibitions, as cultural expressions that can be read, or in other words, materialising narratives that can be analysed, has successfully been transferred to historical studies of collections.[34] It should also be recognised that postcolonial and global perspectives on Western collecting activity have been important in removing its pretence of innocence. By focusing on things, the researcher is placed in direct contact with one of the most important characteristics of European early modernity: the discovery of the New World, or that is, European exploitation and colonisation of non-European geography and population.[35]

For premodern times, it is traditionally the collecting habits of the elite that have been studied: the cultural consumption of rulers and aristocrats has often been framed as a way to manifest power, and thus as an expression of the political and learned culture of the time.[36] For instance, Peter Burke's classical study of Louis XIV underlines the importance of collection display in self-promotion.[37] Susan Bracken, Andrea Gáldy and Adriana Turpin have taken the promotion argument further, by drawing collecting activities together with dynastic drive: that is, the will to endorse one's family prosperity and status. They argue that the formation and display of collections can be considered against the backdrop of genealogical ambition, according to which rich collections indicated the age and power of the linage in question. This ought to be linked to the Swedish royal Vasa family, which was, just like that of the French

Jennifer Milligan, '"What is an Archive?" in the history of modern France', in A. Burton (ed.), *Archive stories. Facts, fictions, and the writing of history* (Durham: Duke University Press, 2005), pp. 159–183.

34 Bleichmar, 'Seeing the world', pp. 15–30; Mordhorst, *Genstandsfortaellinger*, especially pp. 26–28.

35 Daniela Bleichmar & Peter C. Mancall, 'Introduction', in D. Bleichmar & P. C. Mancall (eds.), *Collecting across cultures. Material exchanges in the early modern Atlantic world* (*Philadelphia*: University of Pennsylvania Press, 2011), p. 2; Paula Findlen, 'Early modern things', p. 5.

36 Peter Burke, *The fabrication of Louis XIV* (New Haven: Yale University Press, 1992); two important Swedish studies are Lisa Skogh, *Material worlds. Queen Hedwig Eleonora as collector and patron of the arts* (Stockholm: Center for the History of Science at the Royal Swedish Academy of Sciences, Stockholm University, 2013); and Nilsson Nylander, *The mild boredom*. There are also non-elite-focused studies; for instance, see Renata Ago, *Gusto for things. A history of objects in seventeenth-century Rome* (Chicago: University of Chicago Press, 2013). Another classic study with a European scope is Susan Pearce, *On collecting. An investigation into collecting in the European tradition* (London: Routledge 1995). Pearce argues that collecting was widespread in society, see p. 412.

37 Burke, *The fabrication*, pp. 54–59, 65–69.

Valois king, quite new to the throne.[38] How Vasa genealogy came to permeate the organisation of the Swedish National Archives, and how this affected the plunder there, is thoroughly analysed in Chapter 2. Bracken, Gáldy and Turpin have also underlined that, while collecting might appear to be a fairly harmless activity, dynastic collectors did not hesitate to present themselves as brutal plunderers of collections, if the booty was alluring enough.[39] Thus, they have distinctly connected lineage with collecting and wartime plundering as coherent practices.

For this study, it is relevant to engage with scholarship dealing with different types of early modern collections, as historians of culture and science have demonstrated that there were no precise delimitations between archives, libraries and museums in early modern Europe. Although archives were generally more restricted than other collections due to their legal and governing functions, distinguishing one type of collection from the other was not a pressing issue. This is reflected in the etymology of the word museum: in the seventeenth century, museum was synonymous with library, and a scholar could be likened to a living library and a wandering museum at one and the same time.[40] Modern institutional boundaries and object categories are, however, often projected onto history. While this might be inevitable, it should be stressed that it likely reflects the specialisation of researchers today, and their expertise in different object or collection categories, rather than premodern conditions.

While the plundering Swedish rulers and military commanders tried to lay their hands on all the riches they could possibly take, archival documents and books still seem to have been of superior significance to them. These were often recorded, and explicit instructions were given to confiscate whole archives and libraries. This should be connected to what Jill Bepler has argued: that the plundering of archives and libraries during the Thirty Years War ought to

38 Susan Bracken etc. (eds.), *Collecting and dynastic ambition* (Newcastle upon Tyne: Cambridge scholars publishing, 2009), pp. xv–xvii.
39 Bracken etc. (eds.), *Dynastic ambition*, xviii.
40 See for instance the title of Clement's advice for the 'construction, care and use of the museum or library. [...]', in Claude Clement, *Musei sive bibliothecæ tam privatæ quam publicæ extructio, instructio, cura, usus, libri 4. Accessit accurata descriptio regiæ bibliothecæ S.Laurentii Escuralis. Auctor P. Claudius Clemens* (Lyon 1635); see also Paula Findlen, 'The museum, its classical etymology and Renaissance genealogy', *Journal of the History of Collections*, 1 (1989), pp. 59–78; William Clark, 'On the bureaucratic plots of the research library', in M. F. Spada & N. Jardine (eds.), *Books and the sciences in history* (Cambridge: Cambridge University Press, 2000), p. 190; Bo Strömberg (ed.), *Den äldsta arkivläran. Jacob von Rammingens båda läroböcker i registratur- och arkivskötsel från 1571, samt en monografi om arkiv från 1632 av Baldassare Bonifacio* (Stockholm, Bo Strömberg, 2010), 92.

be understood within the setting of European early modern collecting culture and the art market in general.[41] In a similar manner, William Clark has stressed that archival documents and books were parts of an early modern economy of the rare, just like other precious objects. Making books, just as other collector's items, visible was an important feature of the collection economy.[42] The spatial and visual emphasis of previous research are applied in this book, in order to understand the status of knowledge spoils within a larger market of collectable things.

A spatial ordering of knowledge in a manner that reflects the historicity or temporality of collectable things is brought to the fore and analysed in this study. One of the most essential features of Renaissance culture was the rediscovery of antiquity, which nurtured the collecting of antiquities.[43] In the case of Sweden, it should be pointed out that the National Heritage Board is one of the country's oldest institutions, established by Gustavus Adolphus in 1630, with his old teacher Johannes Bureus serving as the kingdom's first official antiquarian (*riksantikvarie*), even though antiquarian research had been carried out since the late fifteenth century. The Swedish antiquarians were mainly occupied with inventorying and processing ancient and medieval sources, such as runestones and manuscripts.[44] Understanding objects as old was a fairly new way of perceiving matter in early modern times; Zachary Sayre Schiffman has argued that the past was intellectually separated from the present during the Renaissance.[45] Drawing on Sayre Schiffman's argument, my enquiry demonstrates how this distinction took its material forms in the Swedish Empire through the organisation of knowledge collections. In parallel with a strong desire for antiquities among the Swedish elite, the librarians in charge of Uppsala University Library had more than historical values to consider. Many previous studies have emphasised an increased demand among the European scholarly elite for current knowledge, which was a consequence of the printing revolution, the confessional developments of the Protestant Reformation and the Counter-Reformation (or Catholic Reformation) and the emergence of

41 Jill Bepler, '*Vicissitudo Temporum*. Some sidelights on book collecting in the Thirty Years War', *The Sixteenth Century Journal*, 32 (2001), pp. 953–968.
42 Clark, 'On the bureaucratic plots', pp. 191–192.
43 Mancall & Bleichmar, 'Introduction', p. 2.
44 A summary is given in Johanna Widenberg, *Fäderneslandets antikviteter. Etnoterritoriella historiebruk och integrationssträvanden i den svenska statsmaktens antikvariska verksamhet ca. 1600–1720* (Uppsala: Uppsala Universitet, 2006), pp. 20–30. In Chapter 3 I will return to Bureus to discuss his inventory of spoils.
45 Zachary Sayre Schiffman, *The birth of the past* (Baltimore: Johns Hopkins University Press, 2011), pp. 1, 146–149.

modern science.[46] In conjunction with these threads, the chapters of this book recurrently enter into discussion with the meaning, and sometimes conflict, of old knowledge objects in this development: how archival documents, manuscripts and printed books that were perceived as ancient were handled within seventeenth-century Swedish knowledge institutions.[47]

For many years, Swedish research dealing with the subject of spoils of war, from Walde's days until quite recently, was more or less absent. In the studies during this period that did deal with collections holding spoils, their number and usefulness were often downplayed.[48] This indicated an uncertainty among curators and scholars regarding how war booty should be handled. At the same time, during the twentieth century scholars from central and eastern Europe showed continued interest in the old plunder, which was a recurring reminder of what was hidden in the collections. The emblematic shift in the Swedish discourse came in 2005, when curators at the Swedish museum *Livrustkammaren* (The Royal Armoury) started planning an exhibition on spoils of war in their collections, as well as in Sweden in general.[49] This important initiative not only drew scholarly attention to the many once-plundered objects in Swedish state institutions, but also brought them into the public spotlight. In the publications connected to the exhibition, several scholars involved emphasised the connection between warfare, collecting and dynastic aspirations.[50] Most importantly, the Swedish case was related to its European equivalents through an international symposium.[51] This was a crucial event, since the older National

46 See e.g. Luigi Balsamo, *Bibliography. History of a tradition* (Berkeley: B. M. Rosenthal, 1990), p. 5; Malcolm Walsby, 'Book lists and their meaning', in M. Walsby & N. Constantinidou (eds.), *Documenting the early modern book world. Inventories and catalogues in manuscript and print* (Leiden: Brill, 2013), pp. 2–5; Burke, *A social history*, pp. 38–44, 103–106; Helmut Zedelmaier, *Bibliotheca universalis und bibliotheca selecta. Das Problem der Ordnung des gelehrten Wissens in der frühen Neuzeit* (Cologne: Böhlau, 1992), pp. 9–21; Evgenij Ivanovič Šamurin, *Geschichte der bibliothekarisch-bibliographischen Klassifikation. Band 1* (Leipzig: Veb Bibliographisches Institut, 1964), pp. 135–139.

47 One important and inspiring study of this in another geographical and political context is Jennifer Summit's *Memory's library. Medieval books in early modern England* (Chicago: University of Chicago Press, 2008).

48 See for instance Arne Losman, *Carl Gustaf Wrangel och Europa. Studier i kulturförbindelser kring en 1600-talsmagnat* (Stockholm: Almqvist & Wiksell, 1980), p. 14; Lena Rangström, *Krigsbyten på Skokloster* (Bålsta: Skoklosters slott, 1978), p. 3; Hornwall, 'Uppsala universitetsbiblioteks resurser', p. 68.

49 Carl Zarmén, 'Foreword', in S. Nestor & A. Grönhammar (eds.), *War-booty. A common European cultural heritage* (Stockholm: Livrustkammaren, 2009), p. 9.

50 Bursell, 'Krigsbyten i svenska', pp. 13–49.

51 Sofia Nestor & Ann Grönhammar (eds.), *War-booty. A common European cultural heritage* (Stockholm: Livrustkammaren, 2009).

Romantic research tended to view the Swedish Empire's plundering as a uniquely well-planned enterprise.[52]

In line with the developments outlined above, then, this book analyses Gustavus Adolphus' and Carl Gustaf Wrangel's cultural plundering and confiscation of spoils against the backdrop of the extensive collecting activities of the European elite.[53] As prestigious collections were a way of expressing one's identity and status in the sixteenth and seventeenth centuries, researchers have asserted that spoils involving art could serve as tools in dynastic intrigues, those involving books as a way to foil Jesuit missions, and those involving archives as a way to steal the enemy's history.[54] In all these scenarios, however, the true importance of taking spoils is the capacity to deprive the enemy of something. Therefore, with its focus on the long-term perception and impact of plundered knowledge, this study adds novel expertise to the existing body of research. What was it that plunderers of Gustavus Adolphus' and Wrangel's calibre actually gained? Paula Findlen's description of the early modern period as 'an era of things' reminds us that craving objects was a distinct part of elite and scholarly culture at the time.[55] Cultural plundering in Europe was not just war economy and powerplay; it also expressed curiosity and a yearning for knowledge. And as we shall see, the collected spoils demanded their space, care and adoration.

3 Cases and Sources: Spoils in Inventories, Lists and Catalogues

The study traces and analyses plunder taken from five different locations, and follows the spoils into the cabinets of the Kingdom's Archive, the shelves of Uppsala University Library and the newly built rooms of Skokloster Castle.[56] These case studies have been chosen for several reasons. The plunder from

52 Walde, *Storhetstidens I*, p. 16; see also Chapter 1, pp. 36, 40ff.
53 Findlen, *Possessing nature*, pp. 2–3.
54 Bursell, 'Krigsbyten i svenska', pp. 16–23.
55 Paula Findlen, 'Possessing the past. The material world of the Italian Renaissance', *American Historical Review*, 103 (1998), p. 86; the anthology *Collecting Across Cultures* also focuses on the collecting of *Europeana* in Southeast Asia; see Sarah Benson, 'European Wonders at the Court of Siam', in D. Bleichmar & P. C. Mancall (eds.), *Collecting across cultures. Material exchanges in the early modern Atlantic world* (Philadelphia: University of Pennsylvania Press 2011), pp. 155–174.
56 I have chosen to use the name the Kingdom's Archive when dealing with the Swedish National Archives in the seventeenth century. The Kingdom's Archive is a literal translation from relevant sources, and captures what kind of institution the National Archives once were, before they became nationalised.

Livonia, Prussia and Denmark has been selected due to the existing sources associated with it. In all five cases, the contents of each haul were recorded before being mixed with other collections and objects. The fact that the chosen spoils ended up in three of Sweden's most important cultural heritage institutions has provided further advantages. The National Archives, Uppsala University Library and Skokloster Castle have rich internal archives or other forms of documentation that stretch back to the seventeenth century, which have been crucial to the research on the present case studies. Finally, it has been important that a large number of the spoils are still present and traceable in these institutions, and that they are part of what transformed into Swedish national heritage in the nineteenth and twentieth centuries. How this process of nationalisation affected the understanding of seventeenth-century spoils is an important element of their fate and thus a part of their histories as well.

The question of who had access to these collections and their spoils in the seventeenth century needs to be addressed, as this goes hand in hand with their possible impacts. Goeing, Grafton and Michel have underscored that, generally, early modern collections were in the hands of privileged scholars who were either wealthy, powerful men or their employees.[57] For this reason, even if the collections founded by Swedish princes and aristocrats had representative purposes, they were generally accessed by a select few: officials, family members, the court and prominent visitors. Among the three cases here, Uppsala University Library distinguishes itself as it was partly open to students and thus semi-public. The Kingdom's Archive was the most restricted environment, due to the state secrets and legal documents it kept. Skokloster Castle, Wrangel's gigantic cabinet of curiosities where he spared no expense, was likely visited and presented by Wrangel himself on only a few occasions. Instead, the final case of this book particularly illuminates the spoils' long-term effects and seemingly mythic powers in the centuries that followed Wrangel's demise.

While reconstructing plunder is important research, it is impossible to know the exact number of objects once taken. For instance, as Chapter 3 underlines, there are far more manuscripts and books from Braunsberg's Jesuit College present in Uppsala University Library today than were recorded by officials when the loot arrived in Stockholm in the 1620s.[58] Further, one should bear in mind that the Braunsberg booty has been reduced over the centuries through auctions and expurgations. Plunder that was abducted from a Jesuit college, church, or castle could consist of thousands of individual objects and was thus

57 Goeing, Grafton & Michel, 'Questions framing' p. 4.
58 This is proven by the recent inventory of the Braunsberg College's provenance in Uppsala; see Trypućko etc., *The catalogue*.

a heterogenic quantity that needed to be handled. When the opportunity to loot arose, it seems that as much as possible was often taken. Even if inventories were made, it does not appear that everything that was abducted was listed, and records may also have been lost during the campaigns or later. For instance, the Jesuit books confiscated in Riga in 1621 came along with a number of other items, and all were listed in the same inventory; meanwhile, of the archival documents and weapons we know were taken from Mitau Castle in Courland, only the former were listed. And, as I discuss in Chapter 4, from the Rothkirch family's collections in Denmark, Carl Gustaf Wrangel, likely with the help of his servant, chose books, weapons and an emblematic shield; however, today we only know of a detailed list of the books.

Consequently, the core sources of this study are different kinds of descriptions of spoils made during the period studied. Among the descriptions of plunder, inventories, lists and catalogues hold a unique status in relation to other evidence, as they place the researcher in direct relation to the interpretation of abducted objects in certain temporal and spatial contexts, in most cases even coming down to placement in a particular room or chest.[59] On occasion, it has been relevant to compare seventeenth-century descriptions of individual objects with those that are preserved in the present-day institutions. Carl Gustaf Wrangel's book collection is partly preserved and has been reconstructed at Skokloster Castle, and has thus been studied in full. This possibility has not only been valuable for the chapter dealing with Wrangel's spoils, but has affected the entire study. During my work with Wrangel's books, which mainly took place during the summers of 2011 and 2012, I was supported by Skokloster's librarian at the time, Elisabeth Westin Berg, who had also been involved in the reconstruction work in the 1970s and 1980s. Westin Berg's expertise and our discussions have been tremendously important for the outcomes presented in this book. They have deepened my knowledge about materials, provenances, and the compositions of book collections in the seventeenth century and beyond. Thus, my hours in Skokloster's cold and dark library have provided my research with invaluable spatial, visual, and tactile experiences. I have also had the great privilege to consult some of Queen Christina's manuscripts that are present in the Vatican Library (*Biblioteca apostolica vaticana*).

In addition to lists, inventories, catalogues and preserved collections and objects, travel descriptions, letters, and collection treatises and manuals are sources commonly used in studies of early modern collections.[60] All these types

59 Keating & Markey, 'Captured objects', p. 209.
60 Brita Brenna, 'Tidligmoderne samlinger', in B. Rogan & A. Bugge Amundsen (eds.), *Samling og museum. Kapitler av museenes historie, praksis og ideologi* (Oslo: Novus, 2010), pp. 33–34.

of material are consulted here as well, although the number of seventeenth-century travelogues depicting libraries in the kingdom of Sweden are scarce, and there are none available for the Kingdom's Archive, which also reflects that the latter was restricted and only accessible to its trusted officials.[61] Manuals and handbooks presented how collections should ideally be composed and arranged, and while the seventeenth century saw the publication of several guide books to libraries, fewer of them dealt with archives or museums. An exception is Samuel Quiccheberg's *Inscriptiones*, or *Treaty of Museums*, from 1565. It is commonly referred to as the first museum manual ever published, and in it he describes the encyclopaedic museum.[62] When it comes to archives, Jacob von Rammingen's archival manual from 1571 and Baldassare Bonifacio's work from 1632 on the nature of archives are significant.[63] Unfortunately, I have not found indications that these were known in seventeenth-century Sweden, but the fact that archives and their organisation were highly important to the Swedish Government stands without a doubt. Some of these manuals highlight the fluid boundaries between different types of collections, and how certain words were synonymous with each other. The Jesuit Claude Clement's instructions for the construction, care and use of the *musei sive bibliothecæ* (that is, of the museum or the library) from 1635 is one example of this.[64] Manuals, letters and instructions from the Royal Registry (*riksregistraturet*, RR) have also been included, as they illustrate how the plundering was executed. Documents from the institutional archives of the Kingdom's Archive and Uppsala University Library have made it possible to analyse the collections' spatial organisation. All protocols from Uppsala University's consistory that concern the library during the period 1624–1691 have been consulted. For Carl Gustaf Wrangel and Skokloster Castle, the vast material relevant to this study has ended up in various individual archives, mainly the Skokloster and Rydboholm collections now housed in the Swedish National Archives, in addition to the material still preserved at the castle. These former archives are very rich, and their accessibility, through archival guides and databases, varies greatly. Previous research dealing with Skokloster, especially that of Arne Losman, has been extremely helpful to me in tracing the relevant sources.

61 Overall, eyewitness accounts from visitors to early modern collections are rare; see Bleichmar, 'Seeing the world', p. 22.
62 I have consulted two contemporary editions: Samuel Quiccheberg in M. A. Meadow & B. Robertson (eds.), *The first treatise on museums: Samuel Quiccheberg's Inscriptiones 1565* (Los Angeles: Getty Research Institute, 2013); and Samuel Quiccheberg in Harriet Roth (ed.) *Der Anfang der Museumslehre in Deutschland. Das Traktat 'Inscriptiones vel Tituli Theatri Amplissimi' von Samuel Quiccheberg* (Berlin: Akademie Verlag, 2000).
63 Translated and published together in *Den äldsta arkivläran*.
64 Clement, *Musei sive bibliothecæ*.

Lists, inventories and catalogues have a long tradition of being used in historical research dealing with things and collections. In this source category, the dynamic relationship between the interpreting collector or official and the objects in question is brought to the fore. By analysing different classifications and descriptions of the same object, it is possible to unravel their complexity and instability. Statements in lists, inventories and catalogues are attempts to fixate the material object with linguistic terms, but these fixations often seem vague to the researcher who tries to dismantle them hundreds of years later.[65] One must bear in mind that these texts constitute a particular genre that usually follows a certain pattern. In general, they begin with a short preface stating who owned the objects or collection in question, their location, the date of when the record was drawn up, and who was responsible for doing it. A number of scholars dealing with inventories and other kinds of collection records in the early modern era have discussed their ambiguity. For instance, in an analysis of early modern English probate inventories, Lena Cowen Orlin points to what she calls their fictions. She shows how well-known possessions were excluded from these kinds of records, and how entire rooms filled with valuable goods were left out of the same material. In this way, she criticises the typical use of this kind of document as more or less transparent evidence of property.[66] Giorgio Riello rejects Cowen Orlin's fiction concept, instead arguing for an awareness of the subjective representations in lists and inventories. He emphasises that the sources, ultimately, cannot be detached from the objects they describe. Instead, Riello suggests that objects in lists are to be regarded as framed, and that it is more important to focus on how records exclude and include things and spaces, rather than seeing them as fictions.[67] Analysing this type of sources, then, requires an attentiveness to possible fictions and certain framings, which generally equals classification. I have already touched upon the former by pointing out that great numbers of books were definitely excluded from records of plunder. The analytical core of the chapters that follow then lies in comparing different descriptions, classifications, catalogues, lists and inventories of the same objects and collections with one another.

65 Mordhorst, *Genstandsfortaellinger*, pp. 15–16.
66 Lena Cowen Orlin, 'Fictions of the early modern English probate inventory' in H. S. Turner (ed.), *The culture of capital. Property, cities, and knowledge in Early Modern England* (London: Routledge, 2002), pp. 52, 57–60.
67 Giorgio Riello, 'Things seen and unseen. The material culture of early modern inventories and their representation of domestic interiors', in P. Findlen (ed.), *Early modern things. Objects and their histories 1500–1800* (New York: Routledge, 2012), pp. 135–136.

4 Some Prerequisites for Swedish Imperial Collecting

Before embarking on an analysis of legal discourses and practices of plunder in seventeenth-century Europe, it is important to take into account some of the fundamental political traits that affected Swedish imperial collecting. Seventeenth-century Sweden is typically described as a pragmatic military state, meaning that it was dominated by the many wars and the army's needs. The years between 1621 and 1650 meant a more or less uninterrupted period of war for the kingdom. The state administration had rapidly grown to ensure that the necessary resources could easily be extracted for the state's needs, with little consideration for the population.[68] While Sweden was rising in a military sense, other areas had been left behind due the political intrigues of the sixteenth century. The Vasa dynasty, as mentioned earlier, was fairly new to the Swedish throne and the rulers had been occupied with political conspiracies since the first half of the sixteenth century, when Gustavus Adolphus' grandfather, Gustav Eriksson Vasa, rebelled against King Christian II of Denmark and Sweden in 1523. Gustav Vasa fractured the over hundred-year union Sweden had held with Denmark (the Kalmar Union). He was also responsible for the Swedish Reformation, which at least initially served as a means to seize financial resources from churches and monasteries.[69] Together, these changes had negative effects on higher education and learned culture in the kingdom. There was a lack of functioning educational institutions and other reliable infrastructure for knowledge, such as printing presses. Besides the convents and monasteries, Sweden's only university, Uppsala established in 1477, was closed down because it was ruled by the clergy.[70]

Gustav Vasa had made Sweden a hereditary monarchy in 1544, which meant that the political unsteadiness continued with his heirs. His oldest son, Eric XIV, dethroned in 1568 due to mental illness, was succeeded by his younger brother, John III, who entered into a controversial marriage with the Polish Princess Catherine Jagiellon. Their son, Sigismund III Vasa, became king of the Polish-Lithuanian Commonwealth and Sweden in 1587 and 1592, respectively. This conglomeration of territories was challenging, not least on religious grounds. Sigismund's uncle Charles IX, Gustavus Adolphus' father, rebelled against his nephew and deposed him in 1599. This was the beginning

[68] Nils Erik Villstrand, 'Stormaktstidens politiska kultur', in J. Christensson (ed.), *Signums svenska kulturhistoria. Stormaktstiden* (Lund: Signum, 2005), p. 63.

[69] Mari Eyice, *An emotional landscape of devotion. Religious experience in Reformation-period Sweden* (Stockholm: Stockholm university, 2019), pp. 18–19.

[70] Walde, *Storhetstidens I*, 12–13.

of severe dynastic strife between Polish and Swedish rulers that Gustavus Adolphus inherited from his father, expressed not least through a series of Polish-Swedish wars between 1600 and 1629, and continuing with the so-called Deluge during the period 1655–1661. In addition, Sweden had ongoing conflicts with Denmark and Russia.[71]

When Gustavus Adolphus ascended the throne in 1611, many measures were taken in the field of cultural politics through which the King, together with his trusted Chancellor of Realm Axel Oxenstierna, tried to improve the conditions for education in Sweden. For instance, printing houses were established, and classical authors such as Titus Livy were translated into Swedish, the latter made possible through royal aid. The King also established a new type of schools, *gymnasier*, in the chapter cities Västerås and Strängnäs. The place of these schools in the educational system was between primary school and university, and pupils were taught classical languages, the natural sciences and medicine. Gustavus Adolphus also brought new life to Uppsala University, not least by establishing its library, to which Chapter 3 is fully devoted. Gustavus Adolphus' venture was continued by his daughter, Christina, who gathered prominent European scholars at her court in Stockholm. The most famous of these was René Descartes, who died of pneumonia in Stockholm in 1650.[72]

It is against the backdrop of Gustavus Adolphus' cultural politics that his seizures of entire archive and library collections in the 1620s and 1630s should be understood: the plundering became a part of his cultural and educational endeavours.[73] Although semi-public libraries like the university library in Uppsala and the chapter libraries in Strängnäs and Västerås benefited from the plunder, it should be remembered that the line between public and private was not fixed during this era, but was instead fluid. Consequently, the library in Uppsala was sometimes referred to as the Royal Library, although this term usually designated the library at Tre Kronor Castle in Stockholm. And as I later point to in Chapter 3, Queen Christina and her librarians decided that individual manuscripts in Uppsala should be transferred to the Queen's library in Stockholm, as they wanted these valuable objects. This suggests that, as a ruler, the Queen considered herself entitled to the Uppsala library's collections.

Carl Gustaf Wrangel's wartime plundering was shaped by different circumstances. Wrangel's collecting was intended to serve him, his family and their

71 Robert I. Frost, *The northern wars. War, state, and society in northeastern Europe, 1558–1721* (Harlow: Longman, 2000), pp. 114–128.
72 Walde, *Storhetstidens I* p. 13; Sten Lindroth, *Svensk lärdomshistoria 2. Stormaktstiden* (Stockholm: Norstedt, 1975), pp. 15–47, 57, 65–71, 450.
73 Walde, *Storhetenstidens I*, pp. 12–19.

court, and was consequently not part of a kingdom's cultural politics and educational efforts. Nonetheless, Wrangel collected like a European prince. During his time as governor-general of Pomerania (1648–1676, with the exception of the period 1653–1656) and military commander in a number of field campaigns on the continent, along with his wife Anna Margareta von Haugwitz, he took great care in building up his collections through purchases, gifts and the taking of spoils. Wrangel's collecting, as well as Skokloster Castle, have been the subject of several valuable studies. Most notable is Arne Losman's *Carl Gustaf Wrangel och Europa* (1980), in which Losman reconstructs in great detail Wrangel's European network of cultural relations and consumption in the cities of Nuremberg, Frankfurt am Main, Stettin, Greifswald, Hamburg, Amsterdam and London.[74] Losman, for understandable reasons, pays little attention to Wrangel's collecting of spoils. This book's focus on Wrangel's plunder and therefore adds important perspectives to his collecting as well as to Skokloster's history.

In conclusion, both Gustavus Adolphus and Carl Gustaf Wrangel were affected by European ideals and standards in their collecting and taking of spoils, but with very different outcomes. As I will point out in the following chapters, the King was pragmatically greedy in his plundering activities for political reasons: he was struggling to establish necessary knowledge institutions in a kingdom with an insufficient educational system. Wrangel, however, was meticulous in all his collecting activities, looting included, as this was perceived to be a noble virtue in his time. Since he had the means to spend on knowledge and splendour, he could, paradoxically, afford to demonstrate his moderation when taking spoils.

74 Losman, *Carl Gustaf Wrangel och Europa*.

CHAPTER 1

Placed in Chests: The Making of Cultural Spoils in Seventeenth-Century Europe and Beyond

With repsect to the expressions we use when describing cultural looting and loot, Bénédicte Savoy has emphasised that 'terms such as "pillage", "spoliation", "confiscation" or "artistic seizure" carry within them implications of ideology, politics or representation, which in themselves already constitute a particular reading of events'.[1] With this in mind, I scrutinise a number of words and phrasings connected to wartime plundering and the taking of booty in the following, with the purpose of dismantling some of these ideological connotations and dominant understandings of events. According to a frequent contemporary definition, spoils of war, or war booty, are objects of material culture that fall victim to warfare. An object need not be symbolically or functionally tied to the war, but is assigned additional meaning – that of spoils – in connection to being removed through plundering.[2] But is it possible to define spoils of the early modern era in the same way? This chapter carefully considers how booty making was practised in the seventeenth century, and analyses the differences and similarities between now and then. Our contemporary definition accentuates the victimhood of material culture that is affected by war, which resonates with the fact that cultural heritage is in the common interest and highly valued from a global perspective. Not least in some of the twenty-first century's most publicised events in world affairs, artefacts have been actualised and have shown an ability to play key roles in revolutions and civil wars, as witnessed for instance in Egypt and Mali in recent years.[3] According to current regulations, soldiers can remove guns, helmets and similar objects relevant to the continuation of hostilities; as it is considered a fundamental right to be able to defend oneself to the greatest degree possible, taking such items is legal. Abducting cultural heritage in connection to armed conflict, however, is illegal according to international law and the 1954 Hague Convention. Today, one of

1 Bénédicte Savoy, 'Introduction', *Journal for Art Market Studies*, 2 (2018), p. 1.
2 Elisabeth Regner, 'Ur Historiska museets samlingar. Krigsbyten som klenoder och historiebruk', in S. Nestor & C. Zarmén (eds.), *Krigsbyten i svenska samlingar. Rapport från seminarium i Livrustkammaren 28/3 2006* (Stockholm: Livrustkammaren, 2007), p. 43.
3 See for instance https://www.theguardian.com/world/2014/may/23/book-rustlers-timbuktu-mali-ancient-manuscripts-saved; https://www.theguardian.com/artanddesign/jonathanjonesblog/2011/jan/31/egypt-museums-must-be-defended, access 11 August 2021.

the activities of the United Nations organisation UNESCO is to work to protect cultural heritage that is threatened by human conflict.[4]

In previous discussions of spoils in Swedish collections, their history has often been linked to the legal developments of looting.[5] Such representations typically take their starting point in antiquity in order to highlight the long tradition of the custom, and ultimately end up in today's comparatively strict legal framework.[6] Accordingly, there has been broader opposition to the custom of looting at least since the Age of Enlightenment, and as early as the seventeenth century war plundering began to be increasingly regulated, among other things in an effort to protect civilians as well as the property of the elite.[7] While both the legal and moral aspects of looting are of great relevance, these perspectives have a tendency to neglect the objects taken; paradoxically, they end up detached from that which was specific to the time and the conditions that made them into spoils. They then risk becoming static objects, independent of their time. This book, however, demonstrates that what is defined today as spoils of war were (and still are) multifaceted objects that held various meanings for the people who made them into booty during the seventeenth century. This means not least that the precise description of the objects as 'spoils of war' is conspicuous in its absence from the empirical material. The term spoils of war simply did not occur in the Swedish language in the seventeenth century, and this chapter will look into the reasons for this. We should distinguish the making of cultural spoils by the Swedish elite in the seventeenth century from general war plundering as well as from spoils of war as a nationalised cultural heritage in the nineteenth and twentieth centuries.

The problem is addressed by analysing practices of plundering and the exact words used to describe this and the objects taken. I focus on how the spoils of Gustavus Adolphus in Livonia and Prussia and of Carl Gustaf Wrangel in Denmark were made and understood in the first empirical contexts in which

4 A description of UNESCO's task in this area can be found at http://www.unesco.org/new/en/culture/themes/armed-conflict-and-heritage, access 11 August 2021.
5 Krēsliņš, 'War booty', p. 21.
6 Norberg, 'Krigets lön', pp. 16–18; Hannes Hartung, '"*Praeda bellica in bellum justum?*" The legal development of war-booty from the 16th century to date. A chance of bettering museum practice?' in S. Nestor & A. Grönhammar (eds.), *War-booty. A common European cultural heritage* (Stockholm: Livrustkammaren, 2009), 25–35; it should be noted that Hartung starts with Cicero. Redlich takes his point of departure in the Middle Ages, to support his argument that the conditions changed in the early modern period; see Redlich, *De praeda*, p. 2ff. The first case in *Beute*, an anthology of commented sources depicting looting and booty, starts in Uruk in 646 BC; see I. Dolezalek etc. (eds.), *Beute. Eine Anthologie zu Kunstraub und Kulturerbe* (Berlin: Matthes & Seitz, 2021), pp. 14–18.
7 Norberg, 'Krigets lön', pp. 16–19; Redlich, *De praeda*, p. 17.

they figured: the campaigns. I also consider additional material connected to the Swedish campaigning between 1621 and circa 1660. These were mainly letters, instructions and other types of texts created due to wartime communicational needs and logistics, which reveal a great deal as to how precious objects were made into plunder, as matter and practices were turned into words.[8] I have also included a few well-known journals depicting dramatic events of the Thirty Years War. Most of the sources discussed in this chapter thus differ in genre from those commonly associated with studies of early modern objects and collections – registers, inventories and catalogues – but are just as essential if one wants to understand pillaging and the different ways booty came into being.

In order to understand in depth what was characteristic of seventeenth-century looting and the perception of spoils, it is relevant to connect the mentioned sources to the etymology of certain words. The Swedish *byte* (booty, spoils), *krigsbyte* (war booty, spoils of war), *plundra* ([to] plunder, [to] loot), *spoliera* ([to] ruin), *trofé* (trophy) and *kaduk* (escheat) and the Latin *spolia* (spoils) will be discussed in relation to, among the already mentioned sources, *Svenska akademiens ordbok* (the Swedish Academy Dictionary, SAOB), which describes Swedish written language and word usage from 1521 to the present. Examining the historical uses of certain words is one way of historicising spoils, which makes it possible to highlight the difference between past and current meanings and attitudes regarding this object category. This etymological approach to past worlds of thought has been developed mainly within the history of science. For instance, Lorraine Daston has discussed the word 'object' and its etymology to illustrate how the accepted understanding of the word differs from the meaning she wishes to ascribe to scientific objects of study.[9] Paula Findlen has used the word 'museum' as a jumping-off point in analysing the philosophical discussions on knowledge, perception and classification that accompanied humanist and encyclopaedic collecting in the early modern period.[10] Gianna Pomata and Nancy G. Siraisi have studied the Latin word *historia* with the aim of highlighting the differences between the early modern period's and historicism's respective conceptions of history.[11] In a similar manner, in this chapter I demonstrate that it is possible to generate

8 Cf. Keating & Markey, 'Introduction', pp. 209, 211.
9 Lorraine Daston, "Introduction. The coming into being of scientific objects", in L. Daston (ed.), *Biographies of scientific objects* (Chicago: University of Chicago Press, 2000), pp. 1–2.
10 Findlen, 'The museum', pp. 59–60.
11 Gianna Pomata, & Nancy G. Siraisi, 'Introduction', in G. Pomata & N. G. Siraisi (eds.), *Historia. Empiricism and erudition in early modern Europe* (Cambridge, Massachusetts: MIT Press, 2005), pp. 1–17.

a deeper understanding of how cultural spoils were made and understood in the seventeenth century, with the help of the mentioned words' historical uses.

1 Plundering and Ruining in the Age of Grotius

'For when places are taken by an enemy, all things without exception, whether sacred or not, must fall a sacrifice'.[12] This is where the story of early modern spoils often begins. In his famous work *The Rights of War and Peace* (1625), natural law philosopher Hugo Grotius legitimised the victor's right to take spoils in war, through references to a number of writers from antiquity. For instance, he wrote that Cicero had asserted that not even holy places had to be respected during wartime – when a place had been conquered, the laws of peacetime ceased to apply. Grotius, who later served as Swedish ambassador in Paris during the period 1634–1644, put into words something that had long been a well known and established part of warfare: plundering and ruining – that is, destruction – were a constant, and were practised in various ways during the wars in premodern Europe.[13] Gustavus Adolphus himself is said to have appreciated Grotius' *Rights* so much that the King always carried a copy of the book with him.[14] This was no wonder, as the opportunity to plunder was so valuable that it was regarded as one of the strongest drivers of war in the seventeenth century. Everyone, from the lowly soldier to the highest ranking officer, had the right to take spoils as compensation for their military service (see figure 2 on page 191). For most of those involved, war was a livelihood. Until at least the mid-seventeenth century, the rulers' troops were neither nationally nor religiously homogenous but were instead largely comprised of mercenaries. Many career soldiers were not particularly concerned about which side they fought on; indeed, it was customary for the victor of a battle to absorb the soldiers of the losing side under more or less voluntary forms. On the other hand, these conditions do not mean that either the rulers' or the

12 Hugo Grotius, *The Rights of War and Peace. Including the Law of Nature and of Nations* (New York: Cosimo, 2007), p. 332; Latin original 'Cum loca capta sunt ab hostibus omnia desinunt sacra esse', Hugo Grotius, *De jure belli*, p. 605.
13 For examples of plundering's actors, see e.g. Bo H. Lindberg, 'Spoils and trophies', in F. Sandstedt (ed.), *In hoc signo vinces. A presentation of the Swedish state trophy collection* (Stockholm: The National Swedish Museums of Military History, 2006), p. 37; Marcus Junkelmann, 'Den katolska ligans troféer och krigsbyten under trettioåriga kriget', in A. Grönhammar & C. Zarmén (eds.), *Krigsbyte* (Stockholm: Livrustkammaren, 2007), pp. 137–146; Alfred Hessel, *Geschichte der Bibliotheke. Ein Überblick von ihren Anfängen bis zur Gegenwart* (Göttingen: Pellens, 1925), pp. 73–75; Redlich, *De praeda*, pp. 1–18.
14 Müller, 'Hugo Grotius', p. 518.

soldiers' convictions should be underestimated, but rather show how material, political and religious motives could easily be united.[15]

War, then, was simultaneously a matter of both economy and belief. In principle, anyone with the funds – from officers and generals to merchants and finance magnates – could invest in a conflict in the hopes of sharing in the profits of plunder. The individual soldier also made an investment, paying for his own equipment. If successful in his taking of plunder, he could arm himself with better weapons and in this way change his military rank and social status. Thus, for a simple infantryman there was an opportunity to rise in rank with the help of the booty he had taken, and possibly become a musketeer or dragoon.[16] Everything from everyday items to clothes made of expensive fabric and even living, breathing humans could be made into war booty and become a part of the circulation of people and things that the conflicts fuelled.

The Thirty Years War offers a number of illustrative sources that exemplify what general plunder and plundering could look like. Peter Hagendorf was a mercenary who kept a diary of his experiences over a long period of 25 years. He served the rulers of Bavaria for 22 years, and then the Swedish Crown after having been captured in 1633. In his daily observations, he described both his own taking of spoils as well as that of his wife, who had accompanied him: shirts, bed linen and wine, to name a few. After his wife died, this same soldier took a girl as booty.[17] While abducting a young female was apparently considered fair game, a soldier could be executed for taking a civilian's horse.[18] To today's observer, the line between what was accepted and what was denounced appears somewhat erratic and contradictory. However, there were not only scholars like Grotius but also a particular legal framework that aimed to control plundering: the articles of war. These were established by each individual prince, and all soldiers were required to swear an oath upon the articles, the breaking of which could be punishable by death. Both commanders and common soldiers were therefore well acquainted with the difference between legal and illegal plundering. For the Swedish Empire, Gustavus Adolphus' articles of war from 1621 are the most relevant example.[19] Fritz Redlich, in his analysis

15 Geoff Mortimer, *Eyewitness accounts of the Thirty Years War 1618–48* (Basingstoke: Palgrave, 2002), pp. 10–11.
16 Lindberg, 'Spoils and trophies', p. 38.
17 Jan Peters (ed.), *Ein Söldnerleben im Dreissigjährigen Krieg. Eine Quelle zur Sozialgeschichte* (Berlin: Akademie Verlag, 1993), pp. 47, 62–63; Mortimer, *Eyewitness accounts*, p. 18.
18 Mortimer, *Eyewitness accounts*, pp. 30–31; Redlich, *De praeda*, p. 26.
19 Gustavus Adolphus, *Krijgs articlar som fordom then stormechtigste furste och herre, herr Gustaff Adolph, then andre och store, Sweriges, Göthes och Wendes konung, storfurste til*

of the phenomenon of war laws, has asserted that the most interesting aspect is not that the taking of spoils was regulated but rather how it was regulated. Before 1500 plundering was uncontrolled and severe devastation a given part of warfare, but the beginning of the 1500s saw Europe's rulers attempting to control these aspects. They did this hardly for humanitarian reasons, but rather in order to protect their own interests in looting and to ensure their control over the soldiers' raiding.[20]

On an analytical level, the cultural plundering that affected archives, libraries and cabinets of curiosities should be distinguished from plundering that involved the necessary sustenance of the troops on the ground, even if in practice they often blended together. Above all, elite cultural plundering must be connected to the European elite's desire to collect things of knowledge and marvel. They were expected to create rich collections of various types: archives, libraries, museums, art chambers and cabinets of curiosities. Establishing these were one of the era's most characteristic cultural expressions.[21] War represented an excellent opportunity to expand one's collections by taking numerous precious objects as plunder, replacing something that someone else had taken away as booty, or even handpicking especially desirable things. Just like their European peers, Gustavus Adolphus and Carl Gustaf Wrangel consciously made precious things into spoils, with the goal of incorporating them into certain collections. The spoils of knowledge, or the literary booty, to use Walde's words, meant that vast quantities of information were conquered that could be processed into useful knowledge. Thus, besides the opportunity to gain instant prestige, humiliate the enemy and carry away their history by taking, for instance, family portraits and heraldic objects, it was possible to conquer the enemy's world of knowledge.[22] The appropriation and impacts of this knowledge are what the upcoming chapters follow over decades and centuries in the Swedish National Archives, Uppsala University Library and Skokloster.

Finland, hertig vthi Estland och Carelen, herre vthöfwer Ingermanland, etc. loffwärdigst i åminnelse, hafwer låtit göra och författa (Stockholm: Ignatius Meuer, 1621); further, 1632 saw the creation of Gustavus Adolphus' article letter; see Eugen von Frauenholz, *Das Heerwesen in der Zeit des dreissigjährigen Krieges, 1. Das Söldnertum* (Munich: Beck, 1938), pp. 388ff; for the articles of the Habsburg lands and the Holy Roman Empire, see Claudia Reichl-Ham, '"Keiner soll auf Beuth gehen ohne Wissen und Willen seines Hauptmannes". The war-booty laws of the Holy Roman and Habsburg Empires in theory and practice from the 16th to the 19th centuries', in S. Nestor & A. Grönhammar (eds.), *War-booty. A common European cultural heritage* (Stockholm: Livrustkammaren, 2009), pp. 83–93.

20 Redlich, *De praeda*, pp. 14–17.
21 Findlen, 'Possessing the past', p. 86.
22 Bursell, 'Krigsbyten i svenska', pp. 17–18.

While all three collections were enriched by plundered knowledge, the consequences of its presence came to affect each case differently.

Due to the international law discourse represented by Hugo Grotius and several others, the spoils that came to Sweden in the seventeenth century have been regarded as legal acquisitions.[23] That is not to say, however, that there was no one who referred to the taking of spoils as an infringement. Charles Ogier's comment on the sacred spoils in the royal treasury, discussed in the introduction, is one example of such a story.[24] Ogier clearly expressed his emotions regarding the church objects: even though Grotius had argued that not even what was sacred was to be spared in war, and the victor had the right to plunder, the ransacking of churches could still be upsetting.[25] Booty's capacity as emotional triggers is thus an important part of its seventeenth-century history as well. Remarkably, and despite Grotius' arguments, as a rule the early modern rulers' articles of war forbade the plundering of churches and other religious institutions; for instance, Gustavus Adolphus' articles specifically protected churches and hospitals. This rule, however, was obviously not always obeyed in practice.[26]

There are a number of illustrative sources from the Thirty Years War that note the difference between the laws and actual practice and erratic behaviour. The nun Anna Maria Junius, living in a convent outside Bamberg in Bavaria, described in her diary how she and her fellow nuns had been protected by the Swedish King's troops for a number of weeks. But during the same war in 1633, another nun – Clara Staiger from a convent outside Eichstätt, also in Bavaria – unlike Junius was forced to leave the convent along with her fellow nuns. Staiger later described the devastation caused by the Swedish troops that met the returning nuns. The refectory had been smeared with faeces, the soldiers had dug up graves and desecrated the bodies, and pictures and relics had been destroyed.[27] Ogier's and Staiger's stories show how confessional polemic could permeate both the perception of booty and the practices of plundering and

23 For instance, Francisco de Vitoria, Balthazar Ayala and Johann Amos Comenius, see Reichl-Ham, '"Keiner soll"', pp. 88, 92 (footnote 24); regarding the legality of Swedish booty, see e.g. Norberg, 'Krigets lön', pp. 15–17; Munkhammar, 'Böcker som krigsbyte', p. 37; Sofia Nestor, 'Krigsbyten i Livrustkammaren', in S. Nestor & C. Zarmén (eds.), *Krigsbyten i svenska samlingar. Rapport från seminarium i Livrustkammaren 28/3 2006* (Stockholm: Livrustkammaren, 2007), p. 57.
24 Ogier & Avaux, *Caroli Ogerii Ephemerides*, p. 253.
25 Ogier again reacts emotionally upon having seen a relic in Denmark; see Mordhorst, *Genstandsfortaellinger*, pp. 284–285, 287.
26 Redlich, *De praeda*, p. 18; Gustavus Adolphus, *Krijgs articlar*, article no. 99; Reichl-Ham, '"Keiner soll"', pp. 83, 86–87.
27 Mortimer, *Eyewitness accounts*, pp. 103–107.

ruination. Ogier admitted that, due to his Catholic faith, he had a difficult time accepting what he saw in Gustavus Adolphus' treasury, while the nun Staiger actually witnessed what the total desecration of a sacred space looked like. Despite its legality, taking spoils was no neutral trade. This is clearly reflected in the rulers' ambivalent relation to plunder: on the one hand they wanted to protect themselves, which is why they created their articles of war, but on the other they were eager to take part in plundering if the opportunity arose, and then their own laws could quite easily be violated.

2 Plundering, Ruining and Cultural Plunder in Swedish Sources

How, then, did Swedish kings and commanders express themselves when describing plunder and the making of cultural spoils? In early modern times, the Swedish verb *att plundra* (to plunder, to sack) was sometimes used to define both legal and illegal acts of war, with more or less violent implications.[28] Although plundering was carried out for all to see during wartime, after the fact it could be judged to have been wrong, or even be revoked. This applied not only to the soldier who was sentenced to death for having taken a horse, but also to the Swedish rulers, who in some cases were sentenced to returning spoils after various peace negotiations. For instance, under the peace treaty signed at Oliva in 1660, the archives and libraries taken by the Swedish King's troops were to be restored to the kingdom of Poland.[29] This case, however, does not demonstrate that the plundering had been illegal when it was carried out; rather, it was revoked as part of the peace treaty.

The period's articles of war allowed the rulers to tighten their control over the pillaging. In the introduction to Gustavus Adolphus' articles from 1621, it is expressly written that they were created due to the 'scant War Discipline and Order that has been the Practice'.[30] But in the chaos of war it was still not always possible to control the soldiers. A letter from Gustavus Adolphus to a colonel during the 1626 Prussian campaign is an example of this (see figure 3 on page 192).

The campaign was part of an extended dynastic conflict between the cousins Gustavus Adolphus and King Sigismund of Poland. In this case, the Swedish King ordered that the villages that came under the city of Danzig (Gdańsk) were under

28 'Plundra', SAOB, https://www.saob.se/artikel/?unik=P_1053-0353.Ioi4&pz=3, access 6 August 2021.
29 Walde, *Storhetstidens II*, p. 458.
30 Gustavus Adolphus, *Krijgs articlar*; see the introduction.

no circumstances to be sacked, as he had an alliance with the city. But despite the King's prohibition, soldiers had 'plundered Stuthoff and completely ruined many other villages'. After this, the King received daily complaints from those who had been affected. He asked the colonel to find the guilty parties so that they could be put on trial.[31]

If the King, in accordance with the agreement, showed civilians a certain amount of concern, he was less compassionate when it came to the Cistercian monastery in Oliva, located in the Danzig diocese. The same day the letter discussed above was issued, in another letter the King ordered that the monastery in Oliva be plundered. It was to be done properly, without anything being 'thrown or ruined'. All the church's ornaments were to be packed in chests, which then, well sealed, should be sent to Stockholm for storage to await the King's return.[32] As formulated in the articles of war, no church or hospital was to be plundered by the soldiers without orders from their superior.[33] In the case of Oliva the King's orders were very clear, and this is yet another example of religious institutions being sacked. The King's objection to the uncontrolled plundering around Danzig surely had to do with the wish to keep an ally and to keep the soldiers under good control. Perhaps Gustavus Adolphus even worried about missing out on possible income: according to the King's letter about the monastery in Oliva, up to then there had been no order regarding the so-called fire ransom. The fire ransom was the money a village or city was forced to pay the enemy in order not to be burned, and was a significant source of income for the warring parties. Consequently, if villages were ransacked and burned without giving the population a chance to buy themselves free from harm, the possibility of claiming a fire ransom was also lost. To close the Olivian case, it should be noted that an altarpiece, a baptismal font and a pulpit from the Cistercian monastery in Oliva can be found today in Skokloster Church, which received them as gifts from Carl Gustaf Wrangel in 1674. It is unclear whether the items were part of Gustavus Adolphus' 1626 spoils, or were taken later by Wrangel himself.[34]

During the same siege of Prussia, Axel Oxenstierna wrote a number of interesting letters about plundering, burning and ordering fire ransom, in various ways illustrating practices associated with spoils – because, even though the Swedish King had negotiated a ceasefire with King Sigismund, plundering still

31 Gustavus Adolphus to Colonel Wetzell, 3 August 1626, Riksregistraturet (RR), Riksarkivet (RA) Marieberg.
32 Gustavus Adolphus to Admiral Carl Carlsson, 3 August 1626, RR, RA Marieberg.
33 Gustavus Adolphus 1621, Article 99.
34 Rangström, *Krigsbyten*, pp. 15, 18.

occurred. In January, the Chancellor wrote from Elbing (Elbląg) to the States General's envoy regarding the hostile raids (*hostis excursionibus*) Polish soldiers had purportedly conducted in the areas around Braunsberg.[35] The next day Oxenstierna wrote another letter, this time to a Colonel Ernreitter, telling him to hit the Polish as hard as he could, as Oxenstierna had understood that they were still fighting and pillaging despite the ceasefire.[36] But resistance was not the only problem: at a couple of points in April, Oxenstierna wrote to Colonel Herman Wrangel (Carl Gustaf Wrangel's father) and ordered him to make recompense for the illegal raiding his cavalry had taken part in.[37] Interestingly, Oxenstierna was more specific when he wrote about plundering in German, expressly writing plundering ('plündern'). He also pointed out booty makers ('beutemacher') in German, though the Latin 'hostile raids' offered a more discreet description of the pillaging.[38]

Some time later, in March of that same year, Oxenstierna wrote to the commodore in Dirschau (Tczew) with a plea that he not completely ruin the people of Christburg (Dzierzgoń) through the taxing of their farms. According to Oxenstierna, the poverty-stricken people had already suffered ransacking and discomfort on many occasions.[39] But if the people of Christburg managed to elicit Oxenstierna's sympathy, the same cannot be said of the residents of Danzig. In a letter to the King, he attempted to explain why he had once or twice ordered something to be burned. If this had happened, he assured the King, it was because he wished to keep the enemy from abusing Gustavus Adolphus' humanity.[40] Here, Oxenstierna practised a well worn strategy: plundering and burning some villages in order to force others to pay a fire ransom. Successful pillaging was often concluded with the village being burned, and the burning of villages was a proven instrument of power in wartime.[41]

The practices and problems involved with plundering are also familiar from Carl Gustaf Wrangel's time as a military commander. During King Charles x Gustav's wars against the King of Denmark in 1657–1658 and 1658–1660, in which Wrangel participated, numerous sources offer examples similar to what had happened in Prussia 30 years earlier. According to contemporary Danish sources the Swedish advance was notably destructive, especially when it came

35 Herman Brulin (ed.), *Rikskansleren Axel Oxenstiernas skrifter och brefvexling. Afd. 1, Band 4. Bref 1628–1629* (Stockholm: P. A. Norstedt & söner, 1909), 23.
36 *Oxenstiernas skrifter och brefvexling*, 1628–1629, 24.
37 Ibid., 110–111.
38 Ibid., 110.
39 Ibid., 76–77.
40 Ibid., 139.
41 Redlich, *De praeda*, p. 44.

to burning documents such as parliamentary records. Both the King and Wrangel attempted to control unauthorised plundering, and the King also tried to oversee the spoils his commanders had taken for themselves. When the spoils were packed in chests and ready to leave Denmark, King Charles X Gustav required detailed lists.[42] The requirement of inventories of what was shipped off indicated that the King wished to stay informed about and control the pillaging, but that the generals apparently felt they had the right to do as they themselves pleased.

In a Danish source contemporaneous with the time of the Swedish siege, minister Anders M. Hjörring described Wrangel's behaviour in relatively positive terms. According to Hjörring, Wrangel had respected the law of war and prevented the ruining of the farmers' property. On a number of occasions he had also returned archive and book collections he had taken as spoils in that war, sometimes in return for payment.[43] However, against the background of Wrangel's encyclopaedic collecting, which is discussed later in the chapter on Skokloster, his restraint when it comes to the taking of spoils can be seen as an expression of his distinct taste as well as a desire to uphold discipline, rather than as a sign of mercy.

An example of Wrangel's actions concerning spoils and plundering can be found in a letter dated October 1658, where it is clear that he was above all guarding his own interests in this matter. In the letter, addressed to King Charles X Gustav, he wrote about several chests and collections of spoils that sat locked in a room at Korsör Castle.[44] It was possibly here that Wrangel had happened upon the objects from the Rothkirch family's collections, which are discussed later in relation to the collections of Skokloster Castle. The letter primarily concerned the King's donation of the Danish nobleman Gunde Rosenkrantz's book collection, which the King had given to Magnus Gabriel De la Gardie.[45] The books had been taken as spoils during the first stage of the war but the collection seems to have been split up after this, and De la Gardie therefore

42 Walde, *Storhetstidens II*, pp. 215–220; here, the sources contradict Otto Walde's reasoning in the introduction to his thesis that Charles X Gustav, unlike Gustavus Adolphus, is to have allowed the elite to take of the spoils more freely. See Walde *Storhetstidens I*, p. 34.

43 Anders Matthiesen Hjörring, *Leyers eller Beleyrings Dagverck (1663). En dag-for-dag skildring af Københavns belejring 1658–60* (Köpenhamn: Selskabet for Udgivelse af Kilder til Dansk Historie, 2012), 24–25, 84; Walde, *Storhetstidens II*, pp. 212–213, 215, 219 (see footnote 1).

44 Carl Gustaf Wrangel to King Charles X Gustav, 17 October 1658, Brev till Kongl. Majt., RA Marieberg; cf. Walde, *Storhetstidens II*, p. 217.

45 Gunde Rosenkrantz had inherited the library of his father, Holger Rosenkrantz, and this was one of the largest spoils containing books that De la Gardie acquired. Walde discusses the fate of the collection in detail; see Walde, *Storhetstidens II*, pp. 293–326.

attempted to locate what was still missing with help from the King. A part of Rosenkrantz's book collection seems to have been stored at Korsör Castle, and thus to have been under Wrangel's protection. Wrangel, however, wrote to the King that he himself did not have Rosenkrantz's books or any knowledge of their whereabouts. In April of the same year the Danish nobleman had visited Wrangel and asked for his books back, and Wrangel did not want to refuse him as the factions were now at peace. In Wrangel's letter, however, it is unclear whether he actually arranged any delivery of the spoils. He had been promised 1,000 riksdaler for his trouble, but stressed that he had ultimately never received this payment. He also wrote that the chests of spoils being stored at the castle had been broken into and emptied, although the room had been locked. The only things that had escaped the raiders' assault were a number of chests of books, which were Wrangel's own spoils and were therefore held in 'good storage'.[46] Clearly, and perhaps unsurprisingly, he put his own interests first here and the spoils that did not end up with him were secondary. As there are objects at Skokloster that have belonged to the Rosenkrantz family, it is possible that Wrangel tried to hide the fact that he himself had taken parts of De la Gardie's spoils.[47]

In connection with this, a particular and spectacular object in Wrangel's collections should be mentioned: the so-called Skokloster shield, likely taken at the time of the plundering of Rudolf II's famous cabinet of curiosities in Prague in 1648. In a 1651 inventory of Wrangel's collections, the shield was described in relatively simple words: a beautiful and well-executed shield with figures. In this inventory it is mentioned only at the end, under the heading 'Other Things'. Later, however, it would take a central position in Skokloster's armoury. It is possible that Wrangel avoided describing it in more detail because it was a ceremonial princely object; other actors might thereby have felt that it should not be in his hands.[48] This example is interesting precisely because it is an exception: as a rule, the notes on and inventories of the spoils analysed

46 Carl Gustaf Wrangel to King Charles X Gustav, 17 October 1658, Brev till Kongl. Majt., RA Marieberg; cf. Walde, *Storhetstidens II*, pp. 215, 217, 318–319. Walde interprets the letter somewhat differently, asserting that the chests of books that were left untouched were not set aside for Wrangel.

47 See e.g. Wr. hist. fol. 4 in the library. There are also a chest, weapons in the armoury and a portrait in copperplate by Gunde Rosenkrantz; see inventory numbers 3588, 6891, 6892, 6894 and 2770, SS.

48 Åke Meyerson & Lena Rangström, *Wrangel's armoury. The weapons Carl Gustaf Wrangel took from Wismar and Wolgast to Skokloster in 1645 and 1653* (Stockholm: Royal Armoury foundation press, 1984), pp. 30–32, description in German on p. 31, 'Ein schöner gearbeiter Schildt mit Figuren'.

in this book highlight where the plunder came from. There thus seems to have been something Wrangel wanted to downplay or even hide in this case.

Taken together, the examples from Prussia, Denmark and finally Prague show how the Swedish commanders – from King and Chancellor to colonels and officers – had problems controlling their men. The articles of war were thus no guarantee that order would be upheld. The enemy as well as one's own commanders violated obvious agreements, and Gustavus Adolphus could not even trust his own Chancellor on this issue. In the way he related to the residents of cities and villages, Oxenstierna, like the King, could show both compassion and cruelty. And the situation was similar for King Charles X Gustav. This ambivalence and the different practices of plundering all had their place in the complexity of warfare. Raiding was a way of waging war, a way of supporting one's troops and, most importantly to the elite, a way to collect.

3 Cultural Plunder in Livonia and Prussia

With Gustavus Adolphus' capture of Riga in 1621 a habit of cultural plundering began that would later be described, by historians from Otto Walde to those in the present day, as systematic and highly goal-oriented.[49] But, as I have shown, plundering happened for many reasons and it was not always possible for the commander to control the course of events; not even for King Gustavus Adolphus himself. Maintaining control over the pillaging of castles and cities gave Gustavus Adolphus, Axel Oxenstierna, Queen Christina, King Charles X Gustav, and Carl Gustaf Wrangel a greater opportunity to keep as much as possible of the potential cultural spoils.

What happened, then, in Riga in 1621, when Gustavus Adolphus took the Jesuit College's library, an event that later came to be repeated on several occasions? In correspondence to the Swedish privy council, Gustavus Adolphus told its members of the peace treaty he had signed with the governing council in Protestant Riga, shortly after the city had been captured by the King's army. According to the treaty the King's soldiers were to show respect for private property, and the city's privileges were acknowledged by Gustavus Adolphus. In exchange, the Swedish King was to have *jura maiestatis*, which meant that he would now assume the Polish King's rights and incomes, as well as all property

49 Walde, *Storhetstidens I*, pp. 16, 44–45; Lars Munkhammar, 'De många och stora bokroven', in A. Grönhammar & C. Zarmén (eds.), *Krigsbyte* (Stockholm: Livrustkammaren, 2007), p. 89.

belonging to the Jesuit College of Riga.[50] Thus, it should be stressed that in the first known case of a Jesuit college's library being appropriated by Gustavus Adolphus, it was the result of a treaty he negotiated. This made the occurrence unusual; in a typical case, the King would simply have ordered that the city be ransacked when it had fallen (see figure 4 on page 193).

Shortly after the treaty had been signed, the King issued a directive to his new treasurer in Riga, Jesper Mattson Kruus, and his assistants that read:

> They shall allow to *Confiscere* [be confiscated] all that is found in the Jesuit monastery, livestock, grain, hay, wood, books and all manner of household goods, and then provide His Royal Majesty with a certain Roll [list]. They shall also cause the Jesuits to provide the letters and information over the estates belonging to the monastery.[51]

In the King's directive, the library items were mentioned together with everyday things that could be used for the troop's daily provisions on the ground. Thus, in this case the typical sort of plundering for the men's immediate sustenance was combined with cultural plundering. Gustavus Adolphus also demanded a list of this new property that he confiscated. The King's use of the verb 'confiscere' stressed that the property, in a seemingly obvious way, belonged to him and thereby the Crown. In antiquity, the Latin verb *confiscare* referred to property confiscated on behalf of the Roman Republic's treasury, or something that was more generally placed in the treasury or taken into custody, in baskets or chests.[52] Gustavus Adolphus' use of the verb confiscate, as opposed to plunder, expressed a different, less violent side of pillaging. Placing things in chests was literally what the soldiers would later do: when the books and other objects had been separated from everyday essentials such as food, they were packed into chests to be sent to Stockholm.[53] At the time, chests were both a common and sophisticated piece of furniture used for storage and moving, and had been since the Middle Ages.[54] Gathering spoils in chests allowed for order, control and mobility. As a portable storage

50 Gustavus Adolphus to Riksrådet, 17 September 1621, RR, RA Marieberg.
51 Gustavus Adolphus to Jesper Mattson Kruus, 19 September 1621, RR, RA Marieberg. My italics; capitalisation in original.
52 P. G. W. Glare (ed.), *Oxford Latin dictionary: 1–4: A-libero* (Oxford: Clarendon P, 1968), p. 401.
53 Likely the chests Gustavus Adolphus mentioned on 4 November 1621, RR, RA Marieberg; cf. Walde, *Storhetstidens I*, p. 48.
54 William Karlson, *Ståt och vardag i stormaktstidens herremanshem* (Lund: Gleerup, 1945), pp. 168–170.

room, then, the chest is a recurring theme that I draw attention to in all the case studies in this book.

In the same directive to his treasurer, Gustavus Adolphus commanded that his war commissioner, Peder Banér, be allowed to search for any 'Escheats' (Swe. pl. *kaduker*) that might be found in 'the tolls and elsewhere' in Riga, and which thereby rightfully belonged to the King.[55] Just like the verb *confiscere*, the noun *kaduk* had a connection to Roman law, where it was used to denote bequeathed goods that for various reasons had ended up in the hands of someone other than the person to whom they had been bequeathed. The word *kaduk* comes from the Latin *caducus*, which denoted something that had fallen, or fallen away.[56] In older Swedish, the word was used to denote ownerless goods that had been confiscated or had otherwise fallen into the hands of the Crown.[57] This etymological background thus shows that *kaduk* did not entail something taken by force but rather abandoned goods that had been confiscated under legal forms. The King sent further correspondence relating to escheats in Riga, giving a number of colonels, officers and servants of the royal court the authority to help themselves to the escheats still being stored there. Another two similar authorisations were issued the same month.[58]

As Gustavus Adolphus had an agreement with the ruling parties in Riga, the spoils taken from the Jesuit College were not abducted through violent plundering. They could calmly be confiscated by the King, because the council in Riga had given him this right. But, as the books and other items were not ownerless when they were confiscated, they were also not described as escheats.[59] In practice, there can hardly have been any strict boundaries between escheats, confiscated property and spoils taken through plundering. Rather, there was some sort of analogy between the meaning of different categories, just like between the practices of plundering and ruining. Riga was under Protestant rule during the 1620s, and the Jesuit College had been established there with a missionary aim with help from the King of Poland.[60] It was not altogether

55 Gustavus Adolphus to Jesper Mattson Kruus, 19 September 1621, RR, RA Marieberg. Capitalisation in original.
56 Glare (ed.), *Oxford Latin*, pp. 248–249.
57 'Kaduk', SAOB, https://www.saob.se/artikel/?unik=K_0001-0086.5F6Z&pz=3, access 6 August 2021.
58 Gustavus Adolphus to Jesper Mattsson Kruus, 8 December 1621, RR, RA Marieberg; Gustavus Adolphus on 4 December 1621, RR, RA Marieberg; Gustavus Adolphus on 20 December 1621, RR, RA Marieberg.
59 As far as I can tell, Otto Walde makes no distinction between escheats and spoils; see Walde, *Storhetstidens I*, pp. 17, 46, 61.
60 Walde, *Storhetstidens I*, p. 45.

strange then that the city gave the Swedish King the right to the Jesuits' goods, as this did not directly affect anyone in the governing council personally.

After Riga, the Swedish forces occupied the city and castle of Mitau, located some 40 kilometres away. This happened at the beginning of October 1621, and according to Gustavus Adolphus the city stood open and empty upon the army's arrival while the castle held out for one night.[61] There, the King made sure to seize the documents of the Livonian Order that had been left behind, along with other types of archive documents. Objects from the armoury of the Dukes of Courland were also taken (see figure 5 on page 193). The archive documents would later become part of the Kingdom's Archive, later the Swedish National Archives, at Tre Kronor Castle in Stockholm. The Mitau documents left no explicit traces in the Royal Registry at the time they were taken. The royal correspondence that left Mitau in the days after the occupation had begun did not mention confiscation, plundering, or looking for escheats. Walde notes that a number of chests were shipped to the Swedish Empire in November 1621, and that these might possibly have contained the archive documents from Mitau along with the collections from Riga.[62] However, the work with these documents was not begun until the summer of 1622. It is thus impossible to know how the argumentation was presented upon the confiscation or plundering of the documents in October 1621. What happened in Mitau was typical, however, unlike Gustavus Adolphus' negotiations with the council in Riga. The fortified Mitau Castle was seized by the soldiers, and was then ransacked on the orders of the King.

During the campaign in Prussia in the summer of 1626, which was connected to the same dynastic war as in Livonia, the King appropriated book collections in Braunsberg and Frauenburg. In an order to Lieutenant Colonel Zacharias Pauli in Braunsberg, Gustavus Adolphus commanded that Pauli 'take into his protection all that is in the castle and within the Jesuit College'.[63] Everything in these places was thus to be safeguarded by Pauli, likely from the soldiers' more random pillaging. The King further ordered that Pauli, together with an accountant, look into what types of escheats might be found in the city, particularly in the form of goods belonging to the King of Poland's loyal subjects.[64] The King did not refer to either the castle's or Braunsberg College's property as escheats.

61 Gustavus Adolphus to Jesper Mattson Kruus, 4 October 1621, RR, RA Marieberg.
62 Gustavus Adolphus' passport for Hans Winschench, 4 November 1621, RR, RA Marieberg; cf. Walde, *Storhetstidens I*, pp. 48, 51.
63 Gustavus Adolphus to Zacharias Pauli, 1 July 1626, RR, RA Marieberg.
64 Gustavus Adolphus to Zacharias Pauli, 1 July 1626, RR, RA Marieberg.

Shortly after Braunsberg, the cathedral town of Frauenburg was captured, and parts, or the entirety, of the chapter library belonging to the cathedral were confiscated.[65] The King gave Bengt Oxenstierna command over the city, and ordered that all goods belonging to the Jesuits, bishops or canons be surveyed and registered. As the order was later formulated, the King was explicitly referring to estate such as farms, but books and similar personal belongings were also included in the term goods. In the city of Elbing, where Oxenstierna was also in command, he was to collect and make an inventory of all escheats likely to be found there.[66] Thus, taken together, the cases of Riga, Braunsberg and Frauenburg demonstrate that Gustavus Adolphus did not use the words plundering or spoils when writing about the book and library collections that he took from the Jesuits and the cathedral. Neither did he use the word escheat in these cases. In Riga, a peace treaty led to the negotiated confiscation that befell the Jesuits. The same kind of confiscation was repeated later in Braunsberg and Frauenburg on the King's orders, but without previous negotiations. Plundering and confiscation thus flowed into each other.

4 Collecting and Conserving Archives and Libraries

All four cases discussed above show how books and archival documents were made into spoils through plundering and confiscation by the victors: Gustavus Adolphus and his commanders. The spoils were created through both rational negotiation and violent ransacking. In the Swedish research tradition, the appropriation of archive and book collections has been said to be somewhat of a specialty of the Swedish elite during the seventeenth century.[67] Seen from a European perspective, however, it is difficult to claim that the Swedish elite behaved unusually. Jill Bepler has shown that spoils comprised of archive documents and books were especially common during the Thirty Years War.[68] Against this background, it is interesting to look closely at a more general instruction issued by Axel Oxenstierna in 1643, long after the spoils had been seized in Riga and Prussia. In the command, Oxenstierna wrote that the Field Marshal should make sure to confiscate files, documents and proclamations from distinguished places, archives and offices. There were a number of reasons why such documents were to be made into spoils: according to

65 Walde, *Storhetstidens I*, pp. 96–99.
66 Gustavus Adolphus to Bengt Oxenstierna, 10 July 1626, RR, RA Marieberg.
67 Walde, *Storhetstidens I*, p. 16; Munkhammar, 'Böcker som krigsbyte', p. 31.
68 Bepler, '*Vicissitudo Temporum*', pp. 953–968.

Oxenstierna, they could offer information on the enemy's deliberations, they might concern the Swedish Empire, or they could simply aid in the continued recording of history. While the search for intelligence in enemy records might not come as a surprise, the explicit interest in capturing historical sources does. According to Oxenstierna, it was important that such documents not be split up but instead be listed, packed and sent to the Kingdom's Archive at Tre Kronor Castle in Stockholm. Oxenstierna continued with the libraries. If the Field Marshal captured papal cities where there were expensive and beautiful libraries, just as had been the case the previous summer in Neuss and Olmütz (Olmouc), the secretary or a 'trusted man, with adequate knowledge, shall take the opportunity to collect and conserve [save, maintain] the same library'.[69] According to the Chancellor, the books were to be used for the improvement of academies and schools in the Swedish Empire. If difficulties were to arise, the Field Marshal was encouraged to choose only the most distinguished books: manuscripts and books written by the best authors, which likely meant the Church Fathers. The collections were to be kept together and placed in chests and sent to Sweden.[70] Oxenstierna's order is significant, as it is more general in its scope compared to the cases discussed in detail earlier. He stressed archive documents and books as especially important to take as plunder, and, if it came to having to choose what to abduct and what to leave behind, he gave guidelines. It is worth mentioning an earlier instruction from 1638, when Oxenstierna wrote to Field Marshal Johan Banér about the archive of the Duke of Pomerania, whose castle had been captured. The archive was to be taken, packed and sent to the Chancellor for safe keeping. But, according to Oxenstierna, this should be done without reference to the local deeds, as these were of no use. The Chancellor also discussed the Duke's armoury, which could be of use to the troops, as well as the estate of the recently deceased Saxon Duchess, in which he was not particularly interested.[71] In this case, the archive documents were more valuable than everything else.

In both these instructions it is obvious that Oxenstierna had certain selection criteria, even though whole collections were preferable when it came to books. Archive documents and books were undeniably prioritised in his correspondence, but this does not mean they were fixed into a single function or

69 Helmut Backhaus (ed.), *Rikskanslern Axel Oxenstiernas skrifter och brevväxling. Avd. 1, Band 16. Brev 1636–1654 (selection), Del 2, 1643–1654* (Stockholm: Kungl. Vitterhets historie och antikvitets akademien, 2009), 412, my italics.
70 *Axel Oxenstiernas skrifter och brevväxling, 1643–1654*, 411–412. Helmut Backhaus' edition of the letter addresses the differences between concept and RR; Otto Walde follows the registry, cf. Walde, *Storhetstidens I*, pp. 345–346.
71 *Axel Oxenstiernas skrifter och brevväxling*, 1643–1654, 168–169.

meaning. It also does not mean that this behaviour was specific to the Swedish elite; the documents rather bear witness to a more widespread European tendency to collect things in times of war.[72] Oxenstierna stressed how important it was that the spoils be kept together and preserved. The notion of archive documents and books being collected and saved can be interpreted in at least two ways. Oxenstierna was without a doubt worried that the chaos of war and pillaging would create disorder. Collections could be destroyed or scattered to the four winds by soldiers from both one's own and the enemy's armies in search of spoils.

There is another interpretation, however, and to develop it I will use another source from 1643. In a letter to Axel Oxenstierna, the Archbishop Laurentius Paulinus Gothus wrote about the confiscation of Jesuit book collections, with which the Archbishop and other Swedish scholars were well acquainted.[73] Gothus had hopes that he and Strängnäs Cathedral could share in the book spoils that had been entering the country since the 1620s. He wrote:

> In this War, where God at times mercifully helps us to [conquer or acquire] our Enemy's famous Collegia and beautiful Libraries, which they abuse for the Suppression of the true Religion, However here [the books] can be brought to *genuinum usum* [right or natural use] again, which is honourable to God, a powerful defence of Our Christly Religion, and a beneficial continuation of all praiseworthy Studies.[74]

From Gothus' point of view, the books should be saved from Jesuit abuse by being brought into Protestant use. Oxenstierna's encouragement to 'collect and conserve' can be placed in relation to the Archbishop's statement, and be understood as the Chancellor's wish to conserve archival documents and books involving a desire to save them from their owners, Catholic rulers and Jesuits and other religious orders. Gothus voiced a religious polemic that is otherwise conspicuous in its absence in the sources studied here. Notably, Gothus' insinuation that the Jesuits' books were not only confessional tools but also changeable objects is the most interesting thought expressed in his letter. It was the Jesuit College, where the books were being held prisoner, that presented the true threat. But placed in the right context, the books would be able to be used properly. Nothing suggests that Gothus believed that the Jesuits'

72 Bepler, '*Vicissitudo Temporum*', pp. 955–957.
73 Walde, *Storhetstidens I*, p. 25.
74 Laurentius Paulinus Gothus to Axel Oxenstierna, 1 August 1634, E 682, Oxenstiernska samlingen, RA Marieberg. My italics.

collections contained the wrong kind of knowledge, as has been suggested by Otto Walde and Margareta Hornwall.[75] Today, research in the areas of the history of science and book history stresses a more multifaceted view of confessional books. My studies of book spoils in Uppsala University Library and Wrangel's Skokloster will in various ways reflect this perspective, which advocates a multifaceted, less categorical, view of books and libraries in relation to religion in the seventeenth century. It should also be mentioned that the Jesuits' knowledge production and contributions to the Scientific Revolution have been re-evaluated in recent decades. Historians of science have thereby assigned the order a much more progressive scholarly position than has previously been acknowledged.[76]

Gothus' insinuation regarding the books' changeability thereby touches on and harmonises with an essential theme of contemporary materiality theory discussed in the introduction to this book. Moreover, in a book historical analysis, archive documents and books have to be understood as objects, which had, and have, a number of different properties. Their knowledge content was central, of course, but this was not the only quality that made them worth collecting. In this regard, it can be interesting to compare the Swedish elite's confiscation and plundering of archives and libraries with a case from the early phase of the Thirty Years War. The Calvinist Palatinate library in Heidelberg was taken as spoils by the Catholic League in 1622 and given (at the Pope's explicit request) by Maximilian of Bavaria to Pope Gregory XV in Rome. All bindings are said to have been separated from the books when the spoils were to be sent southward. The bindings were replaced with green parchment covers, and every book was provided with a text that read 'I am from the library that was taken as spoils in Heidelberg and that Maximilian of Bavaria sent to Gregory XV as a trophy'.[77] Maximilian thereby gave his magnificent spoils to Gregory XV as a monumental gift. The books were made into trophies of war, not only by being taken but also by having their physical being changed so that the victor's triumph was made even more evident. With the added text, the books were also given a voice (*sum*; that is, 'I am') and a geographical origin, and were made into parts of a historic event. When the Pope wrote and

75 Walde, *Storhetstidens I*, pp. 15–16, 18; Hornwall, 'Uppsala universitetsbiblioteks resurser', p. 68.
76 Mordechai Feingold (ed.), *Jesuit science and the Republic of Letters* (Cambridge Massachusetts: MIT Press, 2003); see especially Feingold's preface, pp. vii–x, and introduction 'Jesuits. Savants', pp. 1–45.
77 The original text reads 'Sum de bibliotheca, quam Heidelberga capta spolium fecit et Gregorio XV. trophaeum misit Maximilianus dux Bavariae'. Cited in Hessel, *Geschichte der Bibliotheken*, pp. 73–74, quote on p. 74; see Bepler, 'Vicissitudo Temporum', pp. 955–956.

thanked Maximilian for the spectacular gift, he stressed the collection's confessional significance. The material foundation of heretical knowledge could now be changed into weapons for the Catholic faith.[78] The books were thus described as something that was transformable: here, books could be made into arms.

Maximilian of Bavaria wanted the spoils to be kept together and placed in a particular place in the Pope's library, immortalising the monument to victory. When the books were to be directed southward, the Pope sent his own scholarly official to supervise the packing. He had clear instructions to see that all traces of the original library in Heidelberg were erased, and thereby its entire history. It was thus not only the books themselves that were packed up but also all sources of the library's history, and a careful floor plan was to be drawn showing how the library had been arranged. Paintings and other decorations that could be associated with the existence of the library were to be taken as well. The seizing of the collections in Heidelberg was thereby highly elaborate, and is typically regarded as the prototype for the plunder of a number of similar libraries.[79] Gustavus Adolphus' confiscation of the Jesuits' collections in Riga, however, occurred one year before the events in Heidelberg, and this was before the King had become engaged in the Thirty Years War. There is an interesting parallel between the two cases: the confiscation in Riga was also extensive and included many different types of objects; that is, all the inventory housed at the Jesuit College. However, the King's officials did nothing to change the Riga books' materiality.

Were plundered archival documents and books, spoils of knowledge, special, more powerfully charged than other valuable cultural objects? When it comes to the Thirty Years War, historian Geoff Mortimer has looked at how books belonging to Protestants were burned by the Catholic League, an act that was committed in order to exercise religious control.[80] Another depiction touching on the destruction of books can be found in Scottish mercenary Robert Monro's diary from the Thirty Years War. Monro wrote of feeling deep aversion at seeing how other soldiers took part in the plundering. A devout Calvinist, he described ransacking as reprehensible. He admitted that he had on a single occasion succumbed to the temptation to take spoils, taking a pair of books and justifying it with the notion that they surely otherwise would have been burned by the enemy.[81] In other words, he believed he had saved the

78 Bepler, *'Vicissitudo Temporum'*, p. 955.
79 Bepler, *'Vicissitudo Temporum'*, pp. 955–956.
80 Mortimer, *Eyewitness accounts*, pp. 71–72, 75.
81 Robert Monro, *Monro his expedition with the worthy Scots Regiment (called Mac-Keyes Regiment) levied in August 1626* (London: William Jones, 1637), p. 32.

books from destruction. Considering the various examples discussed here, it is reasonable to presume that it happened that the Swedish kings and their men destroyed books in a similar way. However, it is worth noting that the enemy's book burning was highlighted in both images and text in the mass-produced propaganda featuring Gustavus Adolphus that circulated at the beginning of the 1630s. On a number of copperplates, the Jesuits are depicted as the King's antagonists, and one of the plates shows them burning books, most of which look like bibles (see Figure 6 on page 194). Another plate depicts how an evangelical library in Augsburg was occupied by the Catholic League's troops in August of 1629.[82] In this propaganda, attacks on Protestant congregations were intertwined with attacks on books. The examples of Heidelberg and the copperplates thus highlight how books could be given a voice; their violent fate was a consequence of their power.[83]

5 The Notable Absence of Spoils, *Spolia* and Trophies

Up to now, this chapter has discussed various types of practices that created booty during the Swedish campaigns and the Thirty Years War. Now it is time to get as close as possible to these spoils, by examining what words were directly used to describe them and thereby make them comprehensible. What were the abducted things explicitly called? For good reasons, I also address what they were not called. This brings up one of this study's perhaps most surprising discoveries: that the terms spoils of war, war booty and spoils or booty are not used in the seventeenth-century descriptions of the plunder studied here. Interestingly enough, according to SAOB, the term spoils of war/war booty did not occur in the Swedish language before 1712, when the first use is registered in Haquin Spegel's Swedish dictionary.[84] The term may therefore have come into being at the beginning of the eighteenth century as a direct consequence of the many cultural spoils that had been incorporated into collections and placed in churches in the Swedish Empire since the 1620s. The fact that the word was coined suggests that there was a need to point out and identify these objects as a category of their own. As opposed to spoils of war, the word booty is documented in the Swedish language earlier, but surprisingly it is not used especially often in the sources studied here. A significant exception to this is

82 Oskar Planer collection, call numbers 45 and 47, Uppsala Universitetsbibliotek (UUB).
83 See Bepler, '*Vicissitudo Temporum*', pp. 953–955. Here, Bepler discusses the great circulation of books in conjunction with the Thirty Years War, and how significant and symbolic books were in this conflict.
84 Spegel, *Glossarium-sveo-gothicum*, p. 74; see 'krigsbyte', SAOB, https://www.saob.se/artikel/?seek=krigsbyte&pz=1#U_K2633_98676, access 6 August 2021.

Gustavus Adolphus' articles of war, which among other things mention that when a city or fort had been captured 'then no [soldier] shall lay claim to [i.e., take] any booty' before the enemy was completely defeated.[85] It was thus possible to use the word booty to describe the things that were taken by the common soldiers in connection to battle, and SAOB indeed gives examples of this from as early as the sixteenth century. Still, the word seems not to have been used especially often, and certainly not in reference to the cultural plundering the elite took part in. The Swedish word for spoils/booty, *byte*, also had additional meanings, and could then just like now be used to describe mutual exchange (trade) or compensation for something. It could also be used to describe change or transformation, in addition to its association with hunting (*byte* meaning prey).[86]

Here I want to go back to Charles Ogier's uncomfortable visit to the royal treasury that introduced this book. When Ogier wrote about his time in the Swedish Empire, he did so in Latin. What he called *spolia* (singular *spolium*) has later been translated as spoils or spoils of war.[87] The word *spolia* could refer to the weapons or trophies taken by the enemy in war, and its antique definition was connected to the skin a hunter took from his felled prey. In an antique context *spolia* had an association with stripping, in that one took from the enemy a costume or suit. It could also refer to a criminal's clothes, which were taken from him or her before execution. Generally, the word was associated with something taken through violent ransacking or desecration.[88] There was even an architectural aspect to the word: in Roman history, *spolia* could mean the reuse of material, when older building elements were recycled for use in new monuments.[89] The architectural meaning, *spolia* as recycling, is especially significant here as the spoils of the seventeenth century truly were recycled

85 Gustavus Adolphus, *Krijgs articlar*, article no. 98.
86 'Byte', SAOB, https://www.saob.se/artikel/?seek=byte&pz=1, access 6 August 2021.
87 Cf. Ogier & Avaux, *Caroli Ogerii Ephemerides*, p. 252, to Ogier, *Från Sveriges storhetstid*, p. 108 (*byte*, spoils) and Ogier, *Fransmannen Charles d'Ogiers dagbok*, p. 36 (*krigsbyte*, spoils of war).
88 P. G. W. Glare (ed.), *Oxford Latin dictionary. 5: libero-pactum* (Oxford: Clarendon P., 1976), pp. 1808–1809.
89 'Spolier', SAOB, https://www.saob.se/artikel/?seek=spolier&pz=1, access 6 August 2021; cf. *spolia* in Roman triumphal processions, in reference to weapons and equipment taken from the enemy in battle, while 'spoils' meant something else; see Martin Olin, 'Trophy triumphs in Stockholm', in F. Sandstedt (ed.), *In hoc signo vinces. A presentation of the Swedish state trophy collection* (Stockholm: The National Swedish Museums of Military History, 2006), pp. 51–53.

in the Swedish Empire's archives, libraries, museums and churches.[90] One of the most spectacular examples of plunder was conducted by King Charles X Gustav's soldiers, when they took precisely architectural elements, columns, floors and heraldic wall decorations, as spoils in Warsaw in the 1650s.[91]

When the English diplomat Bulstrode Whitelocke visited the Swedish Empire, unlike Ogier he did not explicitly write about the spoils (*spolia*). Instead, he described seeing books that had been 'brought out of Germany' to the Swedish Empire.[92] Unlike Ogier, Whitelocke wrote this passage in the vernacular, in this case English. The difference between Ogier's and Whitelocke's ways of expressing themselves illustrates the nuances in the seventeenth century's perception of spoils. For Whitelocke, it was important to describe the books' geographical origin. While he noted the fact that they had been taken, he did not mention plunder or describe them as booty or *spolia*. In the seventeenth-century sources studied for this book, that is, the Swedish Royal Registry, notes, inventories, catalogues and letters, the Swedish elite and their officials never call these objects spoils, in either Swedish, German or Latin. Instead, the spoils are described as objects that had 'come from' a place, thereby emphasising their geographical origin rather than how they had ended up in Sweden.[93] As origin was of paramount importance to early modern collectors, the spoils' geographical qualities are analysed in more depth in the following chapters.

The etymological tension between the words *byte* (booty) and *spolia* is thought-provoking. Whereas the former partly indicates trade and mutual exchange, the latter points to trophies from the battlefield and violent actions. However, the words stand in intimate relation to each other, as both, through

90 In a discussion of *spolia* in early Christian Rome, Maria Fabricius Hansen highlights the variations in the reuse of antique buildings and monuments; see Maria Fabricius Hansen, *The eloquence of appropriation. Prolegomena to an understanding of spolia in early Christian Rome* (Rome: 'L'Erma' di Bretschneider, 2003), pp. 22–25.

91 Hubert Kowalski & Katarzyna Wagner, 'Swedish army and the marbles from Warsaw', *Historisk Tidskrift*, 3 (2016), pp. 571–575; Hubert Kowalski, 'Archaeological examinations of the bottom of the Vistula River near the Citadel in Warsaw in 2009–2012', *Światowit*, X(LI)/B (2012), pp. 335–347.

92 Bulstrode Whitelocke, *A journal of the Swedish embassy in the years M.DC.LIII and M.DC.LIV*, Volume 2 (London: T. Becket and P. A. de Hondt, 1772), p. 92; there are a number of different versions of Whitelocke's diary in manuscript form. The printed version from 1772 is consistent with Add. Ms. 4902, which is believed to be a transcript of Add. Ms. 37347, British Library. Whitelocke prepared several versions of his diary, and at least one of the manuscripts is still owned privately.

93 See e.g. U271, U272 and U273, UUB.

their antique uses, can be associated with the hunt.[94] Furthermore, the connotation of change in *byte* is reminiscent of the transport and recycling connotation in *spolia*. Another synonym of *byte* that could be used in the seventeenth century was *trofé* (trophy). According to SAOB, a trophy was an object that had been won from the enemy in victorious battle. It was often a standard, a weapon, or armour: objects directly connected to the battle. But the word could also describe a constructed monument or memorial. Within Swedish research and cultural heritage institutions, it is common to distinguish both analytically and organisationally between *byten* (spoils) and *troféer* (trophies): while trophies entailed objects that had been taken from the enemy in direct connection to the battle, spoils were not immediately associated with the battlefield.[95] This distinction has its institutional foundations in the Swedish state trophy collection where all trophies have been gathered in one particular place; however, the difference between trophies and spoils does not exist in international research. While a plundering commander in the seventeenth century could indeed draw a distinction between a trophy and booty, a strict categorisation of objects along the lines of those used in modern museums is not desirable to make here; especially considering the processual approach to objects that is advocated in this study, as I consider their versatility and ability to change. One objective in taking new theoretical approaches to material objects has been to dissolve fixed object categories and the clear-cut functions.[96] Accordingly, in some cases, it is indeed difficult to distinguish spoils and trophies from each other.

The blurred line between trophies and booty becomes vivid in the analysis of Carl Gustaf Wrangel's *spolia selecta*, a case in which certain book spoils could take on the role of trophies. But there are other empirical examples that can be used to problematise object categories. For instance, the helmet and spurs taken by Swedish King Eric XIV's soldiers from Nidaros Cathedral in Trondheim in 1564 have been classified as trophies, not spoils, by Swedish researchers.[97] These objects, ascribed to St. Olof already in the sixteenth century, were put on display in the Cathedral as antiquities. They were thus not

94 As regards words and their meanings and analogies, alongside (and similar to) Findlen I have taken inspiration from Michel Foucault's discussion in *The order of things. An archaeology of the human sciences* (New York: Vintage Books, 1994), pp. 17–25.
95 See e.g. Regner, 'Ur Historiska', p. 43; Rangström, *Krigsbyten*, p. 18.
96 Damsholt & Gert Simonsen, 'Materialiseringer', pp. 14–15, 30.
97 Fred Sandstedt & Lena Engquist Sandstedt, 'Proud symbols of victory and mute witnesses of bygone glories', in F. Sandstedt (ed.), *In hoc signo vinces. A presentation of the Swedish state trophy collection* (Stockholm: The National Swedish Museums of Military History, 2006), pp. 71–72.

used by the enemy in battle but were historical objects. Therefore, according to the practice of modern museums, they should be classified as spoils rather than trophies. Another example is that of the silver service of Archduke Leopold Vilhelm of Austria, taken as spoils by Carl Gustaf Wrangel in connection with a battle in Leipzig in 1642. While the service is usually described as booty, it was taken directly from the Archduke's baggage during battle, along with a bishop's staff.[98] At Wrangel's Skokloster the silver service was without a doubt both spoils and trophy, as well as a monument, combined. These objects, the Archduke's service and the bishop's staff, along with St. Olof's helmet and spurs, challenge fixed object categories, as the circumstances that created spoils and trophies are often more complicated. Booty, *spolia* and trophies are words that could all describe objects taken in wartime. They could be more or less synonymous, but there could also be a clear distinction between them: spoils could be a trophy that signified victory and function as a monument. Booty was things taken by force, but at the same time also entailed a legal exchange and collecting, while *spolia* could eventually entail the recycling of material when it was incorporated into a new spatial context. While modern object categories are difficult to project on early modern sources and times, what is certain, however, is that the practice of cultural plundering literally transformed the state of things. In a longer time perspective, the ambiguity and instability of spoils become even more vibrant.

6 Conclusion: Unstable Spoils of War

Among the meanings within the word *byte* (booty/spoils) is that of change, both in its seventeenth-century definition and use as well as in the contemporary understanding of spoils of war. The analysis of the plunder, ruin and creation of spoils in Livonia, Prussia and Denmark, along with the discussion of the words *byte*, *spolia* and *trofé* (trophy), have shown various practices that made objects into plunder, and how plunder was described, and not described, when kings and commanders made enemy riches into cultural spoils. The established contemporary definition of spoils of war entailed that they were material culture that fell victim to war, and seventeenth-century sources show that spoils could literally be seen as animate objects and victims. Such a perspective emerges in connection to the confiscation of the library in Heidelberg by Maximilian of Bavaria, in which the books were given their own voices, as well as in Archbishop Gothus' letter to Oxenstierna, in which books were

98 Meyerson & Rangström, *Wrangel's armoury*, pp. 25–26.

described as the Jesuits' prisoners. But booty objects as victims is only one side of how the spoils were understood, as evidenced in precisely the absence of the terms spoils, war booty and trophy in the descriptions of these objects in Swedish sources. Whoever made spoils could express himself like Oxenstierna did: to him, cultural plundering was a matter of collecting and conserving beautiful and valuable objects of knowledge.

The campaign sources show how important it is not to reduce cultural booty to simply being spoils of war, symbolising a moment of victory. The once plundered objects in Swedish collections are complicated through their long histories, having been understood in various ways throughout the centuries and constantly reinterpreted. The last example I will point out in this chapter illustrates both this and the fact that spoils materialise what can be described as a temporal tangle of different meanings. In the collections of the Swedish History Museum is the Reliquary of St. Elizabeth, a late antiquity agate bowl that was reworked during the Middle Ages into an ornamental piece to hold the skull of St. Elizabeth of Hungary (d. 1235). The reliquary was made into booty by Gustavus Adolphus, taken from Würzburg during the Thirty Years War. Its history shows how spoils were, and are, dependent on their temporal and spatial contexts, as this object has been reinterpreted several times over the centuries. In an object-focused analysis of the reliquary, archaeologist Elisabet Regner shows how its designation as spoils of war has emerged more and more clearly as it and similar objects have been institutionalised, particularly since the end of the nineteenth century. From initially not really fitting into the nation's history as it was not a Swedish object, during the 1930s the reliquary took on a prominent role as precisely spoils of war in an exhibition celebrating Gustavus Adolphus. It has long been number one in the museum's inventories. In connection to the exhibition in 1932, 300 years after the battle of Lützen in which the King was killed, the reliquary was made not merely into spoils of war but notably Swedish spoils of war, and thereby came to materialise a certain state's national honour.[99] The heritage category of Swedish spoils of war was thus created during the National Romantic era when Gustavus Adolphus was hailed as a heroic warrior king. This worldview coincided with that of Otto Walde's, and his influential works on the literary war booty of Sweden's heyday, in which he wrote that 'above all, we must be grateful to our fathers because, unlike so many others, they really sought to preserve and not to destroy and ruin such treasures'.[100]

99 Regner, 'Ur Historiska', pp. 47, 49, 51.
100 Walde, *Storhetstidens I*, p. 42.

The label 'spoils of war', then, has various consequences for an object within a historical analysis. Thus, how the specific object description of spoils of war affected the object's other values and qualities varied. Even though the Reliquary of St. Elizabeth is not a book or an archive document, it shows how cultural spoils, like all other objects with a long history, contain different layers of time with their accompanying interpretations. As Camilla Mordhorst has argued, it is the most distant layers that are the hardest to disclose, as they are often obscured by the more recent ones.[101] The Reliquary of St. Elizabeth has a strong personal link and confessional significance as a relic, at the same time as it is a very old object, dating from antiquity. In the seventeenth century, this type of object had its natural place in a cabinet of curiosity as a historically legitimising object. Even in Gustavus Adolphus' Protestant hands, it is likely that the reliquary's significance as an antique, a historical distinguished object, was central. During the seventeenth century, then, the reliquary's historical significance rather overshadowed its significance as spoils.[102]

With the historicity of the reliquary in mind, the possibility to think more broadly about what Gustavus Adolphus and Wrangel gained through their plundering unfolds. This theme will be addressed carefully in the following three chapters, in which I examine the meanings and impacts of five collections of spoils in the Swedish Kingdom's Archive, Uppsala University Library and Skokloster Castle. The three case studies will reveal how a variety of objects and their orderings together created certain historical narratives: about dynasty, religion and personal honour. Each collection and booty case will in its own way illustrate how genealogical, geographical, material, confessional and temporal values were formed in seventeenth-century Sweden.

101 Mordhorst, *Genstandsfortaellinger*, pp. 15–16.
102 Regner, 'Ur Historiska', p. 50.

CHAPTER 2

Archive Trouble: The Mitau Files in Vasa History

This chapter starts with a catastrophic ending: the great castle fire of May 7, 1697, when the royal Tre Kronor Castle burned to the ground. Countless books, manuscripts and archival documents were lost to the blaze, with catastrophic effects for recorded Swedish history. The extensive fire broke out in the afternoon and was immediately judged to be impossible to extinguish (see figure 7 on page 195). The Royal Counsel Axel Wachtmeister was sent, along with a number of men, to save the Kingdom's Archive housed in the castle, which according to their command was to be moved to a stable on the small island of Helgeandsholmen. They did not have time to save everything, but in their rushed mission simply took what they considered to be the most important. As the fire reached the archive's upper vault first, where foreign deeds were held, the greatest losses were suffered there. Surely some of the archive documents made into spoils in the Livonian town Mitau in 1621, which I analyse here, were lost to it.

Mitau, now Jelgava in Latvia, 40 kilometres southwest of Riga, was an ancient city of the Duchy of Courland and once the residence of the Livonian Order. What is known in seventeenth-century Swedish sources as 'the Mitau files' or 'Courlandian and/or Livonian documents' have been through a great deal: being abducted by Gustavus Adolphus' men in 1621, they were incorporated into the Kingdom's Archive in Stockholm in 1622, where they also caused a great deal of trouble. In time some documents were restituted, others went up in flames and some were possibly stolen or even fabricated. Many of the parchments and paper files once taken from Mitau Castle, however, can still be found in today's Swedish National Archives. Consequently, I follow these papers and parchments in their new Swedish settings, and through this demonstrate what an object-biographical viewpoint can do for a study of plundered records in a young imperial institution. Tracing these documents and the classification of them, I argue, is key to understanding the appropriation and impact of plundered documents in the kingdom of Sweden, and also offers a new approach to comprehending how a national archive came into being and developed over the centuries. Setting aside the documents that are possible to trace in certain inventories and lists, others simply disappeared over centuries of moves, reclassification and reorganisation of the archival collections. What emerges in this chapter is therefore a history of presence and absence, covering what remains as well as what was lost. First and foremost, it is an account of change. As an object of study, I show

that the multiple Mitau files are elusive in the sense that the sources offer only limited information about the object's size and contents, and it never reappears twice in exactly the same state. This insight, I argue, may assist us when we study cultural heritage transformation at large. But before I scrutinise the value and trouble the Mitau files both had and caused at Tre Kronor Castle, I will start by exposing something that can be framed as a seventeenth-century archive fever, in the administrative developments of Gustavus Adolphus and Axel Oxenstierna.[1]

1 Archive Fever in Vasa Administration

> Those princes who do not realize the usefulness of archives and libraries are really followers of the worst precedent in their misguided emulation of the Caligulas and the Jovinians [...]. But those who stored away in places sacred to memory the books and records from which a late posterity, itself ignorant of past events, might draw, as from a storehouse, information for its own erudition and that of its successors, they imitate the Alexanders the Great, the Julius Caesars, the Octavian Augustuses, and the great Constantines to whose generous magnificence we acknowledge receipt of whatever is left to us of a truncated and almost effaced antiquity.[2]

This quote is taken from the Venetian scholar Baldassare Bonifacio's writings on archives, *De archivis*, from 1632. To Bonifacio, archives were holy places due to their historical connection to the temples. Plunderers were no different from archive vandals, committing crimes against both church and king.[3] Bonifacio might therefore have protested had he known of Gustavus Adolphus' and Oxenstierna's collecting and plundering activities during the wars of the 1620s, 30s and 40s. But, just like Alexander the Great or Julius Caesar, men such as Gustavus Adolphus, Axel Oxenstierna and their closest officials did realise

[1] Here I link to Carolyn Steedman, who has brilliantly played with the concept of an actual archive fever of historians, opposed to Derrida's metaphorical one; see Steedman, *Dust*, pp. 17–19.
[2] I have quoted Lester Born's translation in 'Baldassare Bonifacio and his essay *De archivis*', *The American Archivist*, 4 (1941), p. 233; for Latin and Swedish text see *Den äldsta arkivläran*, 100–101.
[3] *Den äldsta arkivläran*, 104–105.

the importance of well-managed state archives.[4] He who had power over the archives thereby had control over people, institutions and territories.

In recent decades' culture-historical research, archives, as both physical place and institution as well as metaphor, have come to be associated with power. In both the recent and remote past, archives have been an environment where state control is exercised through the ordering and handling of information. In turn, this has awoken an interest in how various archive practices have formed historical knowledge and experience over time.[5] Several studies have highlighted that archives are about more than simply making documents available to a select few; they also involve intricate processes of accumulation, classification and preservation. The historian who seeks knowledge of the past in archives stands before a material plethora of sources, which can be kept in anything from exemplary order to the greatest disarray. Thus, through interaction with archives' material and epistemic structures, individual and collective knowledge is created.[6] In relation to this, archives must be seen as material objects with which humans have physical, palpable contact. Within a historical perspective archive matter has inevitably been transformed, and when archive collections are moved or reorganised, their significances and effects are also changed.[7] But even though a rich field of historical research has contributed to a deeper understanding of archives, the early modern archival collections of imperial states that grew out of the rulers' confiscation and plundering during the wars remain to be further explored.

Compared to modern public archives, these early modern archives were not accessible in the same way. At the beginning of the seventeenth century, state archives were primarily there for the governing prince, and this was who determined who was to have access to the kingdom's place of memory.[8] Even so, this chapter underscores that the forerunner to the Swedish National Archives was clearly meant to serve the writing of history, and that past events permeated its entire organisation. Thus, while the archive's political significance in the state-formation process plays a lesser role here, I do highlight the archive's

4 Earlier versions of this chapter are published as Emma Hagström Molin, 'The translocated Mitau Files. An elusive object in the Swedish National Archives', in F. Bodenstein etc. (eds.), *Translocations. Histories of dislocated cultural assets* (transcript Verlag: Bielefeld, 2023) and Emma Hagström Molin, 'Materialiseringen av Riksarkivet. En objektbiografi över krigsbytet från Mitau 1621', *Lychnos. Årsbok för idé- och lärdomshistoria*, 2013.
5 Head, 'Historical research', pp. 191–194; Blair & Milligan, 'Introduction', p. 290.
6 Blouin & Rosenberg, *Archives, documentation*, p. vii.
7 Randolph, 'On the biography', p. 209.
8 In 2007, *Archival Science* no. 7 was a theme issue with particular focus on early modern archives and knowledge cultures; a condensed overview can also be found in Burke, *A social history*, pp. 138–141.

intimate relationship with the ruler and his or her lineage, and how plundered archival materials from Mitau both challenged and supported this relationship.

To understand the interlacing of linage and archival documents of different origins, the formal establishment and development of the Kingdom's Archive, Sweden's first historical archive, need to be considered and related to the plundering activities. At the beginning of the seventeenth century, the Swedish Empire underwent a comprehensive administrative change under Oxenstierna and the then young King Gustavus Adolphus. When Oxenstierna became Chancellor of the Realm in 1612, the royal chancery came under his responsibility. Over the course of a dynamic decade, an increasingly institutionalised archive emerged in the service of the military state.[9] The streamlining of the kingdom's administration is commonly highlighted as an important part of Swedish state formation.[10] As part of the administrative development work, in 1618 the Chancellor issued the chancery orders, in which the phrase 'Riksens arkiv' (The Kingdom's Archive) was used for the first time in an official Swedish document.[11] The next chancery orders, affirmed by the King in 1620, clearly distinguished between the new and the old archive; in other words, the chancery's daily activities and the historical archive were separated.[12] A clear temporality was thereby instituted in the chancery's operations, and its different work tasks were meticulously described in the new orders. With the operations of the Kingdom's Archive established, the 1620 archive orders expressed something that, according to Zachary Sayre Schiffman, was created during the Renaissance: a clear distinction between then and now.[13] Consequently, a royal-state archive's organisation not only reflects the administration of the kingdom in question but also mirrors its history.[14] In the case of the Swedish Empire, it was a matter of royal lineage that was entangled in a severe dynastic conflict. This involved the King and Chancellor issuing a number of archive

9 Thomas Götselius, 'Skriftens rike. Haquin Spegel i arkivet', in S. Jülich etc. (eds.), *Mediernas kulturhistoria* (Stockholm: Statens ljud och bildarkiv, 2008), pp. 54–55.
10 Various theories on the state-formation process in relation to the Swedish Empire have been discussed in depth by Erland Sellberg, *Kyrkan och den tidigmoderna staten. En konflikt om Aristoteles, utbildning och makt* (Stockholm: Carlsson, 2010), pp. 15–38; for the Swedish case in particular, see pp. 36–37.
11 Instructions for the royal chancery are published in Carl Gustaf Styffe (ed.), *Samling af instructioner rörande den civila förvaltningen i Sverige och Finnland* (Stockholm: Hörberg, 1856), 300; cf. Bergh, *Svenska riksarkivet*, p. 12.
12 *Samling af instructioner*, 302.
13 Schiffman, *The birth*, pp. 1, 146–149.
14 This point has been clearly made by Randolph C. Head, 'Mirroring governance. Archives, inventories and political knowledge in early modern Switzerland and Europe', *Archival Science*, 7 (2007), pp. 317–329; see especially pp. 321–326.

orders, at the same time as the officials were organising the collections according to a newly devised system that represented the genealogy of the kingdom's latest ruling dynasty.

This system had been created by the official Per Månsson Utter, the first to hold the new office of archive secretary. According to the chancery orders, the archive secretary was to be responsible solely for the care of the Kingdom's Archive and its historical documents. Utter was a prominent genealogist, and worked until his death on a larger project in which he collected sources for the genealogies of the entire Swedish nobility.[15] When Swedish history, for the first time ever, was independently organised by Utter, it emerged in the genealogical and chronological shape of the Vasa kings: starting with Gustavus Adolphus' grandfather Gustav Vasa, followed by his sons Eric XIV and John III, John's son Sigismund, Gustavus Adolphus' father Charles IX, and lastly, Gustavus Adolphus himself. Thus, the documents' physical order was destined to legitimise the ruling dynasty, in the archive vaults of Tre Kronor Castle. Vasa rule abruptly ended with Queen Christina's abdication in 1654 when she was succeeded by her half cousin Charles X Gustav with the house of Palatinate Zweibrücken thereby ascending the Swedish throne. Despite this, the Vasa-influenced genealogical endeavour of the archive continued, until the collections were reorganised after the catastrophic castle fire in the early 1700s.

The lion's share of the documents stored in the Kingdom's Archive had been produced, processed and arranged by the king's chancery. But the documents taken from Mitau, along with a number of other documents that had come to the archive at Tre Kronor in the seventeenth century under similar circumstances, were another story. According to the 1618 orders, Chancellor Oxenstierna had the right to require that what he or the king saw as the kingdom's documents be placed in the archive. In other words, if by chance he happened to find documents involving the kingdom's history somewhere other than at Tre Kronor Castle, he had the right to move them there. Active collecting was thus an explicit part of the Chancellor's task in relation to the archive, and this circumstance may have directly motivated the plundering of archives during wars.

The arrival of the Mitau documents at Tre Kronor in 1622 coincided with the institution of these fundamental processes, by which parts of the king's chancery were transformed into a historical archive. It is in this dynamic setting that I explore how the officials handled the Mitau files, which had been taken from the enemy and consequently from another epistemological and spatial context than that of the Kingdom's Archive. How did the archive secretaries

15 Bergh, *Svenska riksarkivet*, p. 145.

manage the genealogical challenges that the Mitau documents presented to Vasa history? The search for answers to these questions reveals the significance of the Mitau files and the Kingdom's Archive during the period studied. The actual use of individual deeds among the spoils will be addressed here only briefly, as this aspect is less important to the purpose of this case study. To take up something pointed out by Cornelia Vismann: when we refer to archive documents in the plural rather than to a single file, the documents' materiality overshadows their content.[16] Indeed, these seventeenth-century archive orderings involved various ways of handling matter in order to become acquainted with its deep and vast knowledge, and when necessary, to make it accessible. All the chancery orders stressed the importance of tidiness in the archive, but in practice the collections were not easy to organise or keep in order. When one practical problem had been solved another often arose, as the collections were constantly growing. The royal chancery produced new documents daily, at the same time as the archive secretary and Chancellor were increasing the stock by confiscating and plundering document collections both domestically and abroad, for instance, the event that made the spoils in Mitau in 1621.

John Randolph has argued that a biographical method is especially meaningful when the researcher wishes to study the complexity of archives' physical history, as opposed to writing their institutional history. This is especially true of state archives, which as a rule attempt to convince researchers that they are the only archive.[17] By following appropriated material that did not originate in the Swedish King's administration, this chapter shows how the Kingdom's Archive became the Vasa's history in the seventeenth century. The establishment of the Kingdom's Archive as a historical resource and the part the Mitau documents played in this process can be understood by analysing the archive secretary's practices and organisation of the past. While historians have visited archives in search of the nation since the nineteenth century, I argue that early modern archives could be created and curated by rulers and their officials with the aim of immortalising a dynasty and build its historical legacy.[18] The history of the Mitau documents will thus show how the Kingdom's Archive was initially arranged with the intent to legitimise the Vasas, as the rightful rulers of Sweden, and their history.

16 Cornelia Vismann, *Files. Law and media technology* (Stanford: Stanford University Press, 2008), p. xi.
17 Randolph, 'On the biography', p. 210; Milligan, '"What is an Archive?"', pp. 178–179.
18 This is also emphasised in Steedman, *Dust*, pp. 38, 69.

2 The Documents from Mitau

The birth of the historical archive in Stockholm coincided with the dynastic war against the Polish King Sigismund in Livonia. At the fortified Mitau Castle located about 40 kilometres southwest of Riga, documents that had belonged to the Livonian Order, among other things, were taken as spoils.[19] The Livonian Brothers of the Sword Order, from 1237 an autonomous branch of the Teutonic Order known as the Livonian Order, had been disbanded since 1561, after having controlled Livonia, Courland and Semgallen since the early thirteenth century. The documents had come to Mitau with the Order's last master, Gotthard Kettler, who had converted to Protestantism and thereafter become Duke of Courland. As a consequence of the castle's capture, the documents were sent to Stockholm and came to be part of the Kingdom's Archive, which in the seventeenth century was not housed in any institutional building but instead at the royal Tre Kronor Castle.

There are no orders in the Royal Registry describing the events in Mitau in 1621. A likely scenario is that the castle was captured and then plundered on order of the King. In his book on seventeenth-century spoils, Otto Walde summarised this event as follows:

> The Livonian Order master's archive was stored at the [Mitau] castle, which upon the Teutonic Order's dissolution was moved here from Wenden [today's Cēsis in Latvia] by Gotthard Kettler. Gustavus Adolphus took this valuable archive and caused the same to be sent over to Stockholm, where the still existing remains form a not insubstantial part of the National Archives' collection of Extranea.[20]

This is a concise and uncomplicated summary of the fate of the so-called Mitau Archive. But Walde never explained why the documents from Mitau were especially valuable, or how they were made a part of the National Archives. He saw the Mitau documents as a single archive, but this was a perspective that in many ways simplified what became spoils in 1621.

The documents at the castle were first and foremost part of a larger collection of spoils, consisting of various types of objects. When the documents were inventoried in the Kingdom's Archive in 1622, they had at some point along the

19 Besides archive documents, objects were taken from the ducal armoury; see Nestor, 'Krigsbyten i Livrustkammaren', pp. 58–59.
20 Walde, *Storhetstidens I*, p. 51.

way been separated from the other objects.[21] The procedure here differs from that involving the collections of the Jesuit College in Riga, whose fate is found in the next chapter. In that case, the spoils consisted of books and other objects such as liturgical items and household goods, which were kept together with the books and sent to Uppsala to be incorporated into, and to contribute to the materialisation of, the library there. It is also impossible to know whether the King took all, or only a selection, of the existing documents in Mitau as spoils in 1621. The castle would be seized twice again, in 1658 and 1701, by Swedish troops.[22] Archive documents were taken as spoils on both of these occasions, circumstances that will be discussed in relation to the return of documents.

The records taken from Mitau Castle by Gustavus Adolphus' men had mainly been produced from the thirteenth century onwards by the Catholic military Livonian Order. When the order was abolished in 1561, its last Master Gotthard Kettler became Duke of Courland, and records produced more recently by his administration were thus also taken.[23] It would be misleading to describe what was taken as a comprehensive archive, as the Order's records had been moved around during the Russian-Livonian war (1558–1583), possibly with some losses, and finally ended up in Mitau at the end of the sixteenth century.[24] When Kettler became Duke of Courland, his administration took over the Order's archive and chancery organisation. It was based on a Prussian model: two secretaries worked here, under a chancellor, with the task of handling the duchy's daily affairs. One secretary worked particularly with legal matters while another, along with two scribes, handled the administrative correspondence. The older documents of the Livonian Order seem to have been housed along with the Duke's chancery, in a special room at Mitau Castle. Just what status the historical Order records held in this setting is hard to say, besides the most important deeds that were legally valid and contained information on matters like borders and ownership rights. Unlike the Swedish chancery orders from 1620 on, the Duke of Courland does not seem to have distinguished between the daily activities of his chancery and the historical documents.[25] The files taken at Mitau were mainly from two different offices, even though they were run according to the same administrative principle. However, other documents

21 Nestor, 'Krigsbyten i Livrustkammaren', pp. 58–59.
22 Beata Krajevska & Teodor Zeids, 'Zwei kurländische Archive und ihre Schicksale', in I. Misāns & E. Oberländer (eds.), *Das Herzogtum Kurland 1561–1795. Verfassung, Wirtschaft, Gesellschaft. Band 1* (Lüneburg: Verlag Nordostadt Kulturwerk, 1993), pp. 16–17.
23 Krajevska & Zeids, 'Zwei kurländische Archive', pp. 13–14.
24 Juhan Kreem, 'The Archives of the Teutonic Order in Livonia. Past and Present', *Coleção Ordens Militares*, 8 (2018), pp. 61–62.
25 Krajevska & Zeids, 'Zwei kurländische Archive', pp. 14–16.

were involved as well, for instance parts of family and monastery archives. The Mitau documents thus consisted of several different provenances even though most of them were produced by the Livonian Order's chancery.

Once housed in the Kingdom's Archive, the documents were often referred to as 'the documents from Mitau' or the 'Livonian and/or Courlandian documents', but never explicitly as spoils or as one cohesive archive. When the Mitau documents were classified it was above all their geographical origins that were stressed, as these qualities distinguished them from much of the other material in the Kingdom's Archive. The new archival setting to which the Mitau files came was likewise not a unified archive collection, but rather consisted of a cluster of document collections of various provenances. The Kingdom's Archive furthermore contained more objects than archival documents, such as books containing historical chronicles as well as coins.

The so-called Mitau Archive was described as Swedish spoils of war by Otto Walde in 1916. But at the same time, the files stand out as the most diffuse of the spoils analysed here. Against the background of the administrative development in the Swedish Empire that was occurring in parallel, it is reasonable to consider whether the King and Chancellor felt that they had taken archival spoils in Mitau. Livonian Estonia had been linked to Sweden through Eric XIV in the 1560s, and the Swedish kings had since held a territorial claim to the area. Among the documents from Mitau were a number of incoming letters from Swedish kings and dukes; these documents thereby directly involved the Swedish Empire and the history of its kings. Thus, in accordance with the prevailing chancery orders, the King and Chancellor may have regarded these documents as property of the Kingdom's Archive: from the perspective of the King and Chancellor, the Mitau documents' status as spoils can be questioned.[26] The Courlandian Dukes were likely of another view. Regardless of whether the Mitau documents were understood as spoils or not, they were packed into three chests and two barrels, which were shipped to Stockholm and delivered to the archive's room in the royal castle.

26 In this regard, the Mitau spoils can be compared to the occupation archives from Novgorod, which came to the Swedish Empire during the 1610s; see Elisabeth Löfstrand & Laila Nordquist, *Accounts of an occupied city. Catalogue of the Novgorod Occupation Archives 1611–1617. Series 1* (Stockholm: Almqvist & Wiksell, 2005). The occupation archives were not plunder, but it was by no means given that the documents should be taken to Stockholm after the occupation ended.

3 The Material, Geography and Rarity of Archival Spoils

During the summer of 1622, Per Månsson Utter worked in the Kingdom's Archive with the documents from Mitau. He described his review of the files in a number of letters to Chancellor Oxenstierna, and their arrangement appears in some of the inventories of the Kingdom's Archive from the same time. From Utter's descriptions it is not possible to determine whether the documents from Mitau were arranged based on provenance or some other system. But the person who packed the files did distinguish between parchment and paper, as did Utter when making an inventory of them (see figure 8 on page 196).

In August 1622, Utter wrote to Oxenstierna that he had read through all the parchment documents, those that had been in the chest that the Chancellor himself, in the company of the secretary, had ordered be opened. The second and third chests, along with the two barrels, were exclusively filled with documents written on paper. Utter wrote that the paper documents consisted mostly of missives and concepts, which were more time-consuming to read through than the parchments.[27] His reading was thereby likely based on both material- and content-related factors. Choosing to focus on the parchment documents, he prioritised the older and most valuable, from the early thirteenth century onwards. The use of paper in the archives would later increase by staggering proportions, but not until the Late Middle Ages. Compared to paper, parchment was an exclusive material, used for only the very most important deeds and correspondences. Before the breakthrough of paper, simpler notes were instead made on wax tablets, *tabula cerata*. As access to paper increased in Late Medieval Europe, so did the ability to document. A scribe would use parchment in matters of greater importance, and as a rule in these cases, used fewer abbreviations and larger text. Paper, on the other hand, was suitable for all other texts produced in a chancery, which could be written in a cursive hand and with abbreviations: sloppier, quite simply.[28]

In his letter to Oxenstierna, Utter listed a number of documents he judged to be the most distinguished in the context. For Utter, distinguished documents were a central concept, one that would come to pervade the Kingdom's Archive's organisation throughout the seventeenth century. This created a clear hierarchy among documents classified as distinguished and those that

27 Per Månsson Utter to Axel Oxenstierna, 2 August 1622, E 746, Oxenstiernska samlingen, RA Marieberg.
28 I have had the possibility to consult a smaller selection of the remaining Mitau documents in the National Archives, which confirms this generalising archive-historical reasoning. See Schirren 1, 6, 7, 11 and 13, Livonica, utländska pergamentsbrev, RA Marieberg; Livonica II; Blair & Milligan, 'Introduction', p. 293.

were not; that is, everything else. Among the distinguished documents from Mitau, Utter singled out Danish King Valdemar IV Atterdag's letter, written by Atterdag himself in reference to the districts of Harrien and Wierland, which had been sold to the Livonian Order in 1346. The letter had been cited in a chronicle by Danish historical writer Arild Huitfeldt, but according to Utter the Danes only had a copy of it in their archive. Thus, with the acquisition of the documents from Mitau, the original fell into the Swedish King's possession. When the Livonian Order was dissolved in 1561, Estonia, along with the districts of Harrien, Jerwen and Wierland, came under the protection of the Swedish Crown through the actions of King Eric XIV. This explains Utter's expressed interest in documents mentioning these particular districts, as the Swedish kings had long had interests in Livonia. Atterdag's letter was also a piece in the rivalry between the Swedish and Danish kings, as well as in the propagandist historical writings between the kingdoms from the end of the 1500s that Huitfeldt's chronicle had brought about.[29] Taken together, Atterdag's letter is an example of a single document being ascribed extremely high value in the initial handling of the Mitau spoils.

Utter continued his evaluation and ranking of the Mitau files, listing letters from the Teutonic Order's grand masters in Prussia and their instructions to the masters in Livonia, along with their rights to land areas, castles and cities. Up to this point he had not found any charters, but he had found several important affirmations by emperors, popes and the Order's grand masters. Included here were also recesses between the estates and various types of border letters. Everything else, which Utter had not yet been able to evaluate, was placed in a pile for future reading. Finally, he mentioned a large charter which, along with a number of other documents he deemed important, was unfortunately damaged.[30] By all accounts, even these damaged letters were preserved in the Kingdom's Archive. After Utter's review of these documents, other forms of records are mentioned that could not be directly linked to the Order's chancery, such as documents from the von Tiesenhausen dynasty and several monastic charters.[31] As mentioned, the documents from Mitau

29 Huitfeldt's descriptions of Gustav Vasa upset Charles IX so much that he ordered Erik Jöransson Tegel to write what would be the first of the Vasa's royal chronicles; see foreword in Erik Jöransson Tegel, *Then stoormechtige, högborne furstes och christelighe herres, her Gustaffs, fordom Sweriges, Göthes, och Wendes konungs etc. historia* ... (Stockholm: Christoffer Reusner, 1622).

30 Per Månsson Utter to Axel Oxenstierna, 2 August 1622, E 746, Oxenstiernska samlingen, RA Marieberg.

31 Nya skåpet, förteckning A:2 1622, uppställningsförteckningar och inventarier 1618–1627, D II b a vol. 1, huvudarkiv byrå, Riksarkivets ämbetsarkiv, RA Marieberg.

included a number of missives of Swedish origin, diplomatic letters and the like sent from, among others, King Gustav Vasa and his sons to princely people in Livonia. These fit the description of the documents mentioned in the 1618 chancery orders that were to be taken to the Kingdom's Archive. Once produced in the royal chancery they were the kingdom's files, and were thus part of its history. Overall, Utter's letter to Oxenstierna and the archive secretary's record of the Mitau files bore witness to his specificity and knowledge of historical detail. Utter worked through a substantial body of material, and it is clear that when doing this he had expectations as to what type of information he would find. He demonstrated extensive knowledge of older European history, and as an official he was undoubtedly guided by his genealogical expertise (see figure 9 on page 197).

4 'As a Soul within a Body': Archive Rooms

When the documents from Mitau arrived at Tre Kronor, through Utter's work they were made into an integrated part of the Kingdom's Archive. Utter had already been occupied with making an inventory of and arranging the kingdom's documents as a step in the adaptation to the current chancery orders. The Mitau documents were thus brought into a context characterised by spatial and epistemological transformation. In order to understand how the Kingdom's Archive was materialised and how the organisation work there contributed to reformulating the Mitau spoils, it is important to look more closely at the chancery orders that regulated the archive's operations and rooms during the 1620s compared to the existing conditions before the founding of *Riksens arkiv* in 1618.

Before Gustavus Adolphus became king in 1611, the Crown's documents had no determined space or location. Instead, they followed the king when he travelled between various royal castles, which meant that document collections grew in the different places where he and his administration spent time. In this way, the valuable records were always available to the king. As the kingdom's documents were geographically spread across the country, there was a concrete reason for Oxenstierna to gather them. Gathering the archive in a single place was a way for King Gustavus Adolphus and the Chancellor to facilitate the work of the chancery officials, and to get a better overview as well as control. The archive also included books, particularly law books and political chronicles, for instance from Vadstena Abbey. The abbey was dissolved by Duke Charles (later Charles IX) in 1595, but valuable belongings and property

had already been confiscated by Gustav Vasa during the 1540s. Interestingly, it was not until 1619 that the abbey's book collections were taken, and then by none other than Per Månsson Utter.[32] The documents of executed privy council members Erik Spare (d. 1600) and Hogenskild Bielke (d. 1605) were also confiscated and brought to the archive.[33] In this way, the legal rights and history of both the abbey and the political opponents were able to come under the control of the Crown and be incorporated into the Kingdom's Archive (see figure 10 on page 197).

At Tre Kronor, the officials moved the archive collections between various areas of the castle. In the interest of fire safety, as a rule the documents were placed in vaulted rooms in specific chests. There are telling examples of how unsafe the environment could be for the kingdom's documents in the sixteenth century: files were lost to a smaller fire in 1525, and during the reign of John III the kingdom's documents were moved from the vault where they were being stored in order to make room for the queen's wardrobe.[34] It was not until 1626 that chancery orders were issued, explicitly stating that the Kingdom's Archive and the daily chancery operations were to be localised at the castle in Stockholm and in at least three vaulted rooms; but exactly which rooms this entailed was still unspecified. The most important and distinguished documents were to be stored in cabinets and chests in the innermost and thus most secure room. The next room would house unsorted letters contained in chests, and the archive secretary would have his workplace in the outermost room. In the two inner rooms it was forbidden to use candles or any other form of fire, and the rooms were to be fitted with iron windows and doors, even between the rooms themselves.[35] In the orders, the King and Chancellor emphasised that a well-run chancery was an important priority: 'for whereas the Chancery is nothing else within a Regiment than as [a] soul within a body'.[36]

32 Per Månsson Utter to Axel Oxenstierna, 12 March 1619, E 746, Oxenstiernska samlingen, RA Marieberg; it is possible that books and other items were taken from Vadstena on multiple occasions.
33 Vilhelm Gödel, *Sveriges medeltidslitteratur. Proveniens. Tiden före antikvitetskollegiet* (Stockholm: Nordiska bokhandeln, 1916), pp. 281ff; Bergh, *Svenska riksarkivet*, pp. 374–376.
34 Bergh, *Svenska riksarkivet*, pp. 248–249. This event bears witness to how valuable the clothes were.
35 *Samling af instructioner*, 310–311.
36 *Samling af instructioner*, 306.

5 Utter's Archive Order: Documents Narrating Vasa History

The Kingdom's Archive was not in the well-organised condition dictated by the orders, however, which was accentuated in 1626 when an entire room was designated to house unsorted documents. Already in the early seventeenth century, Oxenstierna and Utter had discussed possible approaches to creating a better, sustainable order in the archive. When the secretary then arranged the archive's documents in accordance with the 1618 chancery orders, the most important and valuable documents were placed in 'the green cabinet'. This cabinet, comprised of 35 cases, was placed in the innermost vault. In a letter to the Chancellor the same year, Utter complained that the disorder in the archive had kept him from performing the tasks set down in the chancery orders. He complained that the archive was in poor condition: documents were out of order and 'in complete disarray'.[37] Considering the disorder, it was Utter's opinion that the archive should be reorganised from the ground up. The documents should be arranged for each king, from Gustav Vasa to Gustavus Adolphus, and within each Vasa king's collection the files should be arranged in chronological order. Further, not only Swedish but also Finnish, Livonian, Danish, Russian and other letters from foreign countries and cities should be sorted according to the type of document: contracts and documents dictating peace, war, mining or quarrying and everything else, significant as well as more common things, should be inventoried. The different document groups should be given alphabetical labels, to which the secretaries could refer. With the help of the alphabetical system, Utter posited, one would be able to find documents quickly, in both the archive and the Royal Registry, when one wished to work with them.

According to Utter, the 'most distinguished issues and documents' from every king's reign should be registered. He defined distinguished documents as those files that mentioned events between fathers, sons, brothers and subjects of the kingdom, and with foreign lords and rulers, in connection with alliances, marriage, war, ceasefire and peace. Here, Utter referred to the fairly new Vasa dynasty: Gustav Vasa, his sons Eric XIV, John III and Charles IX, John's son Sigismund III and Charles' son Gustavus Adolphus. It was also urgent that documents involving religious issues and other valuable events be copied, so that the yet unwritten kings' chronicles could be compiled. And if the documents were sorted, Utter proposed, one might find new knowledge that was

[37] Per Månsson Utter to Axel Oxenstierna 1618 (undated), E 746, Oxenstiernska samlingen, RA Marieberg.

missing from the already existing chronicles and could be added to them.[38] Bringing order to the archive was thereby a way to process and discover the past. Utter's archive arrangement advocated a chronological and hierarchical order based on the Vasas' genealogy, whereby summaries of central political documents would contribute to each ruler's chronicle. The possibility that the disarray in the archive might contain documents yet to be discovered seems to have motivated the archive secretary in his work.

The documents from Mitau thus came to a historical archive that had just begun to be established at a specific place and in specific cabinets, at the same time that it had recently been separated organisationally from the daily chancery operations. In 1622, in addition to the old green cabinet in the innermost vault there was another one, called 'the new one' or 'the new white cabinet'. It was in this cabinet where Utter placed the Mitau files. The new white cabinet contained no less than 47 cases. According to a list from 1622, Utter used cases 20–42 and 45 for the documents from Mitau. The rest of the cabinet was occupied by documents from the Middle Ages in the first 11 cases, from King Magnus Eriksson's time to that of Kalmar Union King Christian II, and after this came documents involving Denmark, Lübeck and Danzig covering the years 1523–1619. In the forty-third case, Utter placed files mentioning the Treaty of Stettin from 1570–71.[39] The Livonian documents from Mitau were thus inserted into a geographical, historical and political context. Though their geographical origin was marked out, once placed in the white cabinet they became unquestionably a part of the legacy of the Vasa kings. Consequently, the booty that had been made in Mitau was now brought into Vasa history.

According to the 1618 chancery orders a certain secretary, Andreas Erici, held the daily responsibility for Livonian documents arriving at the chancery.[40] The fact that the documents from Mitau were nonetheless handled by Utter suggests not only how valuable they were considered to be, but above all that they were associated with the past and thus the old archive. As Utter had placed the Mitau documents in one of the innermost vault's cabinets, he must have regarded them as being among the most distinguished documents in the Kingdom's Archive. In this way, he kept together the booty that had been extracted from Mitau by placing the documents in the same cabinet. There is a clear exception to this, however. A transcribed list of the contents of the

38 Per Månsson Utter to Axel Oxenstierna 1618 (undated), E 746, Oxenstiernska samlingen, RA Marieberg.
39 Nya skåpet, förteckning A:2 1622, uppställningsförteckningar och inventarier 1618–1627, D II b a vol. 1, huvudarkiv byrå, Riksarkivets ämbetsarkiv, RA Marieberg; cf. Bergh, *Svenska riksarkivet*, p. 267, who writes that Utter placed the documents in cases 22–37.
40 *Samling af instructioner*, 301.

old green cabinet that Utter made around 1622–1623 includes an addendum regarding a document in the eighteenth case: 'On the royal election in Poland after [King] Sigismund Augustus taken at Mitau'.[41] Here, Utter had taken an especially significant document out of its Mitau context in the new white cabinet and instead placed it in the old green one among John III's files. In its new setting, he made sure to stress the document's geographical origin. Whether he had plans to sort more of the documents from Mitau into the green cabinet, however, we will never know. In April 1623, the plague came to Stockholm. Utter sent his family away, along with the last of his remaining assistants in the archive. The secretary himself stayed, just to arrange a few last things, as he wrote in a letter to Axel Oxenstierna.[42] Unfortunately, the dedicated archive secretary Utter died of the plague in September of the same year.

6 The Mitau Documents' Transformations

The work Utter had begun continued in 1626 under the leadership of chancery secretary Carl Oxenstierna.[43] Until the castle fire in 1697, officials worked in the archive to achieve the ideal order Utter had initiated in 1618; in this way, the kingdom's first archive secretary had a far-reaching influence on the character of the Kingdom's Archive. The documents continued to be sorted according to his genealogical system, which was characterised by chronological and hierarchical ideals, but not without a certain resistance from the files themselves: they demanded space, and their geographical properties could sometimes make them difficult to classify.

Through the work of Carl Oxenstierna, the Mitau documents were moved already in 1626. A transcription of his inventory includes addenda showing that, for example, '34 Courlandian documents from popes, bishops and others' in the white cabinet's twentieth case were moved to 'an unlocked chest that sits under a cabinet in the innermost room'.[44] Judging from later notations,

41 Gröna skåpet, förteckning E, uppställningsförteckningar och inventarier 1618–1627, D II b a vol. 1, huvudarkiv byrå, Riksarkivets ämbetsarkiv, RA Marieberg.

42 Per Månsson Utter to Axel Oxenstierna, 1 April 1623, E746, Oxenstiernska samlingen, RA Marieberg; Bergh, *Svenska riksarkivet*, p. 147.

43 Helmut Backhaus has rightfully argued that Carl Oxenstierna's time in office has unfairly been overshadowed by Utter's; see Helmut Backhaus, 'Carl Oxenstierna som *custos archivi* 1626–29', in K. Abukhanfusa (ed.), *Av kärlek till arkiv. Festskrift till Erik Norberg* (Stockholm: Riksarkivet, 2002), p. 190. However, Oxenstierna continued to follow the genealogical order envisioned and initiated by Utter.

44 Nya skåpet, förteckning B:2, uppställningsförteckningar och inventarier 1618–1627, D II b a vol. 1, huvudarkiv byrå, Riksarkivets ämbetsarkiv, RA Marieberg.

most of the files seem to have been removed from the white cabinet and placed together in a chest under a cabinet, likely the green one, sometimes simply referred to as 'the cabinet'. Some of the documents ended up in a particular case 'under King Gustav's [Vasa] cabinet'.[45] A later list shows that all of the Livonian documents had been moved from the white cabinet, where a number of Russian documents were placed instead.[46] The documents from Mitau thus ended up in different places in the archive, some of them incorporated into new contexts. This division has made the booty as a whole harder to follow, particularly as there were also other Livonian documents coming into the Kingdom's Archive. All this is further complicated by the fact that the Mitau documents' geographical origin was not always mentioned in the notes, while in some cases the origin or geographical label was changed. Documents previously described as only Livonian now became 'Livonian and Russian'.

Around 1626, the Kingdom's Archive acquired more cabinets: according to Utter's guidelines, one for each king. In a memorandum from 1628, it is noted that the six cabinets were placed in the archive's two innermost rooms. Each year of each king's reign was to occupy its own case. When the documents had been sorted by king and year, the inventory was to further describe the contents case by case. Where possible, the month and date of each document were to be noted and the document sorted according to this, and each document's content was to be briefly summarised in the inventory. Copies and concepts were to be separated from their originals, and finally, an alphabetical compilation of *tituli actorum* was to be made in order to make it easy to find what one was seeking. Of the documents that had not yet been inventoried, only the originals were to be sorted into the cabinets; the concepts and copies were to be placed in the outer chancery room. The very oldest files were to be kept in special chests until the archive had acquired more cabinets, at which point the intent was to arrange them like the others.[47] It was still only the documents regarded as the most significant that were placed in the cabinets. Eventually, the archive officials began also to make specific lists of distinguished documents.[48]

In a later inventory from 1637, it is clear that four cases containing 'old Livonian and *Russian* documents, taken at Mitau' had been placed in Eric XIV's

45 Ibid.
46 Nya skåpet, förteckning C:2, uppställningsförteckningar och inventarier 1618–1627, D II b a vol. 1, huvudarkiv byrå, Riksarkivets ämbetsarkiv, RA Marieberg.
47 '*Dispositio actorum in archivo regni* 1628', uppställningsförteckningar och inventarier 1628 och följ., D II b a vol. 2, huvudarkiv byrå, Riksarkivets ämbetsarkiv, RA Marieberg; cf. Bergh, *Svenska riksarkivet*, pp. 275–278.
48 Bergh, *Svenska riksarkivet*, pp. 293ff.

cabinet.[49] These four cases came to stand highest in the archive's hierarchy: in one of the kings' cabinets in the archive's innermost room. It is interesting that the documents that had previously been Livonian were now described as Russian too, especially as this was a quality that had not been ascribed to the Mitau documents before.[50] It is difficult to know why they were identified in this new way, and whether it was related to language. Daniela Bleichmar has shown that descriptions of so-called exotic (typically non-European) objects in early modern collections were highly alterable, not least when it came to their geographical origin. An object that is ascribed to a Japanese king in one list might be said to have belonged to an Indian king in the next. Bleichmar has asserted that geographical qualities were used to highlight the object as something peculiar and different.[51] It is impossible to say with any certainty, however, whether this was the case with the Mitau documents in Eric XIV's cabinet. Perhaps their background was to be made more noteworthy, or their language was considered, or perhaps they were described as Russian simply because knowledge about their background had been lost. The new description could also have had something to do with the territorial tensions between the Swedish and Russian empires.

At the same time, in 1637, still more documents from Mitau were placed in a completely different area of the castle, 'the vault at the Papist Church'.[52] Inside a black, round-topped chest, an old chest with iron hardware, an oak chest, a half-barrel, and a small white box were stored '*old* Livonian documents taken at Mitau'.[53] Besides these, the vault was filled with other similar documents, such as old German parliamentary documents taken as spoils in Mainz in 1631, land registries and monastic archives Gustav Vasa had confiscated in

49 'Kort förteckning opå dhe handlingar medh hwart Rum för sigh, som dhe nu lagde åhre Vedj Rijkzens Archivo finnas', 1 August 1637, uppställningsförteckningar och inventarier 1628 och följ., D II b a vol. 2, huvudarkiv byrå, Riksarkivets ämbetsarkiv, RA Marieberg. My italics.

50 The most detailed list of the Mitau documents and their geographical connections was made by Utter in 1622. This list mentions two letters from a Russian king, and in the 45th case Utter placed letters between Livonia and Russia. See nya skåpet, förteckning A:2 1622, uppställningsförteckningar och inventarier 1618–1627, D II b a vol. 1, huvudarkiv byrå, Riksarkivets ämbetsarkiv, RA Marieberg.

51 Bleichmar, 'Seeing the world', pp. 17–19.

52 This refers to a Catholic chapel that had been established for John III's wife, Queen Catherine Jagiellon.

53 'Kort förteckning opå dhe handlingar medh hwart Rum för sigh, som dhe nu lagde åhre Vedj Rijkzens Archivo finnas', 1 August 1637, uppställningsförteckningar och inventarier 1628 och följ., D II b a vol. 2, huvudarkiv byrå, Riksarkivets ämbetsarkiv, RA Marieberg. My italics.

the sixteenth century, confiscated documents of executed privy council members and the like. Royal concepts from John III's, Charles IX's and Gustavus Adolphus' times were also stored here.[54]

The collections in the vault at the Papist Church took up just over 50 chests, barrels and boxes. These storage vessels posed a problem when it came to space, as there was not enough room for them in the archive's three rooms. The documents' different origins, from Livonia and Mainz as well as various monasteries and families of Swedish high nobility, meant that they had no self-evident place in the Kingdom's Archive's order based on the genealogy of the Vasa kings. Some of the documents were perhaps not regarded as so important that they should be stored in cabinets or within the actual rooms of the archive. A thematic list made shortly after the 1637 inventory mentions a large iron box, or black box, 'within which distinguished original letters, taken at Mitau' were stored. At the time of the inventory the box was located in the archive's middle room, which also housed, among other things, the cabinets of Kings Sigismund and Gustavus Adolphus.[55] The fact that this is not mentioned earlier suggests that the Mitau documents were still being processed at the end of the 1630s. Documents kept in boxes, chests and barrels were not only safe from fire; they were also portable, which facilitated their accessibility and movement. In his archive manual, Bonifacio wrote specifically about boxes (*scrinium*, which can be translated as either box or chest) as the proper place of storage for books and other writings.[56] When the distinguished original letters from Mitau were stored in a box, they could easily be moved between the rooms of the archive or different areas of the castle. This type of storage was both practical and safe, and the documents' mobility facilitated the officials' work.

The next inventory of the Kingdom's Archive was made by archive secretary Erik Larsson Runell (knighted Palmskiöld) at the beginning of the 1670s. He had been in the service of the archive since the 1630s, and in 1651 was promoted to archive secretary. For most of the time from the 1640s onwards, the officials had worked to consolidate the distinguished documents with registries, concepts and incoming letters that had previously been stored in different places.

54 'Kort förteckning opå dhe handlingar medh hwart Rum för sigh, som dhe nu lagde åhre Vedj Rijkzens Archivo finnas', 1 August 1637, uppställningsförteckningar och inventarier 1628 och följ., D II b a vol. 2, huvudarkiv byrå, Riksarkivets ämbetsarkiv, RA Marieberg; Backhaus has indicated the potential delicacy in the executed privy council's files, Backhaus, 'Carl Oxenstierna', pp. 189–190.

55 'Designation öfwer Rijkzcantzlij Rummen', version A och B, uppställningsförteckningar och inventarier 1628 och följ., D II b a vol. 2, huvudarkiv byrå, Riksarkivets ämbetsarkiv, RA Marieberg.

56 von Ram[m]ingen & Bonifacio 2010, 102.

When the archive was given a new location in Tre Kronor's eastern section, which consisted of a lower and an upper vault, the documents could be consolidated. The Vasa's history thereby grew even more comprehensive, with the addition of more source material. The upper vault would come to house 20 cabinets, labelled with the letters A to V, while the various kings' names were still used to name the cabinets. Each cabinet consisted of three sections: an upper part with three shelves (so-called rooms) of the same width as the cabinet; under these, 20 smaller cases in five rows; and at the bottom, two larger cases. Registries, concepts and diaries were placed in the upper cases, while the smaller cases were reserved for distinguished documents and letters received. Anything that did not really fit in, *miscellanea*, was placed in the large cases at the bottom.[57] Every case became a chapter, and every cabinet a part, in each Vasa king's history.

The inventory from the 1670s only mentions the cabinets' content, with the exception of an addendum listing the documents confiscated in Warsaw in 1656. This distinguishes this list from the previous inventories, which also mention free-standing chests, barrels and boxes. Due to the limited information, it is not possible to discern what had happened with the documents from Mitau that had previously been stored in the vault at the Catholic chapel; they were still somewhere in the castle, however. At this point, the provenance of Mitau had disappeared from the descriptions of what was in the cabinets. Meanwhile, other geographical provenances arose. Archive officials had placed the parliamentary files confiscated in Mainz in 1631 in Gustav Vasa's cabinet; now, these were described as 'various imperial and German princely documents on Parliaments and other proceedings'. This cabinet also contained old books 'with Monks' writing on parchment', which Utter had retrieved from Vadstena Abbey. Thus, it was not only confiscated archive documents that were made a part of the genealogical order but also books from dissolved abbeys and monasteries. Files taken as spoils in Warsaw in 1656 had been placed with Eric XIV's incoming Russian documents, and documents of the same origin also ended up in King Sigismund's cabinet. It was thus a matter of document spoils that had come to the archive later than the Mitau files.[58]

Each Vasa king had a section for Livonian documents, which typically entailed incoming letters and similar princely correspondence. In the search for Mitau documents in King Eric's cabinet, Livonian files can be found in both

57 Bergh, *Svenska riksarkivet*, pp. 284–285.
58 'Register (...) om Archivi acters disposition' (signed EL), uppställningsförteckningar och inventarier 1628 och följ., D II b a vol. 2, huvudarkiv byrå, Riksarkivets ämbetsarkiv, RA Marieberg.

the incoming Swedish and Russian sections. Considering how the officials organised the archive, Livonia was apparently regarded as having belonged to the Swedish Crown starting in Eric XIV's time. The 'various Russian, Livonian and Estonian documents' that were placed in the fifteenth case among the incoming foreign Russian documents likely corresponded, wholly or partially, to the four cases of similar documents listed in 1637. Among the Swedish documents were two cases of 'Livonian and Estonian documents', which may also have included the documents from Mitau. The documents from Mainz and Warsaw were handled similarly, being integrated into the Vasas' histories. Gustav Vasa's cabinet is a clear example of this, with Livonian files occupying two of the cases in his foreign section. The first three categories comprised letters from masters, other persons and various cities, which may have entailed diplomatic writings sent via envoy to the Kingdom of Sweden. However, the second case contained the vaguer 'various Livonian documents', which may have included some of what had been confiscated in Mitau.[59]

Taken together, these examples show that some of the Mitau documents were mixed together with other incoming Livonian documents, as well as documents described as Swedish. Several notes in the lists also suggest that a number of Mitau documents were quite simply placed in the kings' collections, rather than being removed from them. The genealogical order practised in the Kingdom's Archive during the seventeenth century thus made certain Mitau documents parts of the Vasa's history, along with the other confiscated spoils from Mainz and Warsaw.

7 Restitution and Rebirth

Although plundering was legal in wartime, it was common for victims of the ransacking to demand the return of their former belongings. Such demands could be articulated in connection to peace treaties. As regards the Mitau documents, as early as 1622 a demand came from Kettler's sons, the Dukes of Courland, that they be given back the documents that 'from Mitau were brought here [to the Swedish Empire]'. Their request does not seem to have referred to all the documents; at least it was not interpreted this way by Per Månsson Utter, who handled the request. Instead, in a letter to Axel Oxenstierna he wrote that his intent was to make a list of what primarily appertained to the

59 'Register (...) om Archivi acters disposition' (signed EL), uppställningsförteckningar och inventarier 1628 och följ., D II b a vol. 2, huvudarkiv byrå, Riksarkivets ämbetsarkiv, RA Marieberg.

Dukes, and what he judged the Swedish royal chancery could reasonably to do without, if the Chancellor allowed it.[60] Some weeks later, the secretary again wrote to Oxenstierna and informed him that he had listed the youngest documents from Mitau, which he believed belonged to Courland. In nearly all cases, this entailed documents created after the Order had been dissolved and the Duchy of Courlandia had been established; that is, documents that came from Kettler's chancery. Utter wrote that several of the documents were shredded and missing their seals. Because of this, he wrote, they were of no use to the Dukes. There were, Utter continued, more documents belonging to Courland than he had listed, but he felt it was unnecessary to register them.[61] It is clear that Utter wanted to keep as many of the Mitau documents as possible in the Kingdom's Archive; he also mentioned to Oxenstierna how pleased the King was with the documents belonging to 'our Swedish Livonia'.[62]

By only providing limited information on the documents, leaving out details and describing some of them as torn, Utter was able to keep most of them. In total, he listed 17 items referring to documents he regarded as involving the Dukes. The first entry referred to various letters relating to border issues, while the other 16 mentioned individual documents. There was also an addendum mentioning a marriage contract, an undated charter regarding the border between Courland and Lithuania and letters belonging to the Tiesenhausen family. The list briefly mentions the documents' contents and in several cases their material condition. The oldest document is dated 1545 and the most recent 1614.[63] At least 11 of the letters remained in the Kingdom's Archive when the documents were listed towards the end of the seventeenth century, which means that none, or only a few, of the documents were actually returned. As Utter ascribed the Mitau files a high value as old, historical documents, he consequently wanted to keep and preserve them in the Kingdom's Archive. When he described many of them as torn, he may have been exaggerating in order to try to make the collection appear less valuable, particularly from a legal perspective. However, he had actually described torn documents in connection to the first inventory of the Mitau spoils. It is clear that even such documents sometimes were ascribed value: when the documents from Mitau were listed

60 Per Månsson Utter to Axel Oxenstierna, 23 September 1622 (small attached note), E 746, Oxenstiernska samlingen, RA Marieberg.
61 Per Månsson Utter to Axel Oxenstierna, 4 October 1622, E 746, Oxenstiernska samlingen, RA Marieberg.
62 Per Månsson Utter to Axel Oxenstierna, 23 September 1622 (small attached note), E 746, Oxenstiernska samlingen, RA Marieberg.
63 Per Månsson Utter to Axel Oxenstierna, 4 October 1622, E 746, Oxenstiernska samlingen, RA Marieberg.

in 1686, Utter's chosen letters were described yet again, some of them just as torn then as they had been in 1622.[64]

Although the Courlandian Dukes did receive a handful of documents in 1623, they were not satisfied. In connection with the signing of a treaty in 1635 in Stuhmsdorf between the Swedish Empire and Poland-Lithuania, the Swedish Crown was required to return documents that had been taken at Mitau. But, once again, this applied only to documents connected to the Courlandian Dukes' chancery and not the older documents. The fate of the Mitau documents was further complicated by the fact that the castle had been captured by Swedish troops in 1658, with the Courlandian Dukes' records again taken as spoils. These documents were apparently returned, according to the agreement in the Treaty of Oliva in 1660. As the documents do not appear in the Kingdom's Archive's lists from later dates it is likely that they actually were returned, before they had the chance to be mixed in with other collections. A similar situation occurred at the beginning of the eighteenth century during the Great Northern War (1700–1721).[65]

If the Mitau documents taken in 1621 are kept separate from later events, it appears that only a smaller number of documents were returned in 1635 as there was yet another request from Courland in 1686 for the return of documents. Swedish King Charles XI therefore commanded that the Mitau documents again be traced, read through and listed, in order to determine whether they contained anything to the benefit of the Swedish Empire. According to the King, anything that was not to the kingdom's benefit and that only concerned Courland was to be returned to the Courlandian envoy.[66] This meant that the documents that had been taken in 1621 and then gradually placed in the various cabinets and rooms of the Kingdom's Archive (of which a smaller portion had already been returned) were now to be reassembled in a list. This was an impossible task, and this list differed in many ways from the booty of 1621. Some documents were missing, while others, later placed in the Kingdom's Archive, had been added; not from Mitau, however, but rather spoils that had been confiscated in Prussia in 1626. The list also contained domestic documents of Swedish origin.[67] It is also impossible to determine whether the

64　At least one document had been preserved in the archives between 1622 and 1686 despite its torn condition; cf. no. 8 in Per Månsson Utter to Axel Oxenstierna, 4 October 1622, E 746, Oxenstiernska samlingen, RA Marieberg with no. 867 in Schirren, *Verzeichnis livländischer*, p. 152.

65　Krajevska & Zeids, 'Zwei kurländische Archive', pp. 14, 16–18; Walde, *Storhetstidens II*, pp. 178, 193.

66　Karl XI to Bengt Oxenstierna, 8 February 1686, utländska registraturet, 1686, fol. 46, RA Marieberg.

67　Walde, *Storhetstidens I*, pp. 81–82; Schirren, *Verzeichnis livländischer*, pp. 156–157.

documents that had been sorted into the cabinets of Gustav Vasa, Eric XIV or John III were included in the 1686 list, as the information on these is far too sparse.

The list, titled 'the writings and documents that were taken within Mitau in 1621', is comprised of 1,095 items, with one item sometimes containing several individual documents. The list is bound and on the inside of its front cover, long after 1686, an archivist has noted that its contents were a list of Courlandian documents that upon royal command were returned to the new Duke of Courland, Frederick Casimir Kettler. For this reason, the archivist noted, the documents could not be in the National Archives.[68] However, the royal order had stated that, while all the documents were to be listed, only those files that strictly concerned Courland were to be returned. In the end, it seems that as few as 193 items, listed in a receipt that the Courlandian envoy signed, were returned.[69] There are, however, other sources to consider. Firstly, there is a loose note included with the list from 1686, mentioning twelve items expressly concerning Courland that were perhaps of greater relevance to Swedish interest than the rest. These twelve items are marked within the list itself, but others are as well, and it looks as if the marks were made by the same hand. These markings correspond with the Courlandian envoy's receipt, in which item one is equivalent to the fifteenth document in the list of 1686 and so forth (and it is the same document that is listed first on the loose note). Choosing which documents to return may have been done on multiple occasions; at any rate, it was not obvious what to give up and what to spare. There is also a handful of notices in the list, written by a seventeenth-century hand explaining that four copies of documents had been kept, or that a copy had been provided; that is, that a copy had been made for the envoy.[70] Finally, in 1696 in Courland, an official made a list of the Duke's records, mentioning the content of a number of Swedish chests. The inventory of the content of these chests comprised 107, not 193, items. It is not unusual that numbers like these do not match, considering that the lists were made by different officials in different settings, but in this case the difference is striking

68 'Förteckningh uppå dhe skriffter och Documenter ...', huvudarkiv byrå, förteckningar över handlingar rörande Sveriges forna besittningar och över Extranea, D II eg, vol. 1, 1600-talet, RA Marieberg.

69 Huvudarkivet och byrå 1:s arkiv, FXIa, 3 (1686–1823), Riksarkivets ämbetsarkiv, RA Marieberg; Völkersambs receipt is mentioned in Bergh, *Svenska riksarkivet*, p. 389, but I was unfortunately not able to locate this source before my Swedish book was published in 2015. Thus, I have revised my discussion here.

70 See documents 59, 99, 110, and 279, 'Förteckningh uppå dhe skriffter och Documenter ...', förteckningar över handlingar rörande Sveriges forna besittningar och över Extranea, D II eg, vol. 1, 1600-talet, huvudarkiv byrå, Riksarkivets ämbetsarkiv, RA Marieberg.

and should therefore be recognised.[71] At any rate, the Courlandian list confirms that some hundred documents were given back as a result of the 1686 request.

To this day a significant number of the documents from Mitau remain in the National Archives, 26 cases in the foreign parchment letter department and 50 cartons of paper documents in the Livonica collection, although more reductions were to follow that of 1686. Around 1800, a Prussian minister was able to secure the return of a cluster of Warmian documents; that is, documents from the Prussian region of Warmia with the cathedral town of Frauenburg. Among the returned documents was a smaller collection of the 'Courlandian commandant's archive in Mitau'. The documents were first transported to Berlin, but were quickly moved to Koenigsberg.[72] In 1860, the National Archives traded a number of parchment letters from Mitau with an Estonian publisher of source editions, Baron Robert von Toll.[73] That same year, von Toll studied the register of the Mitau documents from 1686 in the National Archives.[74]

Relatively speaking, then, not many of the Mitau documents left the archive in 1686; it was a matter of somewhere between ten and seventeen percent of just over a thousand listed items. For the Duke of Courland, however, the files were just as important in 1686 as in 1621, 65 years after the King and Chancellor had taken the Mitau spoils. The memory of the archival booty from Mitau Castle remained throughout the decades, even over centuries, as von Toll's interest in them shows. But, it was impossible to recreate the exact object of plundered knowledge, of just precisely what the spoils had entailed in 1621.

8 Post-Fire Order, Collectors and Thieves

I now reach the tragedy of Swedish history that opened this chapter, which also affected the Mitau files. After this well-known tragedy, a lesser-known

71 'Dem Schwedischen Kasten'; see Theodor Schiemann, *Regesten verlorener Urkunden aus dem alten livländischen Ordensarchiv* (Mitau: E. Behres Verlag, 1873), pp. V–VI, quote from p. V; different ways of counting items in the early modern period will be further discussed in 'Library Confessions'.

72 Walde, *Storhetstidens II*, pp. 464–465; quote from p. 465.

73 James Cavallie & Jan Lindroth (eds.), *Riksarkivets beståndsöversikt. Del 1. Medeltiden Kungl. Maj:ts kansli Utrikesförvaltningen. Band 1* (Stockholm: Riksarkivet, 1996), p. 38; James Cavallie & Jan Lindroth (eds.), *Riksarkivets beståndsöversikt. Del 1. Medeltiden Kungl. Maj:ts kansli Utrikesförvaltningen. Band 2* (Stockholm: Riksarkivet, pp. 1996), 611–612, 617–618.

74 According to Schiemann, this register was reproduced by Schirren in *Verzeichnis livländischer*. It appears that Schiemann incorrectly believed that the list from 1686 had been made in 1621, as this is the only register reproduced in Schirren. Cf. Schiemann, *Regesten verlorener*, p. I.

mystery occurred; I address it here, as it underlines the value and luminosity of the Mitau files in the longer term. A number of days after the dreadful fire in May of 1697, it was determined that the Kingdom's Archive would be moved from the stable mentioned at the beginning to the house of the late Count Per Brahe, which was also located on the island of Helgeandsholmen. The house was adapted to its new purpose: unnecessary windows and doors were walled over, windows were fitted with iron shutters and the entrances with iron doors, and shelves and cabinets were acquired. The Kingdom's Archive occupied eight vaulted rooms in Count Brahe's house, taking up the entire ground floor. As soon as the archive was safely in place, the work to organise the documents began. The inventory was finished in 1702 and signed in 1703. In connection with the work after the fire, the genealogical archive order formulated by Utter and followed by his successors, that is, that the archive was primarily to be organised based on the respective Vasa ruler as if it were their chronicles and history, was abandoned. Instead, the documents were sorted based mostly on type of document: council protocol, state registry, royal concept, and so on. The kings did not disappear from the archive organisation, but their significance was subordinated to a new organisational protocol. The system of differentiating particular distinguished documents was also abandoned at this point. According to Severin Bergh, an order arose now that has come to be partly preserved in modern time. This would therefore be a good place to end the history of the Mitau files: when the kings had to step aside for an order based on the type of document one was dealing with.[75]

But the story continues here nonetheless as, shortly after the fire at the castle, the documents from Mitau came to be involved in a series of strange events. These events were made possible by the disarray caused by the fire, and also reflect the fact that the Swedish Empire was involved in yet another war at the beginning of the eighteenth century, the Great Northern War, which caused the kingdom to lose its territories in Livonia to Russia in 1710, a loss that was made official in the 1721 Treaty of Nystad. In the National Archives a list of 'Livonian files' is preserved, made by one Richard von der Hardt, a German-born printer who was an active book auctioneer in Stockholm and Uppsala at the beginning of the eighteenth century. When he died, part of his estate entailed 'collections involving Livonia's history'.[76] A clue as to just what type of Livonian collections these were can be found in the report written by

75 Bergh, *Svenska riksarkivet*, pp. 309ff, 318–319, 326–327.
76 Gunnar Carlquist (ed.), *Svensk uppslagsbok*, volume 12 (Malmö: Baltiska förlaget, 1932), p. 658.

Gustaf Peringer Lillieblad in von der Hardt's list in the National Archives.[77] Lillieblad, an orientalist scholar, was responsible for the censorship of books at the beginning of the eighteenth century. He was also a royal librarian, and after the fire at the castle had the task of investigating the losses of books and documents.[78] These losses involved not only books and documents that vanished in the fire; valuable writings and files seem to have also disappeared in the chaos afterward.

On October 26, 1701, the officials in the royal chancery discovered that von der Hardt, without permission, had made a register of the Livonian documents and taken it from the archive. Here, register refers to a type of copy book, a summary of excerpts from historical documents. The register in question summarised Livonian files in chronological order, from the end of the eleventh century onwards, and undoubtedly included documents taken at Mitau in 1621.[79] The list was not the only suspect material Lillieblad found with von der Hardt; there were also printed and handwritten works, the latter of which Lillieblad confiscated.

According to Lillieblad, von der Hardt had planned to publish a history of the Livonian Order masters. It was von der Hardt's collection of material for this work that Lillieblad found to be suspect. How had von der Hardt come across the information in his register and notes? Where had he read the documents? Would he not have had to read them in files from the Kingdom's Archive? Was he allowed access to these? Von der Hardt answered that he had primarily used the Livonian history written by the Swedish official Thomas Hiärne, which at the time was available as a manuscript.[80] He also said he had had access to the collection of Lieutenant Colonel von Kloot (likely Johan Adolf Clodt von Jürgensburg) and, conveniently enough, the notes of a deceased German

77 See in the back, in 'Förteckning öfver de Lifländska Acter som förvaras i Kungl. Sv. Antiq. Archivo af M. Richard von der Hardt', förteckningar över handlingar rörande Sveriges forna besittningar och över Extranea, D 11 eg, vol. 2, 1701, huvudarkiv byrå, Riksarkivets ämbetsarkiv, RA Marieberg.

78 'Lillieblad', *Svenskt biografiskt lexikon*, https://sok.riksarkivet.se/sbl/Presentation.aspx?id =10316, access 26 April 2014.

79 The list begins with an older file, which according to von der Hardt was from 1093. However, it is of course impossible to know whether this date is correct; see 'Förteckning öfver de Lifländska Acter som förvaras i Kungl. Sv. Antiq. Archivo af M. Richard von der Hardt', Förteckningar över handlingar rörande Sveriges forna besittningar och över Extranea, D 11 eg, vol. 2, 1701, huvudarkiv byrå, Riksarkivets ämbetsarkiv, RA Marieberg.

80 Thomas Hiärne's *Ehst- Liv- und Lettländische Geschichte* was published posthumously in Mitau in 1794. The work consisted of seven books, the last of which had not been finished when the author died. See Sixten Humble, 'Thomas Hiärne', *Personhistorisk tidskrift*, 26 (1925), pp. 28ff, 42–46.

student. After some pressure was applied, von der Hardt admitted that he had been in the Kingdom's Archive, but firmly denied having copied any documents there. When Lillieblad asked him where Lieutenant Colonel Kloot had gotten his collection of Livonian files, von der Hardt answered 'that old documents and files can surely be found when one makes the effort'.[81] He then told of a woman who had tried to sell a basket full of old parchment files to the servant of an acquaintance for just twelve *riksdaler*. He particularly mentioned a manuscript, bound in red velvet. But the servant was not educated and therefore declined this incredible offer. This part of the story illustrates how archive documents circulated and were sold just like books in the economy of the rare, where valuable objects were in circulation, to use the words of William Clark.[82] This apparently went on under more suspicious forms as well. The fact that the Kingdom's Archive was a restricted collection that held state secrets and thus differed from other types of collections apparently did not keep the documents from circulating. In other words, they were both desirable intelligence and collectible objects: at a time when knowledge was exhibited in libraries, museums and cabinets of curiosities, the material values of archive documents should not be underestimated.

Lillieblad asked von der Hardt more detailed questions. Had he spent time with Danes or with the Courlandian minister von Sibrand and in those contexts seen any Livonian files? Von der Hardt admitted that he had seen three or four documents in the company of von Sibrand, and that the minister had copied them from Lieutenant Colonel Kloot's collections as the two were good friends. But according to von der Hardt, von Sibrand was not in a position to write anything about Livonian or Courlandian affairs. After having confiscated von der Hardt's collections of manuscripts, Lillieblad submitted a report on the sources on which he had based his summary. He asserted that von der Hardt had primarily copied information from Hiärne and other historical works. Even if von der Hardt had not had direct access to the Mitau documents when he visited the Kingdom's Archive, this episode illustrates how hard it was to control historians and collectors in the archive. It is especially interesting that the documents from Mitau were again in focus after 80 years in the Swedish Empire. Courlandian envoys, historians, Danes and German printers: all of these could have a use for the documents. For Lillieblad, it was a matter of

81 'Förteckning öfver de Lifländska Acter som förvaras i Kungl. Sv. Antiq. Archivo af M. Richard von der Hardt', 'Förteckningar över handlingar rörande Sveriges forna besittningar och över Extranea', D II eg, vol. 2, 1701, huvudarkiv byrå, Riksarkivets ämbetsarkiv, RA Marieberg.
82 Clark, 'On the bureaucratic plots', p. 191.

trying to determine what type of copies and thus information were in circulation, who was collecting old documents and who had an interest in Livonia's history; and, not least, of returning lost documents to the archive.

Mitau Castle was plundered again, in 1701, by Charles XII's troops. Some of the documents of the Courlandian Dukes had already been moved to safety from the war, but those that remained became spoils that were then taken to Riga. When Czar Peter I captured the city nine years later, he ordered that the Dukes' documents be returned. As always, it is difficult to know whether the spoils had been, and would continue to be, kept together. In all the places they have ever been kept, at least some of them have been left behind.[83] Any knowledge as to whether some of the documents returned from the Kingdom's Archive in Stockholm in 1635, 1660 or 1686 were among those taken in Mitau in 1701, or whether anything was again placed in the archive in Stockholm, is lost to the mists of time.

After von der Hardt, the Mitau documents met new collectors: individual people who for various reasons were granted access to the National Archives and came into contact with the files there. In the 1860s, Baltic-German historian Carl Schirren made a comprehensive inventory of Livonian documents in Swedish archives and libraries, and within this project studied the documents from Mitau. Some of the documents he claimed to have found in the National Archives' collections later disappeared under 'uninvestigated circumstances'.[84] These mysterious deeds could have been lost somehow, or to put it bluntly: they may have been stolen, or even been the fictions of an ambitious historian's creative mind. But despite the arbitrary quality of Schirren's inventory and the suspicions of theft, it is his ordering that serves as the National Archives' current arrangement of the Mitau documents in the section for foreign parchment letters. The appeal the documents have had to a number of people runs as a common thread throughout their history: from Axel Oxenstierna and Per Månsson Utter's eager opening of the Mitau chests in Stockholm in 1622, through Richard von der Hardt's suspect copying in the early eighteenth century, to Carl Schirren's assumed thefts around the mid-nineteenth century. At the beginning of the twentieth century, Otto Walde highlighted and coined the 'Mitau archive' as 'Swedish spoils'. However, as is apparent in this case study, the fate of the Mitau documents was far more complicated than that (see figure 11 on page 198).

83 Krajevska & Zeids, 'Zwei kurländische Archive', pp. 17–18, 23.
84 *Riksarkivets beståndsöversikt. Del 1. Medeltiden Kungl. Maj:ts kansli Utrikesförvaltningen Band 1*, 38; *Riksarkivets beståndsöversikt. Del 1. Medeltiden Kungl. Maj:ts kansli Utrikesförvaltningen, Band 2*, pp. 611–612, 617–618.

9 Conclusion: Archive Trouble

This chapter has examined just what type of archive it was that the documents from Mitau helped to create at Tre Kronor Castle in Stockholm, and the different meanings ascribed to the Mitau spoils in their new setting. In short, the Mitau files were perceived as extremely valuable, but they also caused the archivists a good deal of trouble. In the light of their history, the Kingdom's Archive emerges as a place that was created through demanding and time-consuming work. The collections were often hard to get an overview of, and the archive officials' tasks were characterised by a battle with matter, in which disorder was to be converted into order at the same time as new files were constantly arriving.

The Mitau files were initially ascribed with a number of valuable meanings in the Kingdom's Archive: they were appreciated due to their historical knowledge content and rarity, material worth and geographical origin. These were all useful components in the archive's dynastic organisation. Archive secretary and genealogist Per Månsson Utter placed the Mitau files in new spatial and epistemological contexts, where they were organised chronologically and hierarchically, and thus inserted into the history of the Vasa kings. The Mitau documents thereby participated in creating the archive's narrative, which established and legitimised a new royal dynasty and its linage. Likewise, the Mitau files were doubtless highly valued by the Chancellor and the King as the documents were significant knowledge resources in the dynastic and territorial conflicts in which the Swedish Empire was involved: documents concerning the royal election in Poland are an example of this.

The Mitau files had tangible effects in the Kingdom's Archive. The spoils were a collection of plenty that demanded a great deal of space and attention, a disorder that had to be sorted and controlled. The documents' geographical origin and foreign genealogical connections were at times difficult to classify and did not always fit in the archive's system: thus, they caused problems. According to the 1618 chancery orders, the Kingdom's Archive was not only to care for the kingdom's files; the man with the highest responsibility, the Chancellor, was also to collect documents for the archive. What became the Swedish National Archives was thus materialised not only through the documents that were already there and those produced daily in the royal chancery. It also came into being through the rulers' and officials' active collecting and plundering of documents in and outside of the kingdom of Sweden. As the Mitau files are just one example of this, it must be acknowledged that to some degree the Kingdom's Archive, and thus the Swedish National Archives, was an effect of wartime plundering. It is of central importance to recognise this phenomenon when writing the history of national archives.

Although most of this chapter is limited to a period of around 80 years, it is striking how mobile and changeable both the Kingdom's Archive and the Mitau files actually were during this time. As a collection, not only were the Mitau documents' meanings changed in their new settings; the spoils' composition was also transformed over time. The documents were kept together in Utter's first inventory from 1622–23, but were separated shortly thereafter. Some documents were brought into, and disappeared into, the kings' histories while others ended up in chests, barrels and boxes in other areas of the castle as the archive's rooms were too crowded. Some documents were returned in 1635 and 1686. When the spoils from 1621 were to be recreated in connection with the restitution in 1686, documents of other provenances were added to the Mitau files. Assimilation occurred in the sense that what once had been described as Livonian or Courlandian could lose these markers and become integrated with files produced in the Swedish kings' chancery. Assimilated files that lost their Mitau identity are very hard to trace. When one tries to follow the documents from Mitau in different inventories and lists over time, their diffusion and transformations become even clearer: bits and pieces of them disappear, while others surface now and then in different cabinets, chests and places in the royal castle. Consequently, some Mitau files were kept together, which maintained their identity, while others blended with the identity of other records. These makers of elusiveness, assimilation, diffusion, transformation, should be regarded as strengths when reflecting on methodology. The Mitau files' elusive nature actually helps to characterise a general point of this case, concerning the notion of object stability, which many scholars have begun to question in recent decades. The Mitau files' existence in the Swedish Empire illuminates that plunder could be more or less merged with its new context and thus become difficult to separate from it.[85]

Archives have been described as the rooms where the past lives and the place where the historian can make ink and parchment talk.[86] The history of the Mitau documents shows that the Kingdom's Archive was a place for the parchments of the past, at the same time as it is apparent that this place, on which the historian is traditionally dependent, should not be romanticised. The archive's organisation influenced, and still influences, the thoughts that are possible for the historian to think. As I have emphasised, the ideal order created in the Kingdom's Archive was far from neutral: the archive served as a resource for a dynasty that strove after expansion and legitimacy. Anyone who writes about history with support from this archive thus runs the

85 Lash & Lury, *Global culture*, p. 18.
86 Steedman, *Dust*, pp. 69–70.

risk of reproducing the order and hierarchies that were once built into its organisation.[87] This circumstance makes the fate of the Mitau files especially important, as their history highlights how categories like archive, spoils and geographical origin and provenance can and should be problematised. Things, in this case files, were not always what they were described to be. This insight must accompany us into the next chapter, where I analyse spoils and confessional diversity at Uppsala University Library.

87 Jennifer Milligan has emphasised the danger of reproducing the archive's authority in archival research; see Milligan, "'What is an Archive?'", p. 178.

CHAPTER 3

Library Confessions: Catholic Books, Jesuit Epistemology and Temporality at Uppsala University Library

It is widely known that King Gustavus Adolphus was a devout Lutheran who perceived the Jesuits as his personal enemies: to him, they were nothing but vipers' spawn.[1] This is illustrated by a tale recounted by Otto Walde in his work on literary spoils. According to Walde, when the Riga Jesuit College was closed down by Gustavus Adolphus in 1621 he confronted one of the monks, a Norwegian named Lars Nilsson. Nilsson, known in Sweden as '*Kloster-Lasse*', had been invited to Stockholm in the late 1570s by Sigismund's father and Gustavus Adolphus' uncle, John III.[2] In Stockholm, Nilsson was allowed to lead a colloquium at a closed-down monastery as he tried to find a compromise between the Swedish King and the Catholic Church. Due to conflicts with both Rome and the Swedish priests, Nilsson was banished from Sweden in 1580. Reportedly, when Gustavus Adolphus met Nilsson in Riga about forty years later, he addressed him with defamatory and insulting words, which the then eighty-two-year-old monk is said to have answered with the greatest dignity.[3]

Regardless of whether or not this tale is true, Nilsson was an important figure and opponent, and was well known to Swedish scholars in this period. This appears, for instance, in an inventory of spoils taken from the important Braunsberg Jesuit College in 1626. Among more than 2,000 volumes, Nilsson's work *Confessio de via domini* was particularly noted by the librarian, Johannes Bureus, who recorded the haul, and the volume was later placed in shelf α3 in Uppsala University Library.[4] The Riga confiscation of 1621 was the first time Gustavus Adolphus targeted a Jesuit college, and would come to be emblematic. What happened there, including the possible encounter between Gustavus Adolphus and Nilsson, illuminates the religious polemic between Catholics and Protestants in the seventeenth century. The epistemological encounter

1 Munkhammar, 'Böcker som krigsbyte', p. 37.
2 Literally meaning 'Lars of the monastery', Lasse being a common nickname for Lars. His Latin name was *Laurentius Nicolai Norvegus*.
3 Walde, *Storhetstidens I*, p. 45. Walde's source is Giulio Cordara's *Historia societatis Jesu* from 1750.
4 'Klosterlasses' has been added to the inventory in Swedish, U273, Uppsala universitetsbibliotek (UUB), p. (13); K3, bibliotekets arkiv, UUB, 21.

that took place in Uppsala, in which books from Catholic scholarly environments found new settings in a Protestant university library, has been seen as highly problematic by researchers like Otto Walde and Margareta Hornwall.[5] As religious strife has intrigued past historians dealing with this case, it lies at the heart of the present case study as well. What follows, however, takes issue with the idea that Jesuit books in Uppsala University Library were useless.[6]

Notwithstanding the religious controversies of that time, my analysis of how Uppsala University Library was established with the help of spoils abducted from Catholic environments contests the fixity of epistemological categories such as 'Catholic' and 'Protestant'.[7] This is mainly done by scrutinising the librarians' handling of those volumes that the seventeenth-century librarians classified as theology or to which they ascribed a certain confessional identity: typically Lutheran, Catholic or Calvinist, or Jesuit.[8] Accordingly, I am interested in the historical understanding and use of the categories above, the books that constituted them, and also in how they have changed with time. By anchoring this case study in the spatial organisation, classification, reclassification and movements of collections, I intend to generate new insights into the seventeenth-century history of knowledge, libraries and spoils of war.

1 'It Is Not Extraordinary': Library Beginnings

A recurring theme in the history of Uppsala University Library is that it was never good enough. In fact, as the following reveals, during the library's early decades, everyone, from professors to officials to foreign visitors, did nothing

5 Walde, *Storhetstidens I*, pp. 15–16, 18; Hornwall, 'Uppsala universitetsbiblioteks resurser', p. 68.
6 Earlier versions of this chapter have been published as Emma Hagström Molin, 'Spoils of Knowledge. Looted Books in Uppsala University Library in the Seventeenth Century', in G. Williams etc. (eds.), *Rethinking Europe. War and peace in the early modern German lands* (Leiden: Brill, 2019), pp. 252–273; 'To place in a chest'. On the cultural looting of Gustavus Adolphus and the creation of Uppsala University Library during the 17th century, *Barok*, 44 (2015), pp. 135–148; 'Biblioteksmaterialiseringar. Krigsbyten, samlingsordningar och rum i Uppsala universitetsbibliotek under 1600-talet', in M. Cronqvist etc. (eds.), *Återkopplingar* (Lund: Mediehistoriskt arkiv, 2014), pp. 309–327.
7 For a discussion of early modern epistemological conflicts, see Tamás Demeter, 'Values, norms and ideologies in early modern inquiry. An introduction', in T. Demeter etc. (eds.), *Conflicting values of inquiry. Ideologies of epistemology in early modern Europe* (Leiden: Brill, 2015), pp. 1–9.
8 In the seventeenth century theologians would rather have spoken of different confessions as religions, even though the word for this meaning of confession (*konfession*) existed in the Swedish language at the time.

but complain. Sometimes these complaints were directly connected to the spoils of knowledge kept in the library shelves.

Gustavus Adolphus took several measures to improve the conditions at Uppsala University, especially from 1617 onwards. Religious controversies were one of the driving forces in the improvements that were made, which the King could easily combine with his interest in controlling the Church, the educational system and public opinion in Sweden. Ideally, Uppsala University would serve as a Lutheran stronghold against Catholicism, especially against the Jesuit colleges of northeastern Europe that surrounded Sweden, of which Braunsberg was the most influential. Swedish students of modest backgrounds were attracted to the Jesuit schools as they offered free accommodation and up-to-date educational techniques and, not least, had rich and glorious libraries. In order to provide less well-off Swedish students with an education within the Kingdom's realm, and also provide the Crown with loyal officials, Gustavus Adolphus secured the university's financial maintenance through an endowment of several estates and their incomes. The King also established scholarships and new chairs, and last but not least, he donated books and ordered that a library be created. Moreover, in order to attract students and improve the university's reputation, many foreign professors were recruited, for instance the historian and lawyer Johannes Loccenius from Holstein, who returns shortly in a key eyewitness account discussed below.[9] Chancellor Axel Oxenstierna even sent his own sons to Uppsala for their studies; however, most young men of the Swedish nobility continued to travel abroad for their education, as a way to acquire the most exclusive credentials.[10] In 1613, Gustavus Adolphus endowed eight university chairs: two in Theology, one in Politics, History and Law, one in Medicine and Physics, one in Astronomy, one in Logic and Rhetoric, and one in Greek and Poetry. In 1620 the number of professors was increased to thirteen, four of them in theology. Theology was by far the dominant subject at the university in Gustavus Adolphus' day, and it was more or less mandatory that all students study this subject. The numbers of registered students per year grew significantly in the 1620s, from about 50 in 1619 to around 100 in 1621, to over 300 in 1625. The record of 302 newly registered students was not exceeded until 1677.[11]

9 Kurt Johannesson, 'Uppsala universitet och 1600-talets Europa', in S. Lundström (ed), *Gustav II Adolf och Uppsala universitet* (Uppsala: Uppsala universitet, 1982), pp. 20–23.
10 Ola Winberg, *Den statskloka resan. Adelns peregrinationer 1610–1680* (Uppsala: Uppsala universitet, 2018), pp. 20–21, 30.
11 Claes Annerstedt, *Upsala universitets historia. D. 1, 1477–1654* (Uppsala: Uppsala universitet, 1877), pp. 167, 187, 211, 242–243, 251–252.

Although the university was established in 1477, it had no library until the 1620s. This circumstance illuminates the fact that there were many obstacles, sometimes matters of priorities, which kept Swedish rulers from founding solid institutions of knowledge. When Gustavus Adolphus finally took action in this matter, the royal decree of 1620 that ordered the library's establishment was accompanied by the donation of books: volumes that had been confiscated from the libraries of dissolved monasteries, as well as contributions from older royal collections. In a short time, the King's initial donation was matched with the help of spoils. The collections of the Jesuit Colleges in Riga and Braunsberg, as well as books from the chapter library in Frauenburg, were confiscated and given to the university. In 1636, books from Würzburg and likely also Mainz were also added to the Uppsala collections.[12]

Nearly two decades later, English ambassador Bulstrode Whitelocke visited Uppsala. In his journal, he described the visit that he and the French envoy had made to the university library:

> They went together to the library of this university, where there are many good books, for the most part brought out of Germany; but it is not extraordinary, nor exceeding the public libraries in England, and elsewhere. One of Whitelocke's gentleman held it not exceeding his lord's private library at his own house in England, as he affirmed to some of the scholars here, who were not pleased therewith, nor would easily believe, that the English ambassador's library, in his private house, was to be compared to that of their university.[13]

With this brief and somewhat harsh judgement, Whitelocke showed how the Uppsala library could be experienced by a learned diplomat: the stock had mostly been abducted from the Holy Roman Empire and certainly contained many good books, but it was not good enough. To the ambassador, neither the quality of the books nor their number seems to have been especially impressive, which must have been an embarrassment to his Swedish hosts. Without saying whether Whitelocke's impression was right or wrong, there are two circumstances in his account that deserve further attention: that he saw the

12 Annerstedt, *Upsala universitetsbiblioteks*, pp. 9f, 13; Walde, *Storhetstidens I*, p. 168; Annelen Ottermann, 'Dionysius und Jacobus Campius als Buchbesitzer – eine Momentaufnahme (nicht nur) mit Blick auf die Mainzer Karmeliten', in C. Haug etc (eds.), *Buch – Bibliothek – Region. Wolfgang Schmitz zum 65. Geburtstag* (Wiesbaden: Harrassowitz Verlag, 2014), pp. 148–149, 152–160.

13 Whitelocke, *A journal*, p. 92. Whitelocke wrote of himself in the third person, which was not unusual at the time.

geographical origin of the books and that their significance as seized objects as the most noteworthy aspect of Uppsala University Library. Just as Ogier witnessed in the King's treasury at Tre Kronor in 1636, the plunders were certainly there for everyone to see; but what were the profound consequences of their presence?

In early modern Europe, radical scholarly and technological processes such as the printing revolution, the confessional development of the Protestant Reformation and the Counter-Reformation (or Catholic Reformation) and the emergence of modern science left their mark in European libraries. These drastic societal developments had an effect on the educated elite's understanding of knowledge as old *versus* new, which in turn had direct consequences on how libraries were arranged. If book collections had primarily been humanistic and historically oriented before 1600, they were now transformed in the midst of religious conflicts, by changes in the understanding of history and the progress of the so-called Scientific Revolution. This increased the demand for more current knowledge collections that would be up-to-date and useful. It also meant that librarians and other scholars were now forced to deal with objects of older knowledge that they perceived as outdated by comparison.[14] In the following I show how these essential epistemological changes took material and spatial forms through the inflow of spoils to Uppsala University Library: how the librarians understood the books as knowledge, confession and time.

When this chapter analyses the creation of Uppsala University Library through the spoils brought to the Swedish Empire from the scholarly Catholic settings in Riga, Braunsberg and Frauenburg, the focus is on how tactile practice reveals knowledge management and perception. But, I also target how the spoils, through their epistemological and material qualities, influenced the making of Uppsala University Library. At the centre of the present study are several lists of spoils, as well as the library's catalogues. What is interesting here is not trustworthiness of the lists or catalogues as technical bibliography, but rather what their subjective representations, to use the language of Giorgio Riello, say about the work process itself, when the objects were packed, organised and classified.[15] Lists, inventories and catalogues allow the researcher to understand how early modern things could be interpreted, depending on the prevailing spatial and epistemological circumstances at the time the objects

[14] See e.g. Luigi Balsamo, *Bibliography*, p. 5; Walsby, 'Book lists', pp. 2–4; Summit, *Memory's library*, pp. 2–8; Burke, *A social history*, pp. 38–44, 103–106; Zedelmaier, *Bibliotheca universalis*, pp. 9–21; Šamurin, *Geschichte*, pp. 135–139.

[15] Riello, 'Things seen', pp. 135–140.

were handled or displayed.[16] It was thus not only the collections' content and who worked with them that influenced how the objects were described, but also where and when this took place. I will, for instance, make visible how the inventorying and packing of spoils into chests and barrels at Tre Kronor Castle in Stockholm came to have far-reaching effects on the organisation of the collections at Uppsala University Library.

2 The Material, Geography and Confession of Library Spoils

In this section I examine the initial handling and classification of spoils as being of a certain material, provenance and confession, in inventory lists that were created before the booty was moved into the new building that came to house the university library in Uppsala. The first spoils donated to Uppsala University were the items confiscated from the Riga Jesuit College in 1621. Besides around a thousand books, the booty also included liturgical objects such as altar frontals, clergy robes and Russian Orthodox icons, along with objects of copper, tin, brass and wood; household items as well as scientific instruments. Everything was listed separately, likely as late as spring 1627 in Uppsala Cathedral.[17] Unfortunately, it is not certain where or when the list was made, or by whom. It is most likely, though, that it was one of the library inspectors who conducted this work in the cathedral, as the spoils were stored there for a number of years. One thing is certain, though: the fact that the Riga spoils contained various types of objects caused the books to be handled primarily as materials rather than with reference to the knowledge they held.

In the list of the Riga spoils, the books were noted according to the principle of largest first: that is, based on format, in descending order from folio to duodecimo. The titles were given in short form without incipit, the opening words in manuscripts and incunabula, or imprint, which means that there is no information on the year or place of publication for the most recent editions. The librarian did not distinguish between printed books and manuscripts, except

16 Bleichmar, 'Seeing the world', p. 20; Walsby takes a more traditional position in Walsby, 'Book lists', pp. 1–24 (see particularly p. 11). While Walsby makes a number of good source-critical points, it is primarily a matter of whether the information provided in the catalogue or inventory is true or false. Classification as an interpretation practice is not mentioned at all.

17 Walde, *Storhetstidens I*, p. 49; U271, UUB; a reminder to make an inventory of the Riga spoils was sent in 1627 from Johannes Bureus in Stockholm to the rector in Uppsala in connection with Bureus' inventorying of the spoils from Braunsberg and Frauenburg; see Johannes Bureus, 'Bureus' anteckningar', *Samlaren*, 4 (1883), p. 102.

in exceptional cases where he noted whether the volume was printed or handwritten on parchment. Except for the short title, the official paid little attention to the books' knowledge content as they were not classified according to subject. After the bound volumes, a special category was created for what was called 'unbound matter', after which came other types of things described according to their main material, such as brass, copper, lead or wood, collected under the headings 'household goods' and 'tin and brass'. This was a common way of handling things in the seventeenth century: the objects were classified based on their material and then arranged hierarchically, following systems that harken back to Aristotle's natural law.[18] Accordingly, the principle was that a precious metal like gold would come before an alloy like copper, that a book in a grand folio format would come before a smaller quarto. As the books came first in the Riga list this meant that the official, perhaps not surprisingly, saw them as the most valuable items among the spoils.

Some years later, in 1626, Stockholm saw the arrival of the spoils from Prussia, which consisted of books from the influential Jesuit College in Braunsberg and the chapter library in Frauenburg, where the famous astronomer Nicolaus Copernicus had once served. The inventory was made by royal librarian Johannes Bureus and at least one assistant. The well-educated Bureus, who had once been Gustavus Adolphus' teacher, is to this day known for his antiquarian, linguistic and mystical works.[19] The work with the inventory took place at Tre Kronor Castle from the fall of 1626 through February 1627, and in addition to the preserved lists the librarian briefly described the process in his diary-like notes.[20]

In the fall of 1626, Gustavus Adolphus returned from campaigning in Prussia. The day after his return, he met with Bureus in order to give him the assignment of registering the books from Braunsberg. The librarian began his work about a week later, but according to the notes he started with the collection from Frauenburg. Bureus apparently strove to keep the different collections apart, but ultimately combined them in a transcribed list as 'the books from Prussia'.[21] Thus, he alternately described the work as involving one and two

18 U271, UUB; cf. Riello, 'Things seen', p. 134. While Riello calls this approach to organising objects 'a German model', Camilla Mordhorst's linking to Aristotle also seems relevant in this context; see Mordhorst, *Genstandsfortaellinger*, pp. 85–86.
19 On Bureus' life and scholarship, see Håkan Håkansson, *Vid tidens ände. Om stormaktstidens vidunderliga drömvärld och en profet vid dess yttersta rand* (Göteborg: Makadam, 2014); Matthew Norris, *A pilgrimage to the past. Johannes Bureus and the rise of Swedish antiquarian scholarship 1600–1650* (Lund: Lunds universitet, 2016).
20 Bureus, 'Bureus' anteckningar'.
21 Bureus, 'Bureus' anteckningar', pp. 102, 104–105.

collections, which illustrates the tension between compiling an impressive unified collection and maintaining two prestigious geographical provenances linked to the books. Although provenance is a modern concept, David Pearson has emphasised that interest in previous ownership of books can be noted as far back in history as the Middle Ages.[22] What the objects from Riga and Prussia illustrate, together with the Mitau files, is that previous ownership does not necessarily need to be primarily associated with a prominent individual or an institution, but can instead be associated with geographical origin. Hence, geographical origin contributes to creating the object's character and value, and that which can distinguish one book from another, both now and then.[23]

Bureus' work was ambivalent not only in regard to how he addressed origin; this is also visible in his way of handling the large number of objects. Together, the Braunsberg and Frauenburg collections contained far more books than what had been taken in Riga. A survey completed in Uppsala in 2007 found 2,300 books of Braunsberg provenance, which can be compared to the about 2,000 volumes enumerated in Bureus' list of both libraries.[24] The Frauenburg spoils likely consisted of fewer than a thousand books; they also included a number of archival documents the King and Chancellor had placed in the Kingdom's Archive, but Bureus neither mentioned nor inventoried these. The library collections in Uppsala have later, particularly from the end of the seventeenth century, been thinned out through duplicate auctions and other circumstances, which has naturally influenced all reconstructions done since.[25] There were undoubtedly many more spoils from Prussia than the books Bureus listed, which means that more books were sent to Uppsala than those that were recorded.

During the work at Tre Kronor, the books were spread out in different rooms of the castle. Through small notes in his lists, Bureus has provided examples of how books could temporarily leave the inventory and the chests. He had one bible at his home, for instance, while the King had seen another one lying in a particular chamber.[26] This meant that both King and librarian took note of and used individual volumes from the spoils during the work. Certain books are marked in the lists with a pointing hand (manicule), a common *nota bene*

22 David Pearson, *Provenance research in book history. A handbook* (London: British Library, 1994), p. 2.
23 Miles Ogborn & Charles W. J. Withers, 'Introduction. Book geography, book history', in M. Ogborn & C. Withers (eds.), *Geographies of the book* (London: Routledge, 2016), pp. 1–5.
24 Trypućko etc., *The catalogue*, p. 21; cf. the number given at the end of U272, UUB.
25 Walde, *Storhetstidens I*, pp. 81, 92, 97. According to Walde, the spoils from Frauenburg could not have contained more than 428 works.
26 U272, UUB, p. (3); cf. Cowen Orlin, 'Fictions', p. 71.

symbol used in the seventeenth century to indicate objects that were especially valuable.[27] To Gustavus Adolphus and his circle, collecting spoils thus not only entailed a systematic accumulation of large numbers; on the contrary, Bureus' work shows that he took the time to make individual volumes visible.

Bureus' lists of the Prussia spoils are full of descriptions of and judgements regarding the books' material conditions, qualities and characteristics. Consistently, he and his assistants took the time to note whether the Jesuits had made notes in a book, if a volume had lost its title page, if the beginning or end of a work was missing, if the binding had been lost, if the pages were torn, or if a volume had a distinct form or certain type of binding, for instance parchment or paper. In one case, he even noted that a book carried the seal of the Bishop of Warmia.[28] It was important to describe an object's geographical identity and its connection to an office, perhaps even a certain person. Bureus' conservationist interests are reminiscent of what Chancellor Oxenstierna expressed in his order from 1643: if the opportunity arose, the enemy's beautiful and valuable libraries were to be collected and conserved.[29]

Bureus' lists show how he balanced attention to the whole collection and the individually significant in his handling of the books. When he dealt with details and individual objects, it was not only a case of classifying knowledge content; it was about seeing and touching the object. As Daniela Bleichmar has observed, early modern collections demanded of the observer a certain vision, the ability to zoom in and out and thus alternate between the whole and the specific. The observer's gaze thus moved from the whole collection to groups of objects, to the possibility to take hold of one single thing, hold it close and experience its material and shape through touch.[30] The same kind of vision practice was demanded of the person who worked with making inventories of these collections. While some of the Braunsberg and Frauenburg books had once belonged to the famous scholar Copernicus, this was never mentioned by Bureus in the records he created.[31] The work of the controversial monk Lars Nilsson, however, Bureus did take notice of, described as '*Laurenti Nicolai Norvegij, Confessio de Via Domini*', with the Swedish addition 'Klosterlasses' in parentheses.[32]

27 U272 and U273, UUB; the *nota bene* symbol ('manicule') is analysed by William H. Sherman in *Used Books. Marking readers in Renaissance England* (Philadelphia: University of Pennsylvania Press 2009), pp. 29–45.
28 U273, p. (15).
29 Walde, *Storhetstidens I*, p. 344.
30 Bleichmar, 'Seeing the world', pp. 26–27.
31 Regarding the books owned and used by Copernicus, see https://www.ub.uu.se/finding-your-way-in-the-collections/selections-of-special-items-and-collections/copernicus-collection/, access 2 September 2021.
32 U273, UUB, p. (13).

Bureus worked with the two large collections during the years 1626–27, and as we have seen, they were difficult to manage. In Bureus' work with the collections at Tre Kronor in Stockholm, his first list, now filed as concept U272 in the archive at Uppsala University Library, shows how the books were moved around between various chests during the work process. The order in U272, largely matching what was later established in the transcript U273, seems to reflect how the books had been packed in Prussia. Sometimes a chest would be given a new letter label while its contents were left unchanged. This means that the books were mostly packed according to knowledge categories, to which Bureus assigned a label. It is more difficult, however, to say how mixed the Braunsberg and Frauenburg volumes were, both from the beginning and after the librarian had finished his task.

Within each category, Bureus noted the volumes hierarchically, in descending order from folio to duodecimo. His system began with a differentiated theology category, the content of which demonstrated the greatest possible care. When it came to handling the theological books, Bureus' classification practice matched the northern European Jesuits' epistemological regime. The Braunsberg College's own library catalogue was among the spoils, and was thus available to Bureus during his inventory work.[33] As the Braunsberg catalogue was not spatially anchored, however, it says nothing about how the books were arranged in the College's library. Therefore, it is possible that the packing order reflected in Bureus' concept U272 says more about how the College's book collection was arranged than the library catalogue.

According to Bureus' transcript U273, chest A contained bibles and concordances, chest B bible commentaries, and chest C gospels, postils and pericopes.[34] In chest D2, Bureus placed what he called 'Papal Church books' or books for the vestry; that is, missals, breviaries and similar liturgical books used in Catholic Mass. These books are not included in the Braunsberg College's catalogue, which suggests that they were confiscated by the Swedish soldiers in the sacristy.[35] Chest D1 contained dogmatically mixed catecheses and instructional texts, and chests E and F contained texts on the Church Fathers. After this came the contents of chests T, V, X, Y, Z and α. These were not classified by Bureus, and their books were not arranged according to their format. It was Bureus who wrote the headings 'placed books in chest T' and so on, but the

33 The catalogue was created in 1570 and revised in 1605; see U274, UUB.
34 Alphabetical order came to be very common in the centuries following the Reformation, and was considered to guarantee order. This has been interpreted as an effect of the spread of printing and of European scholars' search for new arrangement schemes; see Walsby, 'Book lists', pp. 2–3.
35 U274, UUB; some of them were likely of Frauenburg provenance, but it is nonetheless interesting that the College's catalogue completely lacks references to this type of book.

actual contents of the chests are listed in someone else's handwriting. There was a mix of books in these chests: chest T, for instance, contained works by Aristotle, Cicero and Virgil along with sermons, postils and indices of theological works. After the six unclassified chests, the inventory returns to an order in which the chests are assigned literary classes. Chests K and L contained history, chest M politics and chest N moral philosophy, with works by Aristotle, Philipp Melanchthon and Erasmus. Chests O and P contained law, Q poetry and R Greek writers and Greek grammar.[36]

While there are no chests G, H, I/J or S in the transcript they do appear in the draft, U272, which contains parts of various inventories and systems that were later combined. According to the draft, chest G contained texts on Church Fathers. The letter H is possibly written a couple of pages later (at the top right of p. [49] of the list), where theological literature is listed without subject specification. The pages after this, with the categories French, English and Italian books, likely corresponded to chest I/J.[37] Unfortunately, in both lists, chest S is conspicuous in its absence.

If transcript U273 was meant to be in alphabetical order, the six unclassified chests wound up in the wrong place in the list. It is possible that this happened later, as the inventory was not bound until the nineteenth century. Otto Walde was convinced that these chests actually belonged in another list, and that the books in chests T, V, X, Y, Z and α were not from the Braunsberg collection; they might, on the other hand, have come from Frauenburg. He came to this conclusion after having compared the chests' contents with the Braunsberg College's catalogue.[38] But if the pages in transcript U273 were bound correctly, and chests T, V, X, Y, Z and α primarily contain the spoils from Frauenburg, these books must have been considered so important that they were placed directly after the most important category in Bureus' hierarchical list, namely the theological literature. As the notes show that he was working with two collections, it is highly likely that the order in the transcript is correct.

The chests were finally sent from Stockholm to Uppsala in two batches: Bureus sent 29 chests of books from Braunsberg on May 22, and nine chests and three barrels on June 4. The latter are listed without their provenance, but likely consisted of most of the Frauenburg spoils.[39] In Uppsala, a total of 36 chests and three barrels were received; that is, two fewer chests than Bureus

36 U273, UUB.
37 U272, UUB.
38 Walde, *Storhetstidens I*, pp. 94–95; at least one volume in these chests was of Braunsberg provenance, however, and a number of the bibles presented first were from Frauenburg; see e.g. 33:60 and 37:21, UUB; C94a and C94b, västerländska medeltidshandskrifter, UUB.
39 Bureus, 'Bureus' anteckningar', p. 105.

had sent. They were placed in a depository along the Uppsala Fyris river to await the completion of the construction of the library's ground floor.[40] The circumstances can be turned every which way and still the facts do not add up, even though two inventories and accounts from Uppsala are remarkably informative. This discrepancy between the sources illustrates both the objects' instability and the lists' fictions.[41] The spoils from Braunsberg and Frauenburg were two demanding collections, whose heterogeneities required different approaches. In the work with the spoils from Riga it was foremost the collection's material qualities that were stressed, and the books emerged as one material among other materials. The source material is richer concerning the inventory of the spoils from Prussia which, paradoxically enough, shows that the documentation did not always add up. The collections were hard to handle, and keeping the books in storage, in chests and barrels, offered a way to maintain control. It might be that Bureus simply put off unpacking and classifying a number of chests until later, in order to keep some sort of order.

3 Parting of the Prussian Spoils

The story of the Prussian book spoils must also record the fact that parts of the booty ended up in other places besides Uppsala. Carl Gustaf Wrangel's library at Skokloster, the cathedral library in Strängnäs and the Royal Library in Stockholm, today's National Library, are a few examples of collections where the provenances of Braunsberg or Frauenburg are represented. Individual books had already been removed from the collections in Prussia, and this was done later in Stockholm as well. At the back of one of the inventory lists, Bureus has noted some volumes that were given to a number of officials. Gustavus Adolphus himself kept two polyglot bibles and a smaller bible in quarto format was given to his illegitimate son, 'Little *Gustavus*'.[42] Around 20 years later, Queen Christina and her librarian devoted particular attention to the collections from Braunsberg and Frauenburg. At the end of 1648, the Queen's librarian Johannes Freinshemius retrieved some 50 manuscripts from the library

40 E1, bibliotekets arkiv, UUB.
41 Nappi, 'Surface tension', p. 33; Cowen Orlin, 'Fictions', pp. 52–53.
42 Erik [Schroderus] received, among other things, a collection of Augustine's works and one of Machiavelli's; a Master Jacob received the collected works of Stanislaus Hosius; a Mister Nils received a work by Adam Sasbont and a collection of concordances in quarto format; a Mister Peder received one of Luther's Commentaries. See U272, UUB; notes on the King's and his son's parts of the spoils can be found *Biblia*, in both U272 and U273, UUB.

in Uppsala and sent them back to Tre Kronor in Stockholm, where they were placed in the Queen's manuscript collection. The university library was given a number of printed volumes in exchange.[43] The Queen, or her librarian selected a number of manuscripts, which primarily seem to have been taken from the chapter library in Frauenburg.[44] This is yet another circumstance that demonstrates that the Frauenburg spoils were interpreted as being especially valuable. According to Walde, the chapter library's collection was famous for its scientific literature, but Swedish library researchers seem to have exaggerated its size; the evidence suggests that the collection was not expanded through new acquisitions after the mid-sixteenth century. It is possible that the spoils were selectively chosen in 1626, when Gustavus Adolphus ordered that the Frauenburg Cathedral's books be confiscated. In such case, the person who effected the confiscation was likely one of the court chaplains, an educated servant, who then must have made the selection.[45]

When Christina left the Swedish Empire after her abdication in June 1654, she took with her large parts of all the collections at Tre Kronor. The selection of manuscripts was made by Isaac Vossius, her librarian at the time. Through Vossius, some of the manuscripts from Prussia ended up in Leiden, as he had been allowed to choose these as payment for his services. Other manuscripts accompanied Christina to Rome, and after the Queen's death in 1689 ended up in *Bibliotheca apostolica vaticana*.[46] Some of the manuscripts Freinshemius had retrieved in 1648 were still in Stockholm and were thus lost in the castle fire of 1697, while others can be found in the collections to this day.[47]

The Prussian manuscripts that were retrieved in Uppsala illustrate how these desirable rarities could be ascribed several meanings, and how these meanings gave rise to the objects' circulation. They were undoubtedly important, in both the university library and Christina's collection, due to their geographical origins. The books' origins linked them to a certain place, a particular library and sometimes even a specific office or person.[48] For Christina and her librarians,

43 The manuscripts are listed at the back of catalogue K3, bibliotekets arkiv, UUB; see also Nilsson Nylander, *The mild boredom*, pp. 100–101; Walde, *Storhetstidens I*, p. 101.
44 It is possible to compare the contents of chests T-α (see discussion below) in Bureus' list U273 with Freinshemius' receipt in catalogue K3 but, as only short titles are given, any results must be regarded as speculative.
45 Walde, *Storhetstidens I*, pp. 19, 72–74, 96–99.
46 Nilsson Nylander, *The mild boredom*, pp. 147, 152, 154.
47 According to my investigations, at least A213, B682 and X84, Kungliga biblioteket, correspond to manuscripts listed by Freinshemius as nrs. (15), (5) and (3); cf. list at the back of K3, bibliotekets arkiv, UUB.
48 Nilsson Nylander, with help from Lisa Jardine's study of the Medici family's books, has analysed Queen Christina's collection of manuscripts based on a number of categories.

however, the manuscripts seem to have primarily entailed a particular type of object: according to her own wishes, or perhaps due to her librarians' interests, the Queen collected manuscripts especially. Her collection contained several different versions of important works, and she used her manuscripts differently from how she used printed books. She made notes in the printed texts, but never in the manuscripts. Her librarians also did not mix the manuscripts with printed matter in the catalogues; there, the manuscripts comprised their own material category with no further subject classification. This was also the first category in the catalogue that was made of Christina's book collection in Stockholm. The manuscripts were thus the superior category in the Queen's collections.[49]

On its way to Rome, Queen Christina's book collection was stored in Antwerp during the period 1654–1656. Around the new year 1654–1655 the Queen's entire book collection, both printed books and manuscripts, was unpacked from its chests and exhibited in the gallery of the stock exchange building in Antwerp; the gallery had been made available exclusively for this. In the years that her books remained in Antwerp, they were available to scholars. Among others, many Jesuits visited the famous collection in order to copy certain hagiographic manuscripts.[50] During the Antwerp period, Isaac Vossius again made a list of the Queen's manuscripts, where he described which were in each chest (theology, history, etc.).[51] Shortly thereafter, in 1656, this packing list was given a number of addenda by an unknown librarian who had succeeded Vossius. In many cases, this anonymous librarian took the time to note manuscripts' geographical origin, along with information about their material properties such as the colour of the binding, whether the pages were of paper or parchment, their form or format. Vossius had bought two larger collections of manuscripts for Christina before her abdication. The smaller of the two consisted of 370 manuscripts from her physician Pierre Michon Bourdelot, and the larger over 2,000 manuscripts from Parisian collectors Paul and Alexandre Petau.[52] The latter collection was not mixed with the other manuscripts, but was instead

One of these categories involves objects that established genealogical connections to known collectors; see Nilsson Nylander, *The mild boredom*, pp. 120–121.

49 Nilsson Nylander, *The mild boredom*, pp. 51–52, 96, 98, 163, 177. An exception, however, is the cataloguing of the Petau manuscripts, which Vossius classified in Antwerp in 1655; see Vat. Lat. 8171, index on leaf 404, Biblioteca Apostolica Vaticana, (BAV).

50 Christian Callmer, *Königin Christina, ihre Bibliothekare und ihre Handschriften. Beiträge zur europäischen Bibliotheksgeschichte* (Stockholm: Kungliga biblioteket, 1977), pp. 178–179.

51 Vat. Lat. 8171, BAV.

52 Nilsson Nylander, *The mild boredom*, pp. 54–56, 59.

listed separately by Vossius in Antwerp, even though the Queen had bought the Petau manuscripts as early as 1650. The anonymous librarian also noted among the other manuscripts which had belonged to Bourdelot. Manuscripts from Frauenburg were also noted in a number of places in the catalogue, along with other spoils from the Dietrichstein collection in Nikolsburg (Mikulov).[53] Then, the same librarian noted among the manuscripts when an object did not come from the Petau collection, with the description *non Petanvianum*, marking these with a cross and giving each object an individual number.[54]

Why was it important for Christina's librarian to add information on the books' geographical origins and previous owners and thus give them a history? The answer is that the manuscripts' geographical and genealogical links were important as they gave the objects a lineage. Having historical knowledge about them increased their status as rarities, both to the person handling the collection and to the person observing and consulting it. Accordingly, the librarians who worked with Christina's manuscripts emphasised their material, geographical and genealogical properties that made them desirable.

4 Library Materialisations

Uppsala University Library's collections, like that of the National Archives, suffered losses at various times over the course of nearly 400 years of library history. The building that housed the collection between 1627 and 1691, which I mainly focus on here, is known to us only through a preserved floor plan from the late seventeenth century.[55] This was the so-called older library building, whose rooms will shortly become very familiar here. Richer material is found in the inventory lists and catalogues, where the library's collections and sometimes their placement in the room have been fixed at a specific time. These sources make it possible to understand how the library was materialised. The road to the first catalogues, however, was lined with a number of practical problems. Thus, before I step into the old Uppsala library, I draw attention to the practical issues that preceded it.

Gustavus Adolphus' foundation donation in 1620 consisted of books from dissolved monasteries, as well as parts of the book collections of the Vasa

53 Vat. Lat: 8171, bl. 151, 154, 160, BAV; cf. Callmer, *Königin Christina*, p. 180; Walde, *Storhetstidens II*, pp. 247–305.
54 See e.g. Ottob. Lat. 1429, Ottob. Lat. 638 and Reg. Lat. 941, BAV; Nilsson Nylander, *The mild boredom*, pp. 70–71.
55 U65, bibliotekets arkiv, UUB.

Kings John III, Sigismund and Charles IX. It is likely that the confiscated books of the executed privy council Hogenskild Bielke were also included in the donation.[56] In total, the King's gift contained around 4,450 volumes. Before the King donated the collections to Uppsala University, everything had been stored at a dissolved monastery on the island of Gråmunkeholmen (today Riddarholmen) in Stockholm.[57]

As a direct consequence of the arrival of the Riga spoils arrival in Uppsala in 1622, the work of renovating a building for the library began.[58] The building, located northeast of the cathedral, would house the old library until 1691 and would later be completely remade around the mid-eighteenth century (see figure 12 on page 199). Before the building was finished, the library's collections were stored in Uppsala Cathedral's southern choir, which already housed a smaller book collection belonging to the cathedral.[59] There are few sources that offer information on how the library in the cathedral might have functioned, how it was organised or who had access. The spoils likely lay in their chests and barrels, some of which might have been locked. During these first years, no common inventory was made that combined the different collections and provided an overview of them. At the same time, a number of decisions were made in the academic consistory (the university's executive council) regarding the creation of a more organised and accessible library.

Claes Annerstedt has highlighted three people who he claims served as librarians from 1621 to 1627. In 1626, the consistory instituted a sort of mobile library inspection position, to be held by one of the consistory's members. The first time, two officials were appointed as *Inspectores Bibliothecae* in order to share the burden, and the intention was that the task would eventually be shouldered by each of the faculty's professors. There were thus officials who were responsible for the library's inspection, but no librarian who had the care of the collections as his main task.[60] As early as 1626, University Chancellor Johan Skytte ordered that students were to have access to the library, at the

56 The Bielke collection has been reconstructed; see Wolfgang Undorf, *Hogenskild Bielke's library. A catalogue of the famous 16th-century Swedish private collection* (Uppsala: Uppsala Universitet, 1995), p. 13.
57 Åke Davidsson, 'Gustav II Adolfs bokgåvor till akademien i Uppsala', in S. Lundström (ed.), *Gustav II Adolf och Uppsala universitet* (Uppsala: Uppsala Universitet, 1982), pp. 93–94.
58 E1, bibliotekets arkiv, UUB.
59 Hornwall, 'Uppsala universitetsbiblioteks resurser', p. 66; Annerstedt, *Upsala universitetsbiblioteks*, p. 10.
60 Hornwall, 'Uppsala universitetsbiblioteks resurser', p. 69.

same time as he required that the library's construction be completed.[61] Thus, the library, somewhat contradictorily, was both the collections in the church and a building that was not yet completely built. Despite this order, however, the book collections were not especially accessible in practice, particularly to students.

The consistory's understanding that the library collections needed to be supervised reflects historical changes in library management. From the sixteenth century onwards the role of librarian was increasingly professionalised, from being more of an art to an actual occupation. As a consequence of this, at the beginning of the seventeenth century a number of influential library manuals were published. Catalogues of both public and private library collections were published and, just like the manuals, came to form a literary genre of their own.[62] The most well known of these handbooks is without a doubt Gabriel Naudé's *Advis pour dresser une bibliothèque* (1627): that is, advice for the establishment of a library. Naudé served as Queen Christina's librarian for a short time, and his manual is further discussed in the analysis of Carl Gustaf Wrangel's Skokloster library. Naudé insisted that a library that lacked order did not even deserve to be called a library.[63] Two early examples of published library catalogues are *Nomenclator* from the university library at Leiden, published in 1595, and the catalogues of the Bodleian Library at Oxford, printed in 1605 and 1620.[64] The members of the consistory discussed the possibility of traveling to universities in the Holy Roman Empire in 1631, primarily to Wittenberg, in order to acquire knowledge from the academy and its library.[65] This shows how knowledge about the conditions on the continent could be spread through both printed manuals and actual visits to and experiences of collections (even though this particular trip does not seem to have been made in the end). The university library's first existence in Uppsala Cathedral, along with the decisions of the consistory, demonstrate where the consistory's handling of the collections stood in relation to changes in the world around them as well as in the world of libraries.

61 Hans Sallander (ed.), *Akademiska konsistoriets protokoll*, 1, 1624–1636 (Uppsala: Uppsala Universitet, 1968), 16.
62 Nilsson Nylander, *The mild boredom*, pp. 81–82.
63 Archie Taylor (ed.), *Advice on establishing a library* (Berkeley: University of California press, 1950), p. 63.
64 Kasper van Ommen, 'Legacy of Scaliger in the Leiden University catalogues', in M. Walsby & N. Constantinidou (eds.), *Documenting the early modern book world. Inventories and catalogues in manuscript and print* (Leiden: Brill, 2013), p. 65; Paul Nelles, 'The uses of orthodoxy and Jacobean erudition. Thomas James and the Bodleian library', in M. Feingold (ed.), *History of universities*, 12 (2007), p. 23.
65 *Akademiska konsistoriets protokoll*, 1. 151–152.

The work on the library building continued, and the Riga spoils and the King's donation from 1620 took their place on the building's upper floor, which was finished first, in May 1627. Even objects that were not books were placed in the library building. Hungarian tablecloths, Russian Orthodox icons, clergy robes and altar frontals, along with bowls, trays, candlesticks and wooden astronomical instruments, were initially part of the library's collections but would successively disappear from the building. When the consistory discussed an ongoing inventory of the collections in the fall of 1631 most of the items had been registered, except the books that were on the ground floor 'as well as brass, copper and other such things'.[66] But when the Riga objects were addressed in the consistory as late as 1682, it appears that many of them had been lost. They might have been given to various churches in Uppsala.[67] The fact that they were sought as late as 1682 suggests that there was knowledge of them, that they had been missed, and that they were still considered of interest to the library. If the liturgical Riga objects had indeed been given to churches, this returned them to a sacral context that was more like their residence before their abduction. There are many other examples from the same time of how sacral spoils were placed and thus reused in the churches of the Swedish Empire, in Uppsala and Stockholm as well as at Skokloster.[68]

When the chests and barrels of books from Braunsberg and Frauenburg arrived in Uppsala in June 1627 they were placed in a depository along the river. After the work on the library building's ground floor was finished, the Prussian spoils were carried into the library.[69] Thus, before the first library catalogues were made at the end of the 1630s, the collections were organised on the premises according to a type of accession order, which highlighted their geographical origin. The books and other objects would remain placed in this way for around ten years. This meant that the history of the spoils was stressed in the new library building as well, just as it had played a role in Bureus' work with the Prussian collections at Tre Kronor. Unlike Bureus, though, the responsible

66 According to the protocol, the uncatalogued books were placed *in transcusu funde*, or 'in the passageway of the bottom' (English translation based on my Swedish translation), *Akademiska konsistoriets protokoll*, 1. 174.

67 Cf. U271, UUB, with K6, bibliotekets arkiv, UUB; Hans Sallander (ed.), *Akademiska konsistoriets protokoll*, 15. 1682 (Uppsala: Uppsala Universitet, 1975), 239; cf. Annerstedt, *Upsala universitetsbiblioteks*, pp. 55f; Rudbeck's statement about the objects as cited by Annerstedt does not appear in the printed protocol.

68 Regner, 'Ur Historiska', p. 49; Rangström, *Krigsbyten*, p. 15, cf. Whitelocke, who wrote that Uppsala Cathedral was full of crucifixes and images and therefore did not differ greatly from the Catholic churches, Whitelocke, *A journal*, p. 94.

69 E1, bibliotekets arkiv, UUB.

parties in Uppsala initially placed the books' epistemological qualities completely on the sidelines.

But a library order based on geographical origin was not enough. Bureus was in Uppsala at least twice to arrange the library, first in November 1627 and again in March 1628. But this was a job he would not be able to complete: in May of the same year, through University Chancellor Johan Skytte, the King commanded that 'the library [...] without neglect be arranged and registered', and as Bureus had been given other duties the librarian was to carry out this work.[70] This task was not completed in the decade that followed, probably because the library did not have a librarian who could exclusively devote his time to it. Instead, members of the consistory were assigned with running the library alongside their work as professors. During this period, on several occasions the consistory discussed the need for a specific librarian with the main task of caring for the collections, and keeping a good catalogue of them was one of the key tasks this librarian would be responsible for. Professors who were responsible for the library between 1627 and 1638 cited a lack of time and low pay as their defence when the question of the unfinished inventory came up on the agenda.[71]

The library collections were doubtless seen as a burden, and the work with them was explicitly described as a bother by librarian Sven Jonae.[72] However, the prevailing disorder did not keep the professors from taking books from the library building. On a number of occasions, the librarians claimed that the professors' loans from the collections were an obstacle to the inventory work.[73] Just like in Stockholm, it was hard to keep the collections within the four walls of the library building. Gustavus Adolphus' demand in 1628 for a register highlights that the collections belonged to the Crown.[74] That the collections necessarily must be arranged, that is, placed and organised in the building's various rooms, in order for it to fully be a library, is made apparent through the recurring commands in this regard over the many years the Crown had to wait for this to be done. In 1631, the librarian was yet again asked if the register was finished so that 'the books' usage' could be enjoyed.[75] A functioning library was thus dependent on spatial orderings: the collections had to be organised in order to be enjoyed, that is, to be read, touched and viewed in

70 Johan Skytte to the university consistory, 16 May 1628, kansliets arkiv, E1b:1, UUB.
71 *Akademiska konsistoriets protokoll*, 1. 76, 140, 153–154, 157, 174.
72 *Akademiska konsistoriets protokoll*, 1. 168.
73 *Akademiska konsistoriets protokoll*, 1. 79, 174.
74 In seventeenth-century sources the university library is sometimes called the 'royal library'; see donation book A3, bibliotekets arkiv, UUB, p. 365.
75 *Akademiska konsistoriets protokoll*, 1. 76, 140, 174.

the best possible way.[76] The more spoils that arrived at the library the more urgent it became to create order, at the same time as it grew more difficult to get an overview and maintain control due to the collections' constant growth. Without a catalogue, the collections' materiality overshadowed the library's knowledge contents and utilisation.[77]

5 Ordering the Collections

In 1682 the consistory sought a new deputy librarian, preferably an experienced official who would remain in the position for a longer period. The professors reasoned that it would take three to four years for the vice librarian to 'know all the books and their matter, and their space'.[78] This was how comprehensive and challenging the collections were considered to be towards the end of the seventeenth century. At the turn of the century to 1700, they contained around 30,000 printed volumes and some thousand manuscripts.[79] Besides the spoils added in the 1620s and 1630s, around 2,000 volumes had been acquired through purchases during this period; private donations had also come to the library from the Privy Council and University Chancellor Magnus Gabriel De la Gardie, among others.[80]

When the collections taken from Riga, Braunsberg and Frauenburg were listed separately, the objects' meanings as material as well as their geographical and epistemological qualities had been stressed in different ways. Through various collection practices from 1638 and onwards, the collections of different geographical origins were mixed and the totality was thus transformed into something else. The geographical provenances were successively erased as their various epistemological values were instead stressed in descriptions of the books. This was especially the case in the librarians' encounters with the confessional books. By extension, the library in Uppsala demonstrates how religious polemic could take on a material form through the librarians' handling of the plundered books. How were the spoils interpreted when they were

76 Helmut Zedelmaier has stressed the relation between the possibilities of knowledge production and a well-ordered library; see Zedelmaier, *Bibliotheca universalis*, p. 225.
77 To link to Cornelia Vismann's argument, mentioned in chapter 2, regarding collections of archive documents, in Vismann, *Files*, p. xi.
78 *Akademiska konsistoriets protokoll*, 15. 139.
79 Annerstedt's counts. He asserts that the manuscripts were greatly reduced over the centuries, but it is difficult to know exactly how many were sold or otherwise lost during the seventeenth century; see Annerstedt, *Upsala universitetsbiblioteks*, pp. 29–30, 56–57.
80 Hornwall, 'Uppsala universitetsbiblioteks resurser', p. 69.

yet again classified and began to be mixed with other books, and their geographical origin ceased to be their primary quality? In the following, I investigate how the spoils' confessional properties influenced the university library's organisation.

The university's first full-time librarian, Laurentius Tolfstadius, assumed this position in 1638. Tolfstadius worked with arranging and listing the collections for just under two years, which resulted in the catalogues K2 (for the lower library) and K3 (for the upper library), signed in 1641 by the librarian who succeeded him.[81] These catalogues, designed to be systematic, spatial lists of the books, thus illustrate the relation between the book collections and the rooms, which was a common approach at the time. Classification catalogues without spatial anchoring grew increasingly more common during the eighteenth century.[82] The spatial anchoring of K2 and K3 thus offers valuable insight into how the older university library took on its epistemological-material forms. Moreover, Tolfstadius' work came to occupy a special position in relation to later lists and catalogues of the old library. His catalogues included the entire library, that is, the orderings in all the rooms on both floors, whereas the later catalogues only included certain sections.[83] But despite of his efforts, just like Bureus' lists they are incomplete, for instance failing to mention the library's other object collections such as the liturgical objects and household items from Riga and instead only including manuscripts and printed books of various types. Drawing mainly on Tolfstadius' K2 and K3 catalogues, then, the following will closely examine the variety in orderings in the catalogues and rooms.

A drawing from the end of the seventeenth century gives an idea of how the rooms in the library took shape, and helps us to understand the library's spatial conditions (see figure 13 on page 200).[84] The drawing shows one of the building's façades at the bottom of the image, with the entrance to the lower library. Above the facade drawing are the floor plans of the two floors, with the room layout of the lower library shown at the top of the image. It shows three rooms and a vestibule, an arrangement that resembles what is known through other sources of the first library building's layout. The upper library had the same layout as the lower one but without a vestibule, which made its middle room larger. Meanwhile, the drawing shows what the upper library looked like, or was intended to look like, after the library collections had moved out

81 K2 and K3, bibliotekets arkiv, UUB.
82 Gert Hornwall, 'Uppsala universitetsbiblioteks äldsta uppställnings- och klassifikationssystem', *Nordisk tidskrift för bok- och biblioteksväsen* 56 (1969), p. 182; Clark, On the 'bureaucratic plots', p. 193.
83 Hornwall, 'Uppsala universitetsbiblioteks äldsta', pp. 196–200.
84 U65, bibliotekets arkiv, UUB.

in 1691 when the university consistory moved in. The outer walls of the upper library were half as thick as those of the lower library. The windows were also larger and the ceiling higher, which made the upper library more spacious. There does not seem to have been an internal stairway between the floors; the two libraries were accessed from the outside, from two different sides of the building. Visitors reached the lower library from what is today Akademigatan, and the upper library from Uppsala Cathedral's cemetery.[85] The three rooms on each floor were called the first, middle and inner rooms. Tolfstadius also denoted each room with a lower-case Greek or an upper-case Latin letter. In the lower library the letter for the first room was α, the middle room ß and the inner room γ. The upper library's first room was labelled with A, the middle room B and the inner room C.[86]

The arrangement in the first room of the lower library will be discussed in particular detail, as the conditions there allow me to draw general conclusions about the collections' spatial organisation. Room α was the one that contained the most different sections; this is where legal manuscripts were placed, along with incunabula and older printed books on the same topic, in folio and large quarto formats. Then came the theological literature: bible commentaries in folio format, followed by what Tolfstadius called Catholic bible commentaries in quarto to duodecimo, Catholic controversial theology in folio to duodecimo, dogmatics in octavo to sextodecimo, speeches and sermons in folio to quarto, dogmatics of the Jesuit Order in folio to quarto, sermons in octavo and scholastics in folio to octavo. The listing of the room in the catalogue is concluded with a postscript and an added category, where Tolfstadius showed how he had sorted in remaining theological literature (or perhaps later arrivals) on the various shelves αI–XIII.[87]

In previous analysis of the library's organisation, library historians have looked for a cohesive system. Tolfstadius' orderings, however, were not always consistent. The arrangement in room α varied in a number of ways. He used only certain epistemological descriptions, such as dogmatics and meditation books, for books in smaller formats. Other descriptions, like speeches and sermons, were used exclusively for books in folio and quarto formats. Thus, all categories did not contain books in all formats. As a whole, room α mostly contained books Tolfstadius had classified as Catholic. Furthermore, he repeatedly

85 Ernst Areen, *Uppsala universitetsbiblioteks byggnadshistoria* (Uppsala: Almkvist & Wiksell, 1925), pp. 3–5; Hornwall, 'Uppsala universitetsbiblioteks resurser', p. 66.
86 K2 and K3, bibliotekets arkiv, UUB; cf. Hornwall, 'Uppsala universitetsbiblioteks äldsta', pp. 185, who overlooked the rooms' letter labels.
87 K2, bibliotekets arkiv, UUB.

broke with the expected hierarchical format order, descending from folio to sextodecimo, which was the practice throughout the library.[88] Among the manuscripts in room ß, for example, folio and quarto formats were repeatedly placed on the shelves together.

In the beginning, the library's rooms were fitted with bookshelves along the walls. Later, more shelves were added on the floor space, and a table and chairs were placed in each room.[89] The lack of bookshelves was a problem that was discussed in the consistory on multiple occasions, and was considered to be an obstacle to making an inventory of the collections.[90] In similar Baroque libraries, the use and design of the bookshelves was neither self-evident nor simple. This is clear in Jesuit and librarian Claude Clement's handbook, *Musei sive bibliothecæ* (1635). Clement dedicated more than half of the book to bookcases, their construction and the best way to decorate them: he considered them to be so important to the library that he allowed them to take up around 300 pages of his manual. In Clement's world, the library was a place where knowledge was put on display, which overshadowed all other functions and meanings books could have in a library.[91] While the bookshelves in Uppsala University Library were not given the same attention as Clement gave his, their existence or lack thereof was nonetheless important and influenced the collections there. The shelves made the collections available by allowing a visual and organisational overview of them.

Room ß, the middle room, primarily contained manuscripts, which Tolfstadius listed without subject headings. These were exclusively theological books, such as sermons and various types of theological collective manuscripts along with missals, graduals and similar liturgical printed books. In his lists, Johannes Bureus had called this last type of book 'Sacristae Libri', or 'Papal Church books'.[92] Using Latin, he linked these books to a special place in the church used to store liturgical objects, the sacristy, and, using Swedish, he linked them to the papacy. Meanwhile, the liturgical books did not have

88 This applies to K2 and K3 in their entirety, and was likely an effect of the bookshelves' design; thus, Gert Hornwall was wrong when he wrote that 'The arrangement was systematic, and within each section the books were arranged based on format, starting with folio'; see Hornwall, 'Uppsala universitetsbiblioteks äldsta', p. 182.

89 Hornwall, 'Uppsala universitetsbiblioteks resurser', p. 67; My interpretation is that the decision regarding the table and chairs applied to both libraries; see Hans Sallander (ed.), *Akademiska konsistoriets protokoll*, 3, 1641–1649 (Uppsala: Uppsala Universitet, 1969), 137.

90 *Akademiska konsistoriets protokoll*, 1. 76, 168; Hans Sallander (ed.), *Akademiska konsistoriets protokoll*, 2, 1637–1640. (Uppsala: Uppsala Universitet, 1969), p. 218.

91 Balsamo, *Bibliography*, p. 69; cf. Samuel Quiccheberg, who dedicated an entire chapter of his museum manual to storage furniture, Quiccheberg, *The first treatise*, p. 89.

92 U273, UUB.

the same instrumental meaning in the university library as they had had at the Jesuit colleges or in the sacristy; Bureus' categorisation described their spatial, religious and political properties. Tolfstadius' handling of the books in room ß was based particularly on their specific material qualities: they were manuscripts. This gave them their own space in the library building, without an explicit subject classification.

Room ß also contained a smaller number of volumes with direct links to the Jesuit Order, as well as books written in German, Polish and Italian. The inner room, γ, contained Calvinist theology, as well as legal literature, among which manuscripts and printed books were mixed. As the manuscripts and printed books arranged in the lower library were often classified as Catholic, Calvinist and Jesuit books, it is easy to imagine that it only contained spoils. This was not the case, though; in Tolfstadius' catalogue it is possible to identify several volumes from the confiscated Swedish monastery libraries.[93] This is a clear example of how confiscated objects with different geographical origins were united through the librarian's classifications.

The upper library's arrangement was listed in catalogue K3, which began with room A, containing theological literature. On shelf A1 bibles came first, followed by the Church Fathers, theology and ecclesial history and finally legal literature. The broad category of theology contained all the Lutheran theological literature in the library's collections, but also included other works that Tolfstadius could just as well have classified as Catholic or Calvinist. Examples of these include famous Catholic theologians such as Roberto Bellarmino and Jacob Gretser.[94] This section was doctrinally mixed, which raises questions as to Tolfstadius' intentions concerning the difference between the specifically designated Catholic and Calvinist books in the lower library and those in the theology section of the upper library, as they could in principle contain the same type of knowledge.

The next rooms held secular books: the middle room, B, contained books on medicine, mathematics and secular history, while inner room C was dedicated

93 It is possible to trace Swedish monastic manuscripts by comparing the catalogue of Western Medieval manuscripts (see Margarete Andersson-Schmitt & Monica Hedlund, *Mittelalterliche Handschriften der Universitätsbibliothek Uppsala. Katalog über die C-Sammlung, Band 1, C I–IV, 1–50* (Uppsala: Almqvist & Wiksell, 1988)), with Tolfstadius' short titles in K2, bibliotekets arkiv, UUB. As regards commonly occurring titles, it is not possible to confirm the object's provenance. Instead, though, different alternatives can be offered. Examples include C11, which according to K2 was likely placed on shelf β1; C9 (*Sermones varii de sanctis*), according to K2 a title found on shelves β2 and β4; and C16, according to K2 placed on β3.

94 Hornwall, 'Uppsala universitetsbiblioteks äldsta', p. 186.

to rhetoric, lexicons and reference books as well as philology, poetry and grammar. Manuscripts could also be found here and there in the upper library, but these were not classified according to their material properties. They also did not have their own separate space, as was the case in the lower library's room ß. In the upper library the manuscripts were always placed among printed books, which was the dominant media form there. Among the bibles in room A, for example, he noted two volumes which he described as a bible on parchment in two bindings. He also made a note of the year, 1436, and the fact that it emanated from Frauenburg.[95] Here again, the significance of geographical origin in the collection is actualised, now linked to a single object instead of an entire collection. The consistory's protocol from 1639 provides two more examples of the importance of geography to the officials' work with the collections. The first case involved a student who, through a colonel, had come across two books from the library of the diocese of Würzburg. The books had been traded in to the library, but their titles were never mentioned. The other case also involved a book from Würzburg, which the consistory had bought for the collections as 'it is good that this [copy] joins the others'.[96] Thus, at the same time as Tolfstadius was classifying the books according to various epistemological categories the geographical identities remained important, even if they were not allowed to dictate the organisation of the collections as a whole.

The manuscripts Tolfstadius placed among the printed books in the upper library were inserted into a different context than the manuscripts in the lower library. As objects they had a different production history than the printed books, they were another type of medium and they typically had a longer history than the books. They contained knowledge and simultaneously belonged to history due to their age. In the seventeenth century, manuscripts began being presented as a category of their own in the library. It became more important to distinguish printed books from manuscripts than to classify manuscripts based on their knowledge content; Queen Christina's book collection is a good example of this.[97] For the Queen, the manuscripts were rarer objects

95 K3, bibliotekets arkiv, UUB p. (6). These were most likely the same volumes Bureus described as 'very thick with crude handwriting'; see U273 p. (1). This likely referred to C94a and C94b, Western Medieval manuscripts, UUB.
96 *Akademiska konsistoriets protokoll*, 2. 253, 265.
97 Nilsson Nylander, *The mild boredom*, pp. 86, 96; Clement, *Musei sive bibliothecæ*, pp. 370–373; Emma Hagström Molin, 'The materiality of war booty books. The case of Strängnäs cathedral library', in A. Källén (ed.), *Making cultural history. New perspectives on Western heritage* (Lund: Nordic Academic Press, 2013), p. 136. Cf. Walsby, who claims

than the printed books.[98] In Uppsala, Tolfstadius was unable to decide what to do. While the lower library had entire sections of manuscripts, in the upper library the same type of objects were classified based on their content and mixed with the printed books. Thus, in Uppsala, yet another library-historical change was expressed in Tolfstadius' ambivalent handling of the different media.

Besides the old manuscripts, Tolfstadius also described a number of volumes as *antiqua editio* (or *editionis*), 'old edition', in both the lower and upper libraries. By this he may have meant what today's book historians call incunabula; that is, early printed books from the period 1450–1500. But far from all incunabula are covered by this description by Tolfstadius. The term was limited to books with qualities that he for one reason or another regarded as ancient, as antique. In his spoils lists, Bureus had also shown a particular interest in the old. Above all Bureus' list of the Prussia spoils, U272, contains notes on bibles 'in monk script', referring to printed books dating from the fifteenth century up to 1533. The description monk script indicates another religious past and how the past was interpreted materially. It is unclear whether Bureus was referring to the entire object or just the text's graphic form.[99]

When it comes to the early modern lists of valuable objects, such as books, notes on age have typically been interpreted as something negative. Property was described as old or broken in order to assert its lack of economic value.[100] But when an antiquarian like Bureus took an interest in books' age, it might be more reasonable to understand the comments differently.[101] Again, it was a case of the official's ability to see the individual object and a group of objects within a larger context, but at the same time it is meaningful to relate this example to how the distinction between then and now, old and new, was

that distinguishing between printed books and manuscripts was uncommon at this time, Walsby, 'Book lists', p. 21.
98 Nilsson Nylander, *The mild boredom*, p. 177.
99 See e.g. Bureus' descriptions of bibles in Chest A, U272, UUB; shelves α1:33, α2:3 in K2 and A2:1–2, A2:40, A2:48, A3:15, A7:71 in K3, bibliotekets arkiv, UUB.
100 Cowen Orlin, 'Fictions', p. 72.
101 The antiquarian work of Bureus, among others, has been discussed by Widenberg, *Fäderneslandets antikviteter*, pp. 20–23; the collection of Catholic objects during the latter half of the seventeenth century has been discussed by Helena Wangefelt Ström, 'Heligt, hotfullt, historiskt. Kulturarvifieringen av det katolska i 1600-talets Sverige', *Lychnos. Årsbok för idé- och lärdomshistoria* (2011), pp. 29–53. It would be interesting to compare the collection practices at the university library with the antiquarians' work, as what was interpreted as old or Catholic there was subject to change. Such a comparison, however, is outside the scope of this work.

expressed during the Renaissance.[102] The seventeenth century saw the emergence of a tension between different ways of collecting and handling books. Jennifer Summit has studied how Medieval book collections were handled and thereby transformed in post-Reformation England, primarily stressing the process by which the objects went from being sacral to being historical sources. From serving as weapons of the Church, manuscripts and incunabula instead became part of the kingdom's history.[103] In comparison, the example of Uppsala is more ambiguous, and Tolfstadius' catalogues highlight how manuscripts were treated and described in different ways. It is clear, however, that his work expressed a tension between new and old knowledge and matter, which became especially clear in the university library during the latter half of the seventeenth century.

6 The Effects of Spoils

In an essay on the history of the university library during the seventeenth century, Gert Hornwall observed that its subject classification largely corresponded to the faculties at the university, thereby identifying an order matching a faculty system that was typical of the time. The theological literature was an exception to this, however, and its differentiation can be traced to the library system of the northern European Jesuits. Here, Hornwall identified one of the most evident effects of spoils: that a Jesuit epistemological order was partly imitated by Tolfstadius in Uppsala. To aid him in his work he had not only the Stockholm order that Bureus had followed in packing the books, but also the Braunsberg College's library catalogue, which was part of the spoils.[104] While Uppsala is not the only library in the Swedish Empire where this type of effect can be identified, it is the first. Later, it is clear that the cathedral library in Strängnäs in many ways followed Jesuit Claude Clement's library manual.[105] Eva Nilsson Nylander has shown how Queen Christina's librarian had taken

102 Schiffman highlights that, during the Renaissance, the past was something that had been lost and that the Renaissance humanists sought to revive. See Schiffman, *The birth*, p. 147; see also Summit, who has analysed the handling of Medieval manuscripts as antiquities, Summit, *Memory's library*, e.g. pp. 105–108.
103 Summit, *Memory's library*, pp. 2–9.
104 Hornwall also sees connections to the library order at the Jesuit College in Posen, but this collection and its accompanying catalogue did not arrive at the university library until 1693, as part of Claes Rålamb's book collection in connection to Charles XI's reduction. See Hornwall, 'Uppsala universitetsbiblioteks äldsta', pp. 187, 189.
105 Hagström Molin, 'The materiality', pp. 135–136.

guidance from various catalogues that had accompanied the spoils in his work with the Queen's collections.[106] With this in mind it is interesting to examine whether, and when, Tolfstadius' system differed from a Jesuit epistemological system rather than merely highlighting the expected similarities.

The Braunsberg College's catalogue was based on 14 classes, within which the formats were mixed. First came religious canon such as bible texts and the Church Fathers (*Positivi et Patres*), followed by scholastics (*Scholastici*), sermons (*Sermocinarii*), controversial theology (*Controversiarum Scriptores*), law (*Juristae*), ecclesial history (*Historici Ecclesiastici*), Greek authors (*Greci Authores*), philosophy (*Philosophici*), rhetoric (*Oratores Latini*), secular history (*Historia prophani*), humanists (*Humaniorum literarum Scriptores*), poetry (*Poetae*), grammar (*Grammatici*) and Hebrew authors (*Hebraici Authores*), as well as two added categories for German and Polish books.

An important difference between the Braunsberg catalogue and Bureus' and Tolfstadius' orderings is that the Jesuit system was more inclusive, as Protestant books were not as clearly distinguished through specific categories.[107] Both Bureus and Tolfstadius were comparatively more polemic in their classification. Bureus made more confessional distinctions, similar to the Jesuit system, when describing the liturgical books as papal. Strangely enough, the liturgical books, missals, graduals and the like, were not included in the Braunsberg College's own catalogue. As mentioned, it is likely that the Swedish soldiers confiscated them in the sacristy. Bureus' classification and placement of them in their own chest, D2, is therefore not simply an indication that they were regarded as confessional; special imperatives were also considered when they were classified. Tolfstadius also created categories for what he regarded as specifically Catholic and Calvinist, as well as for books he directly associated with the Jesuit Order. At the same time as he was systematising confessional differences, he simultaneously included books of various confessions in the upper library's theology section.

Another contradictory effect the spoils had on the librarians' classification systems involves the description *loci communes*, which was used by both Bureus (*Catecheses, Loci Com[munes], Confessiones, Summae Examina*) and Tolfstadius for a section in the lower library (*Institutionum sive Locorum communium sciptores*). *Loci Communes* (1521) was the title of a key Protestant text authored by Philipp Melanchthon, regarded as the first dogmatic writing of

106 Nilsson Nylander, *The mild boredom*, pp. 88–98.
107 Cf. Findlen, *Possessing nature*, p. 78. Here, Findlen describes how Jesuit philosophers like Athanasius Kircher adapted antique encyclopaedic strategies to a Jesuit scientific culture. In this respect, his epistemological strategy was inclusive.

the Protestant Reformation. The concept of *loci communes*, however, had its roots in a Medieval Christian thought tradition and was a genre that came to be developed in different ways depending on confessional affiliation. Bureus placed confessionally mixed *loci* books in chest D2. His category was based largely on parts of *Posetivi et Patres* and *Controversiarum scriptores* from the Braunsberg catalogue. In Uppsala, Tolfstadius placed the Lutheran *loci* books in the confessionally mixed theology section in the upper library, while he placed the Catholic *loci* works in the lower library's section *Institutionum sive Locorum communium sciptores*.[108] Within Catholic theology the *loci* concept was developed differently, and in polemic against Protestant authors. In the latter half of the sixteenth century a large number of *loci* works were written in a Counter-Reformation (or Catholic Reformation) spirit, aligning with Medieval scholastics, particularly Thomas Aquinas. Tolfstadius undoubtedly used the *loci* concept in both the Lutheran and the Catholic way: as in the lower library, it described books that reflected the Catholic and polemic understanding of the concept. Thus, he had adapted what he knew as a Protestant concept to the knowledge contents of the spoils.[109]

Up to this point I have shown how two different orderings, one based on the university faculties and one reflecting Jesuit epistemology, were materialised in the university library. Gert Hornwall understood these two competing collection orderings to be natural: as the library contained so much theological literature from the Jesuit colleges, it was not remarkable that their epistemological system was used. He interpreted the upper and lower libraries' different theological sections as parts of a whole, describing them as 'two main sections'.[110] Unlike Gert Hornwall, however, I argue that the upper and lower libraries were arranged as, and could be shown as, two different libraries, and that taken together it is possible to identify three different orderings and collection narratives in the materialisations of the university library. The fact that the library floors had separate entrances and lacked an inner stairway generated clear spatial differentiation. For instance, in 1674, Florentine nobleman and diplomat Lorenzo Magalotti described the university library as 'not [...] particularly notable, *housed in three small rooms*'.[111] Magalotti was apparently only shown one of the libraries, and assumed this to be the entire collection.

108 See and cf. the discussed sections in U273 and U274, UUB as well as K2 and K3, bibliotekets arkiv, UUB.
109 Hornwall, 'Uppsala universitetsbiblioteks äldsta', pp. 191–192; Burke, *A social history*, p. 95.
110 Hornwall, 'Uppsala universitetsbiblioteks äldsta', p. 201.
111 Lorenzo Magalotti, *Sverige under år 1674* (Stockholm: Norstedt, 1986), p. 65. My italics.

Around 1670 the upper and lower libraries together held approximately 30,000 volumes, which undoubtedly was a significant number.[112]

According to Margareta Hornwall, the older library indeed consisted of two separate libraries, the lower serving as a depository for less valuable books and the upper serving as the actual library. But there is nothing that suggests that Tolfstadius reasoned in terms of distinguished and less valuable books as he arranged the library at the end of the 1630s.[113] I assert instead that, alongside the other orderings, he thought in terms of history and old books *versus* new knowledge and universality when he organised the collections. Most of the older matter was placed in the lower library: manuscripts and incunabula, along with what he referred to in the catalogue as Catholic and Calvinist. Thus, Tolfstadius classified books in the lower library according to a temporal order and not only based on their epistemological properties. Not only did these volumes have historical significance, they were history through the power of their materiality.

Besides Magalotti's testimony, other circumstances also suggest two libraries, of which the lower one was historical. The catalogue for the lower library, K2, was bound in a manuscript fragment taken from a Medieval missal. The catalogue for the upper library, K3, on the other hand, was given a simpler paper binding with a leather spine (see figure 14 on page 201).

The older Greek alphabet was used to label the rooms in the lower library, while the younger Latin alphabet was used for those in the upper library. And, last but not least, in a later catalogue dated around 1700, the librarian calls the lower library the 'ancient library'.[114] Bureus' descriptions of monk script in the lists of the collections from Prussia, as well as Tolfstadius' *antiqua editio* and his handling of the collections in Uppsala, show overall that the librarians' collection practices were not simply a matter of classifying knowledge content

112 Magalotti, *Sverige*, p. 124; these 30,000 volumes can be compared to the establishment of the British Museum just under a hundred years later. Sir Hans Sloane's donation comprised around 40,000 printed books and 7,000 manuscripts; Walsby has claimed that a few thousand books would have been a typical number during this period, even for larger institutions. See Walsby, 'Book lists', p. 1.

113 Hornwall, 'Uppsala universitetsbiblioteks resurser', p. 66; cf. Hornwall, 'Uppsala universitetsbiblioteks äldsta', p. 201. In 'Uppsala universitetsbiblioteks resurser' M. Hornwall refers to Johan Eenberg's description of the university library and its 'most distinguished and less valuable books' from 1704; cf. Johan Eenberg, *Kort berättelse af de märkwärdigste saker som för de främmande äre at besee och förnimma uti Upsala stad och näst om gränsande orter* (Uppsala: Johan H. Werner, 1704), p. 56.

114 K12, bibliotekets arkiv, UUB; see also Eenberg's telling, reproduced in Annerstedt, *Upsala universitetsbiblioteks*, p. 111.

but rather involved handling historical matter. Through the organisation of the collections, then, history was made.

7 Material and Immaterial Movements

At the university library, the temporal orderings of the collections continued to play an important role throughout the century. Over time, temporal and chronological features developed in the upper library as well, in connection with the reclassification of the theological books. The catalogues created after Tolfstadius' work show no direct changes when it comes to the secular sections, but the religious books were relabelled several times. The previously dogmatically mixed theology section in the upper library came to be divided into Lutheran, Catholic and Calvinist books. These changes have previously been interpreted as reflections of contemporary theological debates: the so-called syncretic battle and stricter religious views around the mid-seventeenth century that illustrated how a strict Lutheran orthodoxy ultimately defeated a more generous theology that stressed Protestant unity.[115]

I want to challenge this interpretation and instead assert that the changes to the upper library expressed not only confessional battles but also temporality and the librarians' perception of history. In catalogues K5a (1656–1663) and K6 (1675) the religious hierarchy is clear, with *Theologi Lutherani* listed before *Pontificii* and *Calviniani Theologi*. But in K5a, the librarian had a hard time deciding whether *Theologi Lutherani* should instead be labelled 'our theologians' (*Theologi Nostrates*) or, even better, 'the latest theologians' (*Theologi Recentiores*) (see figure 15 on page 202).[116]

In a later catalogue, made around 1700 when the library's collections had been moved to another building, the librarian's chronological thinking had overcome the religious hierarchy. All Catholic literature, from *Liber Rituales* (missals, etc.) to scholastics, dogmatics, controversial theology and the like, was listed *before* the Lutheran theologians.[117] With this, the Catholic books in the upper library slid between different meanings: from having been described as theology, through being a specific confession, to finally forming parts of a European, chronological ecclesial history.

115 Hornwall, 'Uppsala universitetsbiblioteks äldsta', pp. 196–199.
116 K5a, bibliotekets arkiv, UUB.
117 K11, bibliotekets arkiv, UUB; a similar observation of books following a temporal order has been made by Zedelmaier, *Bibliotheca universalis*, p. 226.

At the same time as the librarians were instituting more and more subsections in the theological category and moving books around in the written catalogues, the spatial orderings of theology seem to have remained largely untouched until 1691, when the collections were moved. The catalogues after Tolfstadius' K2 and K3 referred primarily to the contents of the upper library, with some additions from the lower one.[118] For example, in catalogue K5 (1649), which is based on the upper library, librarian Haqvini Andreae has created the category *Scholastica Quaedam Scripta*, which encompasses a number of scholastic works from the lower library. He has unfortunately not used the same room labels as Tolfstadius, which makes it harder to follow the references.[119] The knowledge of what was actually kept in the lower library was increasingly lost over the years. In August 1678, the new librarian and former Rector Olof Verelius spoke in the consistory and raised the question of how anyone was to know what was in the lower library when there was no register of its contents.[120] Later, it was decided that the entire lower library would be inventoried whereas the upper library was deemed to be in good order, and books previously thought to have gone missing had been rediscovered.[121]

The librarians' regroupings of theological books in the catalogues were immaterial movements, in the sense that the books in question remained in their places in the library. At the same time, however, there were also material movements of books between the floors and libraries. This occurred in 1641, for instance, when 'the old law books [...] in the Lower Library' were carried up to the upper floor again.[122] These movements show how it was sometimes difficult to distinguish past from present. Books previously interpreted as historical could suddenly become relevant again and be reinterpreted as useful knowledge. These material and immaterial movements of particularly Catholic and Calvinist volumes reflected an effort to create a complete collection of knowledge in the upper library: a *bibliotheca universalis* where the entire world of knowledge would be represented.[123] Simultaneously, however,

118 Hornwall, 'Uppsala universitetsbiblioteks äldsta', pp. 198–200.
119 Andreae appears to have been using 'a' instead of 'α'; see K5, bibliotekets arkiv, UUB, pp. 62ff and room α in K2, bibliotekets arkiv, UUB.
120 Hans Sallander (ed.), *Akademiska konsistoriets protokoll* 13, 1678–1679. (Uppsala: Uppsala Universitet, 1974), 136.
121 *Akademiska konsistoriets protokoll*, 13. 147.
122 E1, bibliotekets arkiv, UUB.
123 Hornwall, 'Uppsala universitetsbiblioteks äldsta', p. 200; Clark, 'On the bureaucratic plots', pp. 195–196.

these movements highlight that even the librarians trying to create a universal library were selective in their work.[124]

At Uppsala University Library, not only confessional knowledge ideals but also history were materialised through the material orderings of the collections. The entire library was pervaded by temporal thinking, whereby the collections were organised based on different librarians' understanding of the past. Interesting parallels can be drawn to the organisation of the Kingdom's Archive, discussed in the previous chapter. There, around 1620, the daily activities in the king's chancery were separated from historical documents. The most distinguished historical documents were then arranged according to a genealogical system in which each Vasa king had his own cabinet and chronology. The collections in Uppsala also expressed chronology, whereby confessional books were made into parts of the history of Christianity that was told through the library's orderings. The library in Uppsala thus illustrated both the tension between and the combination of a history and a contemporary-oriented collection.[125] Not least, the older university library's spatial conditions, with its two clearly delimited floors, contributed to this; in this older library, until 1691, both collection types could be found under the same roof.

On several occasions during the seventeenth century the consistory determined that the library's catalogues should be published, following in the footsteps of predecessors like the Bodleian Library in Oxford. This was never done in the seventeenth century, however. When the issue was discussed in 1663, the university rector asserted that a new library catalogue should be made and printed so that 'more could see and know what books exist there'. The consistory replied that this was a good idea, but that first, through professor and historian Olof Rudbeck, it should be investigated whether 'such books exist that it merits printing, or if the library was very defective'; if it turned out that the library was incomplete, the professors said, there was no need to tell the world about it.[126] The aspiration to completeness did not involve simply acquiring new books but also actually acquiring knowledge about the books that were already there.

124 Walsby, 'Book lists', pp. 4–5.
125 Balsamo, *Bibliography*, p. 5.
126 Hans Sallander, *Akademiska konsistoriets protokoll*, 6, 1661–1663. (Uppsala: Uppsala Universitet, 1971), 164.

8 Mould and Disorder: The Challenges of Preservation

So far, this chapter has shown how the university library was made possible through spoils, and how with time the spoils' geographical organisation was transformed into collection orderings based on Uppsala University's faculties and the librarians' perceptions of Catholic as well as Protestant epistemology and temporality. By organising the collections and establishing catalogues, the librarians attempted to control the collections and make them available to the greatest degree possible, which was often easier said than done. This section focuses on the practices of preservation and the hazards the collections were exposed to in the old library. The library was intended to be a safe place for knowledge storage and preservation, and the books were preferably not to leave its rooms. But how successful was this ambition to keep together and conserve the collections in the long run? What material stresses were the collections exposed to over the decades?

Previous research on the older library has primarily highlighted the collections' inferior knowledge content as well as the library building's many faults.[127] In the academic consistory's protocols, it is possible to follow the discussions of everything that was not as it should be in the library. The aim of the consistory was precisely to discuss the problems its members wished to air, and the aspects of the library that were functioning well were not addressed.[128] Some matters resurfaced year after year without being remedied, and thus cannot have been as urgent as the discussions suggest. But from an object-biographical perspective, it is clear that the consistory protocols shed light upon the collections as a long-term material problem. Here emerges a battle between officials, objects and spatial conditions. A similar issue was illustrated in 'Archive Trouble', by the constant organisation work with the collections in the Kingdom's Archive. The library's volumes carried with them demands for space, care and an overview, which the responsible parties at the university attempted to handle. It is therefore relevant to look more closely at some of the consistory's discussions about the preservation of the collections from a material perspective.

127 Hornwall, 'Uppsala universitetsbiblioteks resurser', pp. 66–69; Margarete Andersson-Schmitt, 'Biblioteksdebatten i Akademiska konsistoriet 1627–1694', in G. Hornwall (ed.), *Uppsala university 500 years. 12. I universitetets tjänst. Studier rörande Uppsala universitetsbiblioteks historia* (Uppsala: Uppsala Universitet, 1977), pp. 20–21, 28, 30. Andersson-Schmitt makes no mention at all of the spoils that came to the library in her discussion of acquisitions.
128 Hornwall, 'Uppsala universitetsbiblioteks resurser', p. 65.

In connection with an inventory in 1676, consistory member Gartman noted that there was no order to be found in either the upper or the lower library. And what was he to do with the lower library, 'as the books are so full of mould and uncleanliness that no one can describe their titles?'[129] The consistory decided that the books whose titles could not be read would be numbered, thus solving the problem and allowing the inventory to continue. The story of the mouldy books in the lower library bears witness to two types of material effects. The first was spatial, whereby the library building had apparently failed to store its contents in a safe way. The other effect involved the books' mouldy matter forcing the librarians to change their work methods.[130] Most striking of all is perhaps that the mouldy books were inventoried and kept in the library, instead of being thinned out.

The older university library was placed in a building that affected its contents in primarily two ways: through its insufficient size and through its climate. As early as around the mid-seventeenth century, it was noted that the library was too crowded and that another building should be built at a moderate cost. In connection with the discussion of the library building's size, the University Chancellor insisted that the library was the right storage place for the books. If someone wanted to read a book they should do so in the library 'but not carry her home'.[131] The library was thus the place where the books were to be kept in order to be preserved, and only in exceptional cases was the consistory to allow people to take them home. When librarian Johannes Loccenius complained that library visitors 'so promiscuously' went into all the library's rooms and supplied themselves with books from the shelves, the consistory decided to move all the books from the library's outer rooms and limit students' access to the inner rooms. Later, all the bookshelves were fitted with brass bars.[132] Thus, to keep books from disappearing from the library, the consistory took several measures that altered its rooms.

129 Hans Sallander (ed.), *Akademiska konsistoriets protokoll*, 12, 1676–1677. (Uppsala: Uppsala Universitet, 1973), 139.
130 Cf. Lise Camilla Ruud & Terje Planke, 'Rolstadloftet. En vetenskapshistorisk biografi', in S-A. Naguib & B. Rogan (eds.), *Materiell kultur og kulturens materialitet* (Oslo: Novus forlag, 2011), pp. 52–53, where the authors discuss how the Rolstad loft expressed a type of agency through its material collapse.
131 Hans Sallander (ed.), *Akademiska konsistoriets protokoll*, 4, 1650–1655. (Uppsala: Uppsala Universitet, 1970), 154.
132 It is not clear which of the libraries was discussed here but it was likely the upper one, Hans Sallander (ed.), *Akademiska konsistoriets protokoll*, 5, 1656–1660. (Uppsala: Uppsala Universitet, 1970), 187; Hans Sallander (ed.), *Akademiska konsistoriets protokoll*, 8, 1667–1670. (Uppsala: Uppsala Universitet, 1971), 488.

The importance of keeping the collections within the walls of the library, and the fact that this was not always done, is a consistent theme in the protocols up to 1691. When University Chancellor Magnus Gabriel De la Gardie donated a valuable manuscript collection to the library in 1669, he did so with the expectation that in the long run the manuscripts were safer there than in his family's possession. Among these 'old and rare books', De la Gardie believed the *Codex Argenteus* (or the silver bible) to be the most valuable. *Codex Argenteus* had come to the Swedish Empire in 1648 as spoils from Prague, but left the kingdom just a few years later through Queen Christina's librarian Isaac Vossius. De la Gardie later bought the manuscript and thus made it part of his collections.[133]

The story of the mouldy books with their illegible titles shows that the library building could be called into question as a place for storage. It was not only the lower library but also the upper one that had problems with humidity. There, leaks from the peat-covered, 'spiteful' roof were dealt with several times.[134] As early as 1641, the problems were taken up in the consistory: the building needed repairs and the peat roof needed to be covered. The discussions continued in this way, about a constantly demanding and inadequate building in poor shape, until its collections were moved to the *Gustavianum* Academy building in 1691 (today's Uppsala University Museum).[135] As the library was materialised with the help of the spoils, which on several occasions arrived in large quantities, it is not a strange notion that the building would have quickly become too small. The books that came from Braunsberg alone numbered more than was purchased for the library during the entire seventeenth century.[136] And towards the end of the decade, two large private book collections were also added to the library: De la Gardie's manuscripts, mentioned above, and books belonging to Claes Rålamb, some of which were also spoils.

Despite the building's damp environment, the old university library was kept more or less unheated. On a couple of occasions the consistory discussed the need for doors and window shutters of iron, which had also been prescribed for the Kingdom's Archive in Stockholm, to protect the collections from fire.

133 *Akademiska konsistoriets protokoll*, 8. 241–242.
134 See e.g. *Akademiska konsistoriets protokoll*, 3. 35, 173; Hans Sallander (ed.), *Akademiska konsistoriets protokoll*, 10, 1673. (Uppsala: Uppsala Universitet, 1972), 271; *Akademiska konsistoriets protokoll*, 13. 117; Hans Sallander (ed.), *Akademiska konsistoriets protokoll*, 17, 1685. (Uppsala: Uppsala Universitet 1975), 35.
135 *Akademiska konsistoriets protokoll*, 3. 35; *Akademiska konsistoriets protokoll*, 5. 26, 488, 491.
136 Cf. Trypućko etc., *The catalogue*, p. 21 and Hornwall, 'Uppsala universitetsbiblioteks resurser', p. 69.

There were fireplaces in the library, but they seem to hardly have been used. In 1685 the consistory even wanted to demolish a fireplace, both due to the risk of fire and because books could not withstand 'fire heat'.[137] Thus, although the responsible parties were aware that humidity and dampness threatened the collections they avoided keeping the building warm, as heat was also considered to risk the collections' preservation.

In June 1685, Magnus Gabriel De la Gardie wrote to the consistory in regard to his grand donation of manuscripts 16 years earlier. It had come to his attention that a large portion of the books had been misplaced, and that 'Ulphiae Codex argenteus is spoiled by damp, after she [was] not ventilated'. The University Chancellor demanded an inspection of the library, and that books that were out on loan be immediately returned to the collections.[138] Shortly after De la Gardie's letter the library was inspected by the librarian, deputy librarian, rector and some of the consistory members. Sure enough, a large number of manuscripts from De la Gardie's donation were on loan to Olof Rudbeck as well as Johan Hadorph, assessor at the Academy of Antiquities. *Codex Argenteus* itself was carefully examined and found to be neither damp nor badly damaged. The book lay in its own box, which in turn was kept in a beautiful new, well-made oak chest. The librarian gave his assurances that he had ventilated the volume three times in the past year by wiping the pages with a cloth, as the book was sensitive to both sunlight and other weather.[139] This inspection shows not only that some of the complaints brought up in the consistory were exaggerated or false, but also how much care the librarians could show for an object that was regarded as a rarity.

The inspection of and care for *Codex Argenteus* led to further questions involving how manuscripts and older printed books that were not considered rarities or particularly important were treated in the library. For instance, Margareta Hornwall has suggested that 'the hate of Catholicism created a contempt for Medieval manuscripts and incunabula'.[140] But this investigation has shown that epistemological interpretations and religious polemic were somewhat dependent on the situation and subject to change. This is highlighted by the librarians' handling of the confessional books. There was no single approach to the manuscripts and incunabula, and what was considered to

137 *Akademiska konsistoriets protokoll*, 17. 163.
138 *Akademiska konsistoriets protokoll*, 17. 145.
139 *Akademiska konsistoriets protokoll*, 17. 162.
140 Hornwall, 'Uppsala universitetsbiblioteks resurser', p. 68; cf. Claes Annerstedt, who asserted in 1894 that the contempt for Medieval manuscripts had to do with a bitterness towards 'everything that reeked of the papal sourdough', Annerstedt, *Upsala universitetsbiblioteks*, pp. 30–31.

belong in these categories was not self-evident either. Manuscripts and older printed books were interpreted based sometimes on their material properties, and sometimes on their knowledge content. However, the size of the collections posed a problem in relation to the building's limited space and the constant need to acquire more new books.

In the consistory, two problems were consistently linked: issues involving duplicates and those involving 'old monk books'. When the question of how duplicates of the same edition should be handled was raised for discussion in 1644, the consistory determined that such books should be traded for other works.[141] Now and then, there were requests to trade books in the university library for those in other libraries, from both members of the consistory and other officials.[142] The question of what should be done with the duplicates was again discussed in 1662: the University Chancellor was of the opinion that they should be moved to the new university building to comprise a student library, so that the professors could have a 'selecta Biblioteka', a select book collection, in the old one.[143] The discussion around creating a student library resurfaced before the collections were moved in 1691, but never led to any concrete action.[144]

The discussions within the consistory involving selling and in other ways disposing of duplicates clearly shows that the library collections contained codices and not immaterial knowledge. In 1681, there were a number of interesting discussions in the consistory that illustrate how complex and utterly materially oriented the issue of thinning the collections had become. Rector Olof Verelius primarily wanted all the old and defective parchment books to be sold to the bookbinder, and also believed that the duplicates and triplicates that were not useful to the library should be sold. When this discussion came up later the same year, Verelius again noted that old books should be sold so that new, useful ones could be bought. This matter was to be discussed as soon as possible with University Chancellor De la Gardie, who was not present at the consistory's meeting. This time, however, Verelius encountered opposition when the university's questor pointed out that 'among these monk books

141 *Akademiska konsistoriets protokoll*, 3. 136, 278. Exactly what was meant by 'edition' is unclear.
142 Olof Rudbeck; see *Akademiska konsistoriets protokoll*, 4. 91; Schering Rosenhane; see *Akademiska konsistoriets protokoll*, 5. 278.
143 A comprehensive discussion of the select *versus* the universal library can be found in 'War Museums' below. The Chancellor's statement suggests that the university library was not regarded as a select library.
144 Hans Sallander (ed.), *Akademiska konsistoriets protokoll*, 6, 1650–1655. (Uppsala: Uppsala Universitet, 1971), 94; *Akademiska konsistoriets protokoll*, 12. 92.

should be something concerning *historiam et res patriae antiquas*'; that is, the books could offer insight into the kingdom's history and its ancient conditions. It would therefore be necessary for someone from the Academy of Antiquities to be there to approve the books that were to be thinned out. Furthermore, the professors should have the possibility to buy parchment books before they went to the bookbinder.[145] Thus, there was a willingness among the consistory's members to pay for the books that were described as defective, and all the trading and thinning done in the library could benefit private collections. When the University Chancellor was informed of the plans to thin out the books, he urged that the greatest care be taken so that nothing useable was destroyed. He stressed that if there was anything significant on one leaf or just a single page, this was reason enough to keep the entire book. De la Gardie also stressed that it was not only antiquities that were important to preserve but also that '*the matter itself* would be rare and useful to maintain'.[146] Old books, among them spoils and confessional books, could be valuable simply because they were ancient objects.

When the issue of the monk books was raised again in 1682, it emerged that the now deceased Rector Verelius had in fact cut parchment leaves out of books. The discussion that followed this little scandal reveals that several professors in the consistory believed that leaves removed lost their historical authenticity, as the pages were to be validated through their setting, the old material whole of which they formed a part. Leaves that had been torn out could be regarded with suspicion or judged to be counterfeit. For leaf fragments not to lose their credibility, 'they [should] sit in their previous binding, and among *the old matter*, which they of age have been bound with'.[147] The review of duplicates and monk books that was conducted in 1681–1682 did not result in any sales. However, many antiquities were found among the examined books.[148] It was not until 1702 that the first sale of duplicates took place in Uppsala, eleven years after the collections had been moved from the old library building to the *Gustavianum* Academy.[149]

145 Hans Sallander (ed.), *Akademiska konsistoriets protokoll*, 14, 1680–1681. (Uppsala: Uppsala Universitet, 1974), 369, 371–372.
146 *Akademiska konsistoriets protokoll*, 14. 373, 375. My italics.
147 *Akademiska konsistoriets protokoll*, 15. 14. My italics.
148 *Akademiska konsistoriets protokoll*, 15. 14.
149 Otto Walde, 'Hur man sålde dupletter i forna tider. Ett kulturdokument från 1710', *Nordisk tidskrift för bok- och biblioteksväsen*, 2 (1915), p. 212.

9 Back in the War Chests

This chapter concludes with an event connected to the fate of the library collections after their move to *Gustavianum* in 1691. In the previous study of the Mitau files in the Kingdom's Archive, I emphasised that they seem to have been raided by an archive thief at the beginning of the eighteenth century. This episode was made possible by the disarray and state of emergency that affected the collections after the castle fire of 1697. The university library in Uppsala also faced a serious external threat at the beginning of the eighteenth century, in the form of the Great Northern War. When a Russian invasion of Sweden was imminent in 1714, the Uppsala librarians began preparing to move the collections to the Swedish inland. Otherwise, the risk that they would be plundered was judged to be great. This was not the first time collections were moved in an attempt to protect them from the enemy; as recently as the previous year, the Kingdom's Archive had been moved to the town of Örebro. Another example can be taken from the university in Dorpat (Tartu), established by Gustavus Adolphus in 1632. The university's small archive, a book collection of around 300 volumes as well as a small printing press, was walled in when the Czar's army threatened the city in 1656. The cache was not rediscovered until 1688, when Dorpat was again under the Swedish Crown, and an old professor in Turku was the only person who remembered exactly where the collections had been hidden.[150]

In February of 1714 there were growing worries in Uppsala, and academy carpenter Mats Aurer was ordered to construct chests measuring 180 × 60 × 45 cm. When it came to books, such a chest should have room for around six running meters of volumes in octavo format. Ultimately, there would be some 80 chests into which parts of the university library's book stock were packed. The selection was made by members of the consistory and the various faculties.[151] The packing list of the 'most costly as well as the rarest books' residing in Uppsala University Library in 1714 was hastily made, and in many cases offers no more information on the books than a short title and an author name. Without dwelling on details, it is noteworthy that many Papal Church books, to use Bureus' expression, were selected and thereby made into the rarest books among the others. As this occurred after the first duplicate auction had been held in Uppsala, Catholic missals, breviaries and similar books were certainly still preserved and treasured in the library.

150 Tönnes Kleberg, *Bibliotek i krigstid. Uppsala universitetsbibliotek i stora nordiska krigets slutskede* (Uppsala: Skrifter rörande Uppsala universitet, 1966), pp. 7, 16, 23.
151 Kleberg, *Bibliotek i krigstid*, pp. 24–28.

Among a group of quartos, the librarian has noted 'Laurenti Norvegi *Confessio*'.[152] This was the same work that had been noted by Johannes Bureus 88 years earlier, when he made the inventory of the books from Prussia in Stockholm in 1626. It is certainly striking that Bureus made particular note of the book written by Lars of the Monastery as he sifted through thousands of titles. In the vast flood of knowledge materialised by the spoils, the personal, political and religious meanings in Nilsson's *Confessio* outshone most of its competition. In the end, this single book binds together a nearly hundred-year-long history of spoils in Uppsala University Library. It is through the geographical movements of Nilsson's *Confessio*, a number of relations between people, books, confessional epistemologies, geographies and times materialised: from the possible meeting between Nilsson and Gustavus Adolphus in Riga, through the volume at the Jesuit College in Braunsberg that became part of the spoils and was transported from Prussia to Bureus in Stockholm in 1626, to Tolfstadius and his placement of the volume in the lower library's shelf α3 around 1640.[153] When the university library's rarities were to be protected from the Russian Czar's troops, Nilsson's *Confessio* was again selected. Due to war, the volume was finally back in a chest again, like the one where the story of the spoils from Livonia and Prussia had once begun.

10 Conclusion: Library Confessions

'All the books and their matter and their space', 'unbound matter', 'the matter itself' and 'old matter'. Together, these quotes capture the fact that the dominant knowledge media of the seventeenth century, codices, are space-demanding, material objects. This chapter has looked at how different librarians handled, classified and interpreted the spoils that played a key part in the establishment of Uppsala University Library in the 1620s. Studying the library's establishment with the help of the booty has revealed the librarians' understanding of the collections as knowledge, confession and time. The chapter has also highlighted how Uppsala University Library was an effect of its sometimes unwieldy material conditions.

The university library came into being through different epistemological and organisational ideals. Due to their spatial presence, the spoils from Riga, Braunsberg and Frauenburg demanded that librarians and other officials handle them, firstly through classification and spatial arrangement. A compromise

152 K1:11, bibliotekets arkiv, UUB.
153 K3, bibliotekets arkiv, UUB, p. 21.

arose here between orderings that expressed the university's organisation and intertwined ideals of epistemology and temporality. Together, the collections were used to create not one but two libraries, where confessional divergences and hierarchies were articulated, coexisted and eventually changed. Both material and immaterial movements of objects that occurred over time showed that the librarians changed the orderings and thus reinterpreted the books. The tension between these movements is especially interesting, with the immaterial occurring in (certainly material) script when new catalogues were made, but seemingly without being followed by the spatial movement of books. Several catalogues were not spatially anchored, and therefore say little about how the collections were actually arranged. While the variety in the orderings of the library can be understood today as inconsistency, it actually bears witness to the complex interplay between different factors when spatial and material circumstances met with the librarians' epistemological ideals. The books and the knowledge they held were in no way static objects; on the contrary, their mobility had the effect that Catholic and Calvinist books could sometimes be classified as relevant theology and sometimes as history, in the sense of something old. Nonetheless, the movements that took place show how hard it was for the librarians to distinguish history from the present. This shows that the books and collections were transformable participants in a process in which the interpretation of them was not self-evident beforehand.

When Ambassador Whitelocke visited the library in 1656, he saw abducted objects of a clear geographical identity. What made him draw these conclusions? We cannot know the placement of the library's additional objects in the seventeenth century, but the liturgical objects and household items from the Jesuit College in Riga were likely still in the library around 1650. If these objects followed a temporal order, Russian Orthodox icons, altar frontals and candlesticks would have been stored in the lower library. They may have been used to strengthen the sense of history, with the lower library serving as a museum containing another religious past. They may have encouraged Whitelocke to interpret the collections as being entirely of another place. But, as noted earlier, the lower library must have also contained many of the manuscripts and printed books from the dissolved Swedish monastery libraries and also older contributions from the collections of the Vasa kings. This is an important observation, as it illustrates just how unstable geographical identities and the category of spoils were. Even things that had not been brought to Uppsala University Library from the Holy Roman Empire or other enemy lands could be experienced this way; there were clearly many spoils in the library, and these transmitted their special identity of being plunder to objects that had been collected in other ways.

With spoils and other books being mixed with each other at the university library, the boundaries between different geographical origins were erased and the meaning and identity of an object category could thus spill over onto another. Whitelocke's story tells us that the collection could largely be interpreted as abducted books and thereby as spoils. This insight will follow along with us into the next case study, which involves Carl Gustaf Wrangel's war museums at Skokloster. Visiting the upper and lower libraries in Uppsala around 1650 was likely reminiscent of walking into two different worlds. Librarian Tolfstadius had primarily collected the materiality of the past in the lower library, while the upper library saw a striving for current knowledge and universality throughout the century. Together, the two floors, with their intricate orderings of knowledge, materialised the confessions of Uppsala University Library.

CHAPTER 4

War Museums: *Spolia Selecta* in Carl Gustaf Wrangel's Skokloster

'Filled with spoils of war, this castle is totally and completely a magnificent and enduring memorial to victory from Sweden's most glorious time'.[1] The description of Skokloster Castle quoted, appearing in a travel guide published in 1860, represents a perception of the castle and its collections that is still widespread, but far from true (see figure 16 on page 203). In strong contrast to the nineteenth-century National Romantic view, later experts, from Olof Granberg to Arne Losman, have argued that Carl Gustaf Wrangel's plundering played but a moderate role compared to his other collecting activities. The plunder was relatively modest, and even during the wars he had spent great amounts of money on collecting through ordering and buying art and books. Wrangel and his family also often received expensive diplomatic gifts, which have been judged to be more important than the spoils.[2] That the spoils' significance has been toned down by Losman and others is understandable, as there are relatively few sources that explicitly mention them. Meanwhile, there is a huge amount of archive material describing the other ways, inheritance, purchase and gifts, through which Wrangel's collections were created. Previous studies on the plundered goods at Skokloster have arrived at figures suggesting booty accounted for around 10% of the armoury, 15% of the paintings and 20% of the library stock.[3]

Regardless of whether the spoils were substantial, they were (and are) present in the collections and thus participated in their making. I argue that Wrangel's expenditure of such large amounts of money on his collecting activities and on buying books for his library is a circumstance that makes his plundering and spoils especially interesting. The master of Skokloster Castle

[1] Julius Axel Kiellman Göranson, *Sko. Socken, kloster, kyrka, egare och slott. Handbok för resande* (Uppsala: Hanselli, 1860), p. 67.

[2] Granberg, *Skoklosters slott*, p. 15; Rangström, *Krigsbyten*, pp. 3–5; Losman, *Carl Gustaf Wrangel*, pp. 14, 61–71. In an earlier work, however, Losman points out that Wrangel seems to have made conscious choices when it came to spoils. See Arne Losman, 'Vetenskap och idéer i Per Brahe d.y:s och Carl Gustaf Wrangels bibliotek', *Lychnos. Årsbok för idé- och lärdomshistoria*. 1971–1972 (1973), p. 84.

[3] Rangström, *Krigsbyten*, pp. 4–5. The figure of 20% refers to all book collections at Skokloster today, and thus not only Wrangel's books.

prioritised purchases for the book collection and had the capital to do so; unlike, for instance, the university consistory in Uppsala and its more limited possibilities. Why, then, did Wrangel at the same time take books and other things as spoils? In the final case study of this book, the link between war and meticulous collecting culture takes its most explicit expression. Room by room, Skokloster's collections will emerge as Wrangel's war museums, and the spoils in the castle's rooms as his greatest triumphs. But, as I also emphasise, the Skokloster case illuminates that the myth of spoils of war grew over the centuries: objects caught in multiple layers of time and meaning.

1 The Encyclopaedic Museums of Skokloster: Beginnings

Skokloster Castle is located on the Sko peninsula on Lake Mälaren in the Swedish province of Uppland, about 50 kilometres from Uppsala. When culture historian Natalie Zemon Davis visited Skokloster at the end of the twentieth century, she said she had finally found a monument that summarised the world of the seventeenth century in its entirety.[4] Carl Gustaf Wrangel, his family and his court would likely have been satisfied with this judgement. Wrangel began the construction of Skokloster Castle in 1654, at the location where he had once come into the world; the building had not yet been completed when he died two decades later. By building Skokloster as the largest private palace of the Swedish Empire, Wrangel and his wife Anna Margareta von Haugwitz wished to create a safe and grand place to store their collections. During Wrangel's time as governor-general of Pomerania and military commander in a number of war campaigns on the continent, Wrangel and von Haugwitz took great care in building up collections of art and knowledge through purchases, gifts and the taking of spoils. Successively, the collected objects moved to the increasingly complete castle. In Wrangel's birthplace, then, he and those around him created a monument that accentuated the wartime accomplishments of a renowned field marshal.[5] Through the carefully curated collections, Wrangel's life history was materialised, a history that differed in many ways from Per Månsson Utter's Vasa chronicles and the Uppsala librarians' confessional history. While Gustavus Adolphus often confiscated entire collections,

[4] Arne Losman, 'Skokloster slott. Större än summan av delarna', in *Bevarandets hemlighet. Konsten att vårda, förvara och konservera* (Stockholm: Livrustkammaren, Skoklosters slott och Hallwylska museet, 1991), p. 95.
[5] A detailed overview of Wrangel's elaborate collecting, culture consumption and network can be found in Losman, *Carl Gustaf Wrangel*. The armoury is given particular attention in Meyerson & Rangström, *Wrangel's armoury*; see especially pp. 11, 39ff.

Wrangel chose individual spoils with apparent care. Therefore, an important question is whether, and if so how, Wrangel's chosen spoils at Skokloster were ascribed other meanings and had other effects compared to the Mitau documents in the Kingdom's Archive or the objects from Riga and Prussia in Uppsala University Library.

Carl Gustaf Wrangel has not been described as a scholarly man, even though he was appointed University Chancellor in Greifswald in 1660 and happily collected books. Present day judgements have at times been ungenerous, and Wrangel has been described as a representative of 'the grandiose banality'.[6] Florentine count, author and diplomat Lorenzo Magalotti spoke of Wrangel in somewhat more appreciative terms in connection with the count's visit to the Swedish Empire in 1674, portraying him as a curious man with many interests, who was very fond of books and knowledge even though, according to Magalotti, he was not especially educated. Wrangel kept himself constantly busy; if he was not reading his books, the author said, he was standing at his lathe turning wood or building models of palaces and forts.[7] Here, Magalotti sketched a picture of a man who seems to have attempted to meet the encyclopaedic and practically oriented knowledge ideal that was dominant among the European nobility of the seventeenth century. In order to be able to practise the sort of knowledge a ruler or nobleman should command, or at least appear to command, Wrangel needed rooms and collections that made this possible. He could learn from these rooms, and not least show them off to others. Through the creation of carefully selected encyclopaedic collections, like a prince he could demonstrate how he commanded them and thus how he mastered the world.[8]

This chapter will show how Skokloster could function as such a place of learning. Instead of discussing the degree of Wrangel's education or how often he actually spent time at Skokloster, I focus on his collection practices and his incorporation of plunder as a particular, meaningful part of these practices. The cornerstone of nobility at this time was regarded to be either military or civic virtue. The ideal of military virtue was indeed compatible with Wrangel's career and, as this case study underlines, his self-image as a grand warrior: a man of action, unlike the politician who instead engaged in discussion.[9]

6 Losman, *Carl Gustaf Wrangel*, p. 13.
7 Magalotti, *Sverige*, p. 97.
8 Early modern encyclopaedic collections as a reflection of princely power have been discussed by, among others, Mordhorst, *Genstandsfortaellinger*, pp. 108–109; Lorraine Daston & Katharine Park, *Wonders and the order of nature 1150–1750* (New York: Zone, 1998), p. 272; Brenna, 'Tidligmoderne samlinger', pp. 30–31; Findlen, 'The museum', p. 63.
9 Losman, 'Vetenskap och idéer', pp. 81–82.

Wrangel's military merits are reflected throughout Skokloster Castle, and with this in mind, in what follows I place Skokloster's, and Wrangel's, spoils in their relationship to early modern continental collecting ideals and princely museums. Why did Wrangel collect knowledge and splendour through the taking of spoils? How were these spoils handled by him and his librarians and armourer at Skokloster Castle? What meanings and qualities did his officials ascribe to various types of spoils in his collections when they classified and organised them? Did the objects Wrangel took as spoils differ from those he collected in other ways, and what did they signify to him? What properties among the abducted objects contributed to creating and forming the collections' narrative; that is, Skokloster's collections as museums of war?

Skokloster Castle has been compared to a colossal cabinet of curiosities, that contained (and still today contains) all the objects typically associated with early modern collections in archives, libraries and museums. The collections boast a number of various sorts of cultural spoils: everything from archive documents and books taken from Polish kings and Danish noblemen, to their paintings, woven tapestries, weapons and even chests.[10] The objects preserved at the castle since the seventeenth century and the archive documents that now reside in the National Archives are extensive. Wrangel's archive runs to more than 500 volumes, and there are around 50,000 incoming letters and outgoing drafts.[11] This case study will be based primarily on the approximately 90 books that had once belonged to the Danish noble family Rothkirch and that Wrangel, with the help of his servants, handpicked. His choice of spoils reflects both selection and entirety, and many of the books can be identified and followed in the various lists his librarians made of the collection. Wrangel also took other objects besides books, such as a number of weapons and an emblematic shield that had belonged to the head of the family, Wenzel Rothkirch. Therefore, based on the Rothkirch spoils, it is possible to look upon a broader setting: to understand how these spoils together materialised the narratives of the library and armoury at Skokloster, and thereby gain insight into their meanings, properties and effects in Wrangel's war museums in general.

10 Losman, *Carl Gustaf Wrangel*, p. 234. Ingemar Carlsson, *Riksarkivets beståndsöversikt. Enskilda arkiv: person-, släkt- och gårdsarkiv. Del 8. Band 3* (Stockholm: Riksarkivet, 2006), pp. 1164–1166; Rangström, *Krigsbyten*, pp. 7–23; Bengt Kylsberg, 'Krigsbyten på Skoklosters slott', in S. Nestor & C. Zarmén (eds.), *Krigsbyten i svenska samlingar. Rapport från seminarium i Livrustkammaren 28/3 2006* (Stockholm: Livrustkammaren, 2007), pp. 103–106.
11 Losman, *Carl Gustaf Wrangel*, p. 10.

2 The Creation of the Rothkirch Spoils

It is impossible to say exactly when and where in Denmark it was that Wrangel took the Rothkirch spoils. The Schleswig nobleman Wenzel (or Wentzel) Rothkirch had been Danish King Christian IV's equerry and Marshal of the Court, and was sheriff in Korsör and Antvorskov on Zealand (Sjælland) (see figure 17 on page 204).[12] Rothkirch and his daughters Birgitta, Katarina, Kristina, Elisabeth and Sofia all owned book collections, and there were also certain books for the children's education that were kept in a particular space. What makes these spoils special is the source that is connected to the plundering of them. Just as Gustavus Adolphus' men had done at the Braunsberg College, Wrangel's men took with them the Rothkirch family's catalogue of their books when they were confiscated. The catalogue had been made, and was dated 1 July 1650, by the children's teacher Basilius Chemnitz, and is to this day preserved in the National Archives' Skokloster collection.[13] In the same catalogue, a list has been made of the books Wrangel ordered to be packed in chests as he had chosen them to become his spoils (see figure 18 on page 205).

The teacher Chemnitz listed the Rothkirch family's books based on their respective owners, partially according to format in descending order and with some reference to space, but without classifying the volumes based on subject. He began the list with Wenzel Rothkirch's books in folio format. He then listed under their own heading four books that were in Rothkirch's armoury; these books were on the subjects of horsemanship and fencing. After this came quarto format, while octavo and duodecimo were listed together. Among Wenzel Rothkirch's books it was the larger formats that were the most numerous: 44 in quarto and 33 in folio, compared to 48 in octavo and duodecimo combined. After these came the daughters' books, listed according to owner but with no further categorisation. In a few cases, Chemnitz noted a book's format after the title, and sometimes the children each had their own copy of the same work; for instance, Birgitta, Katarina and Kristina had the same German bible edition, and both Birgitta and Katarina owned the *Compendium locorum theologicorum* by the esteemed theologian Leonhard Hutter. This was a matter of some ten books each. Then came the books intended for the children's education that were kept in a special room (*librorum, qui in schola asservantur*). Here as well, Chemnitz listed the books based on their format and in descending order from folio to duodecimo; here, the octavo format was dominant.

12 Rangström, *Krigsbyten*, p. 19; Bengt Kylsberg, 'Den konstfulla tekniken', in C. Bergström (ed.), *Skoklosters slott under 350 år* (Stockholm: Byggförlaget, 2004), p. 236.
13 '*Bibliotheca Rothkirchiana equestris*', E 8580, Skoklostersamlingen, RA Marieberg.

Finally, on one page he listed both books and maps as well as objects such as globes of the earth and the heavens, which had likely also been in the specific room for the children's educational books. At the end of the catalogue, Chemnitz gave an account of the children's instruction.[14]

What, then, did Wrangel select from the Rothkirch family's book collections? On page 35 of Chemnitz's catalogue begins the list one of Wrangel's men made of the spoils. In this list, a Swedish heading was used for those books Wrangel had 'commanded be recorded'.[15] None of the daughters' books appealed to him, and when it came to Wenzel's book collection Wrangel chose mostly history and theology from the books in folio and quarto formats. He showed an interest in several of the books intended for the children's education. For instance, he chose a Hebrew, an Icelandic and a German bible, and a number of theological works in folio. Among the historical works can be mentioned chronicles by Sebastian Franck and Albert Kranz, along with several works on the Danish kings, among them the chronicle of Kalmar Union King Christian II, against whom Gustav Vasa had rebelled. As Wrangel took the time to select the just over 90 books that interested him the most among the Rothkirch family's collections, this list thus differs from the cases discussed in previous chapters, in which the spoils tended to be much more extensive.

In war-torn Europe, taking the time to select spoils in this way was not unusual. When Maximilian of Bavaria had the possibility to confiscate books in Tübingen and Stuttgart in the early 1630s he did so in an extremely deliberate way, ordering his librarians to compare the lists of the newly captured library with those of his own collections in Munich. These had been plundered earlier in the war. The librarians were thereby ordered to replace the books Gustavus Adolphus had taken as spoils.[16] Wrangel's refined way of taking spoils was thus nothing out of the ordinary, seen within a broader European context of princely plundering. This is yet another example of how the collecting possibilities presented by the wars could be used in the most deliberate ways by ambitious collectors.[17] I will continue to discuss Wrangel's collecting ambitions through three themes, linked to the Rothkirch books, that reflect the spoils' meanings as choices of confession, variation and practice. The discussion will show that Wrangel in several cases selected the same types of books

14 'Bibliotheca Rothkirchiana equestris', E 8580, Skoklostersamlingen, RA Marieberg; cf. Walde, *Storhetstidens II*, p. 253.
15 'Bibliotheca Rothkirchiana equestris', E 8580, Skoklostersamlingen, RA Marieberg, p. 35. In Chemnitz's catalogue, someone has marked 30 titles with a lead or graphite pencil. These marks may have been made at a later date.
16 Bepler, 'Vicissitudo Temporum', p. 956.
17 Susan Bracken etc. (eds.), *Dynastic ambition*, p. xviii.

when plundering as when he bought books through his agents in Europe. By analysing three different parts of the Rothkirch spoils, I will highlight Wrangel's interest in theological literature and confessional debates, in the variety of his consumption of knowledge, that is, his interest in owning different editions of the same work and in different languages, and the importance of following contemporary noble ideals by collecting practical handbooks.

3 Confessional Spoils

Along with history, theology dominated the Rothkirch family's book collections. Theological literature was also well represented among the books Wrangel took. Among other things, he chose Martin Luther's *Tischreden* (Table Talk), printed for the first time in 1566 and containing the reformer's advice and sayings, as well as Johann Arndt's *Postilla*. Among the books intended for the children's education, Wrangel took the six volumes of the bible commentaries of Jesuit theologian Cornelius a Lapide.[18] The volumes were later listed in one of his book catalogues, dated 1660, with the librarian pointing out that the work consisted of a total of seven volumes but that there were only six present in the collection.[19] This may be why Wrangel ordered the same work in another ten-volume edition the following year, through one of his book suppliers in Amsterdam.[20] This acquisition was particularly expensive, and this occurrence is interesting in a number of ways. That Wrangel acquired the same work twice suggests a great interest in owning Lapide's commentaries. However, Lapide's books were not the only works of Catholic theologians that Wrangel took from the Rothkirch family. Spanish Jesuit Juan de Pineda's commentary on Job was also included in the spoils, as was French Catholic theologian Simon de Muis' commentary on the Book of Psalms from 1630.

These works show that Wrangel was interested in books that could be classified as Catholic theology in the seventeenth century. He was not the only member of the Swedish elite who held this interest. Magnus Gabriel De la Gardie's book collection contained books from the Jesuit Colleges in Erfurt and Heiligenstadt, which he had bought in 1652. Walde asserted that it was during the time of King Charles X Gustav and the field campaigns in Denmark that the

18 'Bibliotheca Rothkirchiana equestris', E 8580, Skoklostersamlingen, RA Marieberg, pp. 9 and 35.
19 'Catalogus LIBRORUM illustrissimi comitis Caroli Gustavi Wrangelij [...] 1660', E 8580, Skoklostersamlingen, RA Marieberg.
20 Losman, *Carl Gustaf Wrangel*, p. 200.

Swedish aristocrats came across the most useful literature. The Danish collections were of the right faith, unlike the Jesuit collections that had been taken earlier in the 1620s and 30s.[21] But the Rothkirch spoils and other books, such as Wrangel's book spoils from Dane Fredrik von Barnewitz as well as a number of scholars in Poland, show that early modern book collecting was more complicated than this. Wrangel was interested in collecting books of various religions. Just like in the Uppsala case, his theological books illustrate that the book collections of the seventeenth century were not confessionally streamlined, or censored, in the way modern researchers have assumed.[22]

Wrangel left no scholarly writings such as military tracts or similar texts. However, there are examples demonstrating that he was interested in academic debates and showed an engagement in confessional matters. As University Chancellor in Greifswald and Governor-General of Pomerania, he supported former Jesuit J. G. Tremellius, whose appointment as rector in Stettin worried representatives of Lutheran orthodoxy at the university in Greifswald. Wrangel also showed his support for Turku Bishop Johannes Terserus, one of the foremost representatives of syncretism in the Swedish Empire. Wrangel even provided this bishop with an anonymous text discussing joining unification of the Catholic and Protestant faiths, so that it could be discussed by theologians in Turku. For 14 years, Wrangel had also been in contact with irenicist theologian and historian Johann Michael Dilherr, who stressed the importance of ethics and morals over dogmatics. Dilherr also sympathised with the strivings of syncretism. Thus, through his correspondence and contracts, Wrangel demonstrated an interest in the issue of a coming together of the Catholic and Protestant Churches.[23] Taken together, these confessional interests were materialised in his book collection through both the choice of spoils and the books that booksellers supplied for him. In addition to the Christian Churches the

21 Walde, *Storhetstidens I*, pp. 9, 38–40. De la Gardie's acquisition of these went via Danish historian Stephen Hansen Stephanus' book collection. What seems to have primarily interested De la Gardie in Stephanus' collection were the manuscripts. See Gustaf Edvard Klemming, *Om Stephanii boksamling* (Stockholm: Norstedt, 1850), unpaginated.

22 Similar issues have recently been noted within research on Reformation history by theologian Otfried Czaika. Through studies of selection and thinning among the books in Bishop Sveno Jacobi's book collection, he has been able to re-evaluate their confessional stances. Thus, Czaika has been able to revise previous research and demonstrate how a book collection's composition reflects its owner's orientation concerning various issues, even though it is not possible to have access to the owner's thoughts. See Otfried Czaika, *Sveno Jacobi. Boksamlaren, biskopen, teologen. En bok- och kyrkohistorisk studie* (Stockholm: Kungliga biblioteket, 2013), pp. 15–22, 38–42, 49, 57–61.

23 Losman, *Carl Gustaf Wrangel*, pp. 13, 85, 141–150, 154–156.

Islamic faith was also represented in the theology section of Wrangel's library, in a magnificent Koran manuscript he had acquired for his collection.[24]

Thus, the collections of both Wrangel and De la Gardie, as well those of the Danish noblemen Rothkirch and von Barnewitz, show that the collector's personal beliefs need not influence the library's content in such a categorical way as Walde and his followers have imagined; quite the opposite. In Wrangel's Skokloster library, the confessional books were classified differently to how it was done at Uppsala University Library. In Uppsala, it emerged that, over time, the same types of theological books came to be placed in a temporal order. The lower library housed most of that which the librarians regarded as Catholic, Calvinist and Jesuit in a historical library filled with old matter. In time, the theology section of the upper library came to be arranged chronologically. Together, this allowed the libraries to materialise a Christian confessional history through their organisation. One of the works Wrangel chose from the Rothkirch family's collections, Juan de Pineda's Job commentary, was classified by Laurentius Tolfstadius in Uppsala University Library as Catholic theology, and he placed it in the lower library.[25] These confessional and temporal themes thus did not come to be expressed in the same way at Skokloster as in Uppsala. In Wrangel's book collection, all confessional books were interpreted as theology. Each book contributed to creating an encyclopaedic and well thought-out collection.

4 Varieties of Booty

The example of Cornelius a Lapide's bible commentaries shows that Wrangel acquired the same work twice, first as spoils and then by ordering it from a bookseller. While Wrangel's book collection did not contain duplicates to the same degree as Uppsala University Library, it has been noted that Wrangel sometimes acquired different editions of the same work as well as editions of the same work in different languages.[26] This collecting preference was also expressed in his choice of spoils from the Rothkirch family's collections. Among the folio editions he chose three bibles in different languages: Hebrew, Icelandic and German.[27] This interest in different bible versions was related to

24 Arne Losman, 'Skokloster. Europe and the world in a Swedish castle', in A. Losman etc. (eds.), *The age of new Sweden* (Stockholm: Livrustkammaren, 1988), p. 97; Losman, 'Vetenskap och idéer', p. 87.
25 Shelf α2:16, K2, bibliotekets arkiv, UUB.
26 Losman, *Carl Gustaf Wrangel*, pp. 183–184, 200.
27 Wr. teol. fol. 7, 8 and 10, Skokloster Slott (SS).

scholarly ideals, which in turn were linked to the Protestant Reformation. In the sixteenth century Luther and his followers had translated the bible into various vernaculars, and during this century the bible came to be a book that more and more people could own. The scholars who worked with these translations did not base them on the Latin Vulgate but instead went back to the Greek and Hebrew texts, which became increasingly important in the wake of the Renaissance humanists. Polyglot, that is, multilingual, bible texts also allowed those who had little knowledge of Greek and Hebrew to be able to compare ancient texts with the vernacular translation.[28] In his canonical manual from 1627, French librarian Gabriel Naudé pointed out how important it was to own multiple versions of the bible, and in different languages as well; these works and other theology also came first in his ideal library arrangement.[29] The previous chapter recorded that it was precisely two polyglot bibles that Gustavus Adolphus supplied himself with from the Prussian spoils, while Wrangel chose three different bibles from the Rothkirch family. Taken together, then, this shows that collecting various types of bibles was important to their respective interests in following the contemporary ideal.

Another example suggesting that Wrangel had an interest in different versions of the same work is Antoine de Pluvinel's instruction in horsemanship. De Pluvinel was French King Louis XIII's riding instructor, and his handbook is a good example of what a nobleman like Wrangel should own in order to act in the way a man in his position was expected to. In this case it was a matter of a bilingual edition of *Le Maneige Royal*, printed in 1626 in French and German and dedicated to King Christian IV of Denmark. De Pluvinel's *Le Maneige Royal* was the work noted first in Wrangel's list of spoils, which suggests that it was particularly significant. Then, in the catalogue of Wrangel's books from 1660, no less than three copies of the same work were listed in the category for Romance languages.[30] A later catalogue made at Skokloster in 1665 mentions only two copies, one in the history section and the other listed under Romance languages.[31] While we cannot know what happened to the third copy, it does

28 Christopher de Hamel, *The Book. A history of the Bible* (London: Phaidon 2001), pp. 216, 218–219, 223; Sherman, *Used Books*, p. 72.
29 Taylor (ed.), *Advice*, pp. 20–21, 65.
30 'Catalogus LIBRORUM illustrissimi comitis Caroli Gustavi Wrangelij [...]' 1660, E 8580, Skoklostersamlingen, RA Marieberg.
31 After the modern reconstruction of Wrangel's book collection, the copy that belonged to Rothkirch was placed under the subject of history. In the 1665 catalogue, however, librarian Bütner added 'alb.[us]' – 'white' – to the copy placed under history. This comment likely referred to the book's binding and was likely added in order to be able to distinguish one copy from the other. The other copy was described as 'allemande' and placed under Romance languages. Cf. the description of Wr. hist. 4:0 97 with Wr. roman. 10, *Catalogvs*

not seem to have accompanied the other books Wrangel transported from Pomerania to Skokloster. Thus, in his book collection at Skokloster, he had *Le Maneige Royal* in two different sections and in two different versions, and partly in two different languages. Along with Cornelius a Lapide's bible commentaries, *Le Maneige Royal* is an example of Wrangel acquiring the same types of books through purchase as through plundering.

5 Practical Spoils

De Pluvinel's *Le Maneige Royal* exemplifies not only how Wrangel showed an interest in different versions of the same work; the riding instruction was related to the practical exercises an aristocrat of the time was to take part in, and made up a significant share of his education. By collecting different types of handbooks, Wrangel showed that he sought guidance in practising the skills that were expected to be included in his aristocratic life. He chose several books of this sort from the Rothkirchs' collections; they articulated his interest in architectural modelling and theory of perspective, together with hunting, riding and weapons. Some concrete examples are Lorenzo Sirigatti's *La pratica di prospettiva del cavaliere* with instructions on how horses could be drawn, first published in 1596, and Salomon de Caus' *La perspective avec la raison des ombres et miroirs*, that is, perspective as regards shadows and mirrors, from 1611.[32] He also took Jacob von Fouilloux's *New Jägerbuch*, a new book on hunting, from 1590, artist Jacob de Gheyn's weapon handbook *Wapenhandelinge* (1607) and Diego de Ufano's tract on artillery pieces, *Tratado de Artilleria* (1628).[33]

During the early modern period, the living ideal of the elite was transformed due to the knowledge revolutions discussed in the former chapter: novel epistemologies that accompanied processes of reformation, confessionalisation and the rise of modern science. The conflict between the library as a

Librorum in Bibliothecam [...] M.DC.LXV., SS. As 'allemand' is the French word for German, it was thus under Romance languages where Rothkirch's copy of *Le Maneige Royal* was placed in 1665. The book is bound with a dark calfskin binding.

[32] On artistic manuals as a new genre in the early sixteenth century, see Jaya Remond, 'Artful instruction. Pictorializing and printing artistic knowledge in early modern Germany', *Word & Image*, 36:2 (2020), pp. 101–134.

[33] Cf. Wrangel's list in *Bibliotheca Rothkirchiana equestris*, E 8580, Skoklostersamlingen, RA Marieberg with Wr. roman. 20, Wr. roman. 17, Wr. ek. 3, Wr. mat. fol. 8, Wr. roman. 67 in *Catalogvs Librorum in Bibliothecam* [...] M.DC.LXV, SS. Salomon de Caus' *La perspective* (Wr. roman. 17) and Jacob von Fouilloux's *New Jägerbuch* (Wr. ek. 3) remain in the castle's collections to this day. When I examined the collection, *New Jägerbuch* was located in a depository in Tumba.

historically-oriented collection and as an up-to-date compilation to serve the contemporary interests of knowledge was materialised in Uppsala University Library through its various orderings and floors. In Wrangel's book collection at Skokloster, this change had completely taken hold during the 1660s. His Skokloster library consisted primarily of new, current books, many containing instructive knowledge that could be practised, either in other parts of the castle or in the outside world. For noblemen like Wrangel, the new lifestyle and knowledge ideals meant that a classical humanist education was successively crowded out by a view that favoured practical skills.[34] The Florentine Magalotti described Wrangel as both a man who enjoyed reading and a man who enthusiastically created things with his hands, turning wood and building architectural models; this observation unites bookish knowledge and tangible practices in a way that was typical of the time. Wrangel's collecting activities therefore illustrate how he embraced this new ideal, which also seems to have fitted with his personal qualities, and materialised it through his book collection.

6 The Wrangel Library at Skokloster: Past and Present

The spoils from the Rothkirch family's collections were first transported to Pomerania, where they were included in a list of Wrangel's books in 1660. This means that the spoils were relatively quickly classified and mixed with the books he already owned.[35] Once in place at Skokloster, the books were reclassified by Wrangel's court chaplain, Conrad Bütner, in 1665. Bütner's catalogue is not spatially anchored, and it is not possible to say for sure where in the castle the library was located. However, considering the ideal of the seventeenth century, it is likely that it was placed near the armoury, the lathe room and the other rooms found on the castle's fourth floor. This was a museum floor, with areas where various collections were on display.[36] Ideally, Wrangel and

34 Sten G. Lindberg, *Adelsböcker och stormansbibliotek* (Bålsta: Skoklosters slott, 1969), pp. 200–201.
35 *Catalogus* LIBRORUM *illustrissimi comitis Caroli Gustavi Wrangelij* [...] 1660, E 8580, Skoklostersamlingen, RA Marieberg.
36 In her dissertation on spatial disposition in the aristocratic home during the Swedish Empire, Karin Wahlberg Liljeström determined that while it is not possible to know for certain where the library was located during Wrangel's time, a great deal suggests that it was on the fourth floor in the *southern* part of the building; see Karin Wahlberg Liljeström, *Att följa decorum. Rumsdisposition i den stormaktstida högreståndsbostaden på landet* (Stockholm: Stockholms universitet, 2007), p. 199. Today, the books are placed in the eastern part of the fourth floor, cf. Arne Losman, 'Skoklosters byggherrskap', in C. Bergström

his guests could both read about wood turning or weapon care here, and then interact with the collections, that is, turn wood, or look at or practise maintaining of the weapons in the nearby rooms.[37] Those who visited the castle could see and touch everything the Field Marshal and his wife, after many years of collecting, had brought together under one roof.

Just what kind of book collection was it, then, that the Rothkirch spoils participated in materialising? Stepping into Wrangel's library today, one finds books in green wooden cabinets fitted with grates, built in connection with an extensive restoration during the 1830s and 1840s. The paintings on the walls and ceilings in the library rooms were done at the same time. Here, the craftsmen took inspiration from Baroque decor but chose the lighter tones of the Empire style.[38] Today Skokloster Castle has seven library rooms, which house not only Wrangel's books but also the collections of Per Brahe the Younger, Nils Brahe the Younger, Erik Brahe, Carl Gustaf Bielke and Ulrik Scheffer. Each book collection also features a smaller bust portrait of its owner, painted on wood, dating from the eighteenth century. The rooms were named after different cities, such as Stockholm, Rome and Cologne; there used to be city views hung over the rooms' entrances, and a map of Cologne is still in place in the room that bears its name.[39] The library rooms are not the only ones in the castle named after cities, which is interesting considering the highly varied geographical origins of the collections of both books and other objects (see figure 19 on page 206).

The history of Wrangel's library at Skokloster is complicated by the other book collections transported there by later owners. Wrangel's books were catalogued together with those of Per Brahe the Younger as early as 1689, while the other noblemen's collections have with time been mixed on the shelves. When the Swedish Government became the castle's owner in 1967 an extensive reconstruction was begun, during which the books came to be organised according to their former collectors, and the collections were displayed on shelves according to the orderings in the old catalogues. In connection with this, books of uncertain provenance, having possibly belonged to either Wrangel or Per Brahe the Younger, were given a section of their own. The results of the reconstruction work show just over a fourth of Carl Gustaf Wrangel's original 2,400

(ed.), *Skoklosters slott under 350 år* (Stockholm: Byggförlaget, 2004), p. 55; Kylsberg, 'Den konstfulla', p. 227.

37 Several different types of handbooks are discussed in Lindberg, *Adelsböcker*, pp. 191–198.

38 Ove Hidemark & Elisabet Stavenow-Hidemark, *Eko av historien. Omgestaltningen av Skokloster under Magnus Brahes tid* (Stockholm: Byggförlaget, 1995), pp. 80–82.

39 Lena Rangström, Karin Skeri & Elisabeth Westin Berg, *Skokloster. Slott och samlingar* (Bålsta: Skoklosters slott, 1980), p. 67.

books available at the castle, where they have been stored since the 1660s.[40] These books are arranged according to Bütner's catalogue order from 1665, even though it is not certain whether this order was maintained for any longer time or if it was spatially implemented in the seventeenth century.[41]

In Conrad Bütner's catalogue the books are listed according to subject and format, from folio to duodecimo. First came theology, as usual, and then history, topography (including chronology and hydrography), mathematics (including civil and military architecture), law, scholastics (including philosophy, philology and poetry), iconography (including emblematics), medicine and economy (including landscaping). The last section was for Romance languages, a category that encompassed 428 items and reflected Wrangel's particular interest in collecting books holding French, Italian and Spanish texts. There was also an added category, *libri miscellanei*, containing subject-based unsorted books he had acquired after 1665. This addition was made by historian Samuel Pufendorf in connection with his evaluation of the books in 1681.[42] Versatility was an aspect of the elite ideal, and Wrangel subscribed to this through his collection. At the same time, however, the book collection's composition had specific characteristics that bear witness to Wrangel's own interests. Generally, it was foremost newly published books that interested him. This influenced his library's history section, which thus came to hold a remarkable number of contemporary war chronicles in which the campaigning master of the castle himself figured. This also meant that his book spoils could be relatively contemporary. There are examples of him coming across books through his spoils that were only a few years old. Wrangel also showed no interest in buying old books.[43]

40 Arne Losman, 'Tre rekonstruerade 1600-talsbibliotek på Skokloster', *Skoklosterstudier*, 1 (1968), pp. 227–232.

41 A spatial expression can be discerned in Bütner's handling of the Rothkirch spoils, however. In the section for the historical books, some of those in folio format have been catalogued as quarto, at the very end of the section for the latter. Most of these can be ascribed to the Rothkirch family. Meanwhile, in Chemnitz's catalogue from 1650 and in Wrangel's earlier catalogue from Pomerania in 1660, they were classified as folio. See Wr. hist. 4:0 96, 97, 98 and 103, SS; this corresponds to the titles in Chemnitz's catalogue *Bibliotheca Rothkirchiana equestris*; cf. also the catalogue from 1660, *Catalogus LIBRORUM illustrissimi comitis Caroli Gustavi Wrangelij* [...] 1660, E 8580, Skoklostersamlingen, RA Marieberg. A possible explanation for the changing interpretation of the books' formats might involve spatial conditions.

42 'Catalogvs Librorum in Bibliothecam [...] M.DC.LXV.', SS.

43 Arne Losman, 'Adelsbiblioteket som intellektuellt landskap', *Tvärsnitt. Humanistisk och samhällsvetenskaplig forskning*, 4 (1988), pp. 26, 35, 28; Losman, 'Vetenskap och idéer', pp. 85–86, 88–89.

Tellingly, today's preserved collection includes only one incunable and two manuscripts.[44]

Like the Uppsala case, the books were not the only things in Wrangel's library; however, there is very little information on how it was furnished in the seventeenth century. Bütner's catalogue mentions globes of the earth and the heavens, which had been placed among the books in the mathematics section by Samuel Pufendorf in 1681. Through this addition, he showed that the globes not only belonged with the books; he actually classified them as books. It is also possible to get a sense of how Wrangel's library was laid out spatially through later depictions. In 1709, artist, herald and antiquarian Elias Brenner described the library as consisting of two rooms, of which Wrangel's books are to have taken up one and Nils Brahe's the other. As Wrangel's and Per Brahe's books had been catalogued together around 20 years prior to this, it is not certain that Brenner was right that Wrangel's collection would have been stored separately. Brenner's description primarily focused on the manuscripts in the library rooms, 'on paper and parchment written in old times'. Wrangel's Koran occupied a special place among these, and was the individual object Brenner mentioned first. When it came to the room's decoration, Brenner noted two things: first and foremost, he observed the great number of maps and drawings of provinces and estates on the walls; and secondly, he was fascinated by a small mirror of the purest gold that 'represents all that before him comes'.[45] The mirror should be understood not only as an expensive and beautiful object, but also as a scientific instrument. The object's placement in the library can be linked to an earlier mentioned work from the Rothkirch spoils, Salomon de Caus' text *La Perspective avec la raison des ombres et miroirs* from 1611. The library thus held not only books but also objects that were clearly associated with them. Although the manuscripts were especially important rarities for Brenner, they were not, as mentioned, something Wrangel focused on in his collecting. Last but not least, here one could find, apart from the books, other objects and maps, a number of things with valuable geographical qualities that together mirrored and materialised the entire world.

44 Wr. teol. fol. 1, Wr. teol. 4:o 79, samt Wr. roman. 2, ss; regarding the latter, see Oscar Wieselgren, 'Skoklosterhandskriften av Vasco de Lucenas Curtius-parafras', *Nordisk tidskrift för bok- och biblioteksväsen*, 12 (1925), pp. 81–92.

45 Elias Brenner, Skoklosterbeskrivning, Palmskiöldska samlingen 276, UUB, pp. 551–552.

7 Discrepancy in the Descriptions and Numbers of Wrangel's Book Spoils

Following the Rothkirch spoils from Wrangel's list to the book catalogues is not entirely straightforward. The lists and catalogues do not offer much more information than a short title and author name. The Rothkirch children's teacher, Chemnitz, was comparatively more detailed than the servant who listed Wrangel's spoils; unlike Johannes Bureus' lists of the spoils from Prussia, here there is in principle no information on the books' material properties, other than notations of format. Among the texts in folio format, however, 'a beautiful writing book' is noted, one of the few times an object's material qualities are described; this also seems to be the reason it was taken as part of the spoils.

In the catalogue of Wrangel's books that was composed in Pomerania in 1660, the reader is again confronted with short titles, while information on place and year of printing is seldom included. In Bütner's catalogue from 1665, however, the latter have typically been noted. Besides format, there is very little information on the books' material properties in the catalogues from 1660 and 1665. As it was different people who composed the lists of the spoils and the catalogues of Wrangel's book collections, even the titles are referenced differently. Therefore, based on Wrangel's catalogues it is often impossible to know whether a book belonged to the Rothkirch spoils when comparing the sources. How elusive, to use the language of Daniela Bleichmar, spoils and books could be is exemplified through the folio book *Atlas Major*, a work in five parts that Wrangel selected from the Rothkirch collections. Chemnitz's catalogue, however, lists no *Atlas Major*, among either Wenzel Rothkirch's books or those kept in the school.[46] It is likely that the work corresponded to the description *Atlas Maior Novus illuminatus*, as Bütner called it in 1665. The work is no longer in the Wrangel library today.[47] The discrepancy between the catalogues' different descriptions of the books links to the previous chapter's discussion about there being no standardised way of cataloguing books during this period. Instead, each list and catalogue told something about the librarian's or official's knowledge perception in relation to the objects and the room.[48] The different lists that have figured in this book's case studies demonstrate exactly this; it is a

46 Bleichmar, 'Seeing the world', pp. 19–20.
47 Cf. *Bibliotheca Rothkirchiana equestris*, E 8580, Skoklostersamlingen, RA Marieberg med Wr. topo. fol. 7, *Catalogvs Librorum in Bibliothecam* [...] M.DC. LXV., SS.
48 Losman, 'Vetenskap och idéer', p. 86.

matter of a number of variations on how archive documents, books and other objects could be handled, sorted and made understandable.

What was the proportion between book spoils and the other books Wrangel had bought, been given, or inherited? The discussion of Johannes Bureus' Prussia lists in the previous chapter revealed that hundreds of the books that had come from Prussia were never registered in 1626–1627. In the example of the Wrangel library, it has been possible to study each individual book and deliberate over how that volume might have come into his possession.[49] The aim of this case study is not to classify and count spoils of war, but rather to examine their meanings and effects at Wrangel's Skokloster. During the review of the collection as a whole, however, it came to light that there are indeed many spoils among the books preserved at Skokloster.

Today, Wrangel's book spoils sit on the shelves mixed in with books that the Field Marshal inherited, bought or received as gifts. Quickly perusing the books' spines, it is impossible to tell the difference between what were once spoils and what was acquired in some other way. To determine how a book joined the collection, in most cases you would have to look for traces of previous ownership on the insert or binding. Thus, by identifying who owned the book before Wrangel, it is possible to determine whether or not it is a matter of spoils. In some cases, factors like material, form, printer, impressum or subject area can indicate whether a book was once taken as spoils. And in a couple of cases there are written sources to help: Wenzel Rothkirch's catalogue is of course an excellent example of this. In the National Archives, there is even a list that mentions the content of the Polish books in the chests in Stralsund as another example of Wrangel's taking of spoils of knowledge.[50]

Still, it is often difficult to say with absolute certainty just what among Wrangel's book collection was, and is, spoils. Even in cases of foreign provenance notes, it is not clear whether the book was taken as spoils as it could just as well be a matter of inheritance or a gift. To complicate things even further, there are books in Carl Gustaf Wrangel's collection that were taken as spoils by his father, Herman Wrangel, which his son then inherited. And in the previous chapter, Johannes Bureus' list of the spoils from Prussia showed how book

49 The reasoning around the spoils in Wrangel's book collection is based on the review of the collection I discussed in the introduction. The work was done in 2011 and 2012, and I had help from Skokloster's librarian at the time, Elisabeth Westin Berg, who also took part in conducting the inventory in the 1970s.
50 'Inventarium von den Polschen Büchern/Cathalogus der Büchern in den Kasten zu Stralsund', E 8580, Skoklostersamlingen, RA Marieberg.

spoils could be immediately given away as gifts. The histories of the books and the spoils continue to be complicated as they move and are transformed.

It has been estimated that among all the books kept at Skokloster today, in other words not only Wrangel's, around 20% are spoils.[51] Wrangel's books at Skokloster amount to a good quarter of the original 2,400.[52] The theology section is a particularly rich example of this: according to the 1665 catalogue, 234 items were classified as theology; 72 of these, that is, just under a third, remain in the collection today, and among them at least 55 are most likely spoils. This means that around 76% of the preserved theology section consists of spoils, which is considerable and much more than 20%.[53] While the number of spoils in the other sections is generally lower, the law section also has a relatively large number. It is not possible to know what the relation between book spoils and other books would have looked like if all of Wrangel's book collection had been preserved at Skokloster. Taken together, all this is important to include in the history of the book collection.

The preserved book spoils are represented in all formats in the collection. Wrangel chose not only the large, magnificent works as spoils but also the smaller formats, which often contain print of more everyday character; it can be a matter of prayer books or other edifying literature, for instance. The spoils' bindings could also have different appearances, from grand textile bindings in silk or velvet to comparatively more plain, utilitarian bindings of paper or parchment. While some of the books were already well used and filled with notes when they became spoils, others, despite their old age, are to this day in mint condition despite their risk-filled adventure through Europe. The first item in the catalogue from 1665 is Hartmann Schedel's famous Nuremberg Chronicle (*Liber Chronicarum*, printed in 1493). This incunable, today relatively well worn, was taken as spoils in the Bavarian city of Eichstätt, where it had once belonged to a town clerk by the name of Moritz Hagenbeucher. Likely due to the Chronicle's grand format, Bütner placed it, slightly unconventionally,

51 Rangström, *Krigsbyten*, pp. 4–5. In the 1970s, Arne Losman gave a preliminary figure of 40% concerning spoils among Wrangel's books, but in more recent estimates this figure has been reduced. See Losman, 'Vetenskap och idéer', p. 84.

52 Elisabeth Westin Berg, 'Krigsbytesböcker i biblioteken på Skokloster', in S. Nestor & C. Zarmén (eds.), *Krigsbyten i svenska samlingar* (Stockholm: Livrustkammaren, 2007), 109–111.

53 Librarian Elisabeth Westin Berg has noted that the number of spoils in the theology section in Wrangel's library was higher than in the other sections, and mentions 29 (of 72) items as clearly being spoils. See Westin Berg, 'Krigsbytesböcker', p. 111. Through my research I have been able to increase this number, in consultation with Westin Berg.

before the folio bibles in the catalogue order.[54] Last on the list of the preserved books, in the section for Romance languages, is Jean de Serres' *Inventaire general de l'histoire de France* (1603).[55] The book, part of the spoils Wrangel took in Denmark, had once belonged to Fredrik von Barnewitz. Today, von Barnewitz's signature is one of the most frequently occurring spoils provenances in the Wrangel library. An almost humorous example of plunder can be found in the history section, where the book in question has been given an ownership incantation that reads 'this little book is mine and whoever takes it, that person is a thief'.[56] This book is another example of Wrangel's Danish spoils, and while he seized it in accordance with the laws of war, the person who lost it likely felt robbed as it was transported away.

It is unfortunately impossible to search for spoils or calculate their number among the books that disappeared from Skokloster after Wrangel's death, as the catalogues and other records of them do not offer enough information. Thus, it is crucial to acknowledge the value of the material evidence preserved in the Wrangel library's green book cabinets, as it reveals information on Wrangel's collecting activities that cannot be found in the written sources. While these volumes as material sources carry with them their own set of problems, they can be used to add nuance to the picture of the collections' composition that has been presented in previous research on Skokloster. The proportion of spoils in the Wrangel library is greater than 20%, and it is important to point this out as it effects the view of the collection's history.[57] Wrangel's spoils did not form the foundation of his book collection in the same way as in Uppsala, and he did not confiscate entire collections. However, in contrast to what previous research has claimed, Wrangel's plundering was not insignificant to his collecting; rather, considering his specific choices of works, it is possible to argue that it was especially meaningful.

54 See Wr. teol. fol. 1, ss, and in *'Catalogvs Librorum in Bibliothecam* [...] M.DC.LXV.', ss; cf. Taylor (ed.), *Advice*, p. 65.
55 Wr. roman. 426, ss.
56 'Dieses Büchelein ist mein, der sie nimbt der ist ein Diebe', English translation based on my Swedish translation, Wr. hist. fol. 70, ss. The book is a German version of the poet Sadi, *Persianischer Rosenthal*, printed in Schleswig in 1654.
57 In connection to the inventory made of Wrangel's book collection in the 1970s a highly ambitious catalogue was created, containing detailed descriptions of each object, including descriptions of bindings, information on previous provenances, etc. This catalogue regards the books as objects, and is an excellent source of help to anyone wanting to conduct book history research. The main aim of the catalogue was indeed not to classify the books as spoils but rather to inventory them. To my knowledge, my study of Wrangel's books is the first in which the main focus is to analyse plunder.

8 *Bibliotheca Selecta, Spolia Selecta*

Up to now, this chapter has shown how Wrangel's Rothkirch spoils corresponded to his selective way of collecting objects of knowledge in general. In what follows, Wrangel's book collecting and spoils will be analysed in relation to the library ideals of his time. Conrad Bütner's work with Wrangel's books at Skokloster suggests that he was both meticulous and had good knowledge of contemporary continental classification practices, categorising Wrangel's book collection into more than the four sections of the comparatively old-fashioned faculty system. But while all imaginable subject areas were represented, to be sure, Wrangel's approximately 2,400 volumes could not hold a candle to a prominent collector like Magnus Gabriel De la Gardie, who had over 8,000 volumes in his library.[58] Wrangel's book collecting was also not characterised by the quantitative strivings according to which De la Gardie or Gustavus Adolphus and the consistory in Uppsala worked. Rather, Wrangel's guidelines seem to have been encyclopaedic with moderation. When Laurentius Tolfstadius and his colleagues organised Uppsala University Library, among other things they used a Jesuit library arrangement as a template. In Wrangel's case, it is instead relevant to place his book collection in relation to Gabriel Naudé's popular advice from 1627 for establishing a library. While Naudé's manual was not among Wrangel's books, there are obvious commonalities between Naudé's advice for a library's composition and Wrangel's book collection. Wrangel and his librarian can hardly have been unacquainted with the work: Naudé was one of the seventeenth century's most influential librarians, having worked for the famous French Cardinals Mazarin and Richelieu as well as the Swedish Queen Christina.[59]

The three themes around which the Rothkirch spoils were earlier discussed all had counterparts in the collection practices Naudé recommended. According to him, the book collector should be open to works of different faiths; not even books written by heretics and their followers were to be passed over. In this regard, Naudé, being Catholic, particularly mentioned books by scholars in the tradition of Luther and Calvin. As Protestant scholars were schooled in the three biblical languages as well as philosophy and theology, Naudé argued that their texts could be relevant. If the reader could just disregard the burning matters of dispute, impartial knowledge could be found here. The collector also need not avoid the Talmud or the Koran, even though Naudé

[58] Losman, 'Vetenskap och idéer', pp. 82, 86.
[59] Nilsson Nylander, *The mild boredom*, pp. 56, 59, 63.

regarded these as more dangerous than the works of the Protestant thinkers.[60] Under the heading 'Selecting the Books', Naudé stressed the importance of collecting the greatest and most important writers, and in different languages. The bibles should be in Hebrew, the Church Fathers in Greek and Latin, and versions translated into the vernacular should also be included. Naudé thus advocated owning different versions of the same work, and the effect of this advice can be seen in Wrangel's collecting. Naudé also recommended collecting new books, holding that it was more important to spend one's money on books that were useful in the library than on those that were beautiful, for instance manuscripts, illustrated histories, or Chinese and Japanese books printed on parchment or coloured paper.[61] While he did not explicitly speak of the utility of practically oriented works, having new and useful books in one's library was something Naudé held to be important. Seen against the background of Naudé's manual, not only the small number of manuscripts but also the many handbooks in Wrangel's book collection are more than understandable.

According to the seventeenth-century ideal, a universal library should be comprehensive in its contents, and Naudé indeed recommended a book collection that spanned all known knowledge. At the same time, he claimed that the strive for completion should never be at the cost of the collection's quality.[62] The book collector was to be exceedingly careful in choosing the right books, and here Wrangel and his librarians seem to have followed Naudé's suggestion. In this way, Wrangel's book collection can be seen as a sort of Protestant variation of a *bibliotheca selecta*, which makes his book spoils *spolia selecta*, his selected spoils. With this play on words I am relating Wrangel's case and Naudé's manual to one of the most famous and confessionally coloured battles in library history: that between the selected and the universal library. In 1593 Jesuit Antonio Possevino issued *Bibliotheca selecta*, or the selected library, a bibliographical overview intended to spread the books of the Catholic Reformation. In the overview, Possevino listed the books he believed were right, and thereby desirable, to collect in a good library. The bibliography was a complement to the Catholic Church's equally famous index of forbidden books. *Bibliotheca selecta* was in turn involved in controversial debate with Swiss Protestant Conrad Gesner's universal bibliography from 1545. Gesner's ambition was to list all the books that had ever been published.[63] Possevino's

60 Taylor (ed.), *Advice*, pp. 26–28.
61 Taylor (ed.), *Advice*, pp. 20–25, 29–30, 56. Naudé was not negative to manuscripts, however, asserting that they in fact should be found in one's library; cf. pp. 43–45.
62 Taylor (ed.), *Advice*, pp. 14–15, 18–19, 20; cf. Šamurin, *Geschichte*, p. 146.
63 Balsamo, *Bibliography*, pp. 2, 60–62.

selected library was a direct reaction to Gesner's idea that all knowledge could be collected and compiled in one bibliography. *Bibliotheca selecta*, was thus associated with the Catholic faith while Gesner's universal library was linked to Protestantism.[64] That book collecting and libraries were practised in a more nuanced way than this, at least in the Swedish Empire, is demonstrated through my case studies. The circumstances that created the university library in Uppsala and Wrangel's library highlight that the collecting practices among the Swedish elite were in no way uncomplicated when it came to the collections' confessional knowledge content, not even in the highly orthodox Lutheran state.

9 Wrangel's Armoury and the Rothkirch Spoils

Elias Brenner's story from the early eighteenth century shows that it was not only books but also a mirror and various maps that were integral parts of the Skokloster library, not to mention how these objects were linked to each other. To approach the narratives that the spoils and collections at Skokloster materialised, the objects in the library need to be understood in relation to the castle's other collections. This especially applies to the collection Wrangel most treasured: the armoury. While this study is primarily occupied with Wrangel's spoils of knowledge, it should be stressed that, as a collector, his greatest focus was on weapons.[65] The following will therefore shed light on the armoury and the part of the Rothkirch spoils that was incorporated into it.

When Carl Gustaf Wrangel composed his last will and testament in 1673, only one item among his spoils was mentioned explicitly. It was a silver service he had taken from his enemy at the time, Archduke Leopold Wilhelm of Austria, during the battle at Leipzig in 1642. According to Wrangel's will, the service, along with the armoury, was to be eternally preserved at Skokloster in memory of the master of the castle, thus explicitly underlining that the armoury was Wrangel's most favoured collection.[66] The armoury, with over 4,000 objects, and a comparatively smaller silver service were consequently the items Wrangel himself selected to be his legacy: his war museum. While the armoury has in fact been preserved according to his wishes, the silver

64 Zedelmaier, *Bibliotheca universalis*, pp. 3, 10f.
65 Meyerson & Rangström, *Wrangel's armoury*, p. 17.
66 Cf. concept E 8252, Skoklostersamlingen, and matching copy E 8100, Rydboholmsamlingen, RA Marieberg; the will is discussed in Meyerson & Rangström, *Wrangel's armoury*, pp. 9, 11.

service disappeared from Skokloster at some point during the centuries that followed.[67]

Wrangel's weapon collecting can easily be followed from 1644 onwards. In 1653, he and his wife moved a significant part of the collection from Wolgast in Pomerania to Stockholm. Before the construction of Skokloster Castle was complete, his weapons were stored along with other objects in the older mansion (*Stenhuset*); that is, the building that served as Skokloster's manor before Wrangel had his big castle built. The objects were to be stored in chests, barrels and boxes, which according to Wrangel's instructions were not to sit directly on the floor and be exposed to moisture. At regular intervals and as the weather permitted, the objects were to be taken out and aired in the sun.[68] Wrangel's instructions are reminiscent of the care of *Codex Argenteus* at Uppsala University Library at approximately the same time. Wrangel had an armourer employed at Skokloster as early as the 1650s, who was also responsible for the other precious objects, such as the book collection. The armourer was primarily to see to it that the weapons were maintained, so that they did not rust or simply disappear. He was also the person who lived at the castle year-round, which meant that he was the one who was constantly in contact with the collections.[69] Through the will, the establishment of a specific post, and detailed instructions for care, Wrangel showed that his weapon collection was extremely important to him.

To this day, Wrangel's armoury takes up three rooms in the castle's southwest corner. The collection has been stored here since 1669, and the objects are arranged according to an inventory from 1710. Just as with his book collecting, the Field Marshal was interested in new things and the very latest technology when buying weapons for his armoury. And just as with his book collection he received weapons as gifts, as well as inheriting a number of them from his father, Herman Wrangel.[70] For the most part Wrangel's armoury naturally contains weapons, but the rooms were also composed to serve as an art chamber or cabinet of curiosities: objects that in the seventeenth century would have been described as exotic (and that were typically non-European), architectural models and *naturalia* were preserved here as well. These items included a chest containing North American indigenous objects, a kayak from Greenland,

67 Rangström, *Krigsbyten*, p. 7.
68 Meyerson & Rangström, *Wrangel's armoury*, pp. 39–41.
69 Bengt Kylsberg, 'Seklers vård av Skokloster', in *Bevarandets hemlighet. Konsten att vårda, förvara och konservera* (Stockholm: Livrustkammaren, Skoklosters slott och Hallwylska museet, 1991), p. 101.
70 Meyerson & Rangström, *Wrangel's armoury*, pp. 51–54.

a miniature model of the castle and various types of animals, including a blowfish.[71] There are even some Danish chests preserved here, themselves spoils, which had likely been used to transport other booty.

When Wrangel took weapons as spoils, he did this in the same studious way as when he took books. The armoury contains a number of objects that had belonged to Wenzel Rothkirch, but which do not seem to have been listed when they were made into booty; if they were, those lists have been lost to time. These objects include a pair of wheel-lock pistols carrying Wenzel Rothkirch's initials, as well as a jousting shield with the text *Amor mihi astrum* ('Love is a star to me'). The shield is centrally placed over one of the doors between the armoury's rooms.[72] It was associated with an important event in the Danish royal family's history, the marriage between Christian IV's son Prince Christian (who never became king) and Princess Magdalena Sibylla of Saxony. The wedding was incredibly lavish, and went on for several weeks in Copenhagen in 1634 (see figure 20 on page 207).[73]

As mentioned, Wrangel selected several books on weapons and the art of war from the Rothkirch book collection, as well as chronicles mentioning the histories of the Danish kings. A portrait of Danish King Christian IV lying in state, taken as spoils during the same war, also hangs in Wrangel's library to this day. The version of de Pluvinel's *Le Maneige Royal* that Wrangel chose from the Rothkirch estate was dedicated to the same Danish King. Considering that Wrangel already owned a version of *Le Maneige Royal*, a relevant question would be whether it was precisely the connection to this Danish King that made him choose the same work twice.

The spoils in Wrangel's library and armoury were thus intertwined with each other, and together participated in the creation of a field marshal's war museums. De Pluvinel's *Le Maneige Royal* embodies the complexity of Wrangel's spoils. This was the type of book Wrangel typically bought; but the copy he selected from Rothkirch's collection had a genealogical quality due to its association with the Danish King and his equerry. Therefore, it is appropriate to consider the other side of Wrangel's collecting of spoils, which shows how his spoils were chosen based on their histories, genealogical connections and geographical origins. In order to do this, I take hold of Skokloster in its entirety and

71 Mårten Snickare, 'The king's tomahawk. On the display of the Other in seventeenth-century Sweden, and after', *Konsthistorisk tidskrift/Journal of Art History*, 80 (2011), pp. 124–125, 129.
72 Rangström, *Krigsbyten*, p. 19.
73 Mara R. Wade, 'Emblems in Scandinavia', in A. J. Harper & I. Höpel (eds.), *The German-language emblem in its European context. Exchange and transmission* (Glasgow: University of Glasgow, 2000), p. 27.

analyse the castle and Wrangel's spoils in the light of the seventeenth century's encyclopaedic princely collecting traditions.

10 Art Chambers, War and Genealogical Spoils

In Wrangel's time, rulers and people of means collected unusual and expensive objects in an encyclopaedic fashion in order to create museums, art chambers, cabinets of curiosities: all synonyms for microcosms that reflected the macrocosm.[74] However, the early modern understanding of this conception should not be interpreted as an intent for the collection to represent the macrocosm in its entirety. Rather, it was a variety of things described as curious, rare or particularly valuable that were desirable to collect. The princely collections also expressed the special interests of the collector, which has been pointed out in the case of Wrangel's library and armoury.[75] Lena Rangström and Åke Meyerson, in their analysis of Wrangel's weapon collecting, have discussed various people who might have inspired him. Wrangel visited Paris in 1631, and may have been impressed there by stories of French King Louis XIII's enthusiastic weapon collecting. Firearms were of particular interest to the King, and he even repaired and maintained them himself. Wrangel was also aware of Joseph Furttenbach's museum in Ulm, a quite well-visited attraction around the mid-seventeenth century. On the fourth floor of Furttenbach's residence was an armoury, an art chamber and a library.[76] Another case worth discussing in more detail is that of Maximilian of Bavaria's collections in Munich, which Wrangel saw during the Thirty Years War. Here, three generations of princely collecting were housed under a single roof. The project had been started by Albert V through his establishment of an art chamber, and the first known museum manual was developed through work with these collections, published as *Inscriptiones* (inscriptions) by Samuel Quiccheberg in 1565. The author had visited many other famous collections of his time, and also served as a librarian. The manual is relevant because it captures the early modern era's princely collecting habits overall, even though it seems as if the handbook itself was not particularly widely known at the time.[77] Wrangel came in direct contact with the ideas of Quiccheberg, then, since the former experienced the

74 Brenna, 'Tidligmoderne samlinger', p. 30.
75 Daston & Park, *Wonders*, pp. 266, 272.
76 Meyerson & Rangström, *Wrangel's armoury*, pp. 17–18, 20–24.
77 Quiccheberg, *The first treatise*, pp. 36–37; cf. Daston & Park, *Wonders*, p. 272. The latter authors assert that Quiccheberg's work is more known among contemporary historians than it was among early modern collectors.

collections in Munich that had once served as the basis for Quiccheberg's manual. Some of the objects from the art chamber in Munich would even become Gustavus Adolphus' spoils, and it was these objects, among others, that Charles Ogier described in the story that began this book, from his visit in 1636 to the royal treasury at Tre Kronor Castle.

What kind of collections did Quiccheberg work to immortalise, then, which Wrangel later visited? The art chamber comprised a number of rooms where the Duke could receive visitors, for instance ambassadors and traveling noblemen, and display his wealth. According to contemporary descriptions, crocodiles and tortoises hung from the ceiling while antique sculptures, minerals and coins had been placed on tables alongside tools and machines. On the walls hung portraits and, not least, trophies.[78] The latter were surely hunting trophies and souvenirs collected during the Duke's travels.[79] However, considering the rich meanings of the concept of trophy, it is possible that the word also referred to spoils, from both the battlefield and other contexts. As members of the elite collected things by taking spoils, most princely art chambers at the time must have contained booty. The royal collections in Warsaw, for example, included a helmet that had been taken from the Russian czar in the 1610s, and that King Charles X Gustav's men in turn took as spoils in 1655.[80] The Danish kings' art chamber housed Turkish war trophies among other things, and the doctor Ole Worm had a crystal reliquary in his collection, which had come to him as a piece of spoils.[81]

Quiccheberg's museum instructions had clear spatial prescriptions by which he arranged the art chamber's rooms and logistics based on how the prince held court. There should be room to use but also store and display the collections. He dedicated a specific section of the manual to the furniture and containers to be used for displaying and preserving the collections in the best way: through tables, cabinets, chests and boxes.[82] The accessibility of the collections and storage were thus essential themes for him, just as bookshelves took up more than half of the pages of Jesuit Claude Clement's instructions *Musei sive bibliothecæ* from 1635. Quiccheberg highlighted five classes of

78 Brenna, 'Tidligmoderne samlinger' p. 31.
79 Quiccheberg mentions *spolia* once in the manual, in connection with coats of arms as something painted or depicted: *tum et arma et spolia picta*. With this, according to the translator, he was referring to a type of painted family tree that members of the elite collected during their travels. See Quiccheberg, *Der Anfang der Museumslehre*, pp. 74–75; cf. Quiccheberg, *The first treatise*, 2013, p. 70.
80 Nestor, 'Krigsbyten i Livrustkammaren', pp. 62–64.
81 Mordhorst, *Genstandsfortaellinger*, pp. 121, 259–261, 284–285.
82 Quiccheberg, *The first treatise*, pp. 72–73.

objects that he saw as being most worthy of collecting, and described how they were connected to the collector. The first class, *representatio principis*, contained objects that represented the prince, including his or her economic or military accomplishments. In Albert v's case, faith was given a great deal of space, as he was the first Bavarian ruler to practise *cuius regio, eius religio*; that is, the person who rules the realm decides its religion. Albert actively used his collections to promote Catholicism. The self-reflecting category included a geographical subcategory which was to contain, for instance, maps of large territories and models of cities. Warfare was another subcategory, and this is where the ruler's armoury entered the arrangement. Quiccheberg wrote of two types of armouries: one for ceremonial weapons and one for those that could be used in battle. The last object type in this first category was miniature models of machines.

The second main category consisted of three-dimensional artefacts, for example sculptures, metal works, so-called exotic objects (typically non-European), coins, medals and vases; here, the antique was mixed with the contemporary. The third category was comprised of *naturalia*, objects created by nature: animals, plants, metals and stones. This category generally followed Pliny the Elder's significant work in natural history. The fourth category contained various types of tools and instruments for activities such as mathematics or music. Included here were also the things one needed to paint and write, and even the equipment necessary for printing a book. The category also included clothes that held important historical or genealogical meanings, for instance the clothing of an ancestor of the collector. The fifth class comprised two-dimensional artefacts such as paintings, print, maps, coats of arms and wall hangings, as well as these artefacts' storage.[83]

According to Quiccheberg, the prince's self-representation was the museum's first and thereby most important part. In comparison to Albert v, Wrangel was more interested in his own military accomplishments than in the confessional battles of the seventeenth century, although the latter were not completely unimportant to him. As discussed earlier, Wrangel selected his armoury and a silver service, spoils fresh from the battlefield, for his own self-representation. But his armoury contained not only weapons but also many of the other things that Quiccheberg held were important to collect. In the armoury at Skokloster, all these objects, not least the spoils, materialised Wrangel's biography and in this way served as the Field Marshal's self-representation. Alongside the important self-representation, the art chamber was also to house objects representing genealogies; that is, things collected from everywhere, including portraits

83 Quiccheberg, *The first treatise*, pp. 14–22, 62–71.

of great men, coats of arms and trophies. The analysis in Chapter 2 showed how the Mitau documents were subsumed under the Vasa kings' genealogy, and that spoils that were not possible to insert into the kings' histories were harder to handle. At Skokloster, spoils of genealogical importance functioned differently, whether they were in the library or the armoury or somewhere else among the castle's rooms. They were firmly placed into Wrangel's history, but did not become parts of his genealogy. These spoils were instead allowed to keep their indigenous genealogical and geographical identities. There was no conflict between their background and the self-representation Wrangel and those around him were interested in creating. The history that Wrangel, his wife and their officials made possible by collecting and organising objects was not based on a long genealogical timeline; instead, Wrangel's narrative was focused on his own lifetime. For instance, for the most part he avoided motifs of patriotic Gothicism (*Göticism*) in Skokloster's decor.[84] Archduke Leopold Vilhem's silver service from the latest battle at Leipzig was to be preserved, as it was an especially meaningful object for Wrangel's history, spoils from a battle that had been his first great victory, not to mention having been taken from an Austrian Archduke.[85] In Wrangel's library, it was primarily seventeenth-century history that was represented. For instance, he collected the contemporary chronicles from the publishing house Merian, in which his own accomplishments on the battlefield were depicted.[86] In one case, the Field Marshal was able to stop the distribution of a contemporary historical work that spoke of his own contributions in less flattering terms. In other words, it was not only Wrangel's image at Skokloster that he wished to control but also that in the surrounding world.[87]

While much of what Wrangel selected for his library entailed new and current books, the spoils he took could be older than the typical books he acquired through his booksellers. Whereas de Pluvinel's *Le Maneige Royal* had indeed been printed in the seventeenth century, the copy's previous owners and dedication may have been what made it desirable to collect as an item of spoils. Old book spoils, such as Hartmann Schedel's famous Nuremberg Chronicle (*Liber Chronicarum*, 1493) or the manuscript telling of the accomplishments of Alexander the Great (*c.*1450), were important to Wrangel's book collecting, but not foremost as old objects; quite the opposite. For Wrangel these spoils told of the present, as he had collected them in the wars and thanks to the wars. There

84 Gothicism was an intellectual movement that claimed that the Goths had originated Sweden, see Johan Nordström, *De yverbornes ö. Sextonhundratalsstudier* (Stockholm: Bonnier, 1934), pp. 55–76.
85 Meyerson & Rangström 1984, *Wrangel's armoury*, pp. 25–26.
86 Losman, 'Vetenskap och idéer', p. 88.
87 Losman, *Carl Gustaf Wrangel*, pp. 210–212.

is another case of book spoils in Wrangel's library with genealogical qualities that should be brought to attention. Last in the list of the Rothkirch spoils, a small 'script and prayer book in sextodecimo' is noted. While this description is far too unspecific for this copy to be traced in later transactions, Wrangel's book collection contains a number of small prayer books that were made into spoils in Denmark. Some of them have been bound in beautiful personal bindings with cover decorations on which the previous owner's initials are visible, and some have longer provenance notes, telling where and from whom the owner received the book. These small books' owners have sometimes written in them their family history, just as Wrangel and his wife Anna Margareta von Haugwitz wrote their history in the Wrangel family bible. The Danish prayer books often had female owners, and seem to have been passed on generation to generation. At least two of those still at Skokloster today belonged to a Berete Knutsdatter (see figure 21 on page 208).[88]

The prayer books contain explicit traces of reading and personal religious practice, filled with margin notes and underlining.[89] These objects were family treasures to their initial owners, small memorial albums filled with the owners' own history; this history was thus taken over by Wrangel through his plundering. In his book collection, the prayer books were transformed into marks of his victories. They became spoils as well as trophies, as with the silver service. Prayer books and silverware alike participated in making the story of the successful Field Marshal Wrangel who did not look all too far back in history but was rather fully occupied with making an impression in his own time. At Skokloster, book spoils with genealogical qualities, along with the silver service, Wenzel Rothkirch's weapons, the jousting shield and the portrait of Christian IV, materialised the collections', and thereby Wrangel's, greatest triumphs.

11 Skokloster's Geography

When Wrangel collected spoils with clear genealogical properties, he was thus following the ideals expressed in Quiccheberg's manual: the master of Skokloster chose objects with genealogical qualities by plundering during

88 Wr. teol. 8:o 47:1–2; Wr. teol. 12:o 23; Wr. teol. 12:o 46, ss. In one of the books the owner's name has been cut out, a phenomenon I will return to below.

89 Mari Eyice has analysed religious experience in sixteenth-century Sweden, drawing on these kinds of prayer books and the notes made in them; see Eyice, *An emotional landscape*, pp. 49–50, 54ff.

the wars. Another clear theme of Quiccheberg's, which is interlaced with the genealogical, was the object's geographical origin. Geographical properties and variations in origin were undoubtedly the foundation of all early modern collecting. This book has shown that the spoils' geographical qualities were something that was stressed in all examples, from Mitau and Riga in Livonia to Braunsberg and Frauenburg in Prussia. The analysis of the spoils in Wrangel's war museums will conclude by considering the castle building and how geographical features and movements of materials, things and people contributed to creating the castle. In the construction of Skokloster, various geographical metaphors, objects and orderings were of central significance. As discussed, Wrangel filled the castle's rooms with books from across Europe and with objects from around the world. He was interested in owning books that contained geographical knowledge, and was curious about foreign continents and countries. Among other things, he acquired the Jesuit scholar Athanasius Kircher's famous work on China and, among the books he took from the Rothkirch collection was an *Atlas Major* in five volumes.[90] Interestingly, in his handbook, Quiccheberg described the library's ordering with the help of geographical metaphors.[91] Skokloster's exceptional position among Wrangel's estate became increasingly prominent over the years. At his residence in Stralsund there was, or at least there were plans for, a ceiling mural in which Skokloster stood at the centre of the world's history.[92] In Wrangel's lifetime, the Bavarian castle Aschaffenburg (1605–1614) was referred to as the architectural inspiration for the Swedish castle; Wrangel and his forces had captured Aschaffenburg in 1646 along with French General Turenne.[93] But Skokloster shares even greater architectural similarities with another castle from the early seventeenth century, Ujazdów in Warsaw, which Polish King Sigismund completed in 1624 for his son Vladislav.

While Wrangel may not have had the possibility to study at the finest universities of Europe, through the wars he was instead able to see, experience and learn from magnificent residences and their collections. According to Wrangel's personalia as early as 1627 he accompanied his father Herman Wrangel in the field campaign in Prussia, where the father served as commander. As discussed, Wrangel was there when Gustavus Adolphus captured Munich in 1632, and was thereby able to come into contact with the Bavarian

90 Losman, 'Vetenskap och idéer', p. 89; *Bibliotheca Rothkirchiana equestris*, E 8580, Skoklostersamlingen, RA Marieberg, p. 36.
91 Quiccheberg, *The first treatise*, p. 71.
92 Losman 2004, p. 55.
93 Arne Losman, 'Wrangel, Skokloster och Europa', in E. Westin Berg (ed.), *1648 Westfaliska freden* (Katrineholm: Vasamuseet, 1998), p. 74.

dukes' art chambers. He may also have participated in the confiscation of objects from Rudolf II's famed art chamber in Prague.[94] The examples of Munich and Aschaffenburg show how, for noblemen, war could serve as a sort of violent grand tour. War provided geographical and spatial experiences and knowledge of the enemy's great collections. Just like the elite's typical (and peaceful) grand tours, war offered the possibility to collect, to take spoils, place them in chests and carry them home.[95] Returning to Naudé, his library manual stressed that books were to be acquired during trips. In connection with this, he continued by describing how a cunning person could be strategic and seize books that were moved.[96]

Skokloster, then, materialised Wrangel's bellicose life history, through varied but select content, as well as through the castle's overall architectural form. In the castle's architecture, decor and furnishings, various geographical themes were intertwined with the help of the collected objects, the workers who did the constructional work and the very material they used. While the exterior was completed between 1654 and 1668, the work on the interiors took more time; indeed, some of the castle's 80 rooms have never been finished. Seventeenth-century construction scaffolding and tools remain in some of the largest guest rooms and a large banquet hall to this day. The materials used for the building itself included brick and iron from the Uppland area, copper from the Swedish region of Dalarna and limestone and sandstone bought on the island of Gotland, while oak was shipped from Pomerania, just like the glass used for the castle's windows. The glazed roof tiles came from Amsterdam, and the marble for the portico came all the way from Italy. Even the workforce, the men and women who performed the hard, heavy labour, was brought in from different places. The foundation was dug by men from Dalarna, while the heaviest work was done by hired soldiers and women.[97] When it eventually came time to see to the decorations and park construction, stonemasons, stucco workers, painters and gardeners were brought in from Pomerania, Hessia and Italy. Without their knowledge and material from both local and geographically distant places, it would not have been possible to create Skokloster as

94 Losman, *Carl Gustaf Wrangel*, p. 16; Meyerson & Rangström, *Wrangel's armoury*, pp. 18–19, 27–30.
95 For the foreign educational travel undertaken by the Swedish nobility in the seventeenth century, see Winberg, *Den statskloka*.
96 Taylor (ed.), *Advice*, pp. 50–51.
97 In 1655, the construction was nearly ceased due to a threat of strike by the soldiers. They had just realised that they were earning slightly less than the women; the conflict was solved, somewhat reluctantly on the part of their employer, by raising the men's salaries. See Losman, 'Skokloster', p. 88.

Wrangel envisaged.[98] Skokloster's materialisations of the globe were further strengthened by naming the castle's rooms after various cities of the world.

Over the centuries, Skokloster has been described as a gigantic cabinet of curiosities, a theatre of memories and a field marshal's family estate. This last description came from a German visitor in the 1670s.[99] But to grasp Wrangel's collecting of spoils, including those of genealogical and geographical meanings, Skokloster can also be viewed as a genealogy chart, a sort of memory album that was popular among the nobility of northern Europe during the seventeenth century. The Swedish word for it, *stambok*, comes from the German *Stammbuch*, originally a family book in which family trees were collected and notes were made about family members. It served as a type of genealogical scrapbook, and with time came to be synonymous with a memory album. Traveling noblemen had a habit of trading with each other the images from their coats of arms, as well as their signatures, personal mottos and the like, which were all recorded in the books. The genealogy charts were produced in convenient formats that made them easy to bring along when traveling. The first *Stammbücher* are associated with Martin Luther and Philipp Melanchthon, and their students' hunt for their autographs. Thus, this was a German tradition that quickly became popular in the Protestant Nordic countries and the Netherlands.[100] This custom can be linked to something that has happened to a number of book spoils in Wrangel's library. In several of them, owner signatures have been cut or torn out. This can be seen in the Icelandic bible Wrangel selected from the Rothkirch family's book collection (see figure 22 on page 209).[101]

This can hardly have been done by Wrangel or his heirs in an attempt to hide the books' origin; it was precisely their history and genealogical identities that made them valuable to Wrangel. There was also no reason to hide the fact that the books were spoils, quite the contrary.[102] However, there are several travelogues from the eighteenth and nineteenth centuries that show that with time Skokloster came to be a highly popular travel destination among students, professors and other scholars. It is likely that this type of visitor quite simply supplied himself with autographs as a souvenir. The signatures' personal meanings made them collectible, and thus alluring enough to visitors

98 Losman, 'Skokloster', p. 88.
99 Losman, 'Wrangel, Skokloster', p. 99.
100 Eva Dillman, 'Vänskapens minnesmärken. Om nya och gamla stamböcker i KB:s handskriftssamling', *Biblis*, 29 (2005), pp. 4–5.
101 See e.g. Wr. teol. fol. 8; Wr. teol. 8:o 24; Wr. hist. 8:o 20, ss.
102 Books have not been re-bound, for example, and a great number of spoils' provenances have been left alone; Westin Berg, 'Krigsbytesböcker', p. 109.

to cut them out.[103] Like the case of von der Hardt at the Kingdom's Archive, the lost signatures in the book spoils at Skokloster show how these objects have continued to attract collectors throughout the centuries. While the spoils were merely a small part of everything Wrangel collected for his museums of war, with time they came to be the objects that shone the strongest amid the castle's collections.

12 Skokloster's Narrative and Temporal Tangle

I will end this case study by illuminating how the understanding of Wrangel's spoils at Skokloster, and of the castle as a museum, has changed over time by going back to the beginning of this chapter, and the quote from the Skokloster travel guide from 1860, which described the castle as overflowing with war booty.[104] Many is the traveller who, decades and centuries after Wrangel's death, has visited Skokloster and wondered at the Baroque castle and its war museums. For instance, the student Johan Gabriel Oxenstierna wrote 'at this place, I felt myself taken. It appeared to me as if virtue, honour and bravery still resided at this old castle' when he visited Skokloster Castle in May of 1767, just under a hundred years after its master Wrangel had died.[105] When the Benedictine scholar Beda Dudík travelled around Sweden in 1851 to look for spoils abducted from Moravia and Bohemia during the Thirty Years War, he described Skokloster as a place where time had stood still and nothing had changed, according to Carl Gustaf Wrangel's last wish.

But in 1709, when the antiquarian Elias Brenner visited Skokloster, he did not see spoils of war. What he did see was the so-called Skokloster shield, which had been abducted by Wrangel during the German war.[106] And in Skokloster Church, Brenner described the altarpiece as 'lost from the Oliva monastery'.[107] His choice of words is reminiscent of the sources analysed in the chapter 'Placed in Chests'; Brenner did not yet see spoils of war, his visit to Skokloster took place some years before the term was established in the Swedish language in 1712. Just as with the objects they describe, the making of words is a process.

103 A well-known phenomenon that has been noted by, e.g., Pearson in *Provenance research*, pp. 3, 5.
104 Kiellman Göranson, *Sko*, p. 67.
105 Johan Gabriel Oxenstierna, *Ljuva ungdomstid. Dagbok för åren 1766–1768* (Uppsala: Bokgillet, 1965), pp. 60–61.
106 The same shield was discussed in the chapter 'Placed in Chests'. See Meyerson & Rangström, *Wrangel's armoury*, pp. 30–33.
107 Elias Brenner, Skokloster description, Palmskiöldska samlingen 276, UUB, pp. 553, 559.

Sixty years after Brenner's visit to the castle, Wrangel's booty and even gifts and purchased objects had begun their transformation into being nothing but spoils of war.

Unlike the Kingdom's Archive and Uppsala University Library, Skokloster is the one spatial environment that has endured throughout the centuries. Tre Kronor Castle in Stockholm burned down in 1697 and the old library building in Uppsala was remade around 1750, the collections having been moved out of it long before. This makes Skokloster an important, and at the same time treacherous, environment. In the Benedictine Dudík's depiction of Skokloster he referred to Wrangel's will, in which he had seen to it that not a single thing was to leave the castle. In Wrangel's museum, according to Dudík, even the furniture stood exactly where the master of the castle had once placed it.[108] Through accounts like Dudík's, the myth of Skokloster as an untouched seventeenth-century environment was established, even though the castle had just undergone an extensive renovation during the period 1830–1844: rooms had been repainted, new furniture bought and paintings rehung.[109]

In fact, Wrangel's will made no mention of furniture not being moved from some determined place. The only things that were to be preserved at the castle were Wrangel's precious armoury and the silver service. When Wrangel died in 1676 everything in the castle, except the armoury, was divided into four shares for three of his daughters and one granddaughter. One of his daughters, Margareta Juliana Wrangel, who was married to Count Nils Brahe, left her share at the castle. This is also true of her share of the book collection, as well as some of the books from the other shares.[110] Otherwise, Wrangel's books were now on the move again, and much of what had been part of the Rothkirch spoils left Skokloster and began a new geographical dispersal, a story beyond the bounds of this study. The will estblished a seemingly fair, even distribution, and it is not possible to discern any particular pattern in what was left at the castle. In other words, we cannot say whether the heiresses preferred spoils or not.[111] At this time, the work continued to complete the construction of Skokloster, overseen by Margareta Juliana and her husband Count Brahe.[112] She would actually be the one who ultimately finished Wrangel's war museums, by converting Skokloster into an entailed estate through her will in 1701. This meant that Skokloster had to be inherited in its entirety, and that the

108 Dudík, *Forschungen in Schweden*, p. 308.
109 Hidemark & Stavenow-Hidemark, *Eko av historien*, pp. 11–13, 38, 46ff, 87f, 140ff.
110 Westin Berg, 'Krigsbytesböcker', p. 111.
111 E 8074, Rydboholmssamlingen, RA Marieberg.
112 Hidemark & Stavenow-Hidemark, *Eko av historien*, p. 15.

movable property had to be preserved within the castle walls.[113] In her will, she described her and her husband's efforts to maintain Skokloster in memory of her father, Carl Gustaf Wrangel.[114] Margareta Juliana thereby stressed that she saw Skokloster as a place that honoured a person and his history, rather than a dynasty or an empire.

There are thus significant differences between Beda Dudík's experience of Skokloster in 1851 and what Wrangel actually expressed in his will in 1673. The final case study of this book more clearly highlights the problematics of spoils within a longer time frame than our other two cases. Skokloster's spoils both contain and exist within different layers of time, a temporal tangle, and therefore illustrate the instability of material things in a particularly tangible way. While the seventeenth century rooms and decor at Skokloster have been partly preserved, owners at various times, especially the 1830s and 1840s, have been interested in arranging, renovating and interpreting the seventeenth century and its narrative. Indications can be found from the nineteenth century that suggest that Skokloster was in the process of being transformed into some sort of national museum, where Sweden's historical memories would be collected.[115] The tension between national and personal or genealogical narratives is particularly relevant, considering what happened with many of the spoils when they were put on exhibit at Swedish museums in the late nineteenth and early twentieth centuries. In some respects, they did not fit into the nation's history due to their geographical origins: they were, after all, not Swedish objects. Yet they were remnants of the era of greatness and could therefore become beloved symbols of nationalism.[116] What attracted people to Skokloster during the eighteenth and nineteenth centuries were the war museums. For the castle's later owner Magnus Brahe, and his friend King Charles XIV John, the early nineteenth-century Skokloster served as a material possibility to recall a warring kingdom that had once been great, which was more important than remembering its old owner, Field Marshal Wrangel. At Skokloster the Swedish Empire had been allowed to endure, and with a bit of help it could

113 Erik Andrén, *Skokloster. Ett slottsbygge under stormaktstiden* (Stockholm: Stockholm universitet, 1948), p. 14.
114 Hans-Olof Boström, *Ett Eger-skåp på Skokloster. En ikonografisk studie* (Stockholm: Skokloster, 1972), p. 90. Here, Boström cites long passages of the will. Margareta Julianas measures to preserve Skokloster as a museum dedicated to her father are reminiscent of Queen Ulrika Eleonora's creation of a pantheon dedicated to the Caroline kings. See Martin Olin, 'Minnet av karolinerna. Inredningar och samlingar under Ulrika Eleonora d. y:s tid', in G. Alm & R. Millhagen (eds.), *Drottningholms slott. Band 1. Från Hedvig Eleonora till Lovisa Ulrika* (Stockholm: Byggförlaget Kultur, 2004), pp. 257–261.
115 Hidemark & Stavenow-Hidemark, *Eko av historien*, pp. 172–175.
116 Regner, 'Ur Historiska', p. 51.

be accentuated even more clearly. To Wrangel, the war museums had materialised his own rank in society and military career; it was through his successes in the wars that he had earned his high political status.

Despite the decision to make Skokloster an entailed estate, time at the castle did not stand still. From the end of the eighteenth century, and especially at the beginning of the nineteenth century, the noteworthiness of the objects there was enhanced through various collecting practices. For instance, objects that had not been taken as spoils were sometimes made into spoils of war.[117] In this way, responsible castle lords, armourers and others who worked with the collections, along with visitors to the castle, created the myth of a fortress full of spoils of war, at a time that increasingly came to be characterised by nationalism. In Bulstrode Whitelocke's tale of abducted books in Uppsala University Library, it is clear that these plundered objects could transfer their special meaning to other objects that had not been taken from the Holy Roman Empire. The same thing happened at Skokloster, and furthermore in a particularly convincing way, even though Wrangel spent great amounts of money on collecting. The bellicose narrative he and those around him created was both strong and attractive, to the degree that with time it was taken up by later owners and visitors who dreamed of Sweden's glorious past. The myth of the volume of the spoils of war grew ever stronger in connection with this.

The final word goes to Johan Gabriel Oxenstierna, the student who saw virtue, honour and bravery on his visit to Skokloster in 1767. He described how the collections at the castle had fallen into extreme disarray, especially the books. The young student was outraged that the weapon collection was kept in good condition by the armourer, while the books were left in disorder and neglected; they were either covered in the dust of centuries past, or remained in the war chests where he imagined Wrangel had once placed them. 'Considering how it appears', wrote Oxenstierna, 'these chests will be their graves for eternity'.[118]

13 Conclusion: War Museums

This chapter has shown how Carl Gustaf Wrangel and his family, librarians and armourers together created war museums at Skokloster Castle with the help of *spolia selecta*: carefully selected spoils that were ascribed several meanings and qualities within Wrangel's rich collections. His book spoils from

117 Boström, *Ett Eger-skåp*, pp. 11, 66–67; Rangström, *Krigsbyten*, p. 3; cf. Hidemark & Stavenow-Hidemark, *Eko av historien*, p. 172.
118 Oxenstierna, *Ljuva ungdomstid*, pp. 59–60.

the Rothkirch family, and other places, often corresponded with the types of books he acquired for his library in other ways. Some of the book plunder in the library could even be ascribed genealogical properties and, through these, could highlight the Field Marshal's military career and history. Thus, in the story of a successful warrior, certain spoils, be they books or weapons, came to be the triumphs of the collections as they contributed their specific histories; they told of previous owners and faraway places, and not least of the wars and Wrangel's successes in them. Along with each item of spoils came a narrative, and Wrangel chose spoils based on their genealogical and geographical qualities as they contributed stories that were to be included in, and exhibited in, the encyclopaedic museums of a prince. Compared to the Kingdom's Archive and the university library, many of Wrangel's spoils served precisely as spoils to a much greater degree. But the complexity these objects held should not be underestimated, and de Pluvinel's *Le Maneige Royal* highlights how spoils could be both of the sort Wrangel preferred to buy and valuable due to their connection to prominent individuals, in this case the Danish King and his equerry.

The story Wrangel and those around him created through the collections was so successful that with time it came to overshadow the master of the castle himself, and herein also lies the most important effect of *spolia selecta* on Skokloster. The spoils at the castle did not cause any conflict over removals or preservation like in Uppsala. There were also no demands for the return of items as with the Mitau documents in the Kingdom's Archive. At Skokloster, the spoils fitted the castle's collections like a glove. Within a longer perspective, it is possible to see the changes in the booty's identity: its history came to be less and less about precise genealogy and geography, and more about the fact that they were spoils. Time also saw the growth of the myth about the quantity of plunder. Visitors saw spoils of war everywhere, even though there were not many in the collections, especially compared to Uppsala University Library. The strength of Wrangel's bellicose narrative and the utmost triumphs of his collections, his spoils, thereby highlight the weakness of the other objects; their instability.

Conclusion: Spoils of Knowledge, Triumph and Trouble

This book has looked at the material trajectories of plundered knowledge that began when archival documents, manuscripts and books, together with other precious things, were abducted by the order of Swedish rulers and commanders during the wars of the seventeenth century. The valuable plunder was packed into chests, then to be transported to specific rooms for collections in the Swedish Empire. My main focus has been on five cases of archive and library plundering, ordered by Gustavus Adolphus and Carl Gustaf Wrangel in Livonia, Prussia and Denmark. With the help of a biographical viewpoint, I have followed plunder from the event that made it into booty, and then analysed its meanings and effects, its lives, in Swedish collections before 1712, and to some degree also later, compared to our own time. Each chapter in turn has demonstrated how booty was classified, arranged, merged, separated and transformed in different collection contexts. The orderings at the Kingdom's Archive, Uppsala University Library and Skokloster Castle show how objects and collections together formed various types of narratives. In sum, the spoils impacted their surroundings based on their material properties, geographical origins, genealogical values, confessional associations and temporal qualities; aspects that could be highly valued, but could also cause trouble for the official who had been given the task of creating order. The following concluding discussion brings together the histories of the respective booty clusters and institutions in order to compare what the cases had in common or how they differed. Lastly, this closing chapter culminates in a brief reflection on the spoils' identity within a longer time perspective, which includes the subject of modern and contemporary requests for restitution.

1 Making Spoils in the Seventeenth Century

The chapters of this book have followed the creation of spoils from the field campaign chests to the cabinets of the Kingdom's Archive, the shelves of Uppsala University Library and the museum rooms of Skokloster Castle. The object-biographical approach has highlighted the meanings and properties that various people, mostly officials like archivists and librarians, ascribed to these things as they handled, classified and organised them in different collection

CONCLUSION 165

contexts. But spoils also became spoils by being used, viewed, touched, maintained, stored and preserved by collectors and the people around them year after year, for decades and even centuries.

The various examples have shown how spoils of knowledge could be handled and interpreted based on their material. The documents from Mitau Castle were packed according to their material properties, and archive secretary Per Månsson Utter distinguished between paper and parchment when he read through the documents. This approach bears witness to what can be called material hierarchies, whereby parchment was more valuable than paper. It was the parchments that contained the oldest and most important, and thus the most distinguished, documents. As Utter knew this, the material properties helped him to value their contents. Different approaches were used when the spoils from Riga and Prussia were inventoried, but the three recording lists had one thing in common: those who conducted the work placed importance on the books' material condition. Royal librarian Johannes Bureus and his assistants consistently took the time to note whether the Jesuits had made notes in a book, whether any pages were missing, whether the binding was intact, and whether the pages were of parchment or paper. In the inventory of the collection from Riga the books became one material among others, as everything in the record was listed based on the various objects' material properties. The books, organised according to size rather than the knowledge they contained, were also listed first in the inventory, which shows that they were perceived as the most valuable part of the spoils. In the list of Carl Gustaf Wrangel's book spoils from the Rothkirch family, however, the books were primarily treated as knowledge, and there were few descriptions of their material properties. There was a noteworthy exception to this: a beautiful writing book was taken precisely because it was beautiful. Thus, a book could become spoils based on wholly aesthetic values.

In all cases, the spoils' geographical origin and thus their identity were important. The spoils at Skokloster illustrate the relevance of various geographical themes for collectors in the seventeenth century. Samuel Quiccheberg also highlighted this in his museum manual, stressing the importance of each individual object's origin as it contributed to a specific history. In this respect, spoils were no different from objects collected in other ways. While it is not known exactly where in Denmark Wrangel selected the Rothkirch spoils, he did make them into parts of his war museums at Skokloster: a material landscape of objects with innumerable geographical connections. Skokloster took shape based on continental influences, and was materialised with the help of knowledge and precious objects from all over the world. Here, the items' geographical origins were stressed on a comprehensive level: Skokloster was

a curated reflection of the world, where even the castle's rooms were named after European cities. In a similar way, the spoils offered knowledge on a particular form of object circulation, that of war. Wrangel's collecting sheds light on the educational potential of warfare. Taking part in various field campaigns, he was able to experience famous European collections, the rooms where they were housed and their narratives, and at the time it was possible for him to plunder them.

At Skokloster, Wrangel's selected spoils were mixed with all the other objects he had collected. Meanwhile, at the Kingdom's Archive and Uppsala University Library, spoils were initially kept together, which stressed their geographical origin in another way. Utter described the documents from Mitau as Livonian and Courlandian in order to distinguish them from the archive's other files. At Tre Kronor Castle in Stockholm, Bureus worked with the collections from Braunsberg and Frauenburg both individually and mixed. The books from Prussia were sent to Uppsala in two batches, and the arrangement in the newly established library was initially based on geographical origin. While this ordering eventually had to yield to epistemological values and usage, when all books were classified and reorganised at the end of the 1630s in connection with Laurentius Tolfstadius' catalogues, there were a couple of individual cases in which the spoils' geographical origin continued to be stressed. When the consistory was offered individual books from Würzburg they accepted, knowing that these books could then be reunited with the others.

In the case of the Kingdom's Archive, it is clear that the geographical properties of the Mitau documents were unstable: in later lists the documents could be described as Russian, and some of them disappeared into the kings' cabinets as if they had originally come from their administrations. The lists also show that, over time, Swedish documents could be described as Livonian. When the Mitau spoils of 1621 were recreated at the request of the King in 1686, it emerged that the knowledge of what had once been taken at Mitau was now lost. Documents that had their origin in the Swedish kings' chancery, and had never been in Mitau, were nonetheless made into a part of the spoils. In all cases, then the spoils' geographical origins were of central importance. In the initial handling of the booty, it was geographical properties that provided their primary association. However, this quality was not fixed but changeable, and in the case of Uppsala, the spoils' origin became less important over time. The changeability of the spoils' geographical identities thus highlights their instability and their entanglements with their epistemological surroundings.

Genealogical practice, which Utter conducted at the Kingdom's Archive, was a tool the elite used in order to assert their distinguished position and political power. The uniqueness of one's own dynasty was to be accentuated through the creation of ancient, and sometimes imaginative, family ties. At the

CONCLUSION

Kingdom's Archive around 1620, Utter established a new ideal order that was intended to dictate the archive's organisation. This order functioned literally as the Vasa kings' historical chronicles: each king had a cabinet, and each cabinet contained only those documents the archivists regarded as the most valuable, arranged in chronological order. The documents from Mitau were made into a part of Vasa history, first in their entirety; later, though, they were separated and even moved to different parts of the castle. Over time, the documents that could most clearly be linked to the Vasa kings lost their Mitauan identity, and are increasingly harder to trace in the inventories. These documents were thus assimilated by Vasa genealogy.

At Skokloster the spoils' genealogical qualities worked in a different way. Wrangel collected certain spoils precisely because they carried with them histories and traces of previous owners, and thereby told of the Field Marshal's successes in war. His interest in small prayer books illustrates this: the objects had been used by individuals, who had written their family histories on the books' blank pages. This connected them with the armoury, which was supplied with spoils that expressed similar genealogical values. Here, Wrangel placed a pair of Wenzel Rothkirch's wheel-lock pistols, which bore their former owner's initials. Through Rothkirch's name, the pistols' previous history and genealogical value were explicitly articulated. Wrangel curated his life history at Skokloster, where he presented himself as a triumphant warlord. And in parallel with this, he attempted to influence the contemporary political chronicles in which he figured, particularly when his campaigning efforts were depicted in a less flattering light. Lastly, in Uppsala University Library the emphasis on the spoils' genealogical properties was not as strong as in the other cases, but there are a couple of events in which books' biographical or historical connections were stressed. For instance, Bureus made a note of a book that bore the seal of the Bishop of Warmia. The seal and its connection to a particular office, and perhaps even a specific individual, were a significant part of the book's identity and value as a collectible knowledge object.

The Kingdom's Archive and Skokloster highlight how the arrangements of collections could serve as the writing of history. The differences between how the two collections were organised illustrate the multifaceted concept of history at the time: for while Utter worked with long chronological lines that were to be adapted to the ruling Vasa dynasty, Wrangel limited history to his own lifetime: because in this time frame, the spoils and the trophy from his first great victory at Leipzig were especially valuable. However, the spoils he selected often bore histories that reached farther back in time than this. It was precisely their genealogical properties that were important in the materialisation of Wrangel's war museums.

At the university library in Uppsala, unlike the other two cases, the perception of history was not genealogically oriented, linked to the families of kings or aristocrats. Instead, religious battles and epistemological lines of development determined the way the past was handled. A prominent interpretation of the book spoils as they were classified was related to their confessional properties. This meant that the librarians used the labels of Lutheran, Catholic, Calvinist, Jesuit and papal to classify books they associated with a certain faith. Many of the Catholic, Calvinist and Jesuit books came to be housed in the lower library, at the same time as the upper library had a theology section that contained confessionally mixed literature. But the confessional debates among Swedish scholars around the mid-seventeenth century led to a reinterpretation of the theological books in the upper library, and they were separated into Lutheran, Catholic and Calvinist categories. Thus, what the librarians regarded as belonging to a particular confession was both contradictory and changeable. Books were also moved between the floors, and it sometimes happened that a smaller selection of books from the lower library were included in the catalogues for the upper one in an effort to make visible a comprehensive collection that crossed the boundaries of the different confessions. Here, the librarians' labours bore witness to both confessional hierarchies and universal knowledge ideals.

Unlike in the library in Uppsala, Wrangel's theological books at Skokloster were not arranged based on confessional differentiation. Different faiths were mixed in the theology section, and the influence of continental knowledge ideals and Gabriel Naudé's library manual is clear. Book spoils were mixed with the other books Wrangel had inherited, purchased or received as gifts, and the same titles could be acquired in different ways. In the handling of the Mitau documents, Utter demonstrated a particular interest in documents pertaining to certain church councils. His ideal order highlighted documents involving 'the thing of religion' as especially important and valuable. Suddenly, reviewing letters that had been sent between popes, emperors of the Holy Roman Empire and masters of the Livonian Order must have been extremely valuable in this context. With the documents from Mitau, the archivists, King and Chancellor gained control over a significant piece of European confessional history.

With each object of spoils came temporal properties that could be decisive in how the object was classified. In Uppsala, this meant that much of the older matter came to be housed in the lower library, where a historical collection was created with the help of manuscripts, incunabula, and older printed books from the sixteenth century. When manuscripts were placed in the upper library they played another role, as their knowledge content determined their

CONCLUSION

classification. Through their age, though, they legitimised the new knowledge in the upper library. Tolfstadius' handling of the manuscripts shows how they existed on the borderline between being classified according to their knowledge content and according to their material and temporal qualities. They could be handled as knowledge, but were increasingly often classified as manuscripts, which were housed in the lower library's rooms. With time, the librarians' sense of temporality was also expressed in the ordering of the catalogue, where theological literature came to be arranged chronologically. According to this arrangement, all the Catholic books were listed before the Lutheran ones; before this, Lutheran theology had been described in terms such as 'our theologians' or, even better, 'the latest theologians'. The moves between the floors show that it was not always easy for the librarians to decide what belonged to history and what was current and relevant knowledge: this was changeable. In the university consistory, there was even a protracted debate over the usefulness of the older.

In the Kingdom's Archive, the temporal order was at least as tangible as at the university library. Here, something classified as old was ascribed maximum value. When the Courlandian Dukes tried to get the Mitau documents returned, Utter claimed that the oldest documents were not of interest to them; instead, they could have a handful of the youngest ones. By providing as little information as possible about the documents and describing them as torn, he attempted to delay and hinder their return. For Utter, it was important to keep and preserve the old parchments in the archive he managed.

2 Triumph and Trouble: The Effects of Knowledge Spoils

This study has highlighted how spoils both enabled and challenged the collections they participated in creating. By analysing what properties of the abducted objects contributed to forming new conditions for collections in the Swedish Empire, I have demonstrated how spoils in various ways were not only made through human interpretations and actions, but also had material effects in the collections studied.

An initial effect of the spoils from Riga was the establishment of Uppsala University Library: when the Jesuit College's collections were donated to the university, this led to the library building beginning to be put in order. During its initial stages, Uppsala University Library was materialised for the most part by spoils. The spoils that came to the Swedish Empire had effects due to their size and number: at the Kingdom's Archive and the university library, the number of spoils versus the spatial conditions presented a central problem

that had an influence on the officials' work. In the Kingdom's Archive, Utter prepared space for the documents from Mitau in one of the archive's few cabinets; this had an effect on the documents that had to be removed from the cabinet, which were demoted to lesser importance in relation to the spoils that had just arrived. The Mitau documents demanded space and work hours. Those that were not made into parts of the Vasa kings' history first ended up in chests under the cabinets, and were then moved to another part of the castle to await the availability of more room in the archive. They were not forgotten; particularly valuable old documents were kept in cases that could easily be moved from one room to another. This portable archive within the archive could move from the innermost archive room and the most valuable context to a vault in another part of the castle, where archive officials kept files that were not easy to place.

At the university library, the Jesuit collections from Livonia and Prussia had an effect on the library's orderings as they carried with them an epistemological system that, at least confessionally, differed from that of the Swedish officials. Instead of dismissing this quality, though, Johannes Bureus and Laurentius Tolfstadius took inspiration from it. They were influenced by Jesuit knowledge and order, particularly as articulated in the Braunsberg College's catalogue and the initial packing order of the books. Here, they found solutions as to how the large collections could be handled. The analysis of Tolfstadius' catalogues shows that the influence of the spoils was apparent in the fact that large parts of the booty were interpreted as historical objects and placed in the lower library. This included mostly manuscripts, incunabula and early sixteenth-century books. It was not only their knowledge content that was classified as old, however; handling and classifying them as old objects was a direct consequence of their material properties. It is possible that the sacral objects from Riga contributed to this historical effect in the lower library. Utter evaluated the documents from Mitau based on their age and material in a similar way. Together, these circumstances highlight that archive documents and books were not just sources of knowledge; they were objects of knowledge. Or, to express it in other words: you cannot separate knowledge from its materiality.

At Skokloster, the strength of Wrangel's *spolia selecta* destabilised the other objects' identities. His plunder transferred their special meaning as precisely spoils to objects that had been collected in other ways; things that had not been taken as booty could nonetheless be ascribed this quality. After 1712, visitors and new owners of the castle saw great amounts of spoils of war in a collection that had largely been acquired in other ways. Wrangel's spoils thus harmonised with the collections' bellicose narrative. Something similar happened when Bulstrode Whitelocke visited Uppsala University Library in the

1650s. There, he certainly saw books that had been confiscated from dissolved Swedish monasteries as well as gifts from old royal collections. But here as well, the spoils transferred their special meaning to other knowledge objects, causing them all to become books that had been abducted from the Holy Roman Empire and elsewhere.

The spoils' contaminating effect is especially interesting, as it stresses the importance of analysing objects in relation to each other and of being watchful of their instabilities. It also underlines the difficulty of separating individual objects from their contexts. In all the collections I have addressed in this book, objects that were not spoils could be interpreted as if they were, by both visitors and the officials working with the collections. By extension, this means that there was knowledge of how certain objects had once been collected, and that this knowledge remained among rulers, aristocrats and those around them even after the wars had ended. The war plundering that created spoils was perhaps more noticeable as this was deviant during times of peace. With time, these spoils of knowledge came to appear as something alien, non-Swedish, from an era long gone.

3 Enduring Instabilities: From Spoils of Knowledge to Swedish Spoils of War, Reconstructions and Restitutions

This book has studied cultural plunder and spoils of knowledge during a relatively short time span, and spoils of war during a longer period. By this I mean that, with the help of an object-biographical perspective, I have been able to emphasise significant differences in how these objects were interpreted before and after 1712, when the word *krigsbyte* (spoils of war) was established in the Swedish language. The spoils' unstable identities emerged when their geographical origin transformed, or their confessional properties were reinterpreted. As objects they could accentuate a previous owner's genealogy, or have that of a Vasa king forced upon them. Their material qualities and knowledge could be described as ancient, to then be re-evaluated as current and useful. All these changes and variations in classification and meaning can be discerned in the sources related to the making of spoils from Gustavus Adolphus' capture of Riga in 1621 to the beginning of the next century. The object-biographical method articulates temporality. Working with and through different layers of time has been necessary in this study, in order to uncover the spoils' processes of becoming and transforming as well as their everyday ontology in different times. The spoils' long lives cause their identities and meanings from both then and now to be intertwined, to quarrel and harmonise with each other; this is

why it is important to expose, separate and analyse the differences in classification and other linguistic descriptions and material practices in relation to different temporal and spatial contexts.

In the seventeenth-century Swedish sources, cultural spoils were often described as lost or retrieved from a place. Spoils of knowledge and splendour were taken by, and went to the restricted collections of, rulers and aristocrats. Considering this, there were no Swedish spoils of war during the seventeenth century, in the modern sense of the word: public national archives, libraries and museums did not exist yet, and nor did the idea of a common cultural heritage. Nonetheless, Otto Walde rightly pointed out that the plunder in Sweden was never forgotten by rulers and scholars in the regions that had once been ransacked.[1] Scholars representing Austria, its crownlands Bohemia and Moravia, and the Czech Republic can be used to illustrate this. In 1731, the famous Benedictine Bernhard Pez tried to trace once-plundered Austrian manuscripts in Sweden via letters. In 1792, Slavic philologist Josef Dobrovský travelled to Sweden on his way to Russia, hoping to trace and consult Bohemian plunder in Stockholm.[2] This was followed by medical doctor Josef Pečirka visiting the Royal Library in Stockholm in 1850 and shortly after, in 1851, the Benedictine scholar Beda Dudík, researching all the Swedish collections he could access during a four-month sojourn.[3] Dudík's mission was commissioned by the Moravian Diet. Today, the same material is being mapped by Czech scholar Lenka Veselá, in a project supported by the Czech and the Swedish Academies of Sciences. The results are accounted for in a digital catalogue; so far it contains over 3300 titles, but the assumption is that about 25,000 books were abducted from the Habsburg Bohemian Crownlands and ended up in Sweden this way.[4] Remarkably, then, while the empires and nations of Europe have

1 Walde, *Storhetstidens II*, pp. 455–473. I am using the case of Austria/Bohemia/Moravia/Czech here, but Polish scholars have also been especially active in Sweden and collaborated with Swedish heritage institutions, which I pointed to in chapter 3.

2 Joseph Dobrovský, *Reise nach Schweden und Russland* (Prague: J. G. Calve, 1796); Karel Sebesta, 'Från Josef Dobrovský till Beda Dudík', *Slovo*, 42 (1993), pp. 7–12.

3 Josef Pečirka, *Zpráva o rukopisech českých v královské bibliotéce v Stokholmě se nacházejících od Dr. Jos. Pečirky* (Prague: Časopis českého Muzea, 1851); Beda Dudík, *Forschungen in Schweden*; on Moravian historiography, see Emma Hagström Molin, 'Discovering Moravian history. The many times and sources of an unknown land, 1830–1860', in S. Bergwik & A. Ekström (eds.), *Times of history, times of nature. Temporalization and the limits of modern knowledge* (Oxford: Berghan 2022) pp. 275–305.

4 'Project traces books looted by Swedes', Radio Praha, 05-03-2019, https://www.radio.cz/en/section/in-focus/project-traces-books-looted-by-swedes, access 17 June 2017; 'The Swedish booty books from Bohemia and Moravia', https://krigsbyte.lib.cas.cz/Search/Results, access 13 August 2022; Lenka Veselá, 'Aristocratic libraries from Bohemia and Moravia in Sweden'

both fallen and risen several times since the heyday of the Swedish Empire, the interest in tracing and uncovering what was once lost has been a recurring issue, and restitutions have also taken place. In 1878, for instance, thanks to the friendship and scientific collaboration between Swedish librarian Gustaf Edvard Klemming and Beda Dudík, 21 Bohemian manuscripts were donated to the Austrian government.[5] Another more recent and controversial case is the Polish Scroll, restored to Poland by Swedish Prime Minister Olof Palme in 1974. The scroll is a 15-metre-long water colour depicting a royal procession held in Krakow in 1604. Palme was heavily criticised by museum officials for his actions, and in Poland, both authorities and museums have generally accepted the current situation of ownership, although popular and political demands are articulated from time to time.[6]

In general, when the subject of restitution is brought up today, Swedish heritage institutions refer to the laws of the seventeenth century and the fact that the prerequisites for heritage ownership have radically changed since then: from being elite and thus private effects to being objects of a public and common concern. While the provenance research and restitutions related to Nazi cultural looting have doubtlessly changed the European discourse on repatriation, shifting from a legal to a moral argument, this development has recently started to affect the West's understanding of its colonial heritage.[7] When dealing with the plunder of the early modern era, it is important to acknowledge that the scholars' national identities and the classification of the plunder have changed recurrently since the removals occurred. However, while demands for repatriation are usually made in the name of nations that did not exist in the seventeenth century, it should be remembered that one religious society that suffered tremendous cultural losses due to looting Swedish commanders, the Jesuit Order, has in fact endured over the centuries. It is therefore high time to include them in these debates.

Notwithstanding the destruction of cultural heritage that virtually always takes place during wartime, war booty preserved in institutions for 400 years

in S. Nestor & A. Grönhammar (eds.), *War-booty. A common European cultural heritage* (Stockholm: Livrustkammaren 2009), pp. 147–155; see also Marta Vaculínová, 'Bohemica in Sweden and the National Museum Library in Prague', in S. Nestor & A. Grönhammar (eds.), *War-booty. A common European cultural heritage* (Stockholm: Livrustkammaren 2009), pp. 139–145.

5 Hagström Molin, 'Restitutionen verhandeln', pp. 215–222.
6 Andrzej Rottermund, 'Polska föremål i svenska samlingar', in A. Grönhammar & C. Zarmén (eds.), *Krigsbyte* (Stockholm: Livrustkammaren, 2007), pp. 130–131.
7 CFP, 'The restitution of looted artefacts since 1945' (Rome, 16–18 May 2022). In: ArtHist.net, 19 June 2021.

is a reminder that many objects do not die in the way humans do. The spoils of knowledge that have figured in this book have survived centuries of dangers and material stress: first the chaos of war, as well as being packed into chests and transported by sea to the Swedish Empire. After this, they have been exposed to fire, leaky roofs, collection thinning, estate distribution and autograph hunters. They have escaped Russian invasion and archive thieves by the skin of their teeth. They have once again been packed into chests, to then be unpacked again. A smaller number of them have been returned to the place they were once abducted from, or elsewhere, while others have disappeared. Some have lost their identity as plunder and become invisible to the researcher looking for them, while others have been transformed into Swedish spoils of war in the collections of the national cultural heritage institutions that preserve them. These spoils of knowledge have been created and recreated over and over again.

Making spoils during the field campaigns of the seventeenth century meant that the King's men plundered the collections of the continental elite and learned religious orders. Axel Oxenstierna ordered that archives and libraries should be collected and conserved if the possibility arose, while King Gustavus Adolphus commanded that valuable collections be confiscated or placed under the commander's protection. The various officials who then worked with the collections in the Swedish Empire acknowledged that the objects had come from specific places, and classified them based on appearance and content. This book has explored how spoils of knowledge were understood and came into being as objects with particular material, geographical, genealogical, confessional and temporal qualities. In the seventeenth century, much of their attraction and possibility to have impacts resided precisely therein: these qualities and identities participated in creating collections, collectors and the things' own lives and histories. Their attraction as objects has without question spanned 400 years, and their eventful fate still fascinates us today.

Bibliography

Archival Sources

Kungliga biblioteket (the Royal Library)
A213, B682, X84.

Riksarkivet Marieberg (the National Archives Marieberg)
Brev till Kongl. Majt.: 1658.
Riksregistraturet (RR): 1621, 1626.
Oxenstiernska samlingen: E 682, E 746.
Riksarkivets ämbetsarkiv: Uppställningsförteckningar och inventarier 1618–1627, Huvudarkiv byrå, D II b a vol. 1; Uppställningsförteckningar och inventarier 1628 och följ., Huvudarkiv byrå, D II b a vol. 2; Förteckningar över handlingar rörande Sveriges forna besittningar och över Extranea, Huvudarkiv byrå, D II eg, vol. 1, 1600-talet; Förteckningar över handlingar rörande Sveriges forna besittningar och över Extranea, Huvudarkiv byrå, D II eg, vol. 2, 1701; Huvudarkivet och byrå I:s arkiv, FXIa, 3 (1686–1823).
Rydboholmsamlingen: E 8074, E 8100.
Skoklostersamlingen: E 8252, E 8580.
Utländska pergamentsbrev: Livonica, Utländska pergamentsbrev, Schirren 1, 6, 7, 11, 13.
Utländska registraturet: 1686.

Skokloster slott (Skokloster Castle)
Catalogvs Librorum in Bibliothecam [...] M.DC.LXV.
Wrangelbiblioteket: Teologi: Wr. teol. fol. 1, Wr. teol. fol. 7, Wr. teol. fol. 8, Wr. fol. 10, Wr. teol. 4:o 79, Wr. teol. 8:o 24, Wr. teol. 8:o 47:1–2; Wr. teol. 12:o 23, Wr. teol. 12:o 46; Historia: Wr. hist. fol. 4, Wr. hist. fol. 70, Wr. hist. 4:o 96, Wr. hist. 4:o 97, Wr. hist. 4:o 98, Wr. hist. 4:o 103, Wr. hist. 8:o 20, Wr. teol. 12:o 46; Romanska språk: Wr. roman. 2, Wr. roman. 17, Wr. roman. 426.
Övriga föremål med inventarienummer: 3588, 6891, 6892, 6894, 2770.

Uppsala universitetsbibliotek (Uppsala University Library)
Handskriftssamlingen: U271, U272, U273, U274.
Bibliotekets arkiv: A3, E1, K1:11, K2, K3, K5, K5a, K6, K11, K12, U65.
Kansliets arkiv: E1b:1.
Palmskiöldska samlingen: 276, Elias Brenner, Skoklosterbeskrivning.
Västerländska medeltidshandskrifter: C9, C11, C16, C94a, C94b.

Äldre tryck: 33:60, 37:21.
Bild- och kartenheten: Oskar Planer-samlingen, 45, 47.

British Library
Add. ms. 4902, Add. ms. 37347.

Bibliotheca apostolica vaticana (the Vatican Library)
Vat. Lat. 8171, Ottob. Lat. 1429, Ottob. Lat. 638, Reg. Lat. 941.

Printed Sources

Backhaus, Helmut (ed.). *Rikskanslern Axel Oxenstiernas skrifter och brevväxling. Avd. 1, Band 16. Brev 1636–1654 (selection), Del 2, 1643–1654* (Stockholm: Kungl. Vitterhets historie och antikvitets akademien, 2009).
Brulin, Herman (ed.). *Rikskansleren Axel Oxenstiernas skrifter och brefvexling. Afd. 1, Band 4. Bref 1628–1629* (Stockholm: P. A. Norstedt & söner, 1909).
Bureus, Johannes. 'Bureus' anteckningar', *Samlaren*, 4 (1883).
Clement, Claude. *Musei sive bibliothecæ tam privatæ quam publicæ extructio, instructio, cura, usus, libri 4. Accessit accurata descriptio regiæ bibliothecæ S.Laurentii Escuralis. Auctor P. Claudius Clemens* (Lyon 1635).
Eenberg, Johan. *Kort berättelse af de märkwärdigste saker som för de främmande äre at besee och förnimma uti Upsala stad och näst om gränsande orter* (Uppsala: Johan H. Werner, 1704).
Grotius, Hugo. *De jure belli ac pacis libri tres, In quibus jus naturæ & gentium, item juris publici præcipua explicantur* (Paris: Nicolas Buon, 1625).
Grotius, Hugo. *The Rights of War and Peace. Including the Law of Nature and of Nations* (New York: Cosimo, 2007).
Gustavus Adolphus, *Krijgs articlar som fordom then stormechtigste furste och herre, herr Gustaff Adolph, then andre och store, Sweriges, Göthes och Wendes konung, storfurste til Finland, hertig vthi Estland och Carelen, herre vthöfwer Ingermanland, etc. loffwärdigst i åminnelse, hafwer låtit göra och författa* (Stockholm: Ignatius Meuer, 1621).
Jöransson Tegel, Erik. *Then stoormechtige, högborne furstes och christelighe herres, her Gustaffs, fordom Sweriges, Göthes, och Wendes konungs etc. historia ...* (Stockholm: Christoffer Reusner, 1622).
Kiellman Göranson, Julius Axel. *Sko. Socken, kloster, kyrka, egare och slott. Handbok för resande* (Uppsala: Hanselli, 1860).
Magalotti, Lorenzo. *Sverige under år 1674* (Stockholm: Norstedt, 1986).
Matthiesen Hjörring, Anders. *Leyers eller Beleyrings Dagverck (1663). En dag-for-dag skildring af Københavns belejring 1658–60* (Köpenhamn: Selskabet for Udgivelse af Kilder til Dansk Historie, 2012).

Monro, Robert. *Monro his expedition with the worthy Scots Regiment (called Mac-Keyes Regiment) levied in August 1626* (London: William Jones, 1637).

Ogier, Charles & de Mesmes Avaux, Claude. *Caroli Ogerii Ephemerides, sive, Iter Danicum, Suecicum, Polonicum* (Paris: Peter Le Petit, 1656).

Ogier, Charles. *Fransmannen Charles d'Ogiers dagbok öfver dess resa i Sverige med franska ambassadören, grefve d'Avaux, år 1634. Ett bidrag till fäderneslandets sedehistoria för denna tid* (Stockholm: Rediviva, 1985 [1828]).

Ogier, Charles. *Från Sveriges storhetstid. Franske legationssekreteraren Charles Ogiers dagbok under ambassaden i Sverige 1634–1635* (Stockholm: Norstedt, 1914).

Oxenstierna, Johan Gabriel. *Ljuva ungdomstid. Dagbok för åren 1766–1768* (Uppsala: Bokgillet, 1965).

Peters, Jan (ed.). *Ein Söldnerleben im Dreissigjährigen Krieg. Eine Quelle zur Sozialgeschichte* (Berlin: Akademie Verlag, 1993).

Quiccheberg, Samuel, 'Inscriptiones', in Harriet Roth (ed.) *Der Anfang der Museumslehre in Deutschland. Das Traktat 'Inscriptiones vel Tituli Theatri Amplissimi' von Samuel Quiccheberg* (Berlin: Akademie Verlag, 2000).

Quiccheberg, Samuel, 'Inscriptiones', in M. A. Meadow & B. Robertson (eds.), *The first treatise on museums: Samuel Quiccheberg's Inscriptiones 1565* (Los Angeles: Getty Research Institute, 2013).

Sallander, Hans (ed.). *Akademiska konsistoriets protokoll*, 1, 1624–1636. (Uppsala: Uppsala Universitet, 1968).

Sallander, Hans (ed.). *Akademiska konsistoriets protokoll*, 2, 1637–1640. (Uppsala: Uppsala Universitet, 1969).

Sallander, Hans (ed.). *Akademiska konsistoriets protokoll*, 3, 1641–1649. (Uppsala: Uppsala Universitet, 1969).

Sallander, Hans (ed.). *Akademiska konsistoriets protokoll*, 4, 1650–1655. (Uppsala: Uppsala Universitet, 1970).

Sallander, Hans (ed.). *Akademiska konsistoriets protokoll*, 5, 1656–1660. (Uppsala: Uppsala Universitet, 1970).

Sallander, Hans. *Akademiska konsistoriets protokoll*, 6, 1661–1663. (Uppsala: Uppsala Universitet, 1971).

Sallander, Hans (ed.). *Akademiska konsistoriets protokoll*, 8, 1667–1670. (Uppsala: Uppsala Universitet, 1971).

Sallander, Hans (ed.). *Akademiska konsistoriets protokoll*, 10, 1673. (Uppsala: Uppsala Universitet, 1972).

Sallander, Hans (ed.). *Akademiska konsistoriets protokoll*, 12, 1676–1677. (Uppsala: Uppsala Universitet, 1973).

Sallander, Hans (ed.). *Akademiska konsistoriets protokoll*, 13, 1678–1679. (Uppsala: Uppsala Universitet, 1974).

Sallander, Hans (ed.). *Akademiska konsistoriets protokoll*, 14, 1680–1681. (Uppsala: Uppsala Universitet, 1974).

Sallander, Hans (ed.). *Akademiska konsistoriets protokoll,* 15, 1682. (Uppsala: Uppsala Universitet, 1975).
Sallander, Hans (ed.). *Akademiska konsistoriets protokoll,* 17, 1685. (Uppsala: Uppsala Universitet, 1975).
Spegel, Haquin. *Glossarium-sveo-gothicum eller Swensk-ordabook, inrättat them til en wällmeent anledning, som om thet härliga språket willia begynna någon kunskap inhämta* (Lund: Abraham Habereger, 1712).
Strömberg, Bo (ed.). *Den äldsta arkivläran. Jacob von Rammingens båda läroböcker i registratur- och arkivskötsel från 1571, samt en monografi om arkiv från 1632 av Baldassare Bonifacio* (Stockholm, Bo Strömberg, 2010).
Styffe, Carl Gustaf (ed.). *Samling af instructioner rörande den civila förvaltningen i Sverige och Finnland* (Stockholm: Hörberg, 1856).
Taylor, Archie (ed.). *Advice on establishing a library* (Berkeley: University of California press, 1950).
Whitelocke, Bulstrode. *A journal of the Swedish embassy in the years M.DC.LIII and M.DC.LIV,* Volume 2 (London: T. Becket and P. A. de Hondt, 1772).

Literature

Ago, Renata. *Gusto for things. A history of objects in seventeenth-century Rome* (Chicago: University of Chicago Press, 2013).
Alder, Ken. 'Introduction', *Isis,* 98 (2007).
Andersson-Schmitt, Margarete. 'Biblioteksdebatten i Akademiska konsistoriet 1627–1694', in G. Hornwall (ed.), *Uppsala university 500 years. 12. I universitetets tjänst. Studier rörande Uppsala universitetsbiblioteks historia* (Uppsala: Uppsala Universitet, 1977).
Andersson-Schmitt, Margarete & Hedlund, Monica. *Mittelalterliche Handschriften der Universitätsbibliothek Uppsala. Katalog über die C-Sammlung, Band 1, C I–IV, 1–50* (Uppsala: Almqvist & Wiksell, 1988).
Andrén, Erik. *Skokloster. Ett slottsbygge under stormaktstiden* (Stockholm: Stockholm universitet, 1948).
Annerstedt, Claes. *Upsala universitetsbiblioteks historia intill år 1702* (Stockholm: Wahlström & Widstrand, 1894).
Annerstedt, Claes. *Upsala universitets historia. D. 1, 1477–1654* (Uppsala: Uppsala universitet, 1877).
Areen, Ernst. *Uppsala universitetsbiblioteks byggnadshistoria* (Uppsala: Almkvist & Wiksell, 1925).
Backhaus, Helmut. 'Carl Oxenstierna som *custos archivi* 1626–29', in K. Abukhanfusa (ed.), *Av kärlek till arkiv. Festskrift till Erik Norberg* (Stockholm: Riksarkivet, 2002).

Balsamo, Luigi. *Bibliography. History of a tradition* (Berkeley: B. M. Rosenthal, 1990).
Barwiński, Eugeniusz, Birkenmajer, Ludwik & Łoś, Jan. *Sprawozdanie z poszukiwań w Szwecyi* (Kraków: Nakłaem Akademii Umiejętności, 1914).
Benson, Sarah. 'European Wonders at the Court of Siam', in D. Bleichmar & P. C. Mancall (eds.), *Collecting across cultures. Material exchanges in the early modern Atlantic world* (Philadelphia: University of Pennsylvania Press, 2011).
Bepler, Jill. '*Vicissitudo Temporum*. Some sidelights on book collecting in the Thirty Years War', *The Sixteenth Century Journal*, 32 (2001).
Bergh, Severin. *Svenska riksarkivet 1618–1837* (Stockholm: Norstedt, 1916).
Blair, Ann & Milligan, Jennifer. 'Introduction', *Archival Science*, 7 (2007).
Bleichmar, Daniela & Mancall Peter C. 'Introduction', in P. C. Mancall & D. Bleichmar (eds.), *Collecting across cultures. Material exchanges in the early modern Atlantic world* (Philadelphia: University of Pennsylvania Press, 2011).
Bleichmar, Daniela. 'Seeing the world in a room. Looking at exotica in early modern collections', in D. Bleichmar & P. C. Mancall (eds.), *Collecting across cultures. Material exchanges in the early modern Atlantic world* (Philadelphia: University of Pennsylvania Press, 2011).
Blouin, F. X. & Rosenberg, W. G. (eds.), *Archives, documentation, and institutions of social memory. Essays from the Sawyer Seminar* (Ann Arbor: University of Michigan Press, 2007).
Born, Lester. 'Baldassare Bonifacio and his essay *De archivis*', *The American Archivist*, 4 (1941).
Boström, Hans-Olof. *Ett Eger-skåp på Skokloster. En ikonografisk studie* (Stockholm: Skokloster, 1972).
Bowker, Geoffrey C. & Leigh Star, Susan. *Sorting things out. Classification and its consequences* (Cambridge, Massachusetts: MIT Press, 1999).
Bracken, Susan, etc. (eds.). *Collecting and dynastic ambition* (Newcastle upon Tyne: Cambridge scholars publishing, 2009).
Brenna, Brita. 'Tidligmoderne samlinger', in B. Rogan & A. Bugge Amundsen (eds.), *Samling og museum. Kapitler av museenes historie, praksis og ideologi* (Oslo: Novus, 2010).
Brown, Bill. 'Thing theory', *Critical Inquiry*, 28 (2001).
Burke, Peter. *A social history of knowledge. From Gutenberg to Diderot. Based on the first series of Vonhoff Lectures given at the University of Groningen (Netherlands)* (Cambridge: Polity Press, 2000).
Burke, Peter. *The fabrication of Louis XIV* (New Haven: Yale University Press, 1992).
Bursell, Barbro. 'Krigsbyten i svenska samlingar', in A. Grönhammar & C. Zarmén (eds.), *Krigsbyte* (Stockholm: Livrustkammaren, 2007).
Burton, Antoinette. 'Introduction: Archive fever, archive stories', in A. Burton (ed.), *Archive stories. Facts, fictions, and the writing of history* (Durham: Duke University Press, 2005).

Callmer, Christian. *Königin Christina, ihre Bibliothekare und ihre Handschriften. Beiträge zur europäischen Bibliotheksgeschichte* (Stockholm: Kungliga biblioteket, 1977).

Carlquist, Gunnar (ed.). *Svensk uppslagsbok*, volume 12 (Baltiska förlaget: Malmö, 1932).

Carlsson, Ingemar. *Riksarkivets beståndsöversikt. Enskilda arkiv: person-, släkt- och gårdsarkiv. Del 8. Band 3* (Stockholm: Riksarkivet, 2006).

Cavallie, James & Lindroth, Jan (eds.). *Riksarkivets beståndsöversikt. Del 1. Medeltiden Kungl. Maj:ts kansli Utrikesförvaltningen. Band 1* (Stockholm: Riksarkivet, 1996).

Cavallie, James & Lindroth, Jan (eds.). *Riksarkivets beståndsöversikt. Del 1. Medeltiden Kungl. Maj:ts kansli Utrikesförvaltningen. Band 2* (Stockholm: Riksarkivet, 1996).

CFP. 'The restitution of looted artefacts since 1945' (Rome, 16–18 May 2022). In: ArtHist.net, 19 June 2021.

Clark, William. 'On the bureaucratic plots of the research library', in M. F. Spada & N. Jardine (eds.), *Books and the sciences in history* (Cambridge: Cambridge University Press, 2000).

von Clausewitz, Carl. *Vom Kriege. Hinterlassenes Werke des Generals Carl von Clausewitz* (Bonn: Ferd. Dümmlers Verlag, 1952).

Cowen Orlin, Lena. 'Fictions of the early modern English probate inventory' in H. S. Turner (ed.), *The culture of capital. Property, cities, and knowledge in Early Modern England* (London: Routledge, 2002).

Czaika, Otfried. *Sveno Jacobi. Boksamlaren, biskopen, teologen. En bok- och kyrkohistorisk studie* (Stockholm: Kungliga biblioteket, 2013).

Damsholt, Tine & Gert Simonsen, Dorthe. 'Materialiseringer. Processer, relationer og performativitet', in T. Damsholt etc. (eds.), *Materialiseringer. Nye perspektiver på materialitet og kulturanalyse* (Århus: Århus Universitetsforlag, 2009).

Daston, Lorraine & Park, Katharine. *Wonders and the order of nature 1150–1750* (New York: Zone, 1998).

Daston, Lorraine. "Introduction. The coming into being of scientific objects", in L. Daston (ed.), *Biographies of scientific objects* (Chicago: University of Chicago Press, 2000).

Davidsson, Åke. 'Gustav II Adolfs bokgåvor till akademien i Uppsala', in S. Lundström (ed.), *Gustav II Adolf och Uppsala universitet* (Uppsala: Uppsala Universitet, 1982).

Demeter, Tamás. 'Values, norms and ideologies in early modern inquiry. An introduction', in T. Demeter etc. (eds.), *Conflicting values of inquiry. Ideologies of epistemology in early modern Europe* (Leiden: Brill, 2015).

Dillman, Eva, 'Vänskapens minnesmärken. Om nya och gamla stamböcker i KB:s handskriftssamling', *Biblis*, 29 (2005).

Dobrovský, Joseph. *Reise nach Schweden und Russland* (Prague: J. G. Calve, 1796).

Dolezalek, Isabelle, etc. (eds.). *Beute. Eine Anthologie zu Kunstraub und Kulturerbe* (Berlin: Matthes & Seitz, 2021).

Dudík, Beda. *Forschungen in Schweden für Mährens geschichte* (Brno: Carl Winiker, 1852).

Eyice, Mari. *An emotional landscape of devotion. Religious experience in Reformation-period Sweden* (Stockholm: Stockholm University, 2019).
Fabricius Hansen, Maria. *The eloquence of appropriation. Prolegomena to an understanding of spolia in early Christian Rome* (Rome: 'L'Erma' di Bretschneider, 2003).
Feingold, Mordechai (ed.). *Jesuit science and the Republic of Letters* (Cambridge Massachusetts: MIT Press, 2003).
Findlen, Paula. 'Early modern things. Objects in motion 1500–1800', in P. Findlen (ed.), *Early modern things. Objects and their histories 1500–1800* (New York: Routledge, 2012).
Findlen, Paula. *Possessing nature. Museums, collecting, and scientific culture in early modern Italy* (Berkeley: University of California Press, 1994).
Findlen, Paula. 'Possessing the past. The material world of the Italian Renaissance', *American Historical Review*, 103 (1998).
Findlen, Paula. 'The museum, its classical etymology and Renaissance genealogy', *Journal of the History of Collections*, 1 (1989).
Foucault, Michel. *The order of things. An archaeology of the human sciences* (New York: Vintage Books, 1994).
von Frauenholz, Eugen. *Das Heerwesen in der Zeit des dreissigjährigen Krieges, 1. Das Söldnertum* (Munich: Beck, 1938).
Frost, Robert I. *The northern wars. War, state, and society in northeastern Europe, 1558–1721* (Harlow: Longman, 2000).
Glare, P. G. W. (ed.). *Oxford Latin dictionary: 1–4: A-libero* (Oxford: Clarendon P, 1968).
Glare, P. G. W. (ed.). *Oxford Latin dictionary. 5: libero-pactum* (Oxford: Clarendon P., 1976).
Goeing, Anja-Silvia, Grafton, Anthony T. & Michel, Paul. 'Questions framing the research', in A. Goeing etc. (eds.), *Collectors' knowledge. What is kept, what is discarded* (Leiden: Brill, 2013).
Granberg, Olof. *Skoklosters slott och dess samlingar. En öfversikt* (Stockholm: Konstföreningen, 1903).
Guerrini, Anita. 'Material turn in the life sciences', *Literature Compass*, 13 (2016).
Gödel, Vilhelm. *Sveriges medeltidslitteratur. Proveniens. Tiden före antikvitetskollegiet* (Stockholm: Nordiska bokhandeln, 1916).
Götselius, Thomas. 'Skriftens rike. Haquin Spegel i arkivet', in S. Jülich etc. (eds.), *Mediernas kulturhistoria* (Stockholm: Statens ljud och bildarkiv, 2008).
Hagström Molin, Emma. 'Biblioteksmaterialiseringar. Krigsbyten, samlingsordningar och rum i Uppsala universitetsbibliotek under 1600-talet', in M. Cronqvist etc. (eds.), *Återkopplingar* (Lund: Mediehistoriskt arkiv, 2014).
Hagström Molin, Emma. 'Discovering Moravian history. The many times and sources of an unknown land, 1830–1860', in S. Bergwik & A. Ekström (eds.), *Times of history, times of nature. Temporalization and the limits of modern knowledge* (Oxford: Berghan, 2022).

Hagström Molin, Emma. 'Materialiseringen av Riksarkivet. En objektbiografi över krigsbytet från Mitau 1621', *Lychnos. Årsbok för idé- och lärdomshistoria*, 2013.

Hagström Molin, Emma. 'Restitutionen verhandeln', in I. Dolezalek etc. (eds.), *Beute. Eine Anthologie zu Kunstraub und Kulturerbe*, (Berlin: Matthes & Seitz, 2021).

Hagström Molin, Emma. 'Spoils of Knowledge. Looted Books in Uppsala University Library in the Seventeenth Century', in G. Williams etc. (eds.), *Rethinking Europe. War and Peace in the Early Modern German Lands* (Leiden: Brill, 2019).

Hagström Molin, Emma. 'The materiality of war booty books. The case of Strängnäs cathedral library', in A. Källén (ed.), *Making cultural history. New perspectives on Western heritage* (Lund: Nordic Academic Press, 2013).

Hagström Molin, Emma. 'The translocated Mitau files. An elusive object in the Swedish National Archives', in F. Bodenstein etc. (eds.), *Translocations. Histories of dislocated cultural assets* (transcript Verlag: Bielefeld, 2022).

Hagström Molin, Emma. '"To place in a chest". On the cultural looting of Gustavus Adolphus and the creation of Uppsala University Library during the 17th century', *Barok*, 44 (2015).

de Hamel, Christopher. *The Book. A history of the Bible* (London: Phaidon, 2001).

Hartung, Hannes. '"Praeda bellica in bellum justum?" The legal development of war-booty from the 16th century to date. A chance of bettering museum practice?' in S. Nestor & A. Grönhammar (eds.), *War-booty. A common European cultural heritage* (Stockholm: Livrustkammaren, 2009).

Head, Randolph C. 'Mirroring governance. Archives, inventories and political knowledge in early modern Switzerland and Europe', *Archival Science*, 7 (2007).

Head, Randolph C. 'Preface. Historical research on archives and knowledge cultures. An interdisciplinary wave', *Archival Science*, 10 (2010).

Hessel, Alfred. *Geschichte der Bibliotheke. Ein Überblick von ihren Anfängen bis zur Gegenwart* (Göttingen: Pellens, 1925).

Hidemark, Ove & Stavenow-Hidemark, Elisabet. *Eko av historien. Omgestaltningen av Skokloster under Magnus Brahes tid* (Stockholm: Byggförlaget, 1995).

Hill, Kate. 'Introduction', in K. Hill (ed.), *Museums and biographies. Stories, objects, identities* (Woodbridge: The Boydell Press, 2012).

Hornwall, Gert. 'Uppsala universitetsbiblioteks äldsta uppställnings- och klassifikationssystem', *Nordisk tidskrift för bok- och biblioteksväsen*, 56 (1969).

Hornwall, Margareta. 'Uppsala universitetsbiblioteks resurser och service under 1600-talet', *Nordisk tidskrift för bok- och biblioteksväsen*, 68 (1981).

Hoskins, Janet. 'Agency, biography and objects', in C. Tilley (ed.), *Handbook of material culture* (London: SAGE, 2006).

Humble, Sixten. 'Thomas Hiärne', *Personhistorisk tidskrift*, 26 (1925).

Håkansson, Håkan. *Vid tidens ände. Om stormaktstidens vidunderliga drömvärld och en profet vid dess yttersta rand* (Göteborg: Makadam, 2014).

Johannesson, Kurt. 'Uppsala universitet och 1600-talets Europa', in S. Lundström (ed), *Gustav II Adolf och Uppsala universitet* (Uppsala: Uppsala universitet, 1982).

Joyce, Rosemary A. & Gillespie, Susan D. 'Making things out of objects that move', in R. A. Joyce & S. D. Gillespie (eds.), *Things in motion. Object itineraries in anthropological practice* (Santa Fe: School for Advanced Research Press, 2015).

Junkelmann, Marcus. 'Den katolska ligans troféer och krigsbyten under trettioåriga kriget', in A. Grönhammar & C. Zarmén (eds.), *Krigsbyte* (Stockholm: Livrustkammaren, 2007).

Karlson, William. *Ståt och vardag i stormaktstidens herremanshem* (Lund: Gleerup, 1945).

Keating, Jessica & Markey, Lia. 'Introduction. Captured objects. Inventories of early modern collections', *Journal of the History of Collections*, 23:2 (2011).

Kleberg, Tönnes. *Bibliotek i krigstid. Uppsala universitetsbibliotek i stora nordiska krigets slutskede* (Uppsala: Skrifter rörande Uppsala universitet, 1966).

Klemming, Gustaf Edvard. *Om Stephanii boksamling* (Stockholm: Norstedt, 1850).

Kopytoff, Igor. 'The cultural biography of things. Commoditization as process', in A. Appadurai (ed.), *The social life of things. Commodities in cultural perspective* (Cambridge: Cambridge University Press, 1986).

Kowalski, Hubert. 'Archaeological examinations of the bottom of the Vistula River near the Citadel in Warsaw in 2009–2012', *Światowit*, X(LI)/B (2012).

Kowalski, Hubert & Wagner, Katarzyna. 'Swedish army and the marbles from Warsaw', *Historisk Tidskrift*, 3 (2016).

Krajevska, Beata & Zeids, Teodor. 'Zwei kurländische Archive und ihre Schicksale', in I. Misāns & E. Oberländer (eds.), *Das Herzogtum Kurland 1561–1795. Verfassung, Wirtschaft, Gesellschaft. Band 1* (Lüneburg: Verlag Nordostadt Kulturwerk, 1993).

Kreem, Juhan. 'The Archives of the Teutonic Order in Livonia. Past and Present', *Coleção Ordens Militares*, 8 (2018).

Krēsliņš, Jānis, 'War booty and early modern culture', *Biblis*, 38 (2007).

Kylsberg, Bengt. 'Den konstfulla tekniken', in C. Bergström (ed.), *Skoklosters slott under 350 år* (Stockholm: Byggförlaget, 2004).

Kylsberg, Bengt. 'Krigsbyten på Skoklosters slott', in S. Nestor & C. Zarmén (eds.), *Krigsbyten i svenska samlingar. Rapport från seminarium i Livrustkammaren 28/3 2006* (Stockholm: Livrustkammaren, 2007).

Kylsberg, Bengt. 'Seklers vård av Skokloster', in *Bevarandets hemlighet. Konsten att vårda, förvara och konservera* (Stockholm: Livrustkammaren, Skoklosters slott och Hallwylska museet, 1991).

de Laet, Marianne & Mol, Annemarie. 'The Zimbabwe bush pump. Mechanics of a fluid technology', *Social Studies of Science*, 30 (2000).

Lash, Scott & Lury, Celia. *Global culture industry. The mediation of things* (Cambridge: Polity Press, 2007).

Lindberg, Bo H. 'Spoils and trophies', in F. Sandstedt (ed.), *In hoc signo vinces. A presentation of the Swedish state trophy collection* (Stockholm: The National Swedish Museums of Military History, 2006).

Lindberg, Sten G. *Adelsböcker och stormansbibliotek* (Bålsta: Skoklosters slott, 1969).

Lindroth, Sten, *Svensk lärdomshistoria 2. Stormaktstiden* (Stockholm: Norstedt, 1975).

Losman, Arne. 'Adelsbiblioteket som intellektuellt landskap', *Tvärsnitt. Humanistisk och samhällsvetenskaplig forskning*, 4 (1988).

Losman, Arne. *Carl Gustaf Wrangel och Europa. Studier i kulturförbindelser kring en 1600-talsmagnat* (Stockholm: Almqvist & Wiksell, 1980).

Losman, Arne. 'Skoklosters byggherrskap', in C. Bergström (ed.), *Skoklosters slott under 350 år* (Stockholm: Byggförlaget, 2004).

Losman, Arne. 'Skokloster. Europe and the world in a Swedish castle', in A. Losman etc. (eds.), *The age of new Sweden* (Stockholm: Livrustkammaren, 1988).

Losman, Arne. 'Skokloster slott. Större än summan av delarna', in *Bevarandets hemlighet. Konsten att vårda, förvara och konservera* (Stockholm: Livrustkammaren, Skoklosters slott och Hallwylska museet, 1991).

Losman, Arne. 'Tre rekonstruerade 1600-talsbibliotek på Skokloster', *Skoklosterstudier*, 1 (1968).

Losman, Arne. 'Vetenskap och idéer i Per Brahe d.y:s och Carl Gustaf Wrangels bibliotek', *Lychnos. Årsbok för idé- och lärdomshistoria.* 1971–1972 (1973).

Losman, Arne. 'Wrangel, Skokloster och Europa', in E. Westin Berg (ed.), *1648 Westfaliska freden* (Katrineholm: Vasamuseet, 1998).

Löfstrand, Elisabeth & Nordquist, Laila. *Accounts of an occupied city. Catalogue of the Novgorod Occupation Archives 1611–1617. Series 1* (Stockholm: Almqvist & Wiksell, 2005).

Meyerson, Åke & Rangström, Lena. *Wrangel's armoury. The weapons Carl Gustaf Wrangel took from Wismar and Wolgast to Skokloster in 1645 and 1653* (Stockholm: Royal Armoury foundation press, 1984).

Milligan, Jennifer. '"What is an Archive?" in the history of modern France', in A. Burton (ed.), *Archive stories. Facts, fictions, and the writing of history* (Durham: Duke University Press, 2005).

Mordhorst, Camilla. *Genstandsfortaellinger. Fra Museum Wormianum til de moderne museer* (Köpenhamn: Museum Tusculanums Forlag, 2009).

Mortimer, Geoff. *Eyewitness accounts of the Thirty Years War 1618–48* (Basingstoke: Palgrave, 2002).

Munkhammar, Lars. 'Böcker som krigsbyte', in S. Nestor & C. Zarmén (eds.), *Krigsbyten i svenska samlingar. Rapport från seminarium i Livrustkammaren 28/3 2006* (Stockholm: Livrustkammaren, 2007).

Munkhammar, Lars. 'De många och stora bokroven', in A. Grönhammar & C. Zarmén (eds.), *Krigsbyte* (Stockholm: Livrustkammaren, 2007).

Müller, Edgar. 'Hugo Grotius und der Dreißigjährige Krieg Zur frühen Rezeption von *De jure belli ac pacis*', *The Legal History Review*, 77 (2009).
Nappi, Carla. 'Surface tension. Objectifying ginseng in Chinese early modernity', in P. Findlen (ed.), *Early modern things. Objects and their histories 1500–1800* (New York: Routledge, 2012).
Nelles, Paul. 'The uses of orthodoxy and Jacobean erudition. Thomas James and the Bodleian library', in M. Feingold (ed.), *History of universities*, 12 (2007).
Nestor, Sofia. 'Krigsbyten i Livrustkammaren', in S. Nestor & C. Zarmén (eds.), *Krigsbyten i svenska samlingar. Rapport från seminarium i Livrustkammaren 28/3 2006* (Stockholm: Livrustkammaren, 2007).
Nestor, Sofia & Grönhammar, Ann (eds.). *War-booty. A common European cultural heritage* (Stockholm: Livrustkammaren, 2009).
Nilsson Nylander, Eva. *The mild boredom of order. A study in the history of the manuscript collection of Queen Christina of Sweden* (Lund: Institute of ALM and Book History, Lund University, 2011).
Norberg, Erik. 'Krigets lön', in A. Grönhammar & C. Zarmén (eds.), *Krigsbyte* (Stockholm: Livrustkammaren, 2007).
Nordström, Johan. *De yverbornes ö. Sextonhundratalsssstudier* (Stockholm: Bonnier, 1934).
Norris, Matthew. *A pilgrimage to the past. Johannes Bureus and the rise of Swedish antiquarian scholarship 1600–1650* (Lund: Lunds universitet, 2016).
Ogborn, Miles & Withers, Charles W. J. 'Introduction. Book geography, book history', in M. Ogborn & C. Withers (eds.), *Geographies of the book* (London: Routledge, 2016).
Olin, Martin. 'Minnet av karolinerna. Inredningar och samlingar under Ulrika Eleonora d. y:s tid', in G. Alm & R. Millhagen (eds.), *Drottningholms slott. Band 1. Från Hedvig Eleonora till Lovisa Ulrika* (Stockholm: Byggförlaget Kultur, 2004).
Olin, Martin. 'Trophy triumphs in Stockholm', in F. Sandstedt (ed.), *In hoc signo vinces. A presentation of the Swedish state trophy collection* (Stockholm: The National Swedish Museums of Military History, 2006).
van Ommen, Kasper. 'Legacy of Scaliger in the Leiden University catalogues', in M. Walsby & N. Constantinidou (eds.), *Documenting the early modern book world. Inventories and catalogues in manuscript and print* (Leiden: Brill, 2013).
Ottermann, Annelen. 'Dionysius und Jacobus Campius als Buchbesitzer – eine Momentaufnahme (nicht nur) mit Blick auf die Mainzer Karmeliten', in C. Haug etc (eds.), *Buch – Bibliothek – Region. Wolfgang Schmitz zum 65. Geburtstag* (Wiesbaden: Harrassowitz Verlag, 2014).
Pearce, Susan. *On collecting. An investigation into collecting in the European tradition* (London: Routledge, 1995).
Pearson, David. *Provenance research in book history. A handbook* (London: British Library, 1994).

Pečirka, Josef. *Zpráva o rukopisech českých v královské bibliotéce v Stokholmě se nacházejících od Dr. Jos. Pečirky* (Prague: Časopis českého Muzea, 1851).

Pomata, Gianna & Siraisi, Nancy G. 'Introduction', in G. Pomata & N. G. Siraisi (eds.), *Historia. Empiricism and erudition in early modern Europe* (Cambridge, Massachusetts: MIT Press, 2005).

'Project traces books looted by Swedes', Radio Praha, 05-03-2019, https://www.radio.cz /en/section/in-focus/project-traces-books-looted-by-swedes, access 17 June 2017.

Randolph, John. 'On the biography of the Bakunin family archive', in A. M. Burton (ed.), *Archive stories. Facts, fictions, and the writing of history* (Durham N.C.: Duke University Press, 2005).

Rangström, Lena. *Krigsbyten på Skokloster* (Bålsta: Skoklosters slott, 1978).

Rangström, Lena, Skeri, Karin & Westin Berg, Elisabeth. *Skokloster. Slott och samlingar* (Bålsta: Skoklosters slott, 1980).

Redlich, Fritz. *De praeda militari. Looting and booty 1500–1815* (Wiesbaden: Franz Steiner Verlag, 1956).

Regner, Elisabeth. 'Ur Historiska museets samlingar. Krigsbyten som klenoder och historiebruk', in S. Nestor & C. Zarmén (eds.), *Krigsbyten i svenska samlingar. Rapport från seminarium i Livrustkammaren 28/3 2006* (Stockholm: Livrustkammaren, 2007).

Reichl-Ham, Claudia. '"Keiner soll auf Beuth gehen ohne Wissen und Willen seines Hauptmannes". The war-booty laws of the Holy Roman and Habsburg Empires in theory and practice from the 16th to the 19th centuries', in S. Nestor & A. Grönhammar (eds.), *War-booty. A common European cultural heritage* (Stockholm: Livrustkammaren, 2009).

Remond, Jaya. 'Artful instruction. Pictorializing and printing artistic knowledge in early modern Germany', *Word & Image*, 36:2 (2020).

Riello, Giorgio. 'Things seen and unseen. The material culture of early modern inventories and their representation of domestic interiors', in P. Findlen (ed.), *Early modern things. Objects and their histories 1500–1800* (New York: Routledge, 2012).

Rottermund, Andrzej. 'Polska föremål i svenska samlingar', in A. Grönhammar & C. Zarmén (eds.), *Krigsbyte* (Stockholm: Livrustkammaren, 2007).

Ruud, Lise Camilla & Planke, Terje. 'Rolstadloftet. En vetenskapshistorisk biografi', in S-A. Naguib & B. Rogan (eds.), *Materiell kultur og kulturens materialitet* (Oslo: Novus forlag, 2011).

Šamurin, Evgenij Ivanovič, *Geschichte der bibliothekarisch-bibliographischen Klassifikation. Band 1* (Leipzig: Veb Bibliographisches Institut, 1964).

Sandstedt, Fred & Engquist Sandstedt, Lena. 'Proud symbols of victory and mute witnesses of bygone glories', in F. Sandstedt (ed.), *In hoc signo vinces. A presentation of the Swedish state trophy collection* (Stockholm: The National Swedish Museums of Military History, 2006).

Savoy, Bénédicte. 'Introduction', *Journal for Art Market Studies*, 2 (2018).
Savoy, Bénédicte, *Kunstraub. Napoleons Konfiszierungen in Deutschland und die europäischen Folgen* (Vienna: Böhlau, 2011).
Savoy, Bénédicte. 'Looting of art. The museum as a place of legitimisation', in S. Nestor & A. Grönhammar (eds.), *War-booty. A common European cultural heritage* (Stockholm: Livrustkammaren, 2009).
Sayre Schiffman, Zachary. *The birth of the past* (Baltimore: Johns Hopkins University Press, 2011).
Schiemann, Theodor. *Regesten verlorener Urkunden aus dem alten livländischen Ordensarchiv* (Mitau: E. Behres Verlag, 1873).
Schirren, Carl. *Verzeichnis livländischer Geschichtsquellen in schwedischen Archiven und Bibliotheken* (Dorpat: W. Gläsers Verlag, 1861–1868).
Sebesta, Karel. 'Från Josef Dobrovský till Beda Dudík', *Slovo*, 42 (1993).
Sellberg, Erland. *Kyrkan och den tidigmoderna staten. En konflikt om Aristoteles, utbildning och makt* (Stockholm: Carlsson, 2010).
Sherman, William H. *Used Books. Marking readers in Renaissance England* (Philadelphia: University of Pennsylvania Press, 2009).
Sjöberg, Maria. *Kvinnor i fält 1550–1850* (Möklinta: Gidlunds, 2008).
Skogh, Lisa. *Material worlds. Queen Hedwig Eleonora as collector and patron of the arts* (Stockholm: Center for the History of Science at the Royal Swedish Academy of Sciences, Stockholm University, 2013).
Snickare, Mårten. 'The king's tomahawk. On the display of the Other in seventeenth-century Sweden, and after', *Konsthistorisk tidskrift/Journal of Art History*, 80 (2011).
Steedman, Carolyn. *Dust* (Manchester: Manchester University Press, 2001).
Strmljan, Alina. '"Der Prager Kunstraub" zwischen Kulturpolitik und Selbstinszenierung' in I. Dolezalek etc. (eds.), *Beute. Eine Anthologie zu Kunstraub und Kulturerbe* (Berlin: Matthes & Seitz, 2021).
Summit, Jennifer. *Memory's library. Medieval books in early modern England* (Chicago: University of Chicago Press, 2008).
Svenska akademins ordbok, https://www.saob.se.
Svenskt biografiskt lexikon, https://sok.riksarkivet.se/sbl/Start.aspx.
The Guardian, https://www.theguardian.com/world/2014/may/23/book-rustlers-tim buktu-mali-ancient-manuscripts-saved, access 11 August 2021.
The Guardian, https://www.theguardian.com/artanddesign/jonathanjonesblog/2011 /jan/31/egypt-museums-must-be-defended, access 11 August 2021.
'The Swedish booty books from Bohemia and Moravia', https://krigsbyte.lib.cas.cz /Search/Results, access 13 August 2022.
Trypućko, Józef etc. (eds.). *The catalogue of the book collection of the Jesuit College in Braniewo held in the University Library in Uppsala*, vol. 1 (Warsaw: Biblioteka Narodowa, 2007).

UNESCO, http://www.unesco.org/new/en/culture/themes/armed-conflict-and-heritage, access 11 August 2021.

Undorf, Wolfgang. *Hogenskild Bielke's library. A catalogue of the famous 16th-century Swedish private collection* (Uppsala: Uppsala Universitet, 1995).

Vaculínová, Marta. 'Bohemica in Sweden and the National Museum Library in Prague', in S. Nestor & A. Grönhammar (eds.), *War-booty. A common European cultural heritage* (Stockholm: Livrustkammaren, 2009).

Veselá, Lenka. 'Aristocratic Libraries from Bohemia and Moravia in Sweden' in S. Nestor & A. Grönhammar (eds.), *War-booty. A common European cultural heritage* (Stockholm: Livrustkammaren, 2009).

Villstrand, Nils Erik. 'Stormaktstidens politiska kultur', in J. Christensson (ed.), *Signums svenska kulturhistoria. Stormaktstiden* (Lund: Signum, 2005).

Vismann, Cornelia. *Files. Law and media technology* (Stanford: Stanford University Press, 2008).

Wade, Mara R. 'Emblems in Scandinavia', in A. J. Harper & I. Höpel (eds.), *The German-language emblem in its European context. Exchange and transmission* (Glasgow: University of Glasgow, 2000).

Wahlberg Liljeström, Karin. *Att följa decorum. Rumsdisposition i den stormaktstida högreståndsbostaden på landet* (Stockholm: Stockholms universitet, 2007).

Walde, Otto. 'Hur man sålde dupletter i forna tider. Ett kulturdokument från 1710', *Nordisk tidskrift för bok- och biblioteksväsen*, 2 (1915).

Walde, Otto. *Storhetstidens litterära krigsbyten I* (Uppsala: Almqvist & Wiksell, 1916).

Walde, Otto. *Storhetstidens litterära krigsbyten II* (Uppsala: Almqvist & Wiksell, 1920).

Walsby, Malcolm. 'Book lists and their meaning', in M. Walsby & N. Constantinidou (eds.), *Documenting the early modern book world. Inventories and catalogues in manuscript and print* (Leiden: Brill, 2013).

Wangefelt Ström, Helena. 'Heligt, hotfullt, historiskt. Kulturarvifieringen av det katolska i 1600-talets Sverige', *Lychnos. Årsbok för idé- och lärdomshistoria* (2011).

Westin Berg, Elisabeth. 'Krigsbytesböcker i biblioteken på Skokloster', in S. Nestor & C. Zarmén (eds.), *Krigsbyten i svenska samlingar* (Stockholm: Livrustkammaren, 2007).

Widenberg, Johanna. *Fäderneslandets antikviteter. Etnoterritoriella historiebruk och integrationssträvanden i den svenska statsmaktens antikvariska verksamhet ca. 1600–1720* (Uppsala: Uppsala Universitet, 2006).

Wieselgren, Oscar. 'Skoklosterhandskriften av Vasco de Lucenas Curtius-parafras', *Nordisk tidskrift för bok- och biblioteksväsen*, 12 (1925).

Wilson, Peter H. *The Thirty Years War. Europe's tragedy* (Cambridge, Massachusetts: The Belknap Press of Harvard University Press, 2011).

Winberg, Ola. *Den statskloka resan. Adelns peregrinationer 1610–1680* (Uppsala: Uppsala universitet, 2018).

Zarmén, Carl. 'Foreword', in S. Nestor & A. Grönhammar (eds.), *War-booty. A common European cultural heritage* (Stockholm: Livrustkammaren, 2009).

Zedelmaier, Helmut. *Bibliotheca universalis und bibliotheca selecta. Das Problem der Ordnung des gelehrten Wissens in der frühen Neuzeit* (Cologne: Böhlau, 1992).

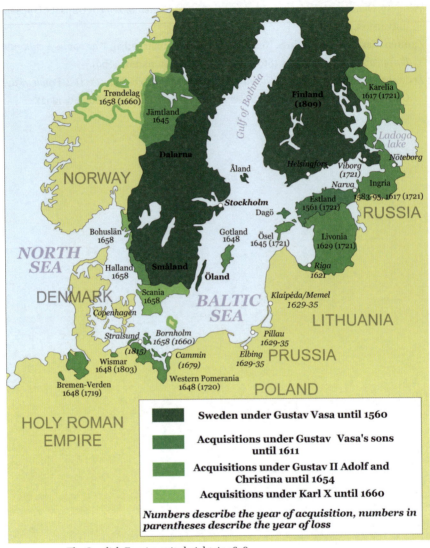

FIGURE 1 The Swedish Empire at its height, in 1658
WIKIMEDIA COMMONS

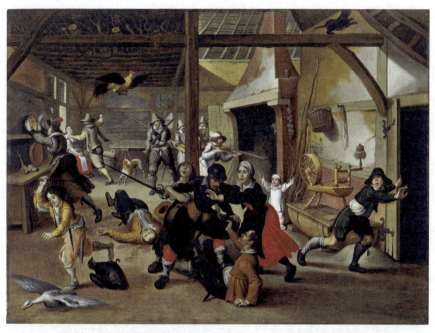

FIGURE 2 Soldiers plundering a farm during the Thirty Years War by Sebastiaen Vrancx
WIKIMEDIA COMMONS

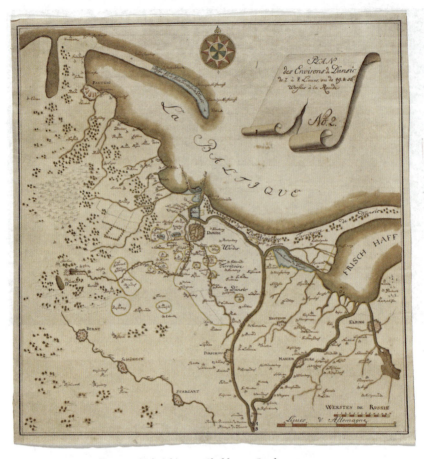

FIGURE 3 Map of Danzig (Gdańsk) area, Skokloster Castle

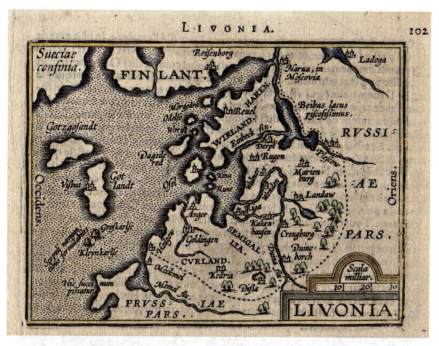

FIGURE 4 Map of the historical region Livonia

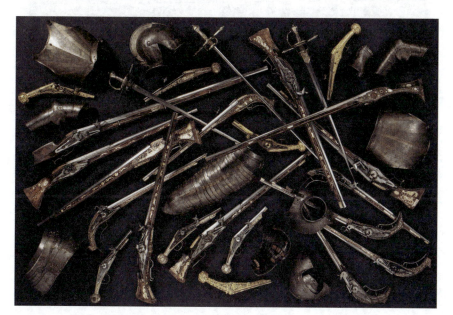

FIGURE 5 Parts of the Mitau spoils preserved in the Royal Armoury in Stockholm
PHOTO: GÖRAN SCHMIDT

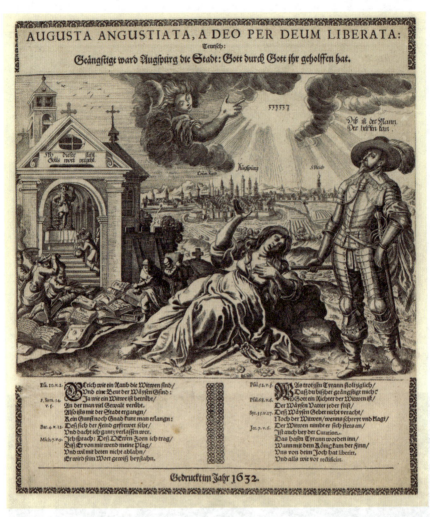

FIGURE 6 Copperplate depicting Gustavus Adolphus, with Jesuits in the background burning books
PHOTO: UPPSALA UNIVERSITY LIBRARY

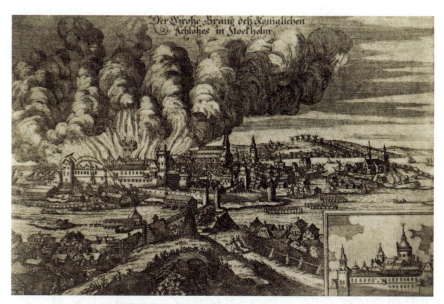

FIGURE 7 Tre Kronor Castle burning in 1697
WIKIMEDIA COMMONS

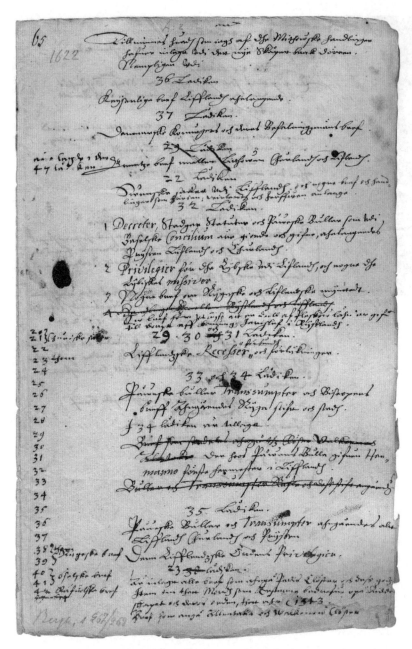

FIGURE 8 First page of Per Månsson Utter's 1622 list of the documents from Mitau in the new cabinet
PHOTO: THE NATIONAL ARCHIVES

ILLUSTRATIONS 197

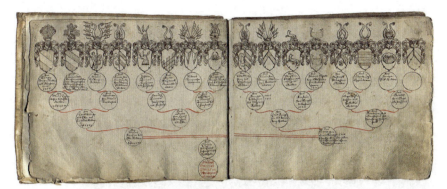

FIGURE 9 Per Månsson Utter's 'coat of arms book', arranged to show the ancestry of various members of the Swedish nobility, including the Vasas. X4, UUB
PHOTO: UPPSALA UNIVERSITY LIBRARY

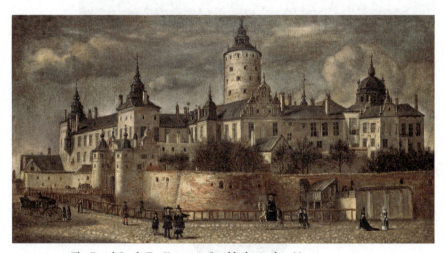

FIGURE 10 The Royal Castle Tre Kronor in Stockholm in the 1660s
WIKIMEDIA COMMONS

FIGURE 11 Call number Schirren no. 6, or a parchment document from the early thirteenth century that became spoils in Mitau 1621
PHOTO: THE NATIONAL ARCHIVES

ILLUSTRATIONS

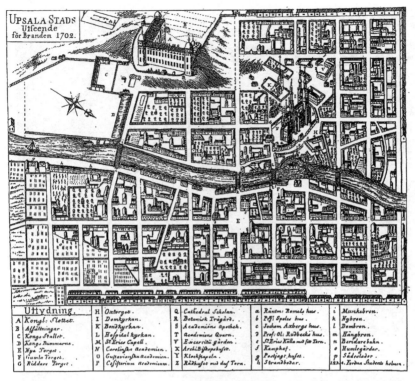

FIGURE 12 Map over Uppsala before the fire of 1702. The library had then been moved from building P, *Consistorium academicum*, to building O, 'Gustavianska academien'.
FROM JOHAN BENEDICT BUSSER, *UTKAST TILL BESKRIFNING OM UPSALA* (BROMBERG: UPPSALA, 1979 [1769]). WIKIMEDIA COMMONS

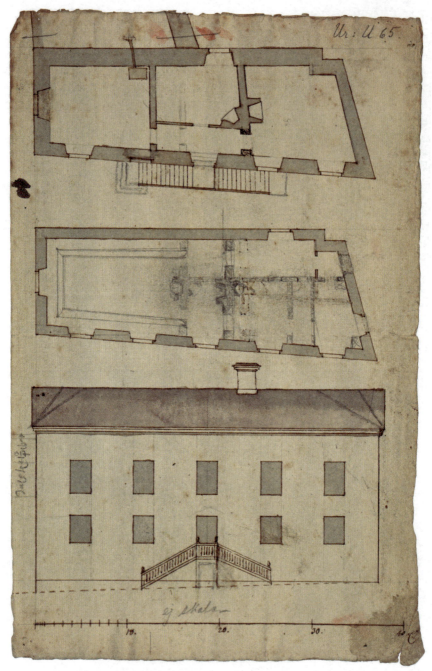

FIGURE 13　Drawing of the building that housed the old Uppsala University Library, c.1700, U65, UUB
PHOTO: UPPSALA UNIVERSITY LIBRARY

ILLUSTRATIONS

FIGURE 14 The two first catalogues, K2 and K3, UUB
PHOTO: UPPSALA UNIVERSITY LIBRARY

FIGURE 15 A page from catalogue K5a, UUB, showing how the Lutheran theology is described in different ways, first as 'our' and then as 'the latest' or 'Lutheran'
PHOTO: UPPSALA UNIVERSITY LIBRARY

FIGURE 16 Skokloster Castle around 1860, in Julius Axel Kiellman Göranson's guide
WIKIMEDIA COMMONS

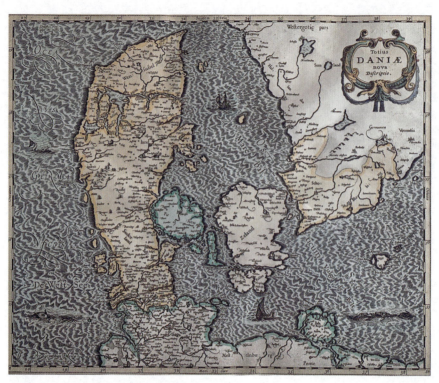

FIGURE 17 Map of Denmark, seventeenth century
WIKIMEDIA COMMONS

FIGURE 18 First page of the list recording Wrangel's Rothkirch spoils, in the catalogue
'*Bibliotheca Rothkirchiana equestris*', E 8580, Skokloster collection, RA Marieberg
PHOTO: THE NATIONAL ARCHIVES

FIGURE 19 Interior of the library at Skokloster
PHOTO: JENS MOHR, SKOKLOSTER CASTLE

ILLUSTRATIONS

FIGURE 20 Jousting shield with connection to a Danish princely wedding
 PHOTO: SKOKLOSTER CASTLE

FIGURE 21 Prayer book that has belonged to a Berete Knutsdatter, Wr. teol. 8:o 47:1–2, Skokloster Castle
PHOTO: BENGT KYLSBERG, SKOKLOSTER CASTLE

FIGURE 22 Bible in Icelandic whose provenance notation has been cut out, Wr. teol. fol. 8, Skokloster Castle
PHOTO: FREDRIK ANDERSSON, SKOKLOSTER CASTLE

Index

Academy of Antiquities 120, 122
Albert v of Bavaria 151, 153
 his collections 152ff., 156f.
Alexander the Great 53, 154
Amsterdam 23, 133, 157
Annerstedt, Claes 99, 101, 113, 120
antiquarian research 14, 90, 109, 141
antiquities 14, 48, 51, 109f., 122, 152f.
Antvorskov 131
archival documents
 as old and rare 14f., 55, 66, 68f., 79f., 169f.
 collecting of 3, 14, 40ff., 56, 79f.
 materiality of 57, 170
 transformations of 11, 54
archives
 and linage 54ff., 65f.
 biographies of 57
 national 57
 Prussian model 59
 research on 11–12, 54–57
Aristotle 90, 94
Arndt, Johann 133
Aschaffenburg Castle, Bavaria 156f.
Augsburg 45
Aurer, Mats 123
Aquinas, Thomas 112

Backhaus, Helmut 41, 67, 70
Bamberg, Bavaria 30
Banér, Johan 41
Banér, Peder 38
Barnewitz, Fredrik 134f., 145
Bellarmino, Roberto 107
Bepler, Jill 13, 40, 45
Bergh, Severin 66, 77
Berlin 76
Bibliotheca apostolica vaticana 96
Bielke, Carl Gustaf 139
Bielke, Hogenskild 64, 99
Bleichmar, Daniela 10, 69, 92, 142
Bodleian Library, Oxford 100, 116
Bonifacio, Baldassare 19, 53, 70
Books and manuscripts
 as gifts 3, 43f., 95, 99, 143f., 168, 171
 as trophies 43f., 48, 155

as weapons 44, 110
bindings of 43, 79, 92, 97, 108, 113, 122, 136f., 143ff., 155, 165
confessional 42ff., 51, 85, 103f., 111, 116, 120, 122, 133ff., 171ff.
in 'monk script' 71, 109, 113, 121f.
materiality of 43f., 103, 122, 124, 126, 142, 169
notes in 92, 97, 158, 165
of dissolved monasteries 64, 71, 87, 99, 107, 125, 171
old and rare 14f., 109f., 113–115, 119ff., 125, 135, 154
owner's note in 92, 143ff., 155, 167
Booty *see spoils*
Bourdelot, Pierre Michon 97–98
Bowker, Geoffry C. 10
Bracken, Susan 12f.
Brahe, Erik 139
Brahe, Magnus 161
Brahe, Nils 139, 160
Brahe, Per the Younger 77, 139, 141
Braunsberg (Braniewo) 7, 33, 39f.
Brenner, Elias 141, 148, 159f.
Bureus, Johannes
 expertise of 14, 84
 inventorying of Prussia spoils 90–95, 101, 106f., 109, 111, 113, 123f., 142f., 165ff.
 organising Uppsala University Library 102
Burke, Peter 5, 12
burning of villages and cities 32f.
burning of books and archival
 documents 34, 44f., 194
Bütner, Conrad 136, 138, 140ff., 144, 146
Båth, Sten 1ff.

cabinet of curiosities 17, 29, 35, 79, 130, 149, 151, 158
Calvin, Jean 146
Catherine Jagiellon 21, 64, 69
Catholic League 43ff.
Caus, Salomon de 137, 141
Charles IX 21, 56, 62, 64f., 70, 99

INDEX

Charles X Gustav of Zweibrücken-
 Kleeburg 4, 33f., 36, 47, 56, 133, 152
Charles XI 4, 74, 110, 166
Charles XII 4, 80
Charles XIV John 161
Chemnitz, Basilius 131f., 140, 142
Chests
 as means of transport 5, 32, 37f., 39, 41,
 60f., 67ff., 80, 94f., 101, 123f., 131, 157,
 164, 170, 174
 as spoils 35, 130, 150
 as storage 18, 34f., 37f., 64, 69ff., 75, 82,
 89ff., 97, 99, 111f., 120, 143, 149, 152, 162,
 165
China 156
Christburg (Dzierzgoń) 33
Christian II 21, 66, 132
Christian IV 131, 136, 150, 155
 his son 150
Christina, Queen 1, 4, 8, 22, 36, 56
 anonymous librarian of 97f.
 as manuscript collector 18, 96ff., 108f.
 book collection in Antwerp 97
 interest in Prussian manuscripts 95f.
 librarians of 22, 96ff., 100, 110f., 119, 146
 move to Rome 96f.
Church Fathers 41, 93f., 107, 111, 147
Cicero 25, 27, 94
Clark, William 14, 79
Clement, Claude 13, 19, 106, 110, 152
Codex Argenteus (the silver bible) 119, 199f.,
 149
collection(s) and collecting
 access to 17, 172
 biographies and narratives of 9ff., 51
 cataloguing and categories of 6, 18, 20,
 48, 83, 85, 97, 102, 202
 culture and ideals of 3, 7, 14, 23, 40ff.,
 127f., 130, 132, 137f., 146ff., 151ff., 168
 elite 12ff., 21ff., 29, 36, 40ff., 133, 137f., 140,
 148, 152, 173f.
 encyclopaedic 7, 19, 26, 34, 111, 128ff.,
 146ff., 162f.
 postcolonial perspectives on 12, 173
 reconstruction of 17f., 82, 136, 138f., 166
 studies 4, 6f. 9ff., 18, 23, 26, 54, 127
 temporality of 14, 56, 65ff. 114, 117, 125,
 167ff., 171

Copernicus, Nicolaus 90, 92
Counter-Reformation *see Reformation*
Courland
 administration of 59, 74
 Duchy of 7, 18, 52, 58, 73ff.
 Duke(s) of 39, 58f., 60, 72ff., 80, 169
 envoy in Sweden 74f.
Cowen Orlin, Lena 20
Czaika, Otfried 134

Dalarna 157
Danzig (Gdańsk) 31ff., 66, 192
Daston, Lorraine 26
De la Gardie, Magnus Gabriel 34f., 103,
 119ff., 133ff., 146
Denmark 3, 7, 17f., 21f., 25, 30, 33f., 36, 49,
 66, 131, 133, 136, 145, 155, 164f., 204
Derrida, Jacques 11, 53
Descartes, René 22
Dietrichstein collection 98
Dilherr, Johann Michael 134
Dirschau (Tczew) 33
Dobrovský, Josef 172
Dorpat (Tartu) 123
Dudík, Beda 159ff., 172f.

Egypt 24
Eichstätt, Bavaria 30, 144
Elbing (Elbląg) 33, 40
Erasmus 94
Eric XIV 21, 48, 56, 60, 62, 65, 68f., 71f., 75
Eriksson, Magnus King 66
Ernritter, Colonel 33
Estonia 60, 62
Etymology and use of words 13, 26f.
 of *byte* (booty, spoils) 26, 45ff.
 of *confiscare* 37
 of *kaduk* (escheat) 26, 38f.
 of *krigsbyte* (spoils of war) 26, 45, 159, 170
 of museums 13
 of *plundra* (to plunder) 26, 31ff.
 of spoils of war 45
 of *spolia* (spoils) 2, 26, 45ff.
 of *spoliera* (to ruin) 26, 31ff.
 of *trofé* (trophy) 26, 43, 45, 47ff.

Findlen, Paula 8, 16, 26, 48, 111
fire ransom 32f.

Foucault, Michel 11, 48
Fouilloux, Jacob von 137
France 1, 145
Franck, Sebastian 132
Frankfurt am Main 23
Frauenburg (Frombork) 7, 39f., 76, 108, 166
Freinshemius, Johannes 95f.
Furttenbach, Joseph 151

Gáldy, Andrea 12f.
Gartman, consistory member 118
Gesner, Conrad 147f.
Gheyn, Jacob de 137
Goeing, Anja-Silvia 6, 9, 17
Gothicism (Göticism) 154
Gothus, Laurentius Paulinus 42f., 49
Gotland 157
Grafton, Anthony 7, 9, 17
Granberg, Olof 127
Gregory XV 43f.
Greifswald 23, 129, 134
Gretser, Jacob 107
Grotius, Hugo 6, 27f., 30
Gråmunkeholmen, island 99
Gustav Eriksson Vasa 21, 56, 62ff., 69, 71f., 75, 132
Gustavus Adolphus
 and administration 56, 53ff., 63ff., 70
 and Jesuits 44f., 84, 124
 and Uppsala University 86f., 99, 102
 articles of war 28, 30ff., 46
 campaigning of 1, 25f., 31ff., 90, 156, 171, 194
 chancery *see royal chancery*
 cultural politics and collecting of 14, 16, 22f., 29, 51, 92, 95, 123, 128f., 132, 136, 146, 168
 exhibition in 1932 50
 his son 95
 reading Hugo Grotius 27
 taking spoils 2ff., 7, 16, 25, 29, 32, 36ff., 44, 50f., 52f., 58f., 84, 96, 124, 128f., 132, 146, 152, 156, 164, 171, 174

Hadorph, Johan 120
Hagenbeucher, Mortitz 144
Hagendorf, Peter 28
Hague Convention of 1954 24

Hamburg 23
Hardt, Richard von der 77ff., 159
Harrien 62
Haugwitz, Anna Margareta von 8, 23, 128, 154f.
Heidelberg Palatinate Library 43ff., 49
Helgeandsholmen, island 52, 77
Hessia 157
Hill, Kate 10
Hiärne, Thomas 78f.
Hjörring, Anders M. 34
Holy Roman Empire 1, 87, 100, 125, 162, 168, 170f.
Horn, Gustav 1ff.
Hornwall, Gert 110, 112
Hornwall, Margareta 43, 85, 113, 120
Huitfeldt, Arild 62
Hutter, Leonhard 131

Italy 157

Jerwen 62
Jesuit Order 173
 books 6, 18f., 37, 40, 42f., 49f., 85, 90, 105ff., 133ff., 147, 156, 168f.
 college in Braunsberg 7, 17, 39, 84, 86ff., 124
 college in Erfurt 133
 college in Heiligenstadt 133
 college in Posen 110
 college in Riga 7, 18, 36ff., 44, 59, 84, 87, 89, 125
 epistemology 6, 43, 93, 110ff., 146, 170
 goods 37, 39f.
 in Frauenburg 40
 library catalogue of the Braunsberg College 3, 93f., 110ff., 170
 mission 16, 38, 86
John III 21, 56, 64f., 67, 70, 75, 84, 99
Jonae, Sven 102
Julius Caesar 53
Junius, Anna Maria 30

Kettler, Frederick Casimir 75f.
Kettler, Gotthard 58f., 72f.
Kingdom's Archive 7, 159, 160, 163
 access to 17, 19, 54, 78ff.
 and the castle fire 76ff.

INDEX

Kingdom's Archive (*cont.*)
 as Vasa history 52ff., 57ff., 65ff., 81f., 116, 128, 154, 167
 at Count Per Brahe's house 77
 at the Catholic Chapel at Tre Kronor 69ff.
 at Tre Kronor 58ff.
 cabinets of 16, 65f., 68, 74, 164
 centralisation and establishment of 55ff., 63f.
 challenges of 56f., 65, 81, 117
 confiscated files in 39, 48, 60ff., 74, 81
 distinguished files of 61f., 65f., 70, 73, 169
 Estonian documents in 72
 inventories of 68, 70, 77
 Livonian documents in 71f., 77ff.
 moving of 71, 77, 82, 123
 narrative of 55ff., 65ff., 116
 objects of 60, 64, 71, 125
 organisation of 55ff., 62–72, 77, 82, 116, 164
 Russian documents in 65, 68f., 71f.
 safety of 64, 77f., 119, 123
 torn documents in 73f.
Kircher, Athanasius 111, 156
Klemming, Gustaf Edvard 173
Kloot, Colonel von 78f.
knowledge
 classification of 5, 52, 85, 90, 92ff., 105ff., 110, 112ff., 125, 142, 146, 168ff.
 materiality of 103, 106, 121, 124, 126, 128, 165, 170f.
 old and new 14f., 88, 109f., 113, 116, 121, 137f., 169f.
 practical 129, 137f.
Knutsdatter, Berete 155
Koeningsberg 76
Kopytoff, Igor 9
Korsör Castle 34f., 131
Krakow 173
Kranz, Albert 132
Kruus, Jesper Mattsson 37

Lapide, Cornelius a 133, 135
Lash, Scott 10
Latvia 52, 58
Leiden 96
 University Library of 100

Leigh Star, Susan 10
Leipzig 49, 148, 154, 167
Leopold Vilhelm of Austria 49, 148, 154
 silver service of 49, 148, 155
librarian, profession 100
libraries
 catalogues and manuals 18ff., 100, 106, 110, 113, 136, 146f., 157, 168
 research on 4ff., 17f., 88f., 110f., 117, 13
Lillieblad, Gustaf Peringer 78f.
Lithuania (Poland) 73f.
Livonia 7, 17, 25, 36, 39, 49, 58, 62f., 70, 72f., 77, 124, 156, 164, 170, 193
Livonian Order 39, 52, 58f., 62, 78, 168
 archive documents of 39, 52ff., 59f., 68, 70, 168
 chancery of 59f., 62
 correspondence of 62
Livrustkammaren (the Swedish Royal Armoury) 15, 193
Loccenius, Johannes 86, 118
Loci Communes (work and concept) 111f.
London 23
Losman, Arne 19, 23, 127, 144
Louis XIII 136, 151
Louis XIV 12
Lübeck 66
Lury, Celia 10
Luther, Martin 133, 136, 146, 158
Lützen 1, 50

Magalotti, Lorenzo 112f., 129, 138
Magdalena Sibylla of Saxony 150
Mali 24
Maximilian of Bavaria 43f., 49, 132
 collections in Munich 151, 156f.
Mazarin, Cardinal 146
Melanchthon, Philipp 94, 111, 158
Merian, publishing house 154
Meyerson, Åke 151
Michel, Paul 7, 9, 17
Mitau (Jelgava) Castle and town 7, 18, 39, 52, 55ff., 165
 armoury 39, 193
 documents from 52ff., 58ff., 66ff., 73, 123, 165, 169
 seizures of 59, 74, 80
Monro, Robert 44

Mordhorst, Camilla 51, 90, 129
Mortimer, Geoff 44
Munich 2, 132, 151f., 156f.
Museology 11f.

Napoleon 11
Nappi, Carla 10
National Romantic era 15f., 50, 127
Naudé, Gabriel 100, 136, 146f., 157, 168
Neuss 41
Nidaros Cathedral 48
Nilsson, Lars (Kloster-Lasse) 84, 92, 124
Nilsson Nylander, Eva 96, 110
Nuremberg 1, 23
Nystad, peace treaty of 77

objects
 as manifold 10
 biographies of 9f., 50, 52, 57, 117, 164, 171
 categorisation of 48, 85
 definition of 11, 13,
 in motion 9f.
 transformations of 9ff., 52f., 68ff., 74, 82, 159f., 163, 170
Ogier, Charles 1ff., 30f., 46f., 88, 152
Oliva, monastery 32, 159
Oliva, peace treaty of 31, 74
Olmütz (Olomouc) 41
Örebro 123
origin *see also provenance* 3, 10, 43, 47, 63, 66ff., 71, 74, 81, 83, 88, 91, 97, 101f., 104, 156f., 165f., 171
Oxenstierna, Axel 1, 32f., 36f., 40ff., 49f., 61, 63, 72f., 80, 86, 92, 168, 174
 and administration 53f., 64ff.
 instruction to take spoils 40ff.
Oxenstierna, Bengt 40
Oxenstierna, Carl 67
Oxenstierna, Gabriel Johan 159, 162

Palme, Olof 173
Pauli, Zacharias 39
Pearson, David 91, 103
Pečirka, Josef 172
Petau, Paul and Alexandre 97f.
Peter I 80
Pez, Bernhard 172
Pineda, Juan de 133, 135
Pliny the Elder 153

plunder *see spoils*
plundering
 female actors 8, 28
 in Europe 16, 40
 in Swedish sources 31ff.
 legality of 6, 27ff.
 of archives and libraries 13f., 40ff., 53f.
 of churches and religious institutions 30f., 32, 48
 of cultural objects and collections 7, 13, 24, 29f., 36ff.
 of Prague 8, 35f.
 practices of 6, 27ff.
 sources 26
Pluvinel, Antoine 136f., 150, 154, 163
Poland, or Poland-Lithuania 3, 21, 31, 38, 67, 74, 81, 134, 173
Polish Scroll 173
Pomata, Gianna 26
Pomerania 23, 128, 134, 142, 149, 157
 Duke of 41
 Armoury of 41
Possevino, Antonio 147f.
printing revolution 14, 88
provenance *see also origin* 4, 17f., 60f., 71, 82ff., 89, 91, 93ff., 103, 107, 139, 143, 145, 155, 158, 173, 209
Prussia (Poland) 7, 17, 25, 31ff., 36, 49, 156
Pufendorf, Samuel von 140f.

Quiccheberg, Samuel 19, 106, 151ff.,
 object classes of 153
 on geographical origin of objects 155ff., 165

Rammingen, Jacob von 19
Randolph, John 9f., 57
Rangström, Lena 151
Redlich, Fritz 7, 28f.
Reformation
 Catholic 14, 88, 112, 137, 147
 Protestant 14, 88, 93, 112, 134, 136f.
 Swedish 21, 64, 69f.
Regner, Elisabet 50
Relic
 of St. Elizabeth 50f.
 of St. Olof 48
 of the True Cross 2
Richelieu, Cardinal 146

INDEX

Riello, Giorgio 20, 88, 90
Riga 7, 18, 36ff., 44, 58, 80, 84, 87ff., 124f.,
 156, 165, 171
Roman law 37f.
Rosenkrantz, Gunde 34f.
Rothkirch, Wenzel 130f., 135, 150, 155, 167
 book catalogue 131f., 143
 his armoury 131
 his daughters 131f.
Royal Chancery 82, 166
 orders 55ff., 59, 60, 64, 66, 81
Royal Registry (Riksregistraturet) 19, 39,
 47, 58, 65
Rudbeck, Olof 116, 120
Rudolf II 35, 157
 his cabinet of curiosities 35, 157
Ruining 31ff.
 of churches and religious
 institutions 30f.
Runell, Erik Larsson 70
Rålamb, Claes 119

Savoy, Bénédicte 11, 24
Sayre Schiffman, Zachary 14, 55
Schedel, Hartmann 144, 154
Scheffer, Ulrik 139
Schirren, Carl 80
Scientific revolution 14f., 88, 137
Semgallen 58
Serres, Jean de 145
Sibrand, von, Courlandian minister 79
Sigismund Augustus 67
Sigismund III Vasa 21, 31, 36, 38f., 56, 58, 65,
 70, 71, 99, 156
 his son Vladislav 156
Siraisi, Nacy G. 26
Sirigatti, Lorenzo 137
Sjöberg, Maria 8
Skokloster Castle 16, 19, 29, 43, 49, 51
 armourers at 130, 149, 162
 as Stammbuch 158
 as tourist attraction 159f., 163
 as war museums 126, 128, 130, 148, 157,
 161, 165, 167
 autograph hunters at 158f.
 book collections at 139
 establishment of 128ff., 157, 164
 genealogical spoils at 151ff., 154, 163,
 167

 geography of 156ff., 163f., 165f.
 indigenous objects at 149, 154
 Koran at 135, 141
 librarians at 130, 138, 140
 materials of 157
 naturalia at 149f.
 related to Quiccheberg 151ff.
 restoration of 139, 160f.
 Skokloster shield 35, 159
 spoils in numbers 127, 142ff.
 spoils at 130, 154f., 159, 167f., 170f.
 Wrangel's armoury at 148ff., 167
 Wrangel's books in numbers 139f.,
 144
 Wrangel's books related to Naudé 146ff.,
 157
 Wrangel's library at 95, 100, 127, 138ff.
Skokloster Church 32, 159
Skytte, Johan 99, 102
Sparre, Erik 64
Spegel, Haquin 45
Spoils
 as difficult heritage 3f., 15, 30, 171ff.
 as recycling 46f., 49
 as trophies 128, 155
 classification and description of 18, 20,
 25f., 52, 60, 67f., 73, 88ff., 164, 172
 contemporary definition of 24, 49
 counting of 17f., 20, 75f., 91, 94f.
 epistemological values of 103, 168
 exhibiting of 3, 15, 50
 fabrication of 52
 females as 8, 28
 from Braunsberg 84, 87, 89ff., 101, 103,
 119, 124, 156, 166
 from Frauenburg 76, 87, 89ff., 98, 101,
 103, 108, 124, 156, 166
 from Fredrik von Barnewitz 134f., 145
 from Mainz 69f., 71f., 87
 from Mitau 7, 25, 52fff., 58ff., 66ff., 80,
 91, 156
 from Nikolsburg 98
 from Prague 119
 from Prussia 7, 25, 74, 90ff., 101, 165, 166,
 170
 from Riga 87, 89, 91, 101, 103, 124ff., 156,
 165, 169f.
 from the Rothkirch family 7, 18, 25, 34,
 130ff., 138, 142f., 155, 160, 163, 165

Spoils (*cont.*)
 from Warsaw 47, 71f., 152
 from Würzburg 87, 108, 166
 genealogical meanings of 3, 51, 81, 98, 150, 163, 166f.
 geographical meanings of 3, 35f., 47, 51, 67, 69, 81, 87f., 96, 98, 103, 150, 163, 165f.
 impacts of 81, 88, 91, 110ff., 162, 164, 169ff.
 in Ole Worm's collections 152
 in Polish collections 152
 in Swedish collections 3ff., 171ff.
 inventorying and recording of 17f., 20, 26, 35f., 41, 47, 52, 61ff., 74ff., 80, 88f., 90ff., 142f., 165, 205
 long term perception of 8, 25, 49ff., 172ff.
 material meanings of 3, 51, 61, 89ff., 124, 165
 nationalisation of 17, 50, 161f., 171ff.
 previous research on 4ff., 15f., 172
 restitution of 8, 72ff., 173
 temporal meanings of 51, 113, 114, 167f.
 transformations of 74, 82, 125f., 143, 159f., 166ff., 171ff.
Staiger, Clara 30f.
Stettin 23
Stralsund 143, 156
Strängnäs 22, 42
 Cathedral Library of 95, 110
Stuhmsdorf, peace treaty of 74
Stuthoff 32
Stuttgart 132
Summit, Jennifer 110
Svenska Akademiens Ordbok (SAOB) 26, 45f., 48
Swedish History Museum 50
Swedish National Archives 5, 13, 29, 39, 52, 54, 76, 80, 98, 130, 143
 Rydboholm collection 19
 Skokloster collection 19
Swedish National Heritage Board 14
Syncretism 134

Terserus, Johannes 134
Teutonic Order 58, 62
Tiesenhausen, von, dynasty 62f., 73
Titus Livy 22
Tolfstadius, Laurentius
 organisation of Uppsala University Library 104–111, 114, 126, 135, 146, 166, 169f.

Toll, Robert von 76
Tre Kronor, castle 1, 39, 41, 52f.
 archive at, *see* the Kingdom's Archive
 fire 52, 64, 76f., 96, 123, 160, 195
 royal library at 22, 95f.
 royal treasury at 1, 4, 31, 88, 152
Tremellius, J. G. 134
Trolle, noble family name 1
Trondheim 48
Tübingen 132
Turku 123
Turpin, Adriana 12f.

Ufano, Diego de 137
Ujazdów Castle, Warsaw 156
UNESCO 25
Uppsala University
 chairs 86
 consistory of 19, 99ff., 108, 117ff., 123, 128, 146
 establishment of 21, 87
 students 86
Uppsala University Library 5, 16, 19, 22, 29, 43, 51, 83, 160, 163
 access to 118
 antiqua editio at 109, 113
 as confessional history 128
 as two libraries 112ff., 125f., 138, 168
 at Gustavianum Academy 119, 122, 123
 catalogues and inventories of 88, 98, 104ff., 113, 114ff., 170
 Calvinist books at 107, 113, 114ff., 168
 Catholic books at 105ff., 113, 114ff., 168f.
 challenges of 102–103, 117ff.
 classification of confessional books at 85, 104ff., 110ff., 114ff., 135
 duplicates at 121ff.
 establishment of 85, 87, 98ff.
 Gustavus Adolphus donation of 1620 99, 101
 in Uppsala Cathedral 89, 99f.
 Jesuit books and epistemology at 105ff., 110ff., 168, 170
 librarians at 99, 102
 library building 1627–1691 98, 104f., 118ff., 160, 200
 Lutheran/Protestant books at 111, 114ff., 168f.

INDEX

Uppsala University Library (*cont.*)
 manuscripts of 107ff.
 moving of 101, 115f., 118, 123
 narratives of 112f., 114ff., 124ff.
 objects of 90, 101, 104
 organisation of 85, 88, 101f., 103ff., 116, 164
 safety of 117ff., 123f.
 shelves of 106, 118, 164
 size of 103, 113, 119
 temporality of 112ff., 138, 168
Utter, Per Månsson 56, 64, 72,
 and the Mitau files 61ff., 66, 73, 80, 81, 165ff.
 expertise of 56, 63
 organisation of the Kingdom's archive 61f., 82, 128, 166f.
 letters to Axel Oxenstierna 61ff., 67, 72ff.

Vadstena Abbey 64, 71
 confiscated books from 64, 71, 87, 125
Valdemar IV Atterdag 62
Vasa, royal dynasty 3, 12f., 21, 56, 167
Vatican Library 18
Verelius, Olof 115, 121f.
Veselá, Lenka 172
Virgil 94
Vismann, Cornelia 57
Vossius, Isaac 96f., 119
Västerås 22

Wachtmeister, Axel 52
Walde, Otto 5f., 34ff., 43, 50, 58, 60, 80, 84f., 91, 94, 95f., 133f., 172
Walsby, Malcolm 89, 108f., 113
War
 articles of 28ff.
 between Russia and Livonia 59
 between Sweden and Denmark 3, 21f., 33f.
 between Sweden and Poland 3, 22, 31, 39, 58
 between Sweden and Russia 3, 22, 69, 77
 Great Northern 74, 77, 123
 laws of 24f., 34
 Thirty Years War 1, 3, 13, 26, 28, 30, 40, 43, 44, 50, 151, 159
Westin Berg, Elisabeth 18, 143f.
Westphalia, peace treaty of 1
Whitelocke, Bulstrode 47, 87, 125f., 162, 170
Wierland 62
William V of Bavaria 2
Wittenberg, University and Library 100
Worm, Ole 152
Wrangel, Carl Gustaf 7, 19
 book catalogues of 136, 138, 142
 campaigning of 25f., 33ff.
 collecting bibles 135f.
 collecting handbooks 137f.
 collecting in general 22f., 34ff., 127ff.
 education 129, 137
 in Munich 151f., 156f.
 in Paris 151
 in Ulm 151
 interests 129, 133ff., 137f., 140, 148f., 151
 self-image 129, 153ff., 167
 taking old books as spoils 154f.
 taking spoils 49, 51, 127, 129, 132, 134, 140, 164
 taking the Rothkirch spoils 131ff., 155, 165
 testament of 148, 159f.
Wrangel, Herman 33, 143, 149, 156
Wrangel, Maria Juliana 160f.
Würzburg 2, 50

Zemon Davis, Natalie 128